The World's Top Photographers

A RotoVision Book
Published and distributed by
RotoVision SA
Route Suisse 9
CH-1295 Mies
Switzerland

RotoVision SA
Sales & Editorial Office
Sheridan House
114 Western Road
Hove BN3 1DD UK

Tel: +44 (0)1273 72 72 68
Fax: +44 (0)1273 72 72 69
Email: sales@rotovision.com
Web: www.rotovision.com

10 9 8 7 6 5 4

ISBN 2-94036-101-0

Designed by Becky Willis at Studio Ink
Art Director Luke Herriott
Cover image © 1998 Michael Frye

Printed in Singapore by Star Standard Industries (PTE) Ltd

The World's Top Photographers

and the stories behind their greatest images

Landscape

Contents

Introduction

Welcome to the *The World's Top Photographers: Landscape*, a collection of inspiring images from an international selection of photographers, all of whom are acknowledged as contemporary 'greats' in their field. Along with the pictures are the stories behind each photographer's rise to prominence, and something of the philosophy that lies behind their work, and it's striking to see how much passion and sheer backbreaking hard work lies behind the fashioning of a reputation.

There is no doubt that landscape is one of the most popular photographic subjects of them all. The chances are that virtually anyone who loves the outdoors has tried to shoot pictures that will remind them of some beautiful place that they have visited, but making those images marketable is a different matter. Professional landscape images can be used to sell everything from cars to washing powder, for posters and books, and it's an area that can prove rewarding for any professional photographer.

It is the very popularity of landscape that is also the reason why it's so difficult to break into this area. Anyone picking up a camera and heading for one of the world's great landscape areas – say Yosemite or the Highlands of Scotland – is treading in the footsteps of so many who have gone before. Landscape photography is big business, and a large number of seasoned full-time practitioners live in the area in which they photograph, and know its every mood. To compete is a daunting prospect for anyone travelling in from outside. Perhaps a beneficial effect of this is that many are encouraged to focus more closely on their own environment, and to work in innovative ways to reveal those regions of the globe that are less well vaunted, but equally special.

Photographers who tackle landscape do so first and foremost because they have it in their blood, and are happy to forego the potentially greater income they could earn from other areas of photography because they are driven to head for the wilder parts of the globe. There is also a spiritual element that unites many of the world's leading landscape practitioners, and many see their craft as a perfect expression of their belief in a Creator, and as a celebration of a world that has retained its splendour despite the hand of humankind.

There are all kinds of challenges for those who take up landscape photography full time: the frustration that the weather only rarely cooperates, the long working hours, and having to routinely rise at ungodly hours. They will also realize very quickly that pictures from public access points, such as parking lots or well-trodden footpaths, won't yield the most original pictures. Sometimes it is necessary to trek for miles, usually with a heavy large-format kit, to get to a place where the light might – and only might – come through and produce a moment or two of magic.

For those talented and committed photorarphers who do break into this market, landscape photography promises more than the four walls of a studio ever can; there is the thrill of the chase, the immense sense of freedom, reliance upon initiative, control, and the matchless feeling of achievement when a fleeting perfect moment is captured on film.

The fact is that, however challenging landscape can be, for the world's greatest, there is no choice. Their livelihood is their passion. The great outdoors calls to them, and for many, the picture-taking continues regardless of the remuneration or the circumstance.

Terry Hope

Theo Allofs

Raised in the lower Rhine River area in Germany, Theo Allofs discovered his love for photography while working on the thesis for his Masters degree in geology in the Iberian Mountains in Spain. While it was not central to his studies, he found himself drawn to portraying the remote Spanish villages and their people on film, and after graduation, he decided to make a career as a travel photographer.

In 1990 he and his wife Sabine emigrated to northern Canada, where they built a log home next to the magnificent Kluane National Park in the Yukon Territory. The wilderness surrounding their new home, combined with Allofs' strong interest in nature, inspired him to do what he had always longed to do, and in 1996 he finally decided to become a full-time nature photographer.

"I love taking pictures of landscapes and wildlife," he says. "I prefer working in regions which are not so well-known and over-photographed. It is no great challenge turning the Grand Canyon into a beautiful image. There is beauty and greatness in everything. It is up to our eye to discover it and express it meaningfully in our photographs."

Allofs now spends up to eight months of the year travelling to some of the most remote corners of the globe in his search for locations and subjects that excite him, and he is always striving to produce images that reflect his personal interpretation of a scene. It has not been unusual for Allofs to spend six months living in a tent, such is the isolation of his photographic destinations, but he considers the lifestyle to be an essential part of his job and relishes the challenge of taking his cameras to new and exciting places.

"Although I travel much, I never travel light. Even if I leave the vehicle for a short hike into the forest, I usually carry a heavy camera backpack with about 25kg (55lb) in it, discounting the weight of the tripod. I don't want to be caught in a situation where a missing lens causes the loss of a great photographic opportunity. Among my favorites are tilt and shift lenses, because these enable me to get both foreground and distant subjects in focus without closing the aperture down too much, which results in loss of image quality," he says. "However, I find that I use all kinds of lenses throughout my landscape work, everything from a 16mm through to a 300mm and sometimes a 600mm. I simply pick the lens to suit the occasion."

Allofs' images have received winning and highly commended awards in the BG Wildlife Photographer of the Year Competition in 1996, 1998, 1999, and 2002, as well as in numerous other international competitions, such as the South African Agfa Wildlife Awards and Nature's Best Photo Contest in the US.

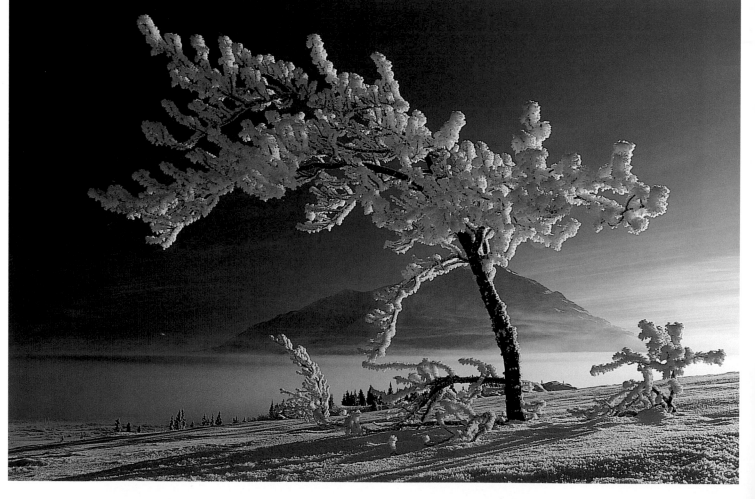

Kluane National Park, Yukon, Canada
"When I took this picture near my home, the temperature was about -30°C. It shows a young poplar tree covered with thick hoar frost that built up over a period of several extremely cold and foggy days. I preferred a position from where I could photograph the tree backlit to enhance the sparkling of the myriad ice crystals."

Nikon F5, 20-35mm zoom lens, Fujichrome Velvia

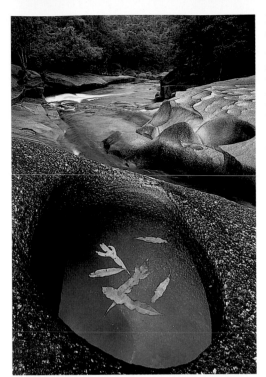

Boulders, Queensland, Australia
"I love photographing rocks, water, and rainforest. Here, at a rainforest creek in northern Queensland in the heart of Australia's wet tropics, I found a harmonious combination of all three elements. After some scouting I discovered a beautifully shaped pothole with leaves in it and used it as a strong graphical foreground that leads the viewer of the image deep into the rainforest gorge."

Nikon F5, 20-35mm zoom lens, Fujichrome Velvia

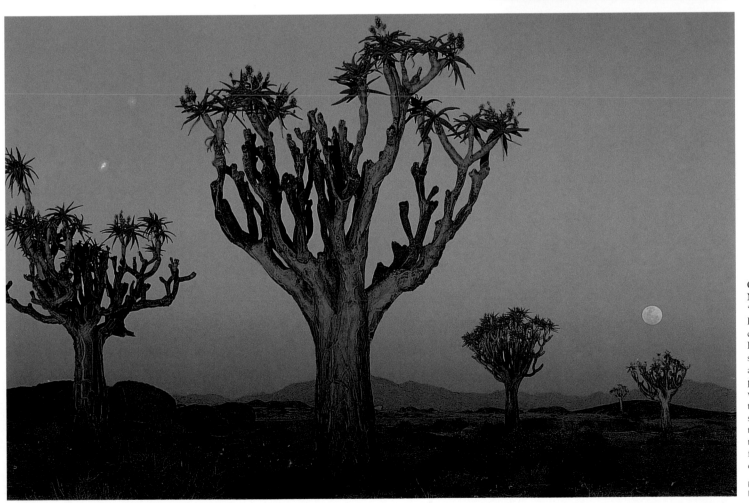

Quiver trees, Namib Desert, Namibia
"While hiking in the Namib Desert I found this group of quiver trees (*Aloe dichotoma*). I was fascinated by their bizarre shape and arrangement and wondered how best to photograph them. I decided to wait for the sunset to see how the light would enhance the scene. Just when the sun was touching the horizon, I pressed the shutter, and miraculously a full moon had risen behind the quiver trees."

Nikon F4, 80-200mm zoom lens, Fujichrome Velvia

Theo Allofs

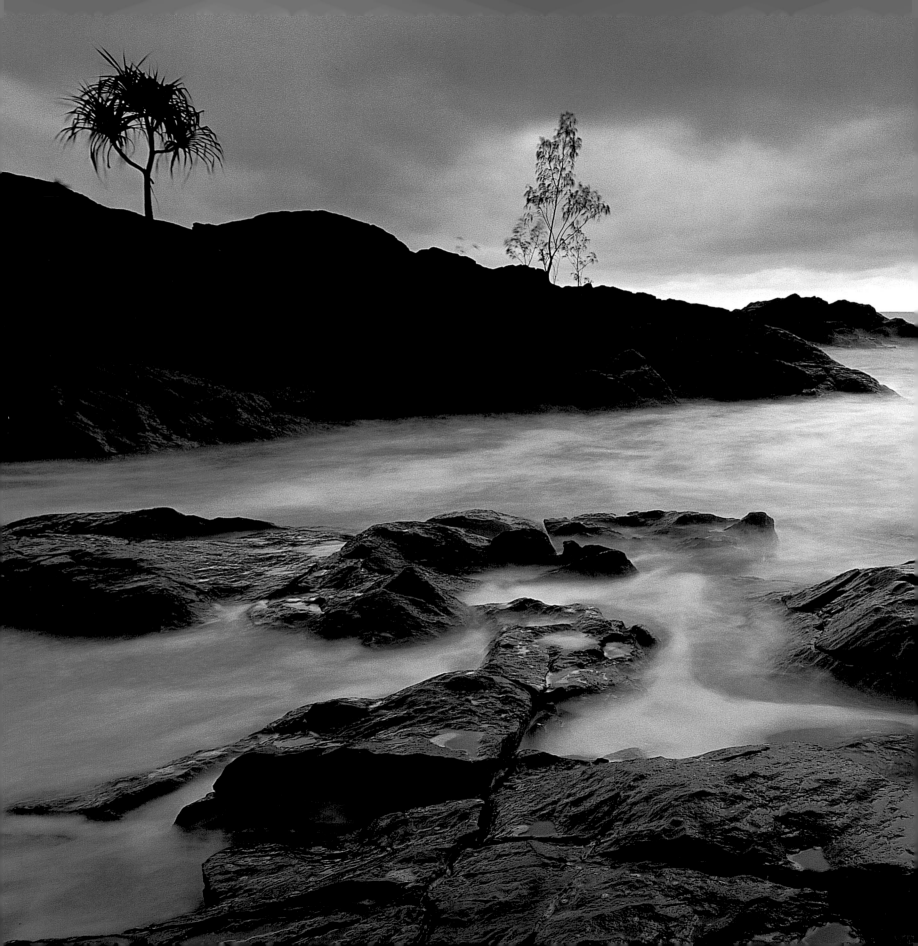

Waves on rocky shore, northern Queensland, Australia
"I have been on photographic assignments in Australia's tropical rainforests seven times over the past few years. Every time, I visited an idyllic spot south of Cape Tribulation to relax for a couple of days on a beach fringed with dense rainforest. While the beach is picturesque and invites great travel brochure photography, I've never favored the idea of capturing clichés on film. I personally dislike photographing white beaches with palm trees and a blue sky. Without success I walked up and down the beach with camera bag and tripod numerous times to find an angle for a picture that would keep this place fondly alive in my memory.

"Finally, during my most recent visit – I was staying in a campground near the beach – I was leaving the tent one morning when the weather was gray, drizzly and cold. I decided to shoulder my camera pack including the tripod to walk to the northern end of the beach where a rocky outcrop with scattered pandanus palms extends into the sea. A tropical storm was brewing, with heavy, dark clouds chasing across the sky, and the world around me seemed to be all black, white, and gray. Suddenly I realized that here was the drama I had always desired at this place where the rainforest meets the sea. When I looked at the results later, I knew that I had managed to produce an image of this area that summed up all my feelings about it."

Canon EOS 1V, 28-70mm zoom lens, split neutral density filter to darken the sky, Fujichrome Velvia

Theo Allofs

Catherine Ames

Photography has always been in the blood of American landscape photographer Catherine Ames. She started taking pictures seriously at the age of 11 and was processing her own film and making prints by the time she was 14. "I was doing it for me, for my own existence," she says. "I felt that there was always something waiting to be discovered, and I put together photographic journals to which I would add a collage or an image every single day that related to something that had happened during that period."

Largely self-taught, she learned simply through experience and by attending a few classes that interested her. Later she worked as a catalog photographer at an auction house in San Francisco for seven years, and then she became part of a communal photographic business that accommodated 15 photographers whose diverse specialisms covered everything from table-top work to editorial.

Having children brought an end to working full time, but it gave her the opportunity to concentrate on her fine art work and to build up her portfolio; since the late 1980s this has led to major gallery representation in several cities in the United States and a string of individual and group shows.

While she doesn't like to be categorized, landscape has always fascinated her because of the endless variety of subjects that can be found in nature, and she has searched for a style that allows her to express an original message. "Many people are interested primarily in taking photographs of other people," she says, "and that's not at all where I'm at. Photography is not a social thing with me; I find that there is a certain purity to being alone, which allows the creative processes to work, and landscape enables me to achieve that. I can't concentrate on my vision at all if there are people around me."

The camera she uses has much to do with her choice of working methods. "I've got a 4x5in Crown Graphic Graflex that dates back to the 1950s," she says. "It's the same type of camera that Weegee used, and the actual concept pre-dates the Leica 35mm camera. I bought it for $100 in the mid-1980s, and I like it because it's a remarkably compact field camera, and I can carry the camera outfit plus dark slides comfortably on my back, and can go on pretty extensive hikes without any problems. It's the most lightweight kit for large-format that I can think of."

Having moved to New York with her family, Ames was directly affected by the September 11 attack; her apartment in downtown Manhattan was severely damaged in the tragedy. She moved to London, which meant leaving behind her darkroom. She used the opportunity to seek out other methods of continuing her work, and has now made the move into inkjet printing. "I will go back to conventional black-and-white printing one day," she says, "but for now I'm enjoying what new technology can offer me, and it's added another dimension to my work."

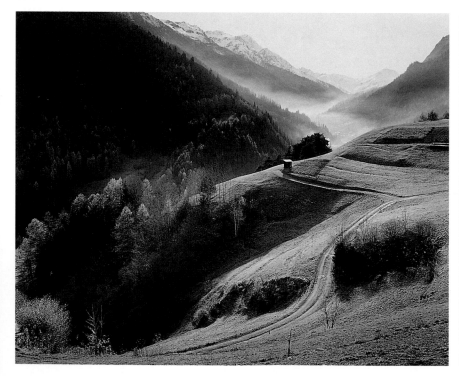

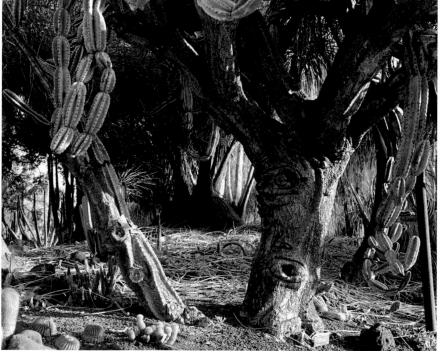

Val Ferret, Switzerland, 1994
(*Facing opposite, left*)
"This is in the Valais of southern Switzerland, in the Alps. It's an image you can't skim over; rather it draws you in, because there are so many different layers and tones within it."

Crown Graphic 4x5in field camera, 124mm lens, Kodak T-Max film

Desert underbrush, Huntington Gardens, Los Angeles, California, USA 1997
(*Facing opposite, right*)
"This image was made in the Huntington Gardens in Los Angeles; it was a hot day and the light was very white. I set the camera up very close to the ground to produce an image that was all about heat and life in the desert."

Crown Graphic 4x5in field camera, 124mm lens, Kodak T-Max film

Funnel cloud, Wellington, Nevada, USA, 1991
"I was travelling all over the southwest of the US and was heading back to San Francisco, driving through the southern California desert. We were just leaving my aunt and uncle's cattle ranch in Smith, Nevada. There is a lot of scope to use the sky in a picture in this area. I just saw this incredible cloud, which is the type that you get when a storm is coming, and I used a red filter to darken down the sky and to highlight it still further."

Nikon F3, 50mm lens, Kodak Tri-X film

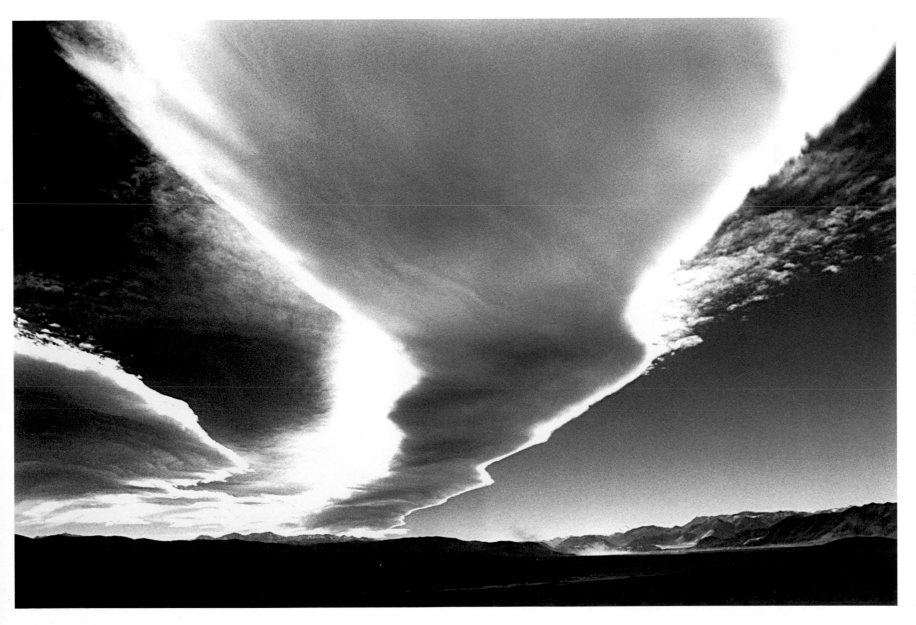

Catherine Ames

Dark woods, Switzerland, 1994

"One of my favorite things to do was to get in my car and drive around looking for locations that I thought would be good for landscape photography. I would effectively live in the car for weeks on end as I explored a specific area, and I loved the lifestyle because I really enjoyed the experience of being surrounded by nature and of getting myself as far away as possible from the crowds.

"I would never achieve a huge quantity of images on these trips. I once worked out that I averaged around 100 miles of driving for every photograph that I took, and I would only come back with something like five to eight pictures from a trip that may have lasted two weeks. It was a very slow and lengthy process, but one that was very satisfying.

"This picture was taken on one of those expeditions, to Switzerland. I have a lot of roots there and had visited many times before on vacation, and so I knew the country very well. This particular location, close to the Val de Travers, is in the Jura Mountains near the French border, which is where my mother and her ancestors were born. As I was driving along, I saw these rays of sunshine coming through the woods and realized that I was witnessing an amazing moment.

"I jumped for the camera and just hoped that I might have enough time to capture the scene before it disappeared. I managed to make just two negatives, each at a different exposure."

Crown Graphic 4x5in field camera, Kodak T-Max film

Andris Apse

Andris Apse became involved with photography in 1963, when the young Forest Service woodsman landed himself a job with the Forest and Range Experiment Station in Rangiora, near Christchurch in New Zealand. The role took him on surveys to the vast and remote wilderness of Fiordland, and brought him into regular contact with the renowned Forest Service photographer John Johns.

On the survey trips to Fiordland and to the North Island's Kaweka Ranges, he quickly fell in love with New Zealand's unspoilt natural wilderness, which seemed to him infinitely preferable to the regimented rows of the production forests. In particular, he found Fiordland wonderfully wild and empty, and was totally overwhelmed by its scenic beauty and grandeur.

It was natural that Apse should turn to photography as a means of trying to capture this enchanting landscape. Accordingly, he acquired the first of his many cameras, an Agfa 'Clack', which, over the next few years went everywhere with him. Slowly, he taught himself the basics of his craft, and learned that there was a great deal more to landscape photography than simply pointing the camera and pressing the shutter.

The interest grew, and in 1970 Apse bought a photographic business in Rangiora and embarked on a career as a professional photographer. In order to survive the early years he undertook a stream of commercial work, including portrait, passport, and wedding photography, which meant that trips to the wilds were few and far between.

However, in 1978 he purchased a Linhof Technorama panoramic camera, capable of producing 6x17cm images that, at the time, was the only camera of its type in New Zealand. Its $5,000 price tag was an enormous investment for a small-town photographer to make for a single piece of equipment, but it was the perfect tool for an aspiring landscape photographer, and Apse took advantage. He used it to build a portfolio of images that finally started to get him noticed on an international basis.

His real breakthrough came in the early 1980s and, after spending a year travelling through Chile with his young family, he decided that the time had come to devote himself full time to landscape photography, concentrating on his native New Zealand and, in particular, the Fiordland region that had originally inspired him. From this point onward, he has never looked back, and he is now acknowledged as one of New Zealand's most successful and innovative landscape photographers.

Clifford Bay, Marlborough, New Zealand (*Facing opposite, bottom*)
"This is a view from Cape Campbell lighthouse. I stayed in the area for about a week and, on the night the image was taken, I waited until well after sunset so that I could use a very long exposure to achieve the pastel tones that I was after, while allowing the movement of the sea to flatten out the detail and to give the image a smooth, soft, plastic texture."

Fujifilm GX617, 180mm EBC Fujinon lens, Kodak E100VS 120 rated at ISO 100

Tennyson Inlet, Marlborough Sounds
"This is a site I have visited many times, and often I have found myself waiting in vain for some 'character' to lift the scene. On this occasion, however, the density of the fog was perfect, allowing me to record both the sun rising and the highlight detail of the background. This image is an example of how the Global Positioning System enables navigation. It has proved invaluable in determining exact sunrise/sunset/moonrise times and magnetic bearings, allowing me to achieve the effects I strive for. It's also great for finding your way back to camp, or for 'fixing' a photographic location."

Linhof Technorama 6x17cm, 90mm Schneider Super Angulon lens, Fujifilm Velvia 120 rated at ISO 50

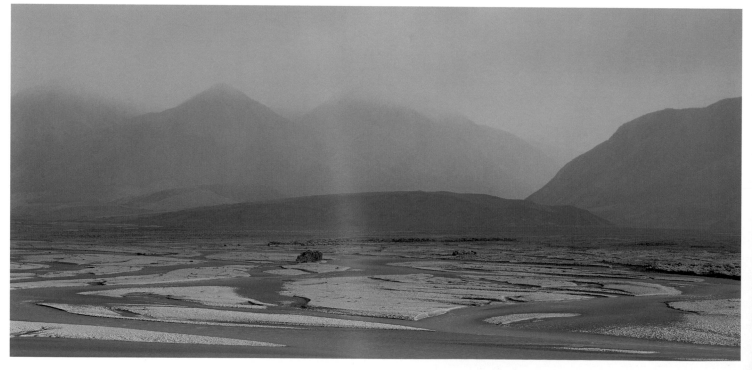

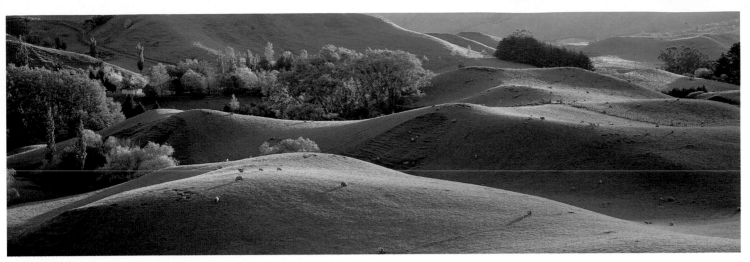

New Zealand farmland
"I was on the Central North Island of New Zealand near Taihaper for a week, and was fascinated with this beautifully undulating scene. With the Global Positioning System I determined where the sun would be morning and evening, and visited the spot twice a day for four days waiting for the right lighting conditions."

Fujifilm GX617, 300mm EBC Fujinon lens, Fujifilm Velvia 120 rated at ISO 50

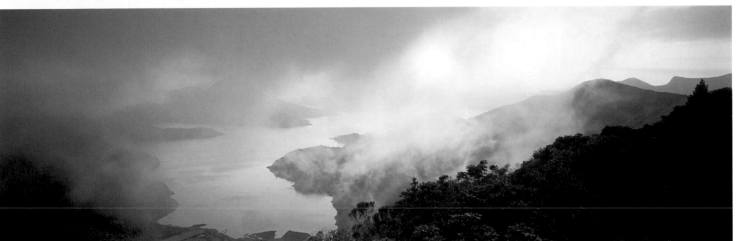

Breaksea Sound, Fiordland National Park, New Zealand
"Although I have spent over 500 days in this park, I had never experienced the soft misty light that confronted me one morning. I was lucky because a friend of mine had flown me into the area in his helicopter, giving me two days in which to take pictures from the air, and these conditions occurred during this brief period."

Pentax 6x4.5cm, 300mm Pentax lens with a camera stabilizer, Fujifilm RDP 120 rated at ISO 100

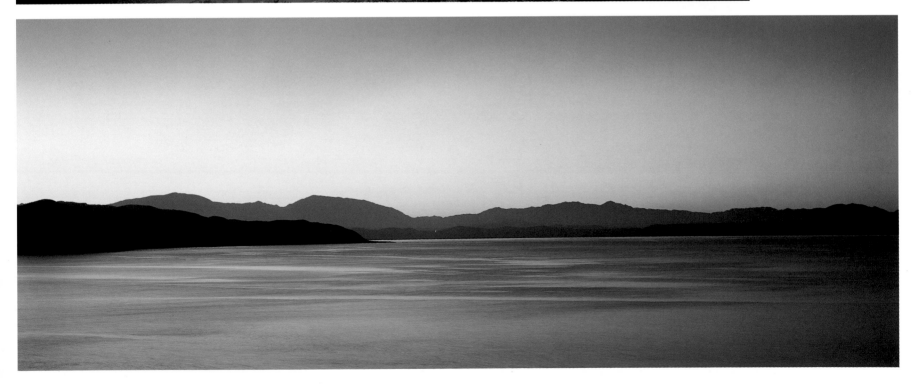

Andris Apse

Wandering albatross, Adams Island, Auckland Islands, New Zealand

"I was camping on Adams Island in the Auckland Island group for six weeks photographing the wildlife and landscape. This is a nature reserve 460km (285m) south of New Zealand and, at a latitude of 50°29 South, the islands are right in the path of 'the furious 50s' winds. Gale-force winds that are impossible to stand against are common. I walked the coastline of Adams Island for a week looking for a single image that would reflect the character of the island.

"The spot I chose was South Cape, an incredibly scenic area of coastline where cliffs 396m (1,299ft) in height provided a dramatic backdrop. I camped for five days in a gully about 300m (984ft) from the site and waited for the right conditions. During that period I experienced the full range of subantarctic weather: snow, sleet, hail, rain, and wind. On two occasions, during brief calm periods, my camera and I were so rain-saturated that a photograph was impossible. Each downpour required a two-hour session in the tent drying camera parts over a stove fired by white spirit.

"Eventually, I got the image, shooting close to sunset in between southwesterly fronts, and the inclusion within the frame of a wandering fledgling albatross was the final element that I had been looking for. The next downpour, with its accompanying gale-force winds, can be seen approaching on the right. For me this was the best image of the expedition. In this one image I believe that I've portrayed the character of the island: the isolation, wildlife, and the dramatic weather changes for which this area is famous."

Linhof Technorama 6x12cm, 65mm Schneider Super Angulon lens, Fujifilm RDP 120 rated at ISO 100

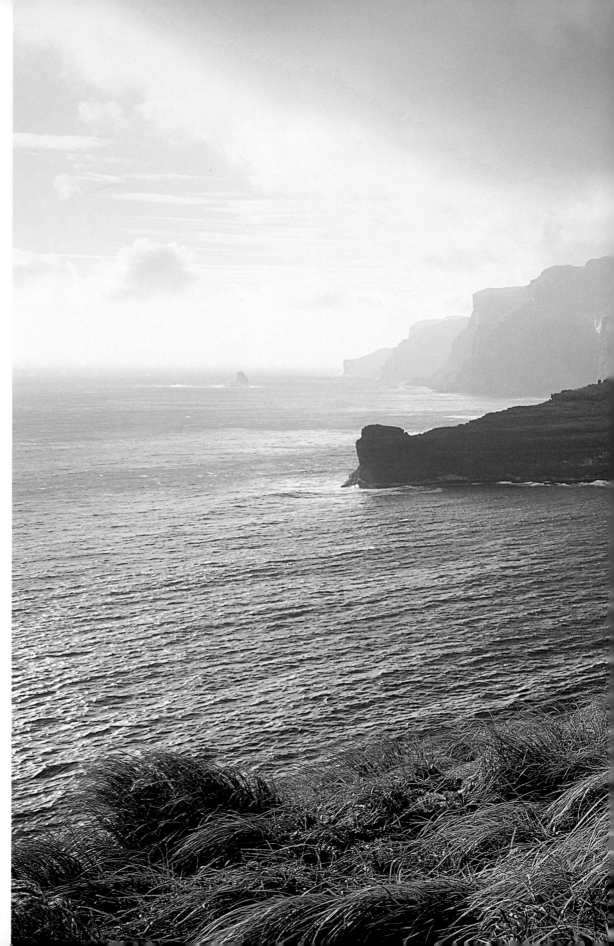

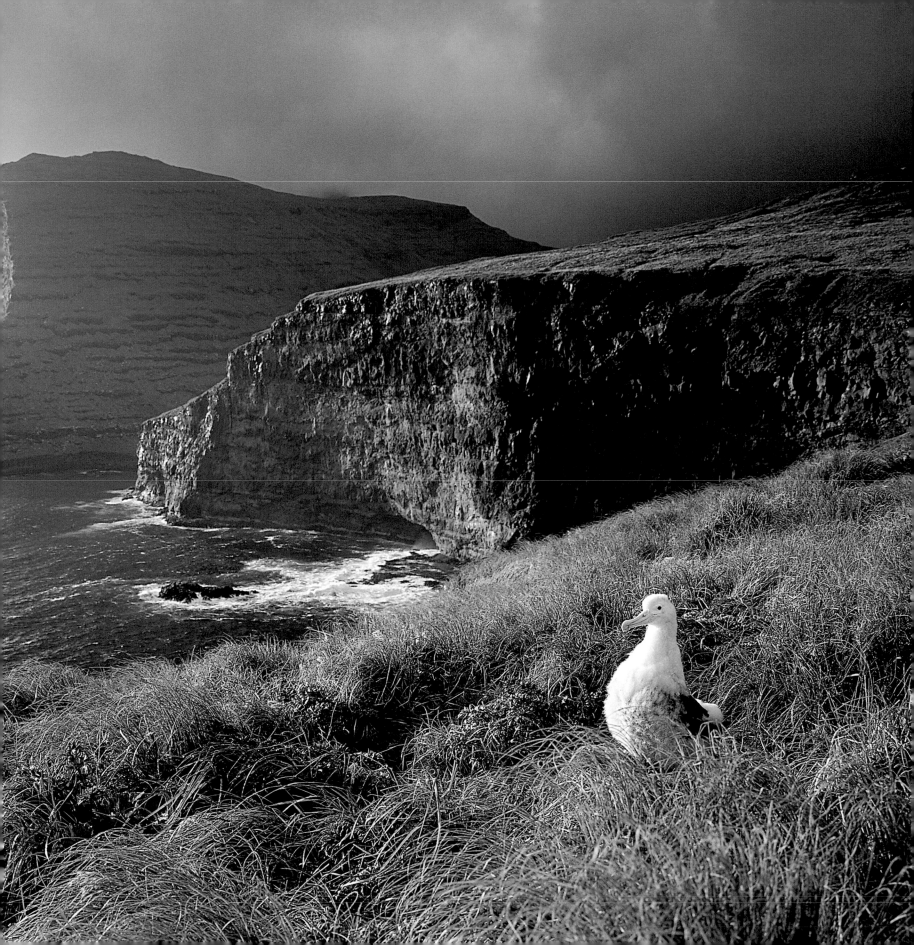

Yann Arthus-Bertrand

The thing that Yann Arthus-Bertrand is very insistent about is that, despite the exquisite landscape photographs that he produces, he is not a dedicated landscape photographer. "The real landscape photographers are the ones who work alone with a large camera and a tripod and sleep in a tent so that they can be in the right place at the right time to take their pictures," he says. "I'm not like that at all; I fly in a helicopter and ask the pilot to take me to the places where I want to go, and my main problems are not technical, they are mainly concerned with getting the necessary permission to fly in the places where I want to go."

Born in France in 1946, Yann Arthus-Bertrand was established long before his much-acclaimed 'Earth from the Air' series, but he started out on his career much later than most. He was 30, and had moved with his wife to Kenya to study lions in the Masai Mara Reserve, before he first picked up a camera in earnest.

"I was doing a thesis on the lions and wanted to photograph them as part of that," he says. "I saw at this time that photography was capable of providing information that it was not possible to convey through writing. This is what attracted me because I wanted to explain things, and I've always just seen myself not as an artist, but as a photographer who is a witness to things."

While in the Masai Mara he took a flight over the reserve in a hot air balloon and found the view that he got was extraordinary: "I discovered how important aerial photography was in terms of offering me a new perspective on the territory where the lions lived," he says. "After that I decided to become a photographer full time."

On his return to France he became a photojournalist specializing in adventure and nature photography, and he covered stories such as the Paris–Dakar rally and the activities of naturalist Dian Fossey and her reserve for gorillas in Rwanda. By the time he began working on 'Earth from the Air' he had produced 50 books and was contributing to the world's top magazines. It was contacts that he had built up through his career, together with his reputation, that enabled a project as comprehensive as 'Earth from the Air' to

get underway. "It was always going to be a very expensive thing to do," he says, "because it involved travelling all over, spending time getting permission to take the pictures."

In total he spent ten years carefully researching the landscapes that he wanted to include, and then flying over 76 countries, clocking up 3,000 flying hours. The project involved travel to Antarctica, Alaska, southern Argentina, Australia, Siberia, and Africa, and it is still ongoing. He shoots nearly all his pictures from a helicopter because this gives him the chance to maneuver around his subject to get the right angle, and he hand-holds his Canon EOS 1 or Pentax 645 cameras so that he can quickly adjust his composition. The film he uses exclusively is Fuji Velvia.

The motivation for the project was not a desire to produce beautiful pictures; rather it was to promote environmental awareness, about which Arthus-Bertrand is passionate. It's why he is so keen for the exhibition of images that he has produced to travel the world and to be seen by as many people as possible.

"At any one time there are 20 big exhibitions of the pictures from 'Earth from the Air' on display around the world," he says. The exhibition that I put up on the railings of the Jardin du Luxembourg in Paris in 2000 had two million visitors, and there have also been around two million copies of the book sold."

It's a satisfying achievement, but the real success of the project from the point of view of this photographer would be if the pictures that he has produced managed to change attitudes and to convince more people of the urgent need to safeguard the future of the planet.

Bora Bora, French Polynesia
Bora Bora is 15 square miles in area, and is made up of the emerged portion of a crater of a seven-million-year-old volcano, and surrounded by a coral reef. Motus, coral islets covered with vegetation consisting almost exclusively of coconut trees, developed on the reef.

The lagoon's only opening to the sea is the pass of Teavanui, which is deep enough to allow cargo and war ships to enter.

As with most of the coral regions of the world, the waters of Bora Bora are rich in biological diversity; more than 300 different fish species have been identified.

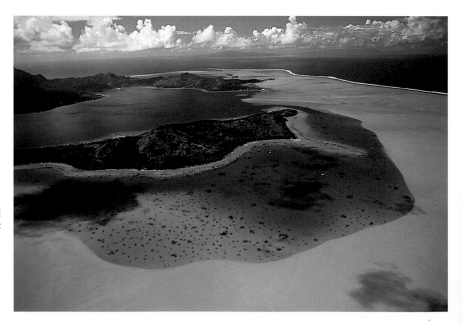

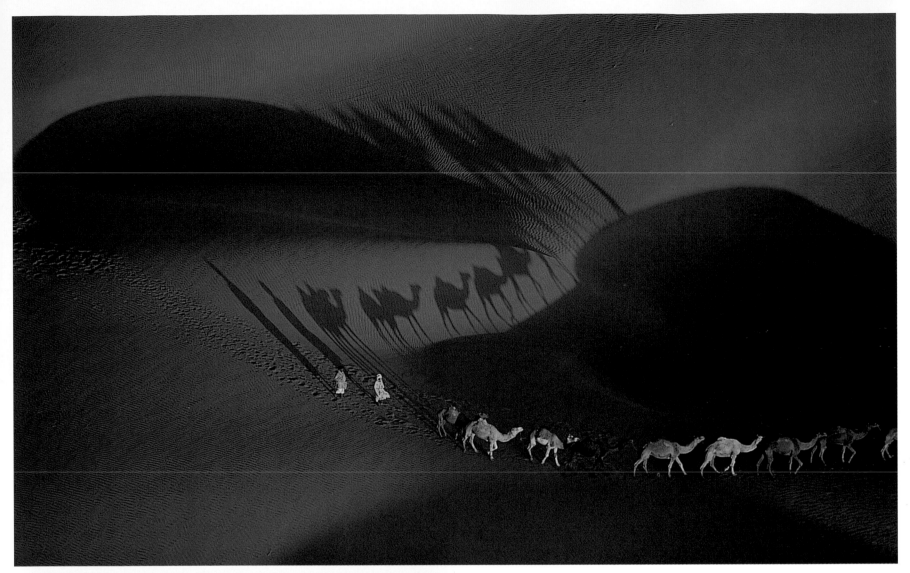

The Eye of the Maldives, atoll of North Mali, Maldives
The Eye of the Maldives is a faro, a coral formation on a sunken rocky base, revealing a ring-shaped reef that encircles a shallow lagoon. Coral can only form in water of a relatively high temperature, and thus atolls develop, principally in intertropical regions.

The Maldive Archipelago in the centre of the Indian Ocean is composed of 26 large atolls comprising more than 1,200 isles or islets. The lowest country in the world, with a high point of 2.5m, the Maldive Archipelago has suffered the devastating effects of several tidal waves. If the ocean levels were to rise it would be the first territory to be submerged.

Dromedary caravans near Nouakchott, Mauritania
In Mauritania, as in all countries bordering the Sahara, the dromedary proves to be the domestic species best adapted to the arid conditions. This animal can do without water for many months in the winter. In summer, however, because of the heat and expended effort, the dromedary can last only a few days without drinking; by comparison, a human would die of dehydration within 24 hours. The reserve fat contained in its single hump helps thermal regulation, allowing the dromedary to withstand the heating of its body without needing to perspire to cool down. The Maurs, the ethnic majority in Mauritania, raise the dromedary for its milk and meat as well as its skin and wool. In the late 1990s, the country's dromedary livestock equalled about one million.

Yann Arthus-Bertrand

Grand Prismatic Geyser, Yellowstone National Park, Wyoming, USA

Situated on a volcanic plateau that straddles the states of Montana, Idaho, and Wyoming, Yellowstone is the oldest of the US national parks.

Created in 1872, it covers 3,500 square miles (9,000 km²) and contains the world's largest concentration of geothermal sites, with more than 3,000 geysers, smoking cavities and hot springs. Grand Prismatic Geyser, 360ft (112m) in diameter, is, in area, the park's largest thermal basin, and the third largest in the world.

The color spectrum for which it is named is caused by the presence of microscopic algae, which grow faster in the hot water at the centre of the basin than at the periphery, where the temperature is lower.

Declared a world heritage site by UNESCO in 1978, Yellowstone National Park receives an average of three million visitors a year. The United States and Canada contain the world's five most frequently visited natural sites, and the continent of North America receives more than 100 million tourists annually – more than one-fifth of world tourism.

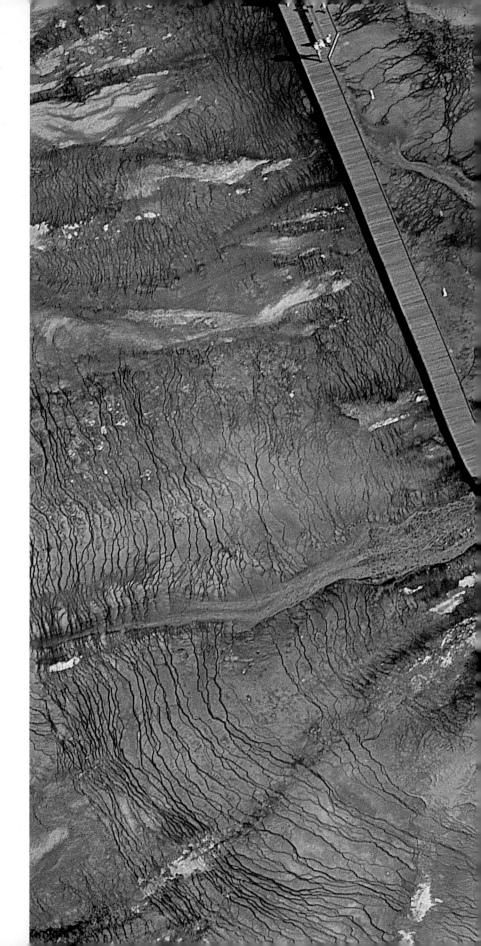

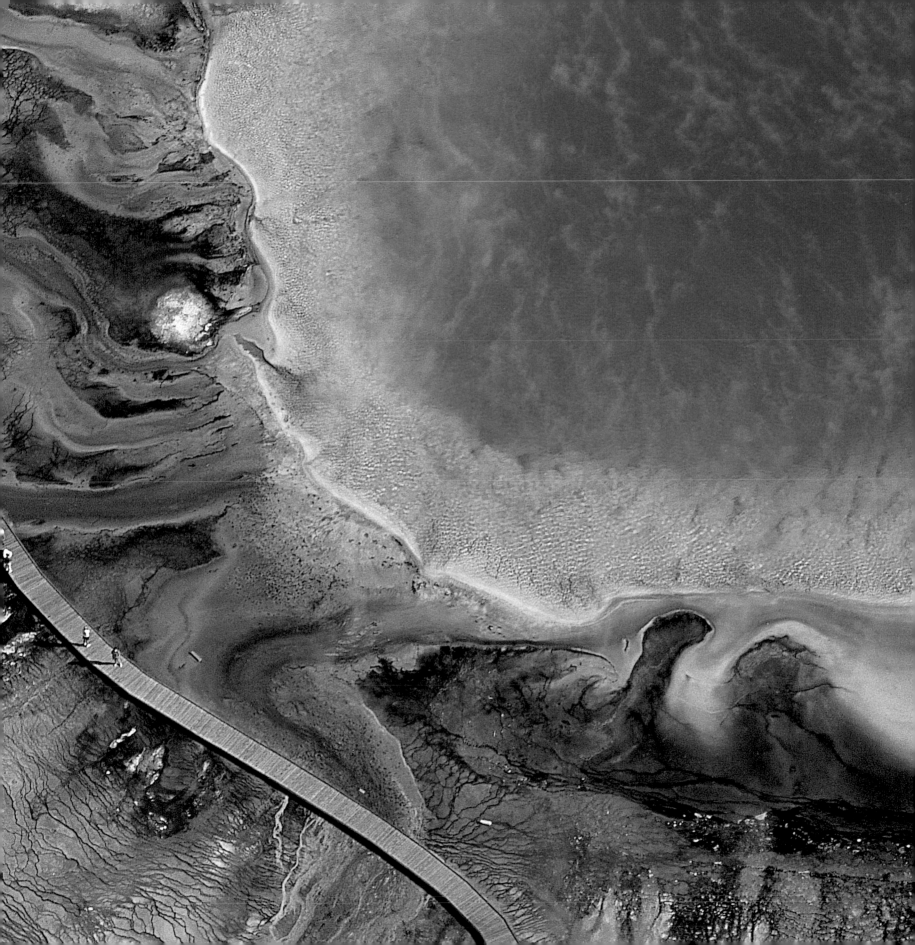

Niall Benvie

Born in Angus, Scotland, in 1964, Niall Benvie was fortunate enough to grow up in a area surrounded by countryside, and it encouraged him to take an interest in landscape from an early age. After leaving school he worked on his family's fruit farm near Friockheim and later decided to take an honours degree in geography at the University of Dundee.

"I had started to get interested in photography long before this," he says, "but felt that the four years required for a degree course would have been wasted since there was nothing geared towards landscape photographers at that time. Geography, on the other hand, encompassed different subjects that I was interested in, and it served to give me a much better all-round education."

While at university Benvie founded and organized the first Scottish Nature Photography Fair, an event that was taken on, and is still run today, by Scottish Natural Heritage. This quickly established a reputation among those who sought a forum where the range of issues facing nature photography could be discussed, and where it was possible to meet some of the world's greatest practitioners.

"The fair was my way of having a legitimate excuse to get in touch with professionals and to meet with others who were tackling similar areas to myself," he says. "It was also a good way for me to deal with magazines who were interested in covering the event, and it helped me to get my first pictures published."

Since graduating in 1993, Benvie has produced many exquisite landscape images of his native country, but has found himself increasingly questioning his approach and what he sees as the poor biological condition of the Scottish countryside. "On the face of it," he says, "there are few places in the world that can match Scotland for natural beauty. But when you look harder you start to realize how biologically impoverished this area is compared with west Norway, Latvia, and Estonia.

"You have to ask yourself where all the trees are, and the diversity of wildlife that would go with that kind of environment. In its natural state the landscape of Scotland shouldn't look the way it does, and that troubles me a little.

"I also think that it's really quite hard for me to keep returning to an area of landscape where I already feel that I've achieved work that I'm fairly satisfied with. Some of the most popular areas of Scotland are being worked by so many other photographers and they raise the profile to the point where it's difficult for me to see how I can get anything that's different."

He also finds himself taking a hard look at what he can achieve through his landscape work. "It's easy to get into a way of working where all you produce is pretty pictures," he says. "What I am more interested in is the relationship between people and the land, the stories behind the pictures, and what is contained within the scene beyond its straightforward appearance. I think it's gratuitous to have an image that is simply nice to look at; I hope that some of my work will still have something to say years from now."

For these reasons he's found himself travelling more to find the kind of landscapes that he relishes, and Estonia and Latvia have become regular destinations. "These are much more productive places for me," he says, "because they are far more unspoilt and, consequently, there are a lot more things to photograph, which allows me to achieve much more in a shorter space of time."

He has not completely turned his back on Scottish landscape, however. "It's still a beautiful place," he concedes. "And sometimes when I visit the Highlands and the light is particularly wonderful I think to myself that, really, I still do like this place."

Haystacks, Latvia (*Below*)

"I was up very early one morning trying to photograph a Ural Owl and, while this was ultimately unsuccessful, it meant that I was around as the early morning sun hit the landscape. When I saw these haystacks I thought that they would make a good picture, but my first feeling was that the picture would be better from the other side. Eventually, however, I realized that this viewpoint, where the haystacks were still in shadow and the trees beyond were picking up the sunshine, was more interesting."

Hasselblad Xpan, 45mm lens, Fujifilm Velvia

Sea ice in fjord, Lofoten Islands, Norway

"For this picture of sea ice, taken in a fjord near Sennesvika on the Lofoten Islands in Norway, I was very much trying to accentuate the blues that were already inherent in the scene. So, although it was quite a bright sunny day, I was creeping around the edge of the fjord, concentrating on the areas that were in shadow. By cropping in tight so that there is no reference to scale, I was able to make this image more of a celebration of form and shape."

Nikon F4, 28mm lens, Fujifilm Velvia

Rotten oak, Moricsala Island, Latvia (*Facing opposite*)

"This is an area of ancient forest that hasn't been cut in 300 years, and it's in a strictly protected nature reserve. I got permission to go there. On the morning I visited, it was raining heavily, conditions that seemed to enrich the greens within the scene. This, in turn, made the brown of the wood stand out more vibrantly, and gave me a good color contrast. It was taken with the Hasselblad Xpan: this is a 35mm model which, to me, is much more flexible than a format such as 6x17cm. I can get 21 exposures at 24x65mm on a 36-exposure film, for example, rather than the four images that can be achieved on a 120 rollfilm with 6x17cm, and that means that I can shoot off a roll of film without worrying too much about the cost of materials."

Hasselblad Xpan, 45mm lens, Fujifilm Velvia

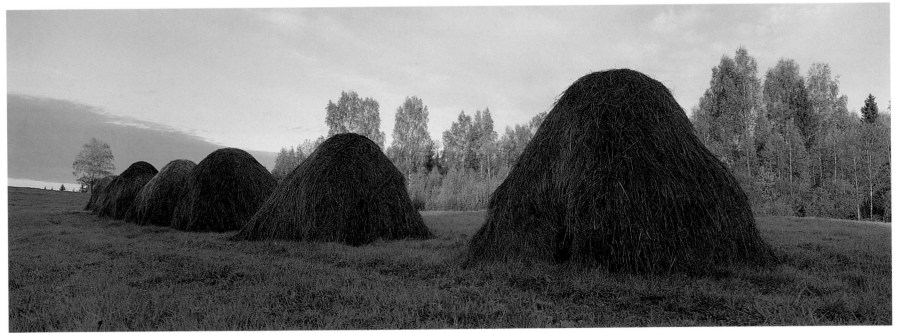

Niall Benvie

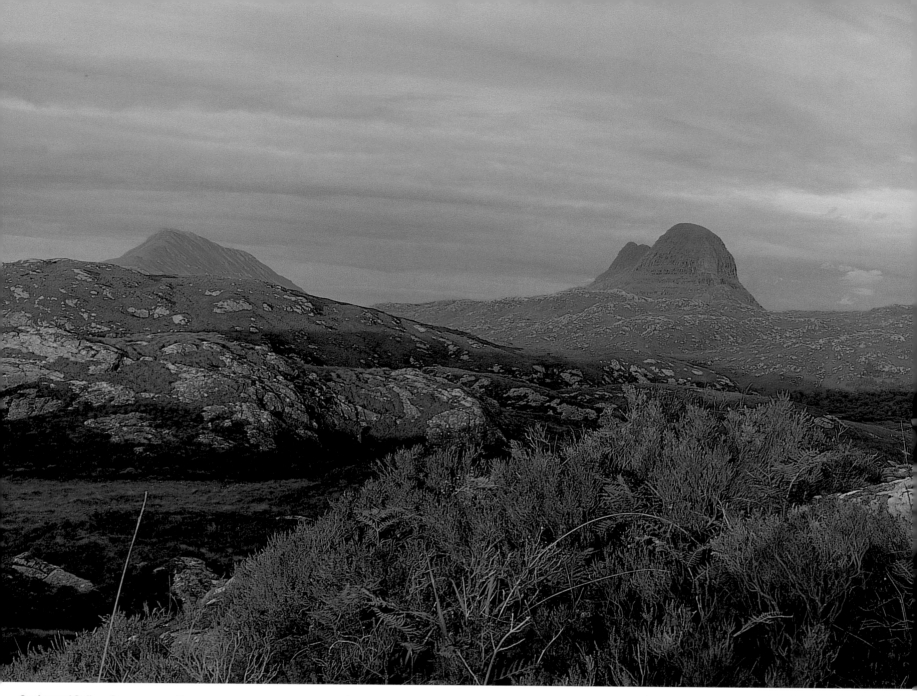

Canisp and Suilven from near Lochinver, Sutherland, Scotland

Scotland still inspires Niall Benvie, particularly if he's travelling to an area of the country that he hasn't visited regularly. "This picture was taken in the northwest Highlands," he says, "somewhere where I hadn't photographed for about 15 years. I decided to spend a week in the region scouting for pictures, and was particularly keen to obtain some good images of Canisp and Suilven.

"Although not particularly high mountains – and, consequently, not so regularly photographed – they are very dramatic in terms of their setting, rising from a surrounding area that's very low-lying, and all around this region they keep coming into view. I spent

some time looking for a good vantage point, and finally came to this place, just about a mile by road from where I was staying, with another half-a-mile's walk to achieve the position that I wanted.

"Although the image is full of browns and has quite a fall feel, it was, in fact, shot in the middle of summer. Because Scotland is so far north, at this time of year the days are incredibly long; the sun is up by around 4am and hasn't fully set until around 10.30pm. I'm a real sucker for the full-blooded light that can be found at the start and toward the end of the day, and so I made sure that I was in position as the sun started to set.

"This picture was taken at around 9.40pm, and there really is a very small window of opportunity when the light is absolutely perfect for landscape, perhaps just five to ten minutes before the

sun actually goes down, and you have to be ready and waiting to take advantage of that.

"Although it looks like a classic pretty picture of a Scottish landscape, from my perspective, as a botanist, it says more than that. I can't help seeing how stripped of vegetation this scene is and, to me, it's not a picture of hope or inspiration, but one that's just a little bleak."

Hasselblad Xpan, 45mm lens, Fujifilm Velvia

Niall Benvie

Jim Brandenburg

Jim Brandenburg began his career as a natural history photographer and filmmaker while studying at the University of Minnesota, Duluth. He went on to become picture editor of the *Worthington Daily Globe* in southern Minnesota and, at the same time, began freelancing for *National Geographic* magazine; his first story was published in 1980.

Since that time he's become one of the world's most respected practitioners of the art of landscape and wildlife photography, producing a further 18 features for *National Geographic,* along with 19 books and innumerable television features.

He lives in an area of the United States renowned for being a wild, unspoiled tract of land. The town of Ely is close to the border with Canada, situated on the edge of the Boundary Waters Canoe Area Wilderness, which consists of three million acres of protected land, with further land, the Quetico Provincial Park, in Canada. Within a 30-mile (48km) radius of his home, Brandenburg has access to over 1,000 lakes, and the whole region is teeming with wildlife.

While Brandenburg's best-known subject may be the wolf, he's covered a vast range of subjects over the years, and picked up an impressive list of awards. He was twice named 'Magazine Photographer of the Year' by the National Press Photographers' Association (NPPA), and has won the BBC Wildlife Photographer of the Year. In 1991 he was also the recipient of the World Achievement Award from the United Nations Environmental Programme in Stockholm, Sweden.

One of Brandenburg's most lauded projects, 'Chased by the Light', involved taking a single picture a day for 90 days between the fall equinox and the winter solstice. Published in *National Geographic* in 1997, it represented the largest publication of photographs ever used in one feature in the magazine's history and, impressively, was achieved using the minimum of film. The working method is close to Brandenburg's heart; to really penetrate and understand the significance of a subject before pressing the shutter. The approach took him right back to basics, and reminded others that simplicity can be key to great imagery.

Brandenburg has long been a Nikon devotee, and currently his main cameras are Nikon F100s and 90s. "I don't tend to use the F5," he says, "because I travel around a lot in a canoe and if my camera was to fall overboard it would cost a fortune to replace it!"

Accompanying his SLRs are a range of lenses, but he shoots some 80–90 percent of his pictures with just two optics: a 14mm wide-angle and an 80–400mm image-stabilizing lens, which has recently replaced an 80–200mm model. The zoom is a lens that suits his philosophy perfectly. "I use a tripod less than most people," he says. "Over the years this has meant that I have lost many wonderful images due to camera shake, but I reckon that I've gained many more by being ready to shoot a picture while others have been trying to set up their gear.

"The image-stabilizing capability of the Nikon lens has been a revelation. With the zoom set to its longest focal length I can now hand-hold down to 1/30th of a second easily and have even managed to go as slow as 1/8th of a second without problems. It has revolutionized my photography."

Other cameras favoured by Brandenburg include a Pentax 6x7cm, a Fujifilm 6x17cm and a Hasselblad XPan, both panoramic models. "The XPan is a particular favorite of mine," he says. "Because it's a 35mm model I can just put it in my pocket and take it anywhere."

An interesting recent development for Brandenburg has been digital technology. "The advantages of new technology far outweigh drawbacks," he says. "I could not run my gallery the way I do without computers. I design and produce my own books and take complete control of almost every aspect of the creative process. It's put me in charge, and I appreciate that."

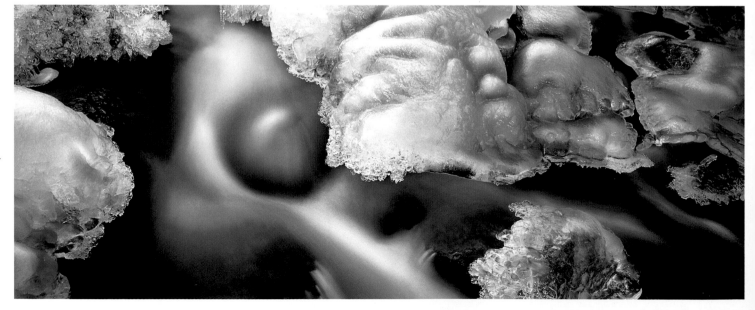

Judd Creek rapids
"This picture was taken literally just outside my window, at a time when I was trying out my new Hasselblad Xpan panoramic camera. It was getting dark, and I used a large floodlight next to my house to illuminate the stream, which made the scene brighter and helped to warm it up a little."

Hasselblad Xpan, 45mm lens, Fujifilm Velvia

Badlands deer
"This was taken while I was undertaking a *National Geographic* project. I was very pleased to include the two mule deer in the picture; animals in a landscape add a sense of perspective and scale to a picture, but I like to keep them small so that they are just a detail in the overall image."

Nikon FE, long end of an 80–200mm zoom lens, Kodachrome 64

Pipestone Creek (*Below*)
"This location is a very sacred site for Native Americans. You can make out stones in the middle distance, which is the debris from a quarry where pipestone was mined. It was used to make the bowls for peace pipes, and was very special.

"I ran up there one evening. It was a good time to visit, and I took about 15 shots.

"If you shoot into the sun there is no chance of retaining foreground detail. Shielding the sun behind the trees took away a lot of its intensity, and I got a manageable contrast level. I also captured reflections of its color, and my three- to four-second exposure blurred the water."

Fuji 6x17cm camera, 90mm lens, Fujifilm Velvia

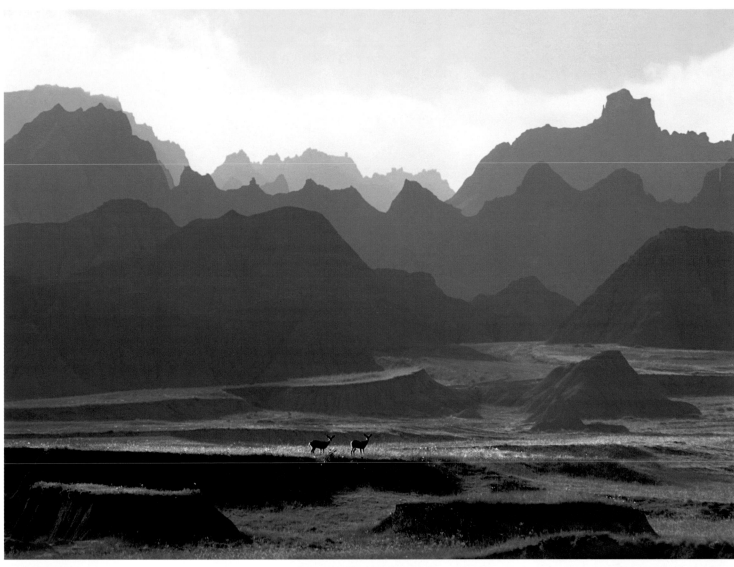

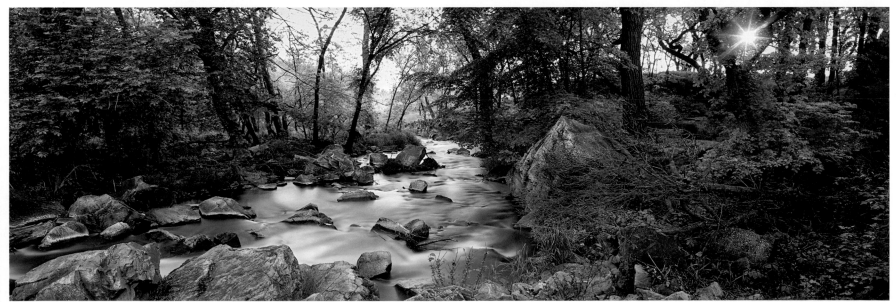

Jim Brandenburg

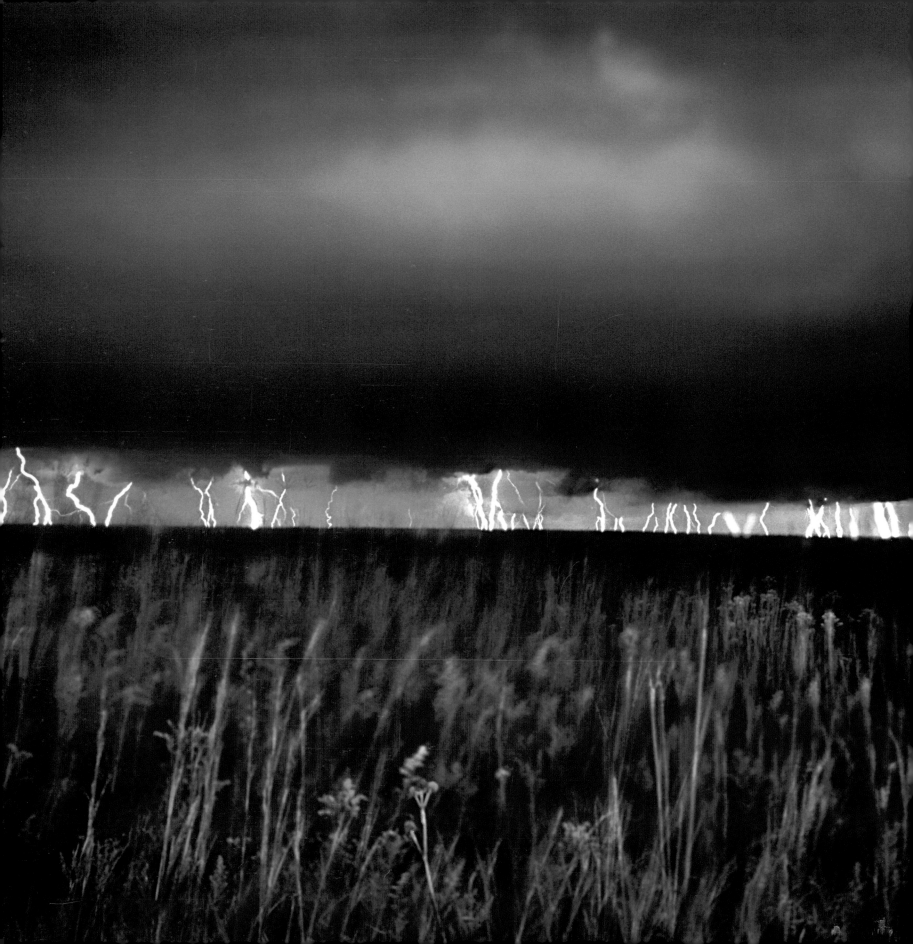

Prairie lightning

"People tend to think that wolves are the subject that I love the most, but the prairie is my favorite place to be. It's the area where I was born, and it's gone from being one of the most widespread areas of North America to being one of the most endangered. Less than one percent remains unplowed, and it's important that what is left is preserved.

"I took this picture while undertaking a project for *National Geographic* magazine, and the location was a tall grass prairie preserve in Oklahoma. This is storm country, and the local name for the area is Tornado Alley. I happened to be camping out on the prairie when I saw a storm arriving and, before the rain reached my tent, I decided to try to make a timed exposure of the lightning that I could see on the horizon.

"I set the camera up on a steady tripod and, at the start of the exposure, I fired a flash to make sure that there was a little detail present in what otherwise would have been a very dark foreground. I left the camera's shutter open for around ten minutes to make sure that I got plenty of information on the film, and the fact that it was so dark made sure that there was no danger of overexposure.

"In total I took around 10 to 15 exposures without really knowing what I was going to achieve, and it was only when I received the film back from the processor that I knew that I had this image. These days a digital camera makes things so much easier; I could have seen on the spot whether or not my approach was successful."

Nikon F3, 20mm lens, Kodachrome 64

Jim Brandenburg

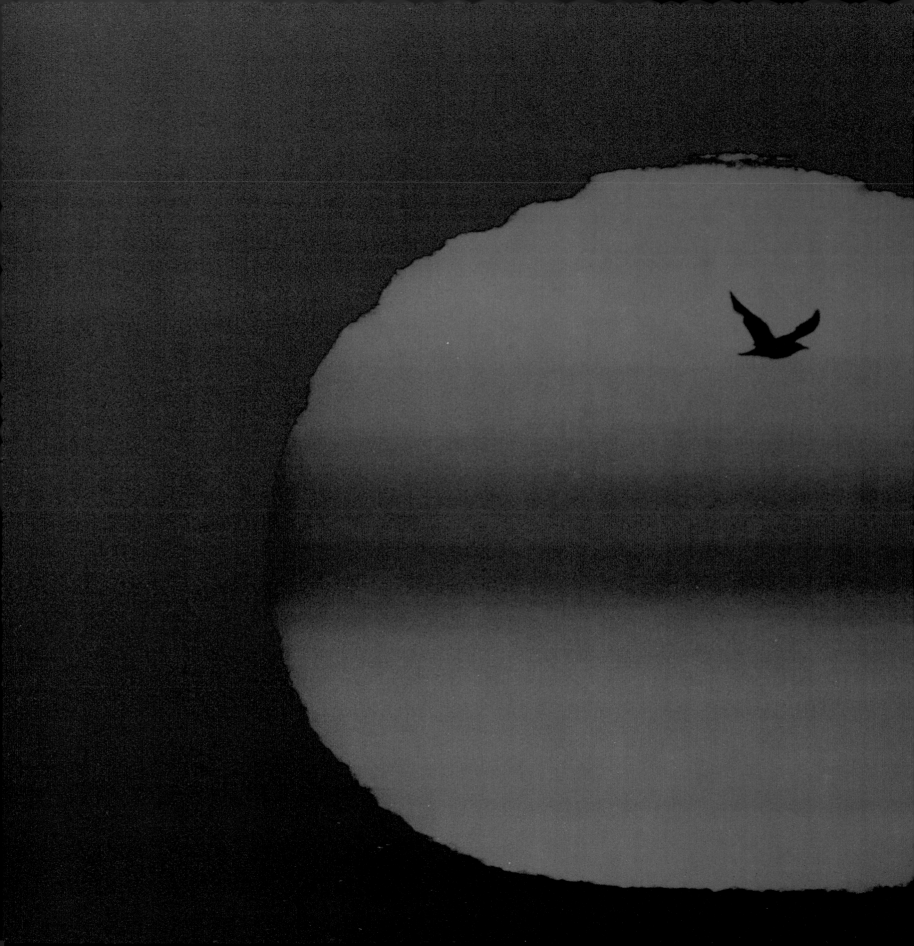

Red rising sun

"I used to live at the edge of Lake Superior in Canada which, in terms of surface area, is the largest lake in the world. It is so big that it's not possible to see the further shore, which means that when the sun rises it comes up over the water, and you can see the effect of the curvature of the earth's surface, much as you could if the sun was rising over the sea.

"The picture that I wanted was one that made the most of the sunrises that you get in this area, and which would emphasize the deep red color that it has first thing in the morning. I set up my camera and fitted an enormous 1200mm F8 lens that I had – which was around a metre (3.2ft) long – which ensured that the sun and nothing else filled my viewfinder. I also positioned myself close to a rookery to make sure that there was a good chance of birds that were waking up for the day flying across the sun as I photographed it.

"The biggest problem that I had was the fact that, even at this time of day, there was enough intensity in the sun for it to damage my retinas, had I looked at it for a prolonged period through the lens. Also, the sun rises very quickly, and it was necessary for me to frame the picture every few seconds to make sure that it was in the position that I wanted."

Nikon F2, 1200mm F8 lens, Kodachrome 64

Jim Brandenburg

Christopher Burkett

Born in 1951 and raised in the Pacific Northwest of America, as a child Christopher Burkett was severely near-sighted. When he was given glasses in the first grade, suddenly everything became clear. He was astonished to discover the world that, until this point, had been nothing more than a sequence of blurred shapes was charged with 'incredible, miraculous detail everywhere.' "My eyes were opened," he says, "and I could see, really see the physical world and all of its exceedingly fine, exceedingly important details."

As a photographer that love of detail was to play a vital role in his life but, at the age of 19, he entered an Orthodox Christian order that he was to serve in for seven years as a brother. He left in 1979 to pursue photography, and was married the same year.

Since then he and his wife Ruth have, for two months every year, journeyed around much of North America, avoiding national parks and other familiar locations. To achieve ultimate quality in his photographs, he made the decision to work primarily in the 10x8in format, and invested in an old-fashioned Calumet C-1 metal flatbed view camera. The combination of heavy equipment and offbeat settings for pictures has ensured that it's been a demanding process to reach the required set-up position, but it's a chore that Burkett considers necessary to achieve his personal vision.

The nature of the camera also means that long exposures are required, and the resultant problems form many of Burkett's challenges. "Wind is the bane of every large-format photographer," he says. "Most exposures I make are between one and 20 seconds, and even the slightest motion of leaves and branches can destroy sharpness and the crisp definition of details." Burkett's perfectionism is the stuff of legend. For example for 'Sunrise and Autumn Blueberries', he took three days and 50 exposures before he considered the result to be successful.

During the ten months each year when he's not travelling and taking pictures, he spends 14 hours a day, six days a week in his darkroom, meticulously printing his 10x8in transparencies and turning them into dazzling 20x24in and 30x40in Cibachrome (Ilfochrome Classic Deluxe) fine prints. A purist by nature, Burkett does not use filters and his images are never cropped, digitally manipulated or enhanced in any way. Instead he uses sophisticated masking techniques to adjust the contrast, sharpness, brightness levels and relative weights of tones and colors.

"These are not mechanical reproductions," he says, "but images in which I have invested my heart and soul, with the hope that they bring hope and inspiration to others for many years."

Resplendent leaves (*Below, left*)
"I made this image as the last rays of sunshine were coming through the trees at a low angle, and this was mixing with colder blue light coming from the sky.

"I'm very pleased with the picture, not just because the lighting was perfect, but also because the composition works well here as well, with opposite colors working to reinforce the impact of one another."

Hasselblad 205TC, 250mm Super Acromat lens, Fujifilm Velvia

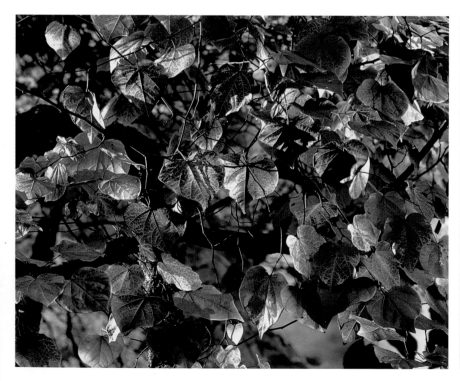

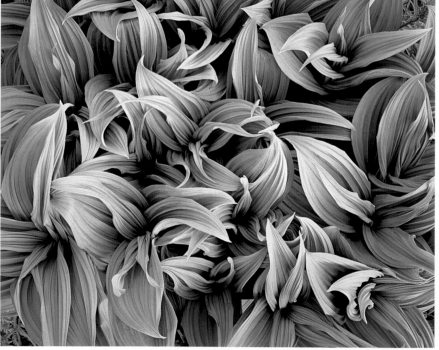

Green Veratrum, Alaska, USA
(*Opposite, right*)
"While photographing Alaska, I spent a week in the Valdez area. This area is amazingly beautiful, featuring steep, rocky canyons and snow-capped mountains, and yet it's only a few miles from the ocean.

"I explored many side roads and, on one excursion, I came upon a large collection of wild Veratrum plants in a sheltered canyon next to a small river. The days are very long at this latitude, so it really never gets dark during the summer.

"Due to the long days and the rich flood plain soil, these plants were growing at an explosive rate. I kept returning to this location, viewing them under different lighting conditions, trying to find a way to express what I saw. The forms were quite unique and gave me an opportunity to portray an aspect of life that is rarely seen."

Calumet C-1 10x8in camera, Nikkor 240W lens, Fujichrome 100

Glowing forest
"I took this picture one fall in Virginia, and the conditions were incredible. Fog was rising from a lake in the forest and was hovering in the trees, and this was colored by light reflecting from the fall leaves, creating a three-dimensional effect. I radioed my wife Ruth to ask her to get as close to me as she could, and then surveyed the scene. When Ruth arrived I set up my 10x8in camera in less than five minutes – and I had time for just one exposure before the light was no longer at its best.

"I was so excited about the picture that I took a flight back to my studio so that I could get working on the picture straight away. I rang Ruth while she was on her way to tell her that, after working as a photographer for 30 years, if I had to pick out one picture that truly accomplished what I wanted to say about the beauty of the landscape then this was it."

Calumet C-1 10x8in camera, 800mm APO tele Xenar, Fujifilm Velvia

Christopher Burkett

Aspen grove, Colorado, USA

"Twilight was falling as I travelled through the high mountains of Colorado one fall, and at the top of a high mountain pass I encountered this grove of aspens. These trees were literally on the top of the ridge, so that the soft-colored light of evening was causing the trunks to glow from all sides. At this time of day, with the sun just over the horizon, the air oftentimes becomes quite still; it's as if nature is holding her breath, and it's a sharp contrast to the rest of the day, when strong breezes rush over the mountain tops, causing the leaves to constantly rustle and shimmer.

"Working rapidly, I focused the image on the ground glass in the fading light and had time for only one exposure. Because of the low light levels, it was necessary to give the film about 90 seconds of exposure. In making the print, I strived to preserve the delicate feelings of calm peace conveyed by that soft, luminous radiance."

Calumet C-1 10x8in camera, 600mm Fujinon C lens, Fujichrome 100

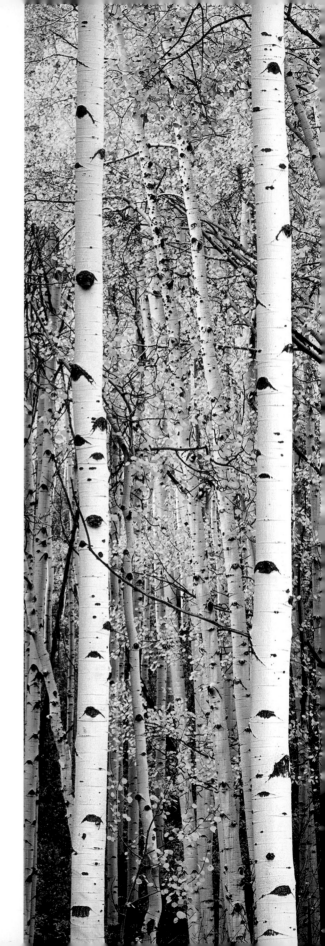

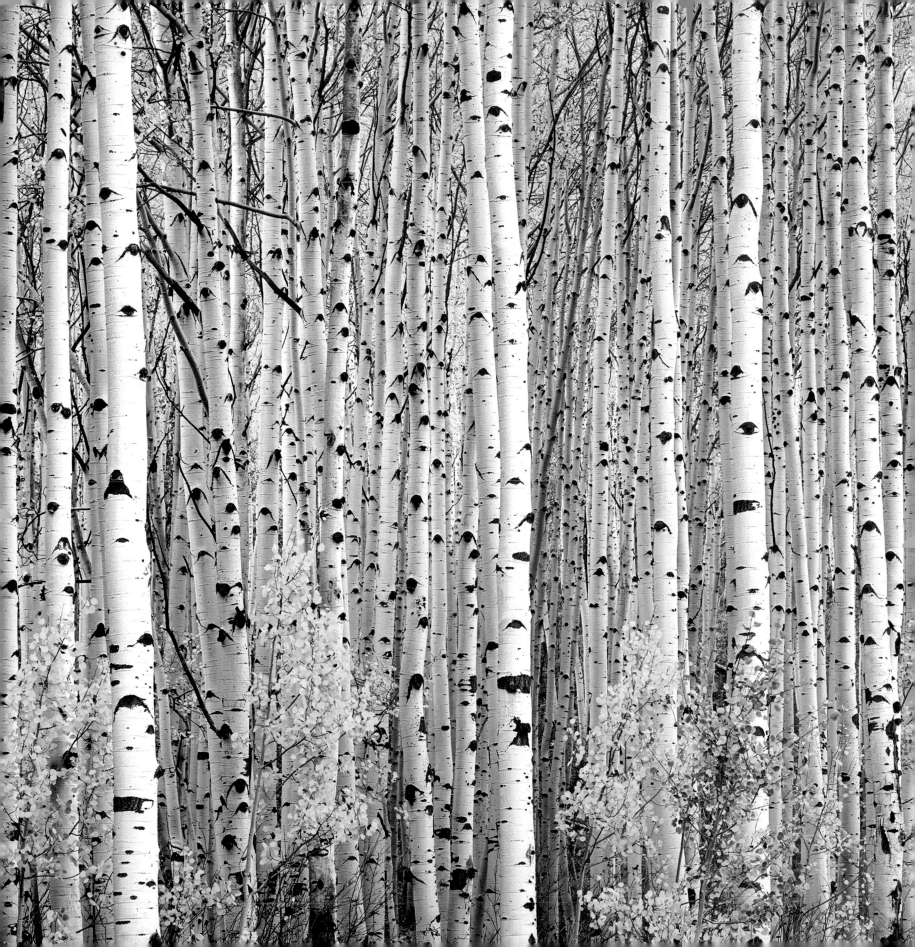

Sunrise and autumn blueberries, Maine, USA, 1994

"Having heard of the wild red blueberry fields of Maine I decided to travel to the area to take some pictures, because I was sure that had real potential. The blueberries are native and wild to Maine, and they grow only a few inches off the ground. Managed by the local farmers, often they are not particularly exciting to photograph, but I did find one field to be just what I was looking for. It was quite large, had some areas of rolling terrain, and there were colorful fall trees at the back of the field. For four days I photographed this field, mostly in the first few minutes of sunlight in the morning and the last few rays at night.

"I took more pictures of this field than I have done of any other subject: about 50 sheets of 8x10 film! My wife Ruth talked with the owner of the property and got his permission to use the dirt roads which traversed it and we camped about one mile away so that we could be there morning and night. I found the conditions in the morning to be visually the most interesting due to the frost that often formed overnight, and gave more shape and color to the plants. Over a few days' time, I began to understand precisely where the sun would rise and how the light played across the fields.

"This photograph, taken on the last morning, was the most successful image of the series. It was especially difficult for me to print it properly and it took me almost a year to make a print that I considered was successful."

Calumet C-1 10x8in camera, Red Dot Artar 30in Goertz lens, Fujifilm Velvia

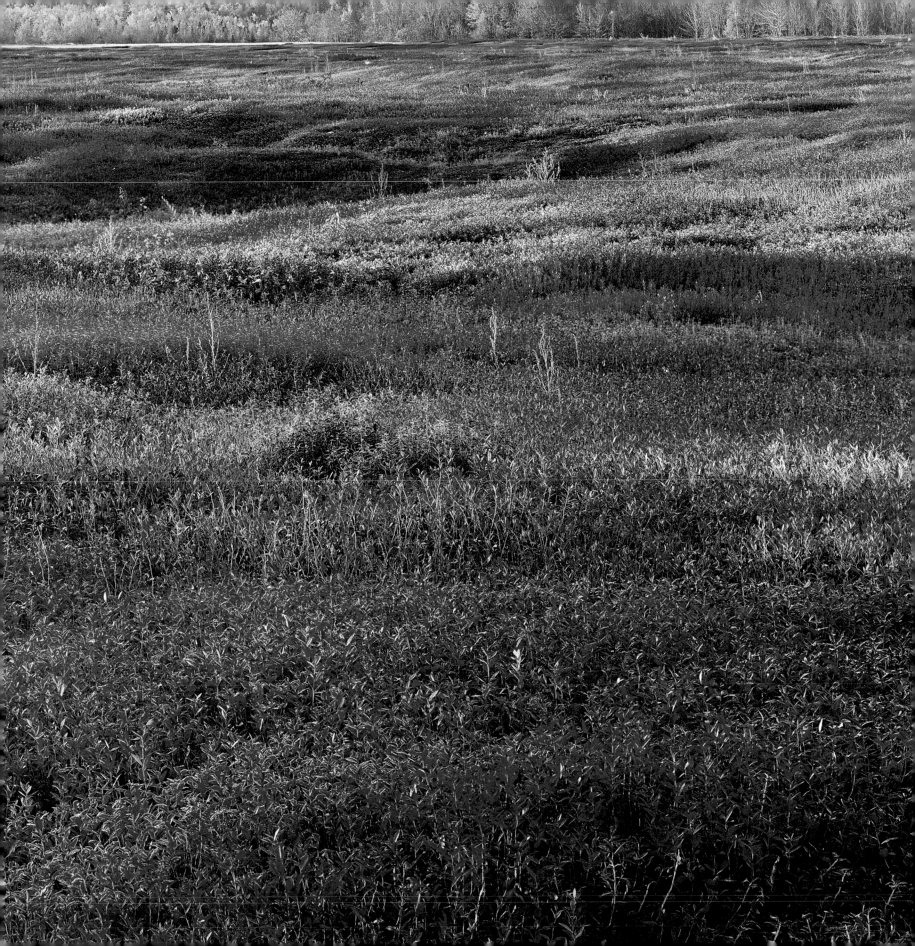

Michael Busselle

Landscape photography has always been close to Mike Busselle's heart and, of the nearly 50 books that he's produced to date, many of them feature landscape as the central theme. Although his most regular haunts have been the UK, France and Spain, he's also travelled extensively and photographed in locations such as the US, India, and Morocco.

"I started out as a junior nuclear scientist," he says with a chuckle. "I got a job as a lab assistant, but realized that I wasn't cut out for the work, although there was a photographic aspect in that some of it involved taking pictures with a projection microscope and I got to do the processing and printing. I realized that this was the side of the job that I enjoyed the most and, from there, I got myself a job as a dye-transfer printer for a top London color laboratory."

After a period a former colleague, who was working as a professional photographer, contacted Busselle and offered him the job of assistant. In this role he got to work on advertising campaigns and to learn more about the technical side of the craft.

"Throughout this entire period I was also taking pictures for myself," he says, "and I particularly enjoyed travel photography, being a bit of a Cartier-Bresson acolyte with a hand-held camera and a candid approach. Then I started to get a few things published, receive commissions, and, finally, I plucked up the courage to go freelance. Although it took me a while to get going, I started to pick up work and was eventually able to open a studio in central London." While this period was largely devoted to commercial commissions, landscape remained the focus of his personal work, and he steadily amassed a collection of images.

Things changed in 1977 when he was approached to write and illustrate a book on photographic technique. *Master Photography* went on to become a big seller.

"Suddenly all the pictures that I had produced for my own pleasure became useful," he says. "I realized that this was the way that I wanted to go, and that I could shoot pictures for future book projects and for use as stock photographs."

From the 1980s he concentrated increasingly on landscape and travel, eventually giving up his studio and taking to the road for lengthy periods. His skills earned him accolades that helped to raise his profile: his book *Landscape in Spain* (1988) was the runner-up in the Ortiz Echague competition sponsored by the Spanish Ministry of Tourism, and was featured in the *Sunday Telegraph* magazine. *Three Rivers of France*, published the following year, was featured in the *Sunday Express* magazine. His book on UK landscapes, *England: The Four Seasons* (1993) drew heavily on his work closer to home, and was followed by *France: The Four Seasons* in 1994.

"My landscape work has evolved over the years," he says. "These days I find it harder to get excited about classic views bathed in the evening light. I prefer to shoot more abstract landscapes that have a bit of individuality to them. These are the pictures that sell better as stock in any case, because they are a little different and give clients new things to look at.

"From a personal point of view I just find this approach more satisfying. I suppose that, having shot so many of the traditional views over the years myself, it's nice to be able to step back a little and to concentrate on extracting something more out of a scene."

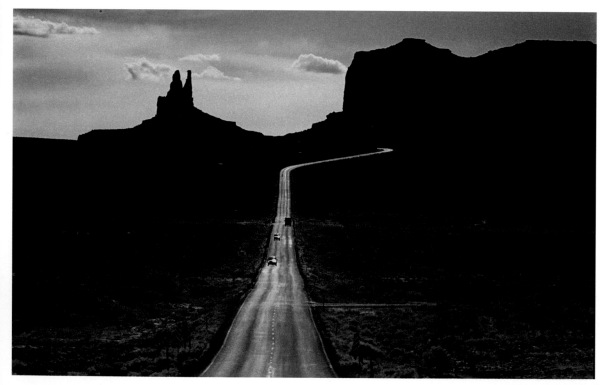

Monument Valley, Arizona, USA
"This was the classic view in Monument Valley, looking into the light with a long lens, so that the road was picked out as a silver ribbon. I wanted the nearest car to be some distance away, and had to stand in the middle of the road to get this particular viewpoint, which was a little dangerous, but the result was worth it. The original picture was in color and I felt that it was rather disappointing, so I used Photoshop to change the image to monochrome, and the result now is much stronger."

Con EOS 1V, 70–200mm with 1.4x converter, Fujifilm Velvia

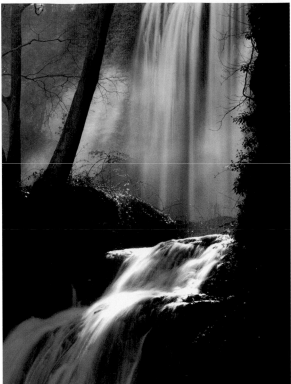

Lake Kariba, Zimbabwe
One of Zimbabwe's top tourist attractions, Lake Kariba is surrounded by wildlife lodges. Created in the 1950s as a result of the damming of the Zambezi River, it is now one of the biggest man-made lakes in history.

Mike Busselle was struck by the skeletal remains of drowned trees that can be found at the edges of the lake. "They were a real feature of the shoreline," he says, "and I was determined to get a landscape picture that would show one of them in its environment."

Busselle's trip involved staying on a boat. Having anticipated that the sun would set nicely over the lake, he negotiated a trip to shore in a dinghy, which enabled him to feature one of the trees in the foreground.

Setting up on the shore, Busselle fitted a graduated neutral density filter to his lens, and this enabled him to reduce enough contrast between the foreground and sky to make a perfect image.

Nikon F4, 20–35mm wide-angle zoom, Fujifilm Velvia

Waterfall near Nuevelos, Alhama de Aragon, Spain (*Above*)
"There is an area in Spain called the Monastery of Piedra at Nuevelos near the town of Alhama de Aragon, and it's a curious place because it's a small, almost circular and very steep-sided valley that is the location of dozens of waterfalls. Because it's so heavily wooded it's difficult to get a clear view of many of them and, with this image, I decided to include the upper level of the falls in the frame because it was impossible to show the sky.

"I quite like images like this where something else is in place of the sky; it gives an element of surprise to the picture."

Mamiya 645, 55–110mm zoom, Fujifilm Velvia

Michael Busselle

Woolacombe Bay, Devon, England

"I took this picture at Woolacombe Bay, which is on the southwest coast of England. It's one of the UK's best beaches for surfing, and I took a trip down there towards the end of the day, just as the sun was starting to dip in the sky.

"It had actually sunk below the horizon, and then the color started to fill the sky, and this was reflected in the sea and the wet sand. As a panoramic image it worked really well, because all the interest in the scene was crammed into the centre section, while the top and bottom was fairly uninteresting. This was the first picture I ever took with the Hasselblad Xpan, and I love this camera. I've shot panoramic pictures before with a 6x17cm camera and on a view camera with a 6x12cm back, and gave up really because I've become too used to the user facilities provided by my SLR cameras. The Xpan was just as convenient as normal 35mm, however, and it made the whole process of making pictures much simpler."

Hasselblad Xpan, 45mm lens, Fujifilm Velvia

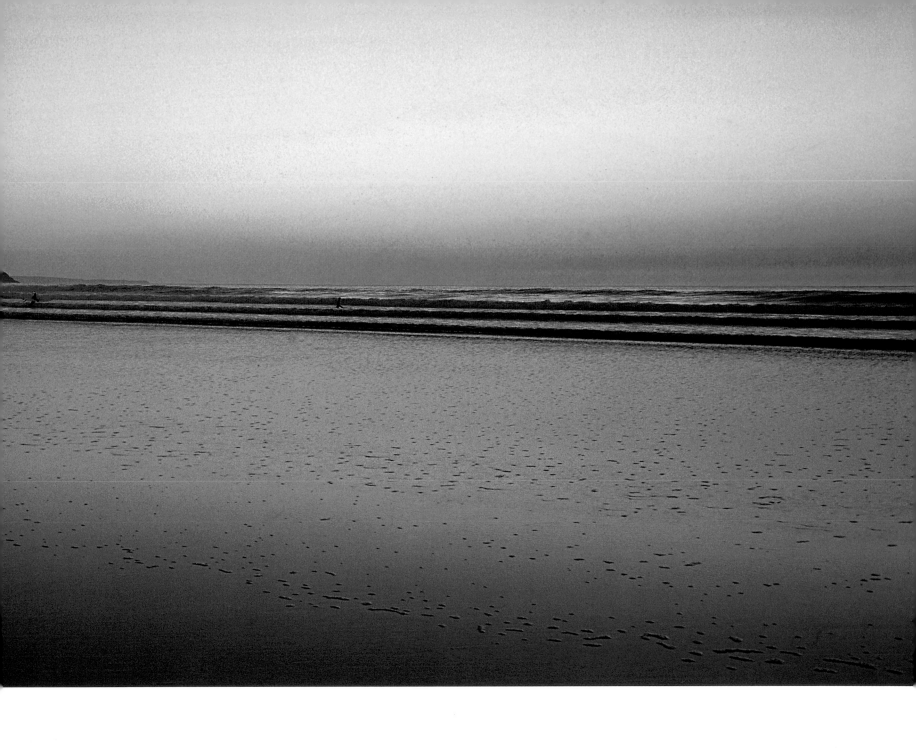

Michael Busselle

Joe Cornish

Always passionate about art, Cornish pursued a fine art degree at Reading University, England, in the late 1970s. It was here that he first used a camera to record paintings and constructed work. As an exercise the students placed a single light bulb in differing positions around objects to study shapes and shadows, using their cameras to record the results. In this simple way Cornish realized the creative power of photography. His fascination was confirmed on a trip to the USA during an exchange program, when he spent a day in the studio of photographer Mike Mitchell.

Having presented a degree show of black-and-white landscape photographs, he returned to Washington as Mitchell's assistant. This photographer's repertoire ranged from highly intricate studio table-top work to corporate location shoots in New Mexico. It proved a challenging and technically demanding education, and, among other things introduced Cornish to the American West.

On returning to the UK he made a living with further assisting work, shooting portraits of actors and musicians, and London scenes. He also continued shooting landscapes in his free time. A break came in the form of a commissioned book for the National Trust in the UK, and this was followed by a guidebook series on French regions. Photographer Charlie Waite recommended Cornish to his publisher, and with the stream of commissions that followed he became a full-time travel photographer.

In 1989 the National Trust commissioned him to photograph the book *In Search of Neptune*, a celebration of the British coastline. Subsequent to the exhibition, Cornish was snapped up by Tony Stone Picture Library (now Stone). He relocated to North Yorkshire which provides ample inspiration for a landscape photographer.

By 1995 he decided to pursue landscape work full-time. A long-time Nikon and Hasselblad devotee, he switched to a 6x12 format Horseman. Within two years he changed again, to the 5x4in Ebony 45S field camera, for its robust simplicity.

The precision and quality of the photographs he can make with this camera more than compensate for the extra cost of film, and slower response times. He has learned to anticipate rather than react to lighting opportunities, and thrives on the discipline and accuracy that large-format work demands. He also believes the big camera has helped him see deeper into the landscape, not just in terms of focus, but intellectually and spiritually too.

While the National Trust remains Cornish's main client, he also leads workshops for Charlie Waite's company 'Light and Land', lectures and writes , and produces new images for his own company, Joegraphic. *First Light*, his book on the art of landscape photography was published in 2002, and sold out in weeks.

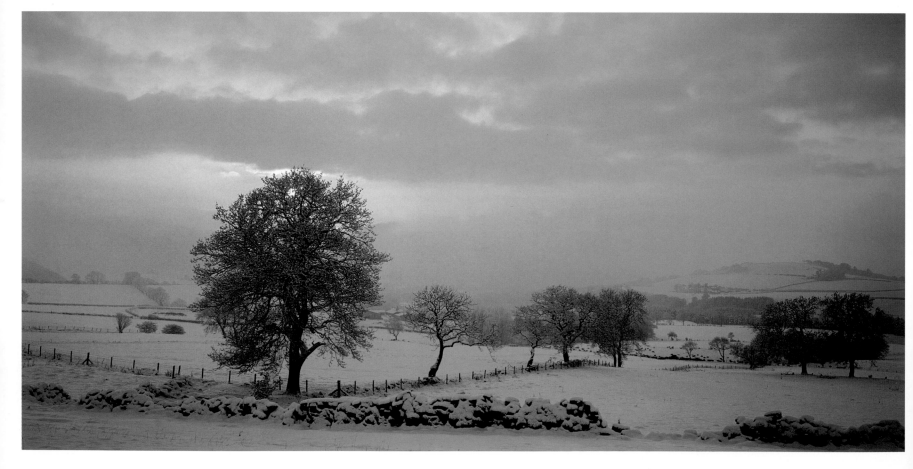

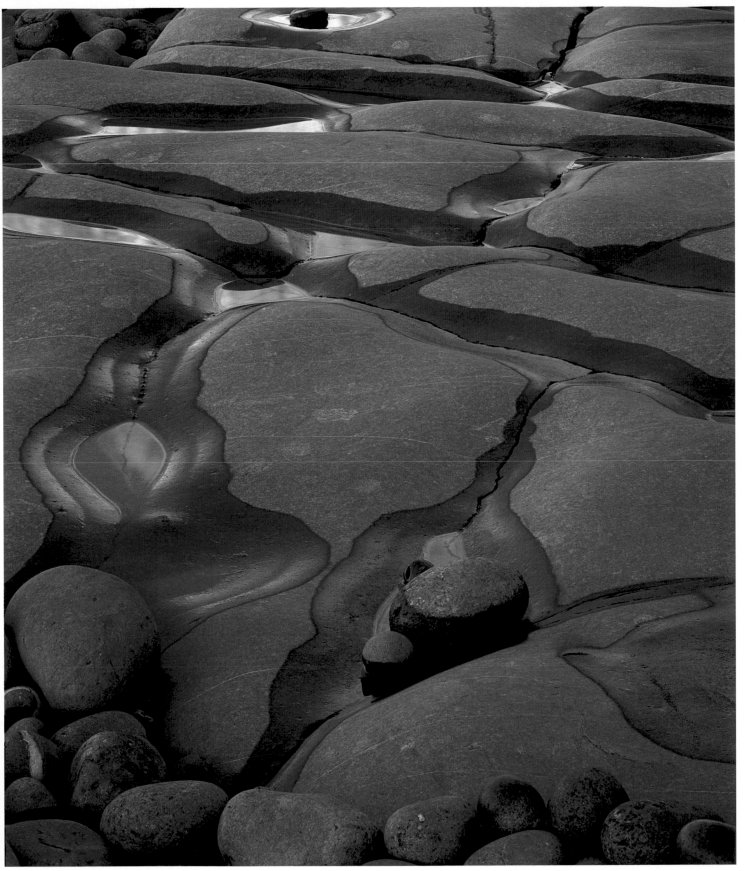

Dunraven Bay, Glamorgan coast, Wales (*Left*)

"Few pictures I have taken better illustrate the color of light on the landscape. The film has recorded the light as it truly was.

"The limestone platform on this beach looks gray in daylight. But when this was taken it lay in shadow, and the main light source was the blue sky. The color temperature soared, leaving only blue wavelengths reflecting off the neutral tones of the rock. My instinct was to use an 81-series warming filter to suppress the blue. But I realized that the impact would be greater without it, allowing the blues to contrast with the wet rock.

"I used a short telephoto lens, and employed front- and rear-tilt on my view camera to hold focus through the picture space. The frame edges, the lines of energy, the balance and weight of the shapes within, all had to be resolved. The sun's setting rays threatened to encroach onto the image. I made my exposures just one minute before light crept into the frame!

"The blue of the limestone, very blue on Velvia, is surreal, and the gold reflections provide the desired contrast. This image transcends the sum of its parts – that is something that I often seek, yet rarely find."

Ebony SW45 5x4in field camera, Fujinon-T 300mm lens, Fujifilm Velvia

Ayton Banks Farm
(*Facing opposite*)

"Mist, sleet, and snow covered the village. Snow always cheers me up, and I threw my camera bag in the car and headed for the moor. Soon I emerged from the mist into a landscape where winter had arrived in earnest. Trudging through the snow brought me to this point, as the sun descended into the misty valley.

"Being in the right place at the right time is at the heart of my method. A combination of unique conditions and magical light produces great images."

Ebony SW45 5x4in field camera, Nikkor-SW 90mm lens, Fuji Provia F

Joe Cornish

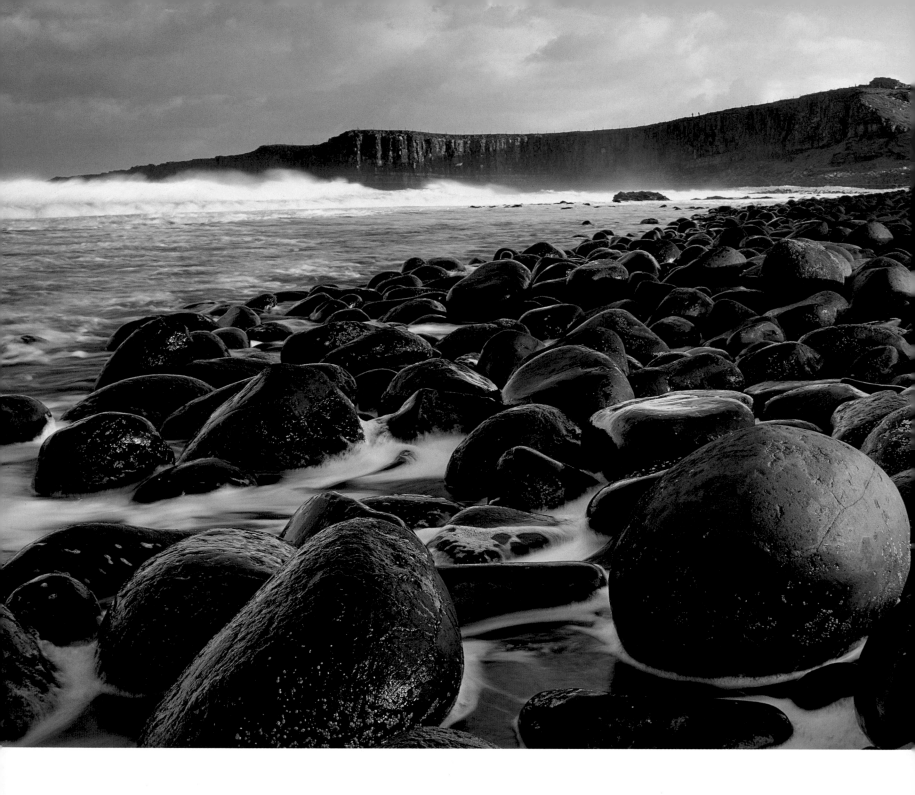

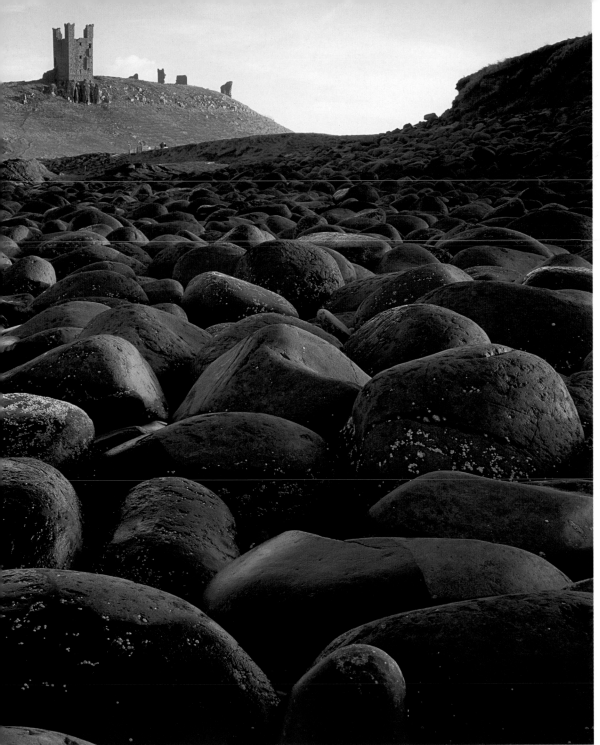

Cannonball Beach, Embleton, and Dunstanburgh Castle, Northumberland, England

"I always question the height of my tripod. Since my six-foot standing height is limiting, I often climb to a higher vantage point to open up a vista. At other times, as here, I will flatten the tripod to the deck, getting my camera as close to the textures of the landscape as I dare. A more revealing image is often achieved by avoiding the obvious standing-height perspective.

"At this time, however, my main preoccupation was with the rapidly rising tide. As I made my meter readings a wave splashed in, wetting some of the foreground, and to my surprise, pleasantly improving it. Now I was ready. I made my first exposure as normal, but as I wound on and prepared to adjust the aperture a much larger wave roared up over the rocks. In frustration I picked up the tripod at the last possible moment and carried the camera to safety. The moment had passed, but at least my one exposure proved useable!"

Ebony SW45 5x4in field camera with 6x12cm back, Nikkor SW 90mm lens, Fujifilm Velvia

Joe Cornish

Charles Cramer

As a young man, Charles Cramer was convinced that he was going to be a pianist, and spent the majority of the mid-1970s in music school in New York. "It was a contrast to the place I had visited before leaving California," he recalls. "Yosemite!

"It was there that I heard about Ansel Adams. I felt a kinship with him since he also spent many years studying the piano. What sealed my fate was reading *The Eloquent Light*, the biography of Ansel by Nancy Newhall. I had played with a 35mm camera and printed images in my father's darkroom, but had never considered it to be a career."

After his Master's degree, Cramer took a year off to photograph in Yosemite and the Sierra using his 4x5in camera. He became a disciple of the cult of the fine print. Around 1980, he made what was to be a fateful decision: a determination to use the Dye Transfer Process for color printing. At the time, it was considered the best way to make a color print. The downside was its complexity: contrast masks, three-color highlight masks, separation negatives, and a set of film matrices to make a print.

However, since colors are separated out into the three primaries, it's possible to control each color independently. These steps allow for the incredible fine-tuning of an image. "The first print would take a whole day," says Cramer, "and if something went wrong, I had to figure out where the mistake occurred." Since creating his most popular Yosemite image in 1982, Cramer estimates that the time he has spent refining this print could amount to five months.

In 1994, Kodak, the only supplier of Dye Transfer materials, discontinued their production and, while Cramer managed to stockpile materials, time was running out for the process. "I taught Dye Transfer printing in the early '90s," he says, "and a student there, Bill Atkinson, one of the original Apple Macintosh design team, felt that, although Dye Transfer prints were beautiful, doing all those steps was crazy! Bill went on to become a pioneer in digital fine printing, and kept me informed of developments. With the invention of the Lightjet digital enlarger, there was a way to create prints that could rival a Dye Transfer. Bill mentored me and, since my stockpile was dwindling, the timing was fortuitous."

Although he now does most of his fine prints with the Lightjet, Cramer has combined both techniques into 'digital Dye Transfers'. The only difference between the traditional and new prints are the separation negatives.

The negatives are contact-printed onto Dye Transfer matrix film, and the matrices are dyed and transferred in register to a special paper, akin to silkscreen printing. "This is an expensive and time-consuming process," says Cramer, "but it has produced the best Dye Transfers I've ever made. The best results are with images that feature very saturated colors or extensive shadow areas that show off the density range that Dye Transfer offers."

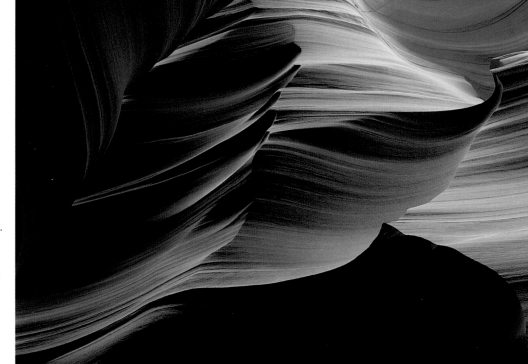

Peach Canyon Hollow, Arizona, USA
"I was travelling with Bruce Barnbaum in 1984, exploring a sandy wash near Page, Arizona. A deep gash in the ground suddenly appeared – the infrequent flash floods had cut a slot canyon in the soft Navajo sandstone. We made our way down to a depth of around 60ft (18m), where the narrow canyon opened just enough to allow a tripod to be set up."

Linhof Technika, 135mm lens, Kodak Ektachrome

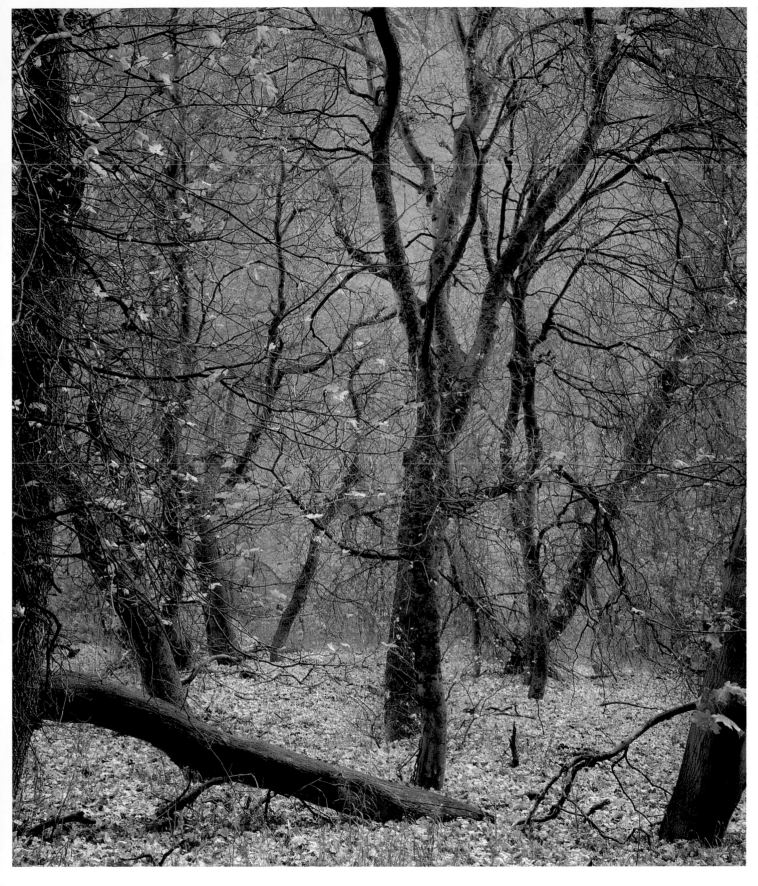

Trees, Kolob Canyon, USA
"This was the perfect Southwestern day – clear blue sky and a deep canyon. The sandstone wall you see in the background was illuminated by warm light reflected from the opposite red canyon wall. The trees are reflecting a little of the blue from the sky. Although the scene is completely in shade, it benefits greatly from the warm and cool light playing off each other."

LinhofTechnika, 210mm lens, Fujifilm Velvia

Charles Cramer

Cascade Creek, Yosemite, California, USA, spring

"When I first started photographing in Yosemite in 1974, I had big dreams of being out with my camera on those beautiful, endless summer days. It took a few years to realize that the really good light is found at the fringes of daylight, around sunrise and sunset. So the landscape photographer (especially if he or she is working in color) learns to mostly avoid direct sun.

"In 1987, I was an artist in residence in Yosemite, and spent quite some time exploring the nooks and crannies of the Park. Early one May morning, after several hours of good light, I came upon this scene just as the sun was starting to peek through the forest canopy. I used the fastest shutter speed my camera, lens, and film combination would allow. I knew that exposures more than a half-second or so would blur out detail in the water (depending on how close you are, and how fast the water is moving). Sometimes this 'silky' blurred effect is wonderful, but I didn't want smooth, featureless areas in this water – I wanted all the frantic, rushing detail I could get!

"With large format necessitating relatively longer lenses, you need to stop down a fair bit to ensure you have everything in focus. I exposed the film for around 1/15th of a second at f/22. This worked out well, since the water closer to me (on the right) blurred somewhat, yet the more distant water (on the left) shows a little spray frozen in midair. Near the middle of the image, you'll see a brighter spot due to a shaft of sunlight just starting to illuminate the water. Normally, this would completely ruin a scene, but this sunlight was diffused and filtered through many trees, resulting in a range of contrast that the film could handle easily.

"Most of the time I will use warming filters to remove the bluish cast found in shade. Since our visual processing automatically removes color casts, I use a color temperature meter to determine how much corrective filtration to use. In this case, with a little spot of sun shining through, I decided not to eliminate the blue, but just reduce it, using something like an 81C filter. The slight bluish tint adds to the otherworldly, dreamy quality of this image."

Linhof Technika 5x4in camera, 210mm Nikkor lens, Kodak Ektachrome 100

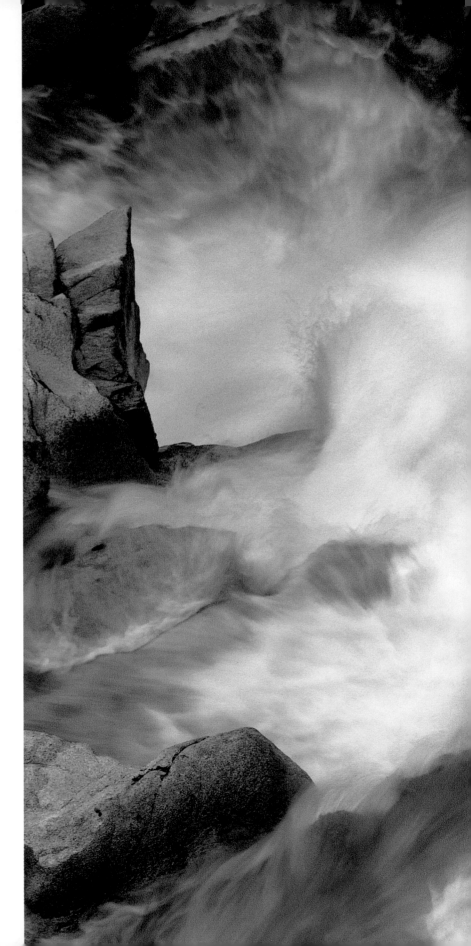

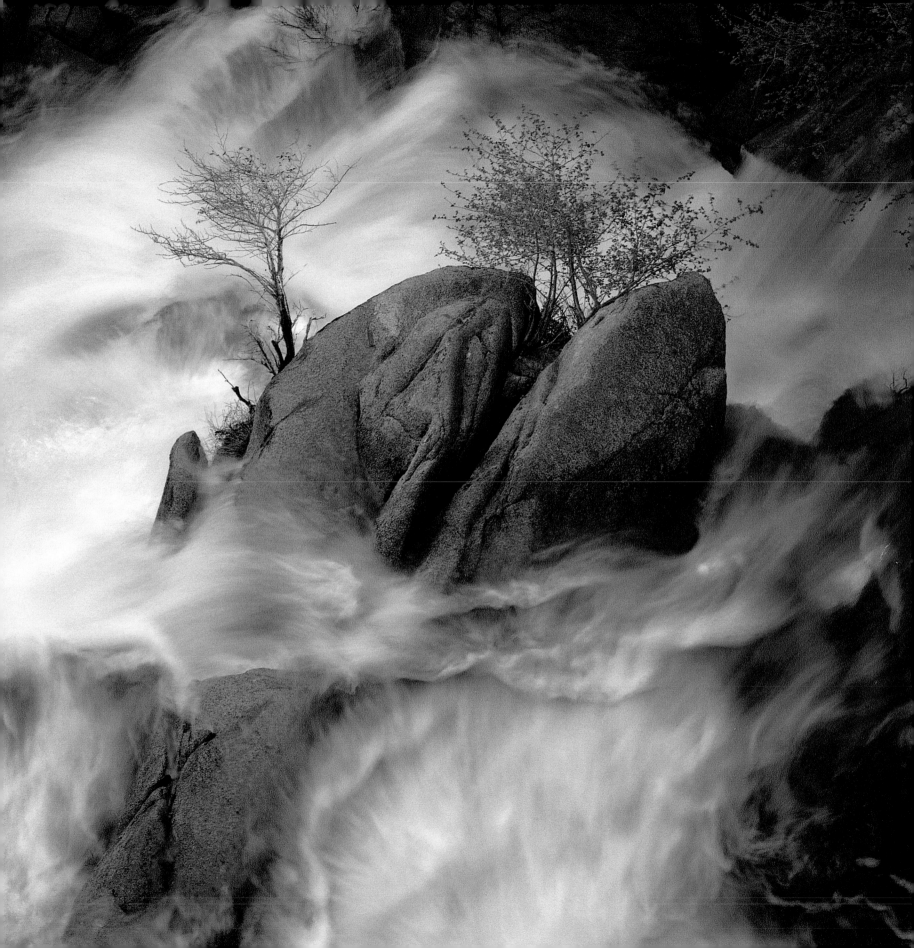

Ken Duncan

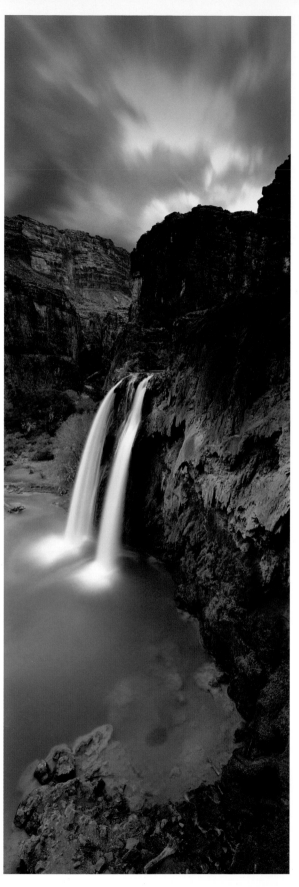

Havasu Falls, Grand Canyon, Arizona, USA
"While taking this picture a fellow photographer who was shooting for *National Geographic* looked at what I was trying to capture and said, 'you will never be able to hold the sky and the foreground together at this angle as there is a difference of more than four f-stops between the sky and the red rock'. Well, as you can see, he was wrong!"

Linhof 617, 72mm lens, Fujifilm Velvia

Ken Duncan has been interested in photography since his early teens, when he rendered himself unpopular with his father by dismantling his bellows camera to make a black-and-white enlarger. His subsequent career saw him progress to the position of senior technical representative for Australia's leading photographic supply house.

The turning point came for him when the company imported the Widelux camera. While testing the camera's capabilities, he realized he had found a vehicle with the ability to translate onto film exactly what he could see in a landscape.

Taking photographs had become a passion and, in 1982, Duncan left Sydney to realize his dream of producing a quality book of Australian images. Little did he know that the dream would cost him everything he owned in the five years it took to complete. In the course of his journey, Duncan endured many hardships, including taking a fall which resulted in the amputation of a big toe. In western Tasmania, the freezing damp conditions gave him hypothermia, severely damaging his nervous system.

Described by Australian *Professional Photography* magazine as, 'the photographer who is now undoubtedly Australia's (and possibly the world's) leading exponent of panoramic landscape photography', Duncan counters that he is simply "an average photographer with a great God". His modesty belies the work that he has completed since his first expedition. His travels around Australia have produced over 80,000 images in panoramic format. Unrivalled in depth, the library has been hailed as the best collection of Australian landscapes ever seen. Duncan sought out places that capture the 'real' Australia and its pioneer spirit.

In late 1985, Ken was the only Australian chosen to join a team of 40 photographers who travelled to China for a project that resulted in the book, *China, The Long March*. Five years later he joined 46 top-class photographers in Malaysia to shoot a book called *Malaysia: Heart of South-East Asia*. In 1991 he was also involved in the shoot for 'A Day in the Life of Hollywood', a project that involved 76 photographers, each world leaders in their fields. Duncan was the only Australian photographer to participate.

Among his many book projects, the most memorable is perhaps *The Ken Duncan Collection*, published in 2000, which featured a selection of his best Australian landscape images, all produced as limited edition prints. Only 1,000 copies were printed. The book won a Gold and a Silver Medal at the Australian Print Awards in 2001 and, subsequently, also won a 'Benny' (Best of Category) Award in the prestigious American National Print Awards.

Duncan followed this project with his first solo international publication *America Wide: In God We Trust*, which involved a three-year journey to America's most beautiful, awe-inspiring locations. The book is the first to feature panoramic images from all 50 states. So successful was this project that Duncan next published *Australia Wide: The Journey*, an awesome gallery of Australia's landscapes.

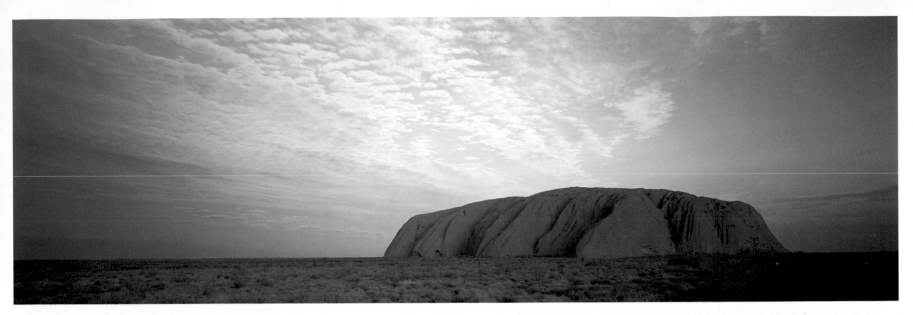

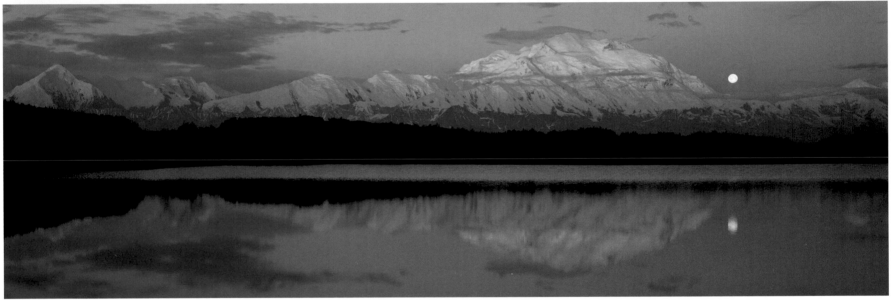

Heart of a nation, Uluru, Northern Territory, Australia (*Top*)

"I believe God speaks to us through His creation, and the message I received on taking this image was the way God felt about the division that is going on in my country, and around the world. This image was shot under difficult conditions as it was blowing a gale with heavy rain."

Linhof 617, 90mm lens, Fuji Velvia

Moonlit majesty, Wonder Lake, Denali National Park, Alaska, USA

"How can anyone deny a Creator when they are faced with such awesome wonder?

"There were no technical problems involved in taking this picture other than my having to ward off plagues of annoying insects that continually threatened to land on my lens. I had to keep swatting them away with my hat. After I had taken the shot, my assistant and I were chased by a huge bull moose, but managed to escape on our bicycles.

"One of the good things about shooting in Alaska in summer is the fact that the sun sets at around 11pm and rises again at around 1am the next morning, so you get to shoot both ends of the day in one hit virtually."

Linhof 617, 180mm lens, Fujifilm Velvia

Ken Duncan

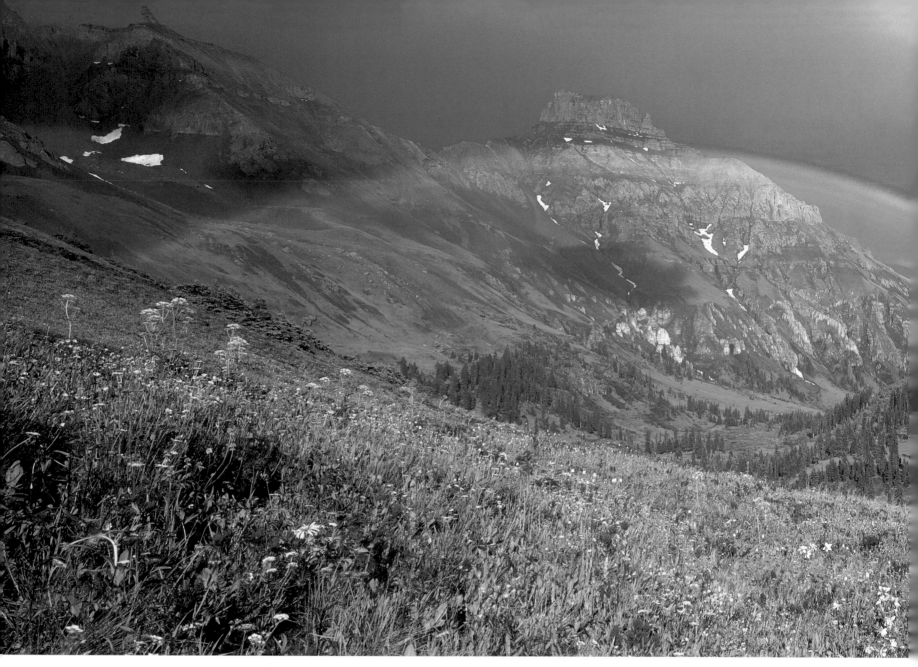

Promise of peace, Yankee Boy Basin, Colorado, USA

"I had been in Colorado for over a week looking for that quintessential shot of wildflowers in a mountain setting. Time was running out as I was due to return to Australia the following day. I had found a beautiful location in Yankee Boy Basin but the morning light had been bland. To make matters worse, many other photographers had joined me and were tramping through the fields on their own quests. One was so absorbed that he would walk right in front of where others had set up to shoot, flattening the flowers as he went.

"I was getting a bit irritated at his attitude and was almost at the point of offering a few pointers on photo etiquette. The guy was like an insect – buzzing around, landing here, landing there. I knew I shouldn't be angry, but I was, and it was useless to pretend otherwise. I realized that the way I was feeling was

wrong and in that frame of mind I would not be sensitive to God's presence nor be able to capture the spirit of the moment in this place. So I left that location and went for a drive.

"Travelling through the Colorado countryside, my anger washed away. I marvelled at the awesome creation around me. At peace once more, I asked God where He wanted me to go and felt He wanted me to revisit the site of my earlier frustration.

"When I returned to the location, the weather had turned really cloudy and overcast and had chased away all the other photographers. I wondered whether I had misunderstood God. What could I possibly photograph in these conditions? Then I felt God was telling me to set my gear up and get ready to take a shot. I had nothing better to do, so why not?

"After I was all set up, it began to rain. There I sat under a huge multicolored umbrella looking very obviously like an idiot.

Two hours passed. I was really bored with the rain. I suggested to God that if He could give me a small break in the clouds, maybe we could have a little rainbow. After all, nothing is impossible with God!

"Suddenly there was a huge clap of thunder. I thought either God had heard me and was going to do something or I'd be hit by lightning. What happened? It rained even harder! The torrential rain only lasted about ten minutes, then the clouds parted, the sun broke through, and a marvellous rainbow appeared over the field. It was absolutely breathtaking – far more spectacular than I had imagined – and I was there alone to capture the spectacle on film. Just as another photographer arrived, the magnificent light disappeared. The other photographer ran up to me and said, 'Man, you were lucky!' to which I replied, 'No, I was blessed.'"

Linhof 617, 72mm lens, Fujifilm Velvia

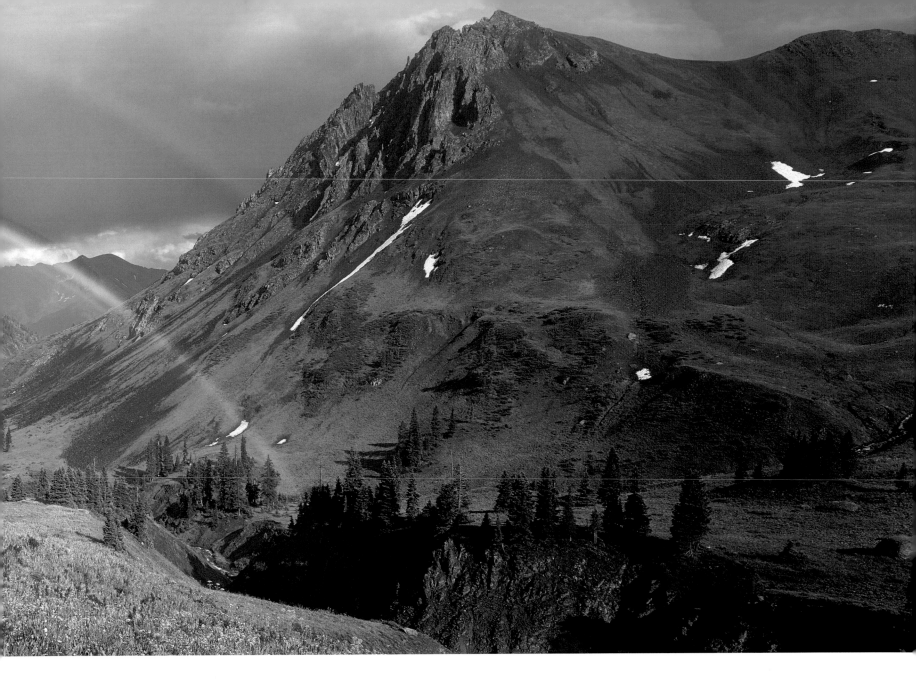

Ken Duncan

Jack Dykinga

Jack Dykinga's career began as a photographer and photo editor on newspapers in Chicago, until a combination of factors led him to make the transition to landscape photography. "I saw a piece that someone had written about the landscape photographer Philip Hyde," he says. "He was a man who had used his camera as an advocacy for the creation of several national parks in the United States.

"The story got me thinking, and made me realize that while the photojournalism that I was doing was impacting on the social conditions in Chicago, it wasn't directed towards environmental issues. I had always wanted to do something that was connected with the land.

"I left the *Chicago Sun Times*, where I had won the Pulitzer Prize for feature photography in 1971, and moved to the *Chicago Tribune*. There I proposed doing a story for them documenting a regular guy in mid-life crisis attempting to climb Mount Rainier in the State of Washington. Ultimately he didn't make it, but I did the trip myself, and witnessed the landscape at sunrise above the cloud line. It was life-changing, and I couldn't go back. I had just survived the turbulent 1960s, I had covered all kinds of riots and civil rights marches, and I knew that it was simply time to move on. I felt that the most important issues were the subtle issues, and the environment was not sexy enough to be picked up by the media."

After a move to Tucson and a stint as director of photography for *The Arizona Daily Star*, he went freelance. He also began leading backpacking trips and teaching photography. Wes Holden, the managing editor at *Arizona Highways* magazine suggested he consider using large-format. It was the epiphany that Dykinga had been looking for. Large-format gave him the control that he needed to develop his distinctive landscape style.

"Initially I leaned heavily on people that I respected for advice," he says, "and that helped me a lot. Eventually you learn that what large-format can't do is actually an asset. It slows down the process of composition and makes you think more, and when you place that black hood over your head it hides you from distractions and allows you to bore into the scene."

As his reputation grew, Dykinga's philosophy evolved beyond the aesthetic; the photos had to have a purpose. "As I got more into it I learned about issues that were confronting landscape, and I realized the power that pictures could have. They could help to put bread on the table, but they could also change opinions."

Combining an eye for a picture with campaigning zeal, Dykinga has become one of America's most respected landscape photographers. His work has been used to promote the creation of a national park along the American/Mexican border, and he has devoted a substantial part of his career to the campaign. "While in Chicago I had a thing about maps," he says, "and I was fascinated by this part of Arizona that bordered Mexico. It's an amazing place because it's so untouched in many ways. The fact that there are military overflights in the area and part of it has been used as a bombing range has meant that people have been kept out.

"On the other side of the border there are two parks in Mexico that comprize four million acres of the Sonoran Desert and a further 1.3 million acres on the US side. It's the closest thing that you'll get to a complete ecosystem. The plan is to unify the management of public lands on the US side into the Sonoran Desert National Park, giving it the highest level of protection. I'm not doing this just by myself: I met up with Mexican photographer and publisher Patricio Robles Gil, and writers Charles Bowden and Exequiel Ezcurra, and we're working on this project together."

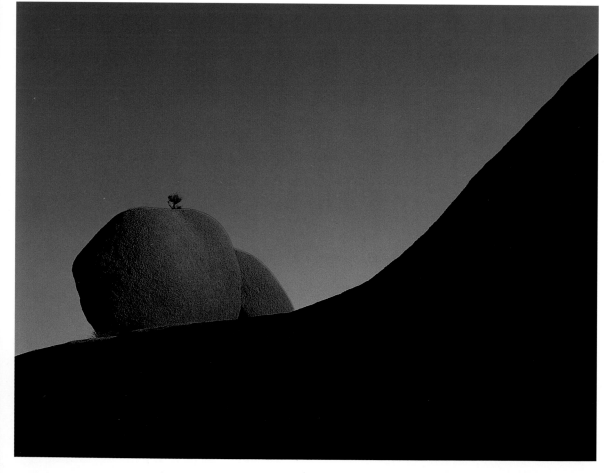

Boulder
"This was taken in the Joshua Tree National Park in southern California, and I went back to this area three or four times until I encountered the lighting conditions that I wanted. The boulder just looked like a big marble, and the tiny plant just set it off."

Arca-Swiss 4x5in f-field camera, 180mm APO Symmar lens, Fujifilm Velvia

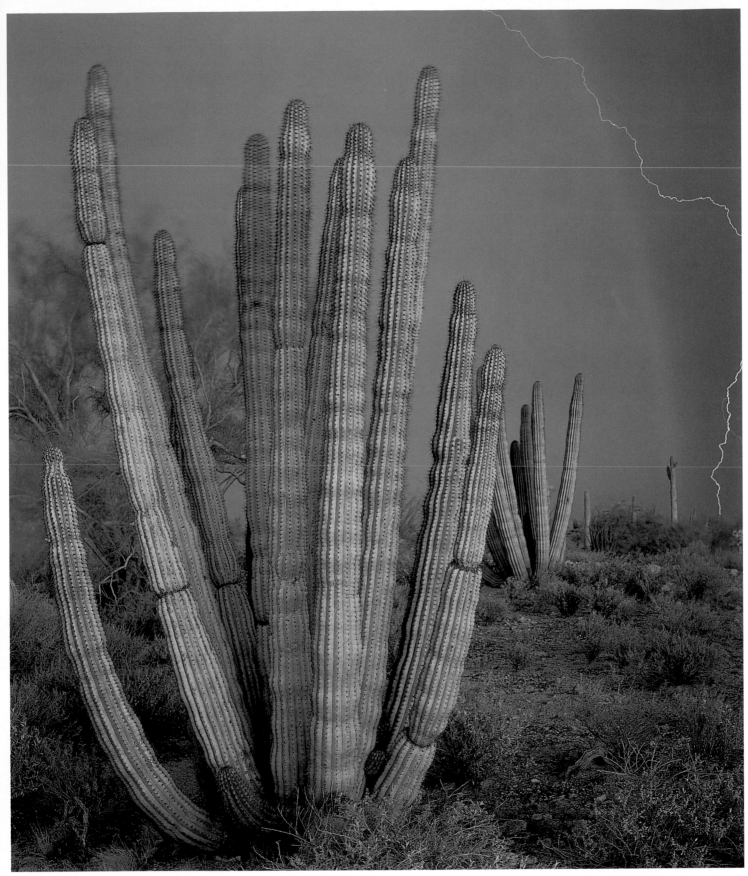

Organ Pipe Cactus National Monument, Arizona, USA
An organ pipe cactus against an approaching 'monsoon' storm in the red light of sunset, with a lightning strike behind.

Arca-Swiss 4x5in f-field camera, Schneider APO Symmar 180mm lens, 4 seconds at f/22, Fujifilm Velvia

Jack Dykinga

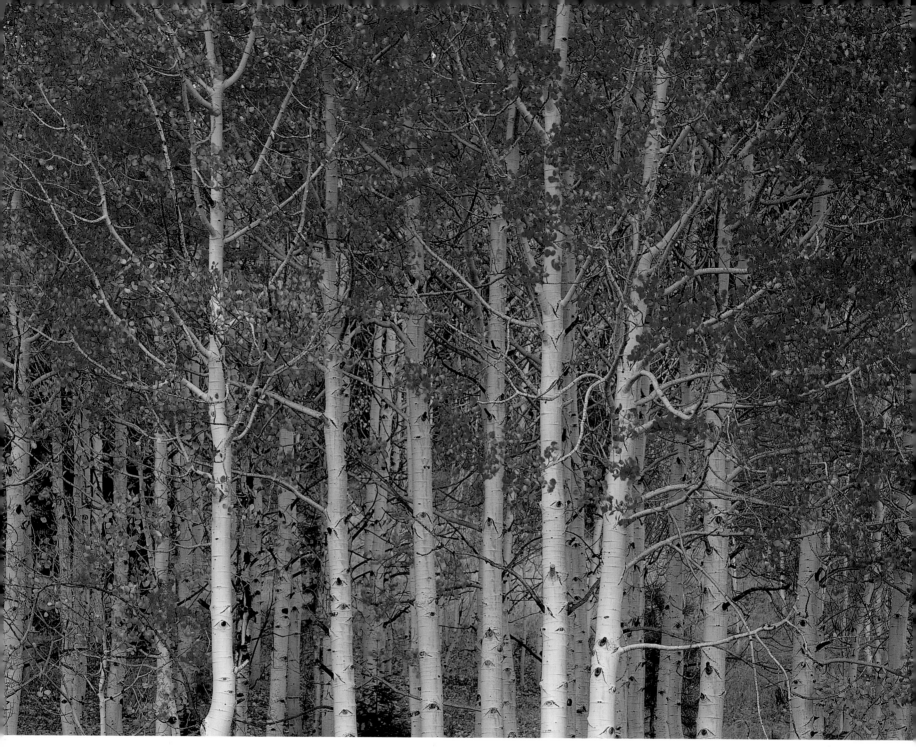

Quaking aspen trees, Dixie National Forest, Utah, USA
Aspen trees at dawn atop Boulder Mountain in the Dixie National Forest, Utah.

Arca-Swiss 4x5in f-field camera,
400mm APO Tele-Xenar lens,
4 seconds at f/32, Fujifilm Velvia

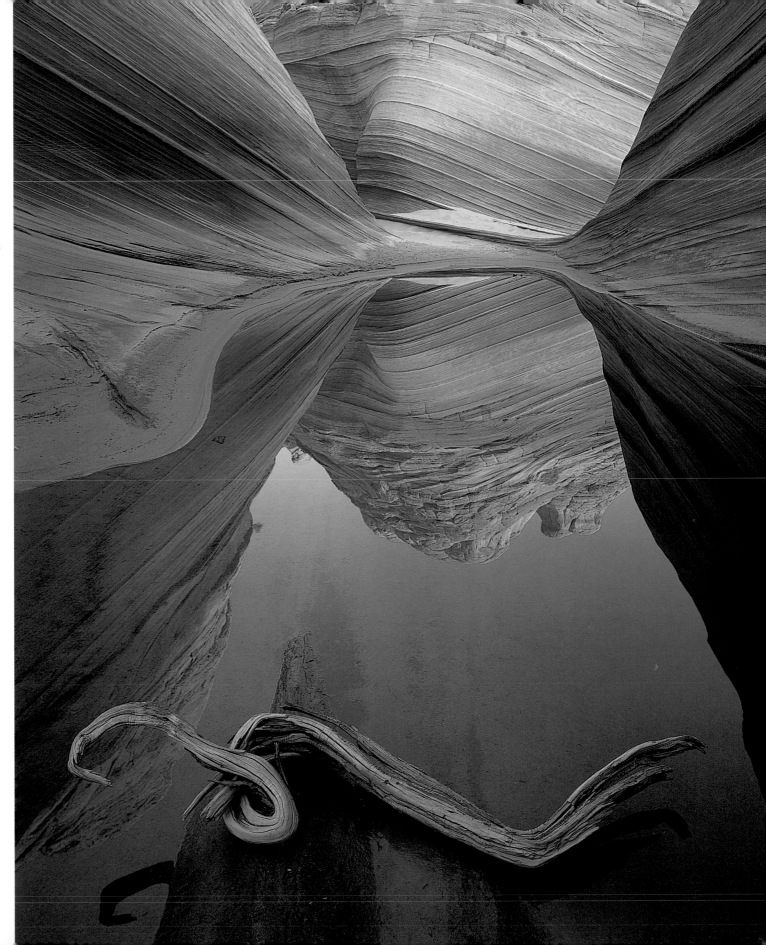

Reflections

"This is something of a signature image of mine; a picture that took several attempts to achieve, and it was taken in one of the canyons that can be found on the Arizona/Utah border. I had to hike in around three miles (4.8km) to get to this spot and, following a rainstorm, this pool of water had formed in a pothole, and right in the middle was this curved tree root. I tried to photograph it but the light wasn't right. I persisted and returned several more times in the next couple of weeks, and each time something wasn't quite right. Either the light wasn't what I wanted or the wind would be blowing and ruining the reflections.

"One night I was in Salt Lake City having dinner at around 5pm, and I decided to give it one more try. I drove back to the spot, arriving at around midnight, and camped for a while, getting up at 4am just as the sun was rising. This time I encountered perfect conditions, and this was the picture that resulted."

Arca-Swiss 4x5in f-field camera,
75mm Super Angulon Schneider
lens, Fujifilm Velvia

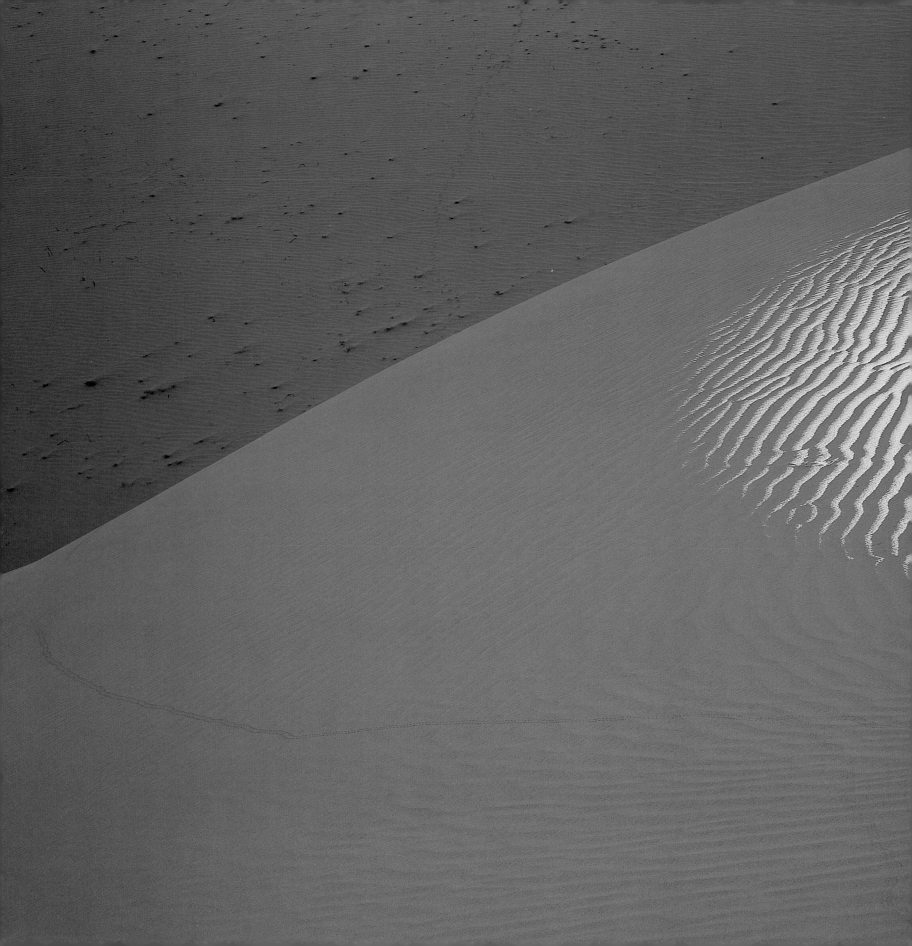

Sand dune

"This was taken in the east Mojave Desert and was part of a book project that I was working on called *Desert: The Mojave and Death Valley*. This lighting was just something that I saw, and I put it down to serendipity."

Arca-Swiss f-field camera, 240mm APO Symmar lens, Fujifilm Velvia

Jack Dykinga

Patrick Endres

Growing up in west Wisconsin, Patrick Endres first encountered the wild and largely uninhabited Alaskan landscape in 1981 when, attracted by a course on marine sciences and developing his interest in biology, he began studies at the University of Alaska, in Fairbanks. He was captivated by the beauty of the country, but had no serious thoughts at that time about taking up photography.

Post-graduation, Endres remained in the region. A key turning point came about as a result of the Exxon Valdez disaster. The Valdez leaked tons of crude oil into the waters around Alaska, threatening one of the world's most important ecosystems. This spurred him to action. He took a job with the Alaska Department of Environmental Conservation and, for three years, carried out scientific observation that was designed to measure the extent of the oil-damage. He explains, "I was given a camera, and part of my remit was to take pictures because the budget that the department had didn't cover the hiring of specialist photographers."

As the clean up progressed the job was scaled down, and Endres started to contemplate his options. He had always had an interest in photography, and now he realized that there was an opportunity to take this further. The on-site training that he had received had given him a good grounding in terms of the skills that were required to become a professional photographer, and he supplemented this with further studies.

Endres specialized in images of the region, and set up a library, 'Alaska Photographics' (www.alaskaphotographics.com), but it's his landscape work for which he has become internationally known. He loves the challenges of combining composition with dramatic lighting so fundamental to landscape photography. He has dedicated himself to travelling extensively throughout the state, observing and photographing the delicate balance of nature in the arctic and subarctic environments, making him an expert on the state's ecosystems, geography, and natural history.

"Alaska is just such a spectacular place to take landscape pictures," he says. "It offers a unique variety of things to photograph, and the lighting is often fantastic. In the summer months at the latitude that Fairbanks lies within, it doesn't get dark for three months. Instead there's a long period where the sun is at a very low angle, and the land is bathed in the golden light of dawn and dusk.

"In equatorial regions the sun rises and sets in a heartbeat. Here you get that beautiful light for a long time, particularly in the winter. On December 21 you could watch the sun rise for two hours; it's just an incredible experience, and I just love shooting landscapes here."

Moose antlers and bear tracks, Naknek Lake, Alaska, USA
"I made this picture in the Katmai National Park. My aim was to experiment with the pre-dawn light. I found a vantage point where I could use these moose antlers to create interest.

"This area is populated by grizzly bears, which travel the lakeshore en route to a stream. I put on a two-stop neutral density grad filter to balance the contrast between the sky and the foreground, and angled this so that it followed the shoreline.

"Having setting up the shot, I had to move because of an approaching bear, and that's how the footprints were created, which add a strong sense of presence. I hurried back to the scene to get my picture before the next bear came along!"

Canon EOS 3, 17-35mm zoom lens, Fuji Velvia

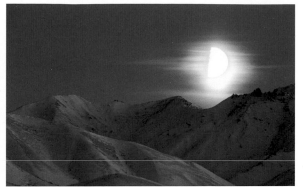

Paper moon, Denali National Park, Alaska, USA *(Top)*
"As I made this photograph, a strange phenomenon occured as clouds drifted across in front of the moon. I call it 'Paper moon' because the edge of the moon looks like ripped paper. Right after this I saw a wolf running down a river bar under the light of the moon, and that image is still vivid in my mind."

Canon A2, 300mm lens, Fujifilm Velvia

Snow bow near sunset, Alaska, USA *(Above)*
"This location was 70 miles south of the Arctic Ocean on the coastal plains of Alaska. The wind was blowing severely, and this creates patterns on the tundra called 'sastrugi', which adds interest to an otherwise flat landscape. The wind had lifted enough particles of snow to create a 'snow bow' (halos, popularly known as sun dogs) either side of the sun."

Canon EOS 3, 17-35mm zoom lens, Fujifilm Velvia

Aurora borealis over the Canwell glacier, Alaska, USA *(Left)*
"I made a 25-mile snowmobile journey to get to to this location. That night the aurora borealis was phenomenal. I used 35mm and 6x8cm medium-format cameras. Because long exposures can blur the aurora, I used a fast lens and pushed the Velvia one-and-a-half stops. The exposure took six seconds. I planned the photography around the phases of the moon so that it enabled light to fall on the foreground."

Canon EOS 3, 24mm lens, Fujifilm Velvia pushed 1.5 stops to ISO 150

Patrick Endres

Winter camp, Twaharpies Glacier Moraine, Alaska, USA

"This was taken in the glacial moraine close to the Twaharpies Mountains in the Wrangell St. Elias National Park and, in the winter, there really is no travel system to get you to this part of the country. It's a very rugged landscape, and the only way for myself and a friend to get to this area, where we intended to camp for three nights to take pictures of the aurora borealis (the Northern Lights), was to travel around 60 miles (96km) on a snowmobile, pulling the bulk of our gear on sledges. It took us a full day to complete the journey.

"This really was a beautiful location, but on this particular evening there was cloud cover and it meant that there was no chance of us getting the pictures that we wanted. However, although there was cloud that shielded the night sky, it was high enough to reveal the adjacent mountains, and I thought that I would try to set up a picture of our campsite at dusk, and judge the shot so that there was a balance between the ambient blue light and the tent, which was lit with a lantern.

"There was a fairly narrow window of time during which this was possible, probably not more than ten minutes, and I had to use my experience to make a guess about what the exposure would be. The lighting was getting weaker all the time, and so the exposure was changing rapidly. It started off at 30 seconds and eventually lasted four minutes for the very last image, when the light had largely faded from the sky. I shot with two cameras, 35mm and a 6x17cm panorama.

"This is one of the earlier, most successful frames. As the exposure got longer to maintain the blue of the sky, the tent started to burn out, and the later pictures were unusable."

Canon EOS 3, 16-35mm lens, Fuji Velvia

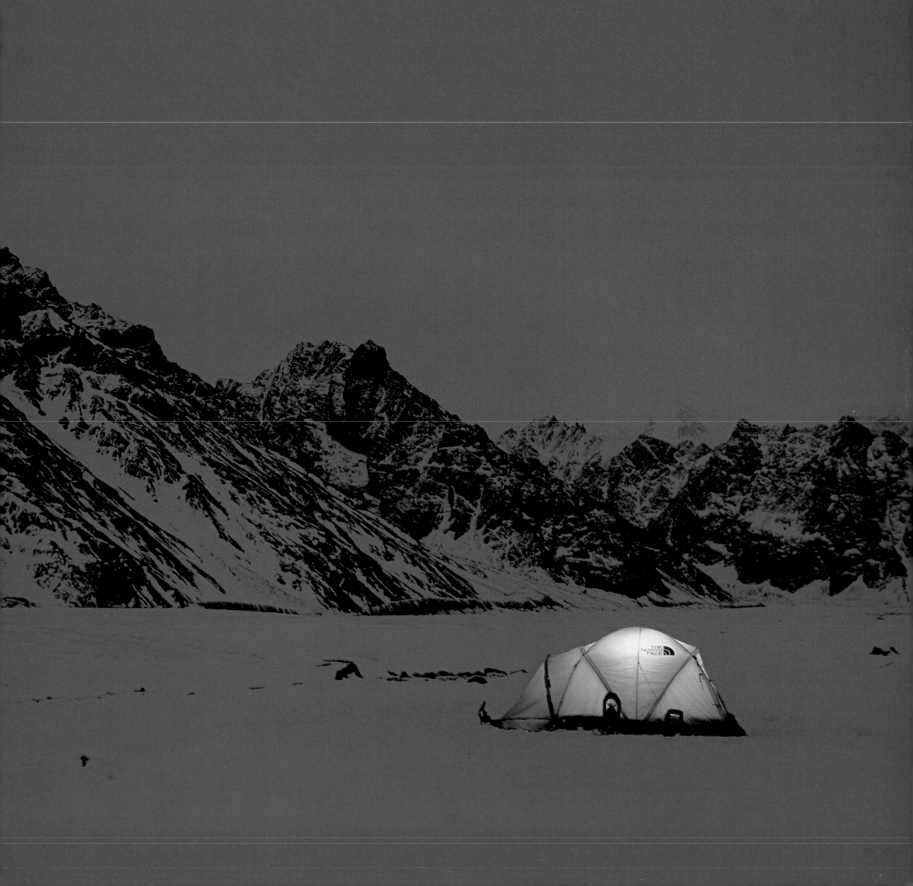

Macduff Everton

Macduff Everton first travelled to Mexico in 1967 when he was hired to make anthropological and archaeological filmstrips. His only qualification was that he knew how to travel, and that he'd picked up a camera while exploring the globe because he didn't want to look like a tourist. Two years later he returned to Yucatan with the view of documenting the Maya in the style of *Life* magazine's 'Day in a Life' series.

It was a project that was to change his life. The several months he intended to spend there became 20 years, and occupied him until 1991 when *The Modern Maya* was published. In it he documented the lives of seven individuals and their families during the period that he'd lived with them.

Everton was pleased with his documentary work, but once in a while someone would look at a photograph and Everton realized that they were not seeing what he saw. "I might have walked two days through the jungle to get to a ruin," Everton says, "and they would want to know where the hotel was. At first I thought it was a stupid question until I realized that there wasn't enough information in the photograph. I became dissatisfied with a regular camera and lens and I sought out something that could convey what I saw. I bought a Widelux panoramic camera and for the first time felt that I could convey a sense of place. The camera saw how I saw things. There was no learning curve. The first roll that I shot with the Widelux was good."

The panoramic format has dominated his life ever since, although the technical problems that he experienced with the Widelux did persuade him to switch to a 120 format Noblex 150 50x120mm camera. The Noblex is a unique panoramic model that features a swing lens; the lens is recessed into a revolving drum which rotates a complete 360°. During the first half of this revolution, the lens is hidden from view, and this is to allow the lens to get up to a steady speed that is maintained during the second half of the rotation, which is when the exposure is made. Light entering through the lens is exposed on to a curved film plane, and because the lens always maintains the same distance from the film plane, it produces a distortion-free panoramic image.

"It's a very simple camera to use. I want it to be an extension of my mind, " says Everton. "Because of depth of field, you don't have to focus; in fact I don't even have to look through the viewfinder because the camera covers 145°, which is what you see with peripheral vision. I use one film so I can figure out exposure by looking at the light. I hate carrying a tripod – I'll only use it for multiple exposures when the light is too low for a single revolution. I added a centre-weighted bubble on top of the lens barrel so I can level the camera without using the viewfinder. Photography is all about light, and every once in a while you have to chase it. It is best to travel when you are not weighted down with too much stuff."

Coming from a family of Oregonians, Everton also has Scottish ancestry, which has driven him to visit the UK on expeditions. His approach to the weather that so typifies the British upland areas sums up his entire approach to landscape. "My technique for shooting anywhere in the UK is to buy a copy of *The Independent* newspaper," he says, "and when I arrive at the place where I want to take pictures, if I feel that the light might get better I sit down and read the paper and wait for things to happen. If the temperature really drops, I have the option of rolling up the newspaper and sticking it in my clothes for insulation!"

Everton's point is that you can't hurry landscape photography, and having the patience to wait for something special is one of the essential attributes for any photographer who seeks the same level of inspirational landscape work.

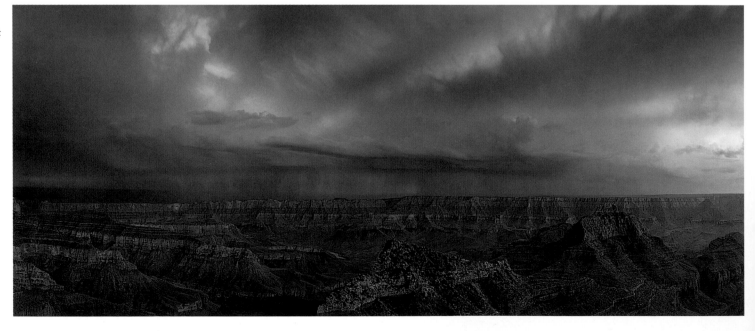

Sunset storm, Cape Royal, Grand Canyon north rim
"I was on assignment, and hadn't shot anything because of a day-long rainstorm. About an hour before dark I had to make a decision whether to stay. If I waited, I wouldn't get dinner!

"It was raining, and lightning was striking around me, but I stayed. The edge of the storm appeared in the west just as the sun was setting and it painted the canyon and clouds a brilliant orange-red. Some can't believe that I don't use filters to achieve an effect like this, but anyone who knows the back country will see light like this."

Noblex 150 50x120mm panoramic camera, Fuji NHG rated at ISO 800

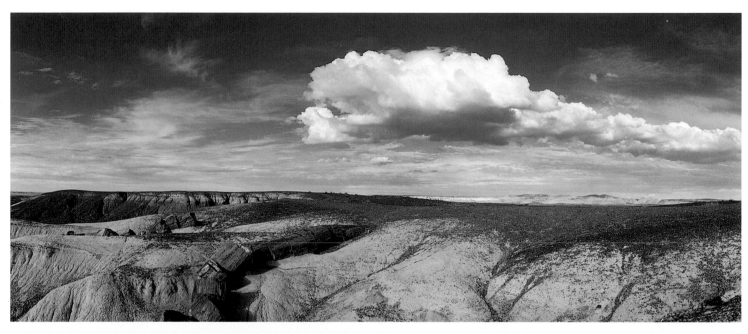

Petrified Forest National Park, Arizona, USA

"This is from *The Western Horizon* project. I waited for some clouds to enhance an otherwise very plain sky.

"The picture was taken at around 2-3pm, and I shot all day long. It just depends on the light and the season. In the Outer Hebrides in November you cast a long shadow at noon. It is glorious. It is as if you have these golden hours of sunlight all day long."

Noblex 150, 50x120mm lens, Fuji NHG rated at ISO 800

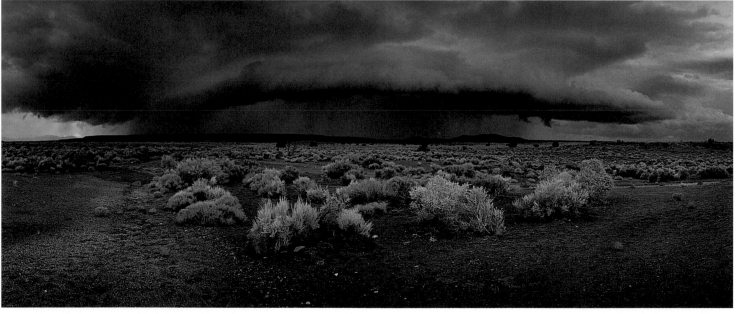

Approaching storm, Wupatki National Monument, Arizona, USA

"This storm came racing towards me and the cloud was upon me in around a minute-and-a-half. I had very little time to shoot before I got soaked. I think that the light during stormy weather is often dramatic. My wife Mary jokes that when a storm is approaching, she can always find me because I'm the one running towards it rather than away from it."

Widelux panoramic camera, Kodak Gold

Macduff Everton

Blowdown, Mount St. Helens National Volcanic Monument, Washington, USA

"I took this picture hanging out of the open door of a helicopter ten years after the eruption of Mount St Helens, and things had hardly changed at all. It was an amazing sight, and the road in the bottom left-hand corner gives some idea of the scale of it all."

Widelux panoramic camera,
Kodak Gold

Macduff Everton

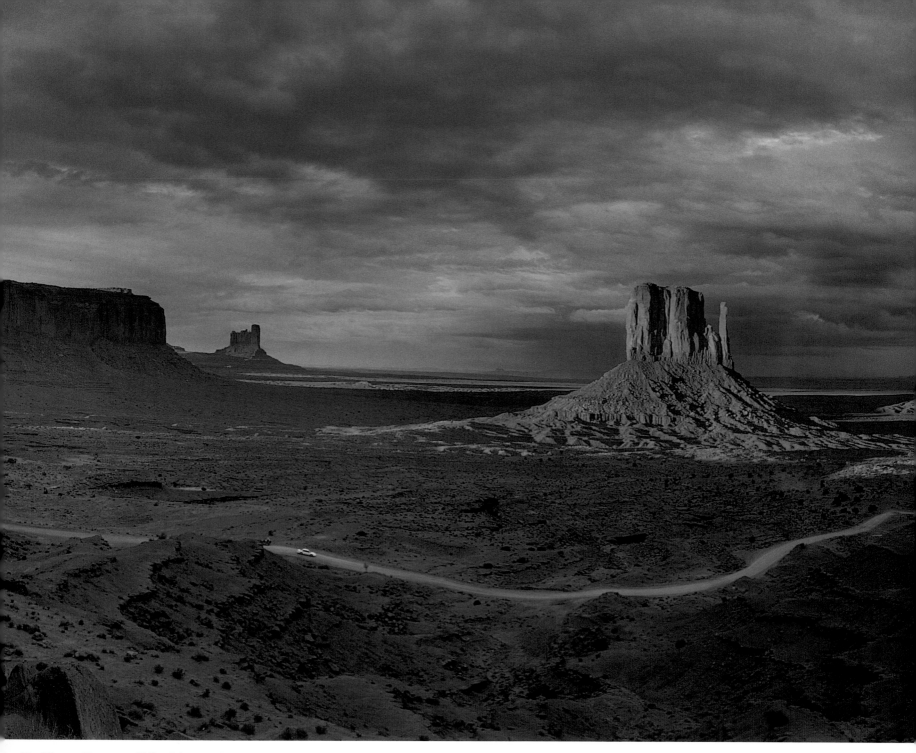

The Mittens, Monument Valley, Arizona, USA

"This was a day where the weather was pretty miserable. There hadn't been any good light all day, but I thought there was a chance that as the sun set it could drop underneath the clouds for a couple of minutes, and if it did, it would light up the undersides of the clouds and sky.

"Sometimes you are lucky, sometimes you aren't. In either case, you have to wait and make your choices based on experience and a good amount of hope. This was shot during a crazy three-month period of photographing for *The Western Horizon*, a book that I collaborated on with my wife Mary Heebner, who wrote the text. We didn't receive a contract for the project until the end of March, and we had a September 1st deadline. My wife is a painter who refuses to write from photographs, and so we set off and went everywhere on a tight schedule in order for both of us to meet the deadline."

Noblex 150, 50x120mm lens, Fuji NHG rated at ISO 800

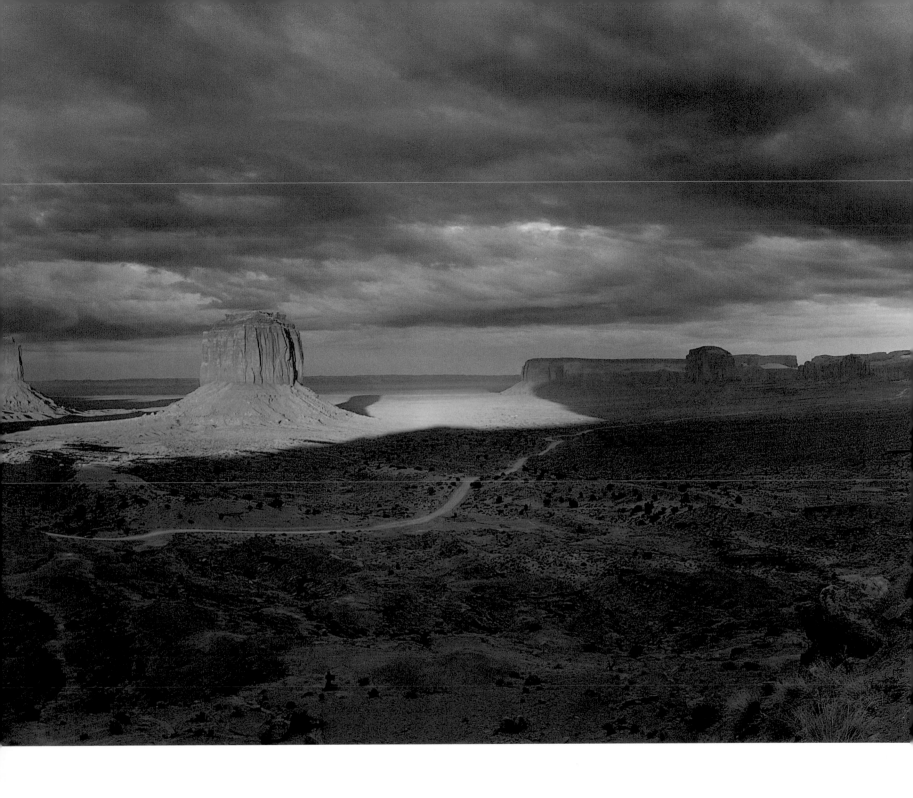

Macduff Everton

Michael Fatali

Born in Brooklyn, New York, in 1965, Michael Fatali moved to southern Arizona at the age of six, and thus began his love affair with the desert of the Southwest. Photography soon became an outlet for expressing his passion for the region.

At the age of just 15, he lost his mother to cancer. It was a blow which precipitated a journey of self-discovery, and his intimate relationship with nature as 'motherhood'. By 1990, however, he was still struggling as an artist, with only his large-format camera and a dream to keep him going.

He moved closer to the land that he was most inspired by: southern Utah. Later, he opened his first Fatali Gallery in Arizona and then Springdale, Utah, to showcase his images of the now world-famous slot canyons. Media coverage gained him recognition that highlighted his eye for canyon light and established him as one of America's most talented landscape photographers.

"Selecting the right equipment is a big part of my process," he says. "I work with an 8x10in compact field camera customized by Dick Phillips and Sons of Midland, Michigan. It is one of the finest cameras made. I like its simplicity and rugged, lightweight construction. It has also held up well in extreme conditions and environments during my journeys through the Southwest.

"Using this oversized, primitive camera is a way to become more intimate with my subjects. It forces me to approach my subject in a methodical, sensitive manner instead of randomly exposing images.

"I use a wide range of lenses from 110mm to 800mm. With film, I have had most success with Fujichrome Velvia and Kodak Ektachrome VS. The most difficult issue is their extreme inherent contrasts. But they work wonderfully in soft, even lighting.

"When visualizing a scene, I first make my exposure evaluations with a Pentax 1° spot meter. This enables me to read small areas of values in my scene, from shadows to highlights.

I stay within three stops of exposure from the brightest value. This serves as an aid to explore the range of values and color tones within my compositions. I can select an exposure that makes a canyon wall reflecting an orange-like glow turn red with less exposure, or yellow with more exposure. Either is a matter of choice to the end result.

"In making fine prints, I work with the natural light when exposing my images. I don't use color filters or artificial lighting in the field. I find it pleasing to control the result in my darkroom.

"Working with the 8x10in film size also enables me to capture and reveal every detail in the photographic print. I have been using the 'classic' Ilfochrome materials – formally known as Cibachrome – for my gallery prints. I own a Durst 10x10in enlarger with a color Proveli head and process with a 26in-width Hope.

"Ilfochrome is my first choice for producing a handmade print. I use contrast masks for my images when printing. The recipe is the most intricate part of this process, and has to be right. Depending on the exposure and development of the pan masking material by Kodak, I can control the contrast and density of a specific area, or the entire negative. I often use filtration when exposing the masks to enhance the depth of color. I have seen nothing that compares to a well-printed Ilfochrome for the beauty of a color image. I am finding from museums and collectors that this printmaking, without digital application, is becoming more appreciated and desirable."

Tales of time, Southwest desert, 1999 (*Right*)
"I took my family and friends here on New Year's Eve, and the light in this image was the last light of the millennium. I anticipated that moment as the sun was setting, and waited until the background was in shadow to add drama.

"My first discovery of this location was in the early 1980s. I was fortunate that most of my successful images of the mystery plateau were made when I camped out at my favorite spots for several days waiting for the magic light. A permit is now required and is restricted to just 12 people for day hikes only."

8x10in custom Phillips camera, 360mm lens, f/45, Ektachrome ISO 100, spot-zone metering, reproduced from a Cibachrome contact print

Heaven's gate, Southwest desert, 2000 (*Far right*)
"I have photographed this scene many times, and this one is one of the most successful images I have made in slot canyons. I used a wide-angle lens to create a sweeping feeling of space, and the fleeting light draws the eye nicely through the image. The broad range of exposure values in this image makes it attractive and very difficult to expose.

"This is one of my favorite canyons on the planet. My first encounter was life-changing, and the beginning of my passion for canyoneering. I consider underground canyons a place of sanctuary."

8x10in custom Phillips camera, 150mm lens, f/45, Ektachrome ISO100, spot zone metering, reproduced from a Cibachrome contact print

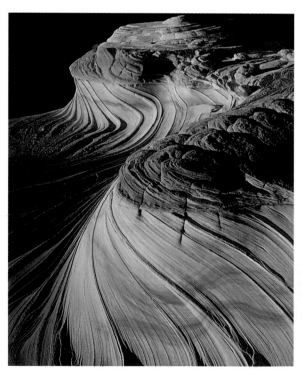

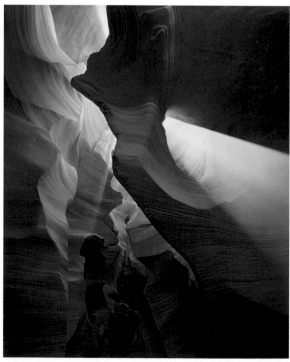

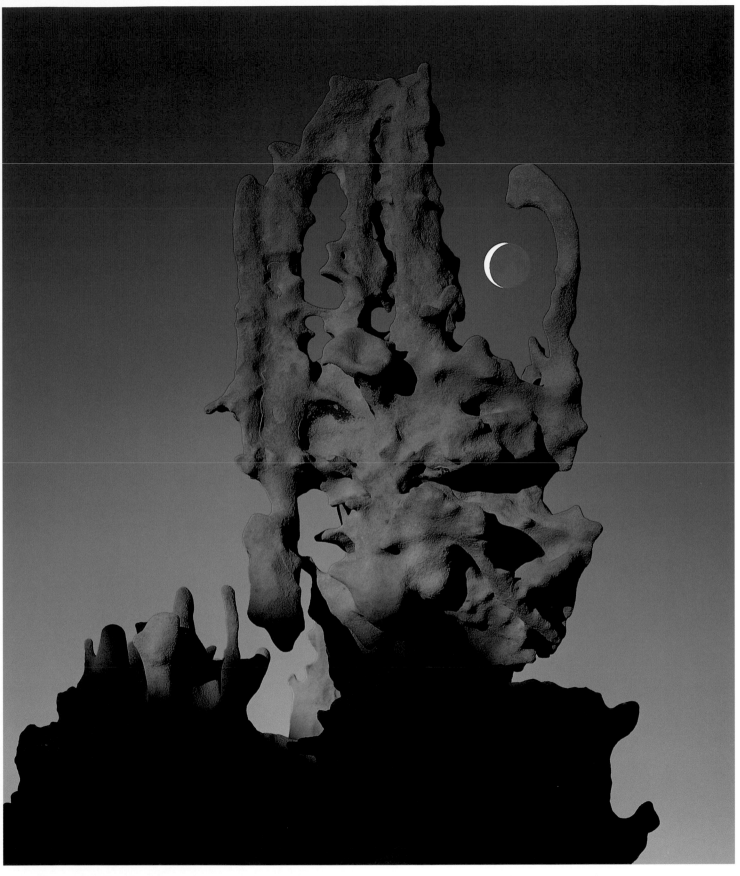

Back of beyond, Southwest desert, 2000

"Throughout my explorations of the Southwest I have never seen such an amazing and mysterious sandstone structure as this. As I stood looking upwards in front of this massive yet delicate temple of stone, my first reaction was to drop to my knees and bow in prayer, grateful to witness such incredible beauty and mystery from the Creator. I knew I had discovered something which deserved to be represented in all its power and glory.

"This was not a snap-and-go image. I began with a visual study of the structure, making different compositional drafts and experimenting with a variety of lenses to discover how to frame the scene in its simplest, most powerful way. Having found a pleasing composition it was a matter of waiting for the perfect light – and I mean waiting!

"A year later I captured what I would call that 'perfect light'. As the sun began to set, with its colors throwing golden light across the valley and in-between the two high-peeked mountain vistas, I made my first exposure. Waiting for the moon to rise before my next exposure enabled the balance of the photograph to be improved, and evoked a sense of mystery in the scene.

"After many return trips to this location, I later discovered that there is only a week or so in the year during which the sun sets in-between the mountain ridges, allowing the low-angle light to embrace the sandstone formation that stands to the east. It may be my all-time favorite image, and it's the one that best defines my vision and style of photography."

8x10in custom Phillips camera, 300mm lens, f/32, Ektachrome ISO 100, spot-zone metering, reproduced from a Cibachrome contact print

Michael Fatali

Earth spirit rising, Southwest desert, 2000

"On another desert adventure I stopped by a desolate gas station, and the attendant and I started a conversation about different places of interest to explore in the area. He mentioned something about thermal hot springs, which were known only to the local people. While not disclosing its exact location he did give me some idea where to start the hunt. I went off quickly to unravel the sketchy clues. After many hours bouncing on endless dirt roads I was losing light fast. Disappointed that I did not find the geyser, I was determined to make a trip back for another attempt.

"A few years later I returned to continue my hunt for the geyser and this time I was lucky, it turned out to be much closer than we imagined. We were surprised to find that the geyser was on private property and, disappointed, the next day was spent seeking permission to enter the property. Finally, we were successful. When we arrived at the spot, I paused for a moment, transfixed by its mysterious beauty. I could not believe such a place could exist. The water was continuously splashing and spilling over these incredibly colorful calcium deposit structures. I walked around the geyser many times to see which angle I liked before taking my camera out of my backpack. Having found an interesting composition I exposed some sheet-film during the late afternoon and at sunset. The following morning, I took more pictures. The morning light behind the geyser was everything I had hoped for, although there were only a few seconds of great light that backlit the spouting water of the geyser's throat. I was not 100 percent sure that I had captured the perfect moment, so I attempted more images over several days.

"These days, the property has changed hands, and now no-one is permitted to enter the property. Perhaps someday it will be a preserve with restricted visitation to allow it to be witnessed by more then a few."

8x10in custom Phillips camera, 150mm lens, f/32, Ektachrome ISO 100, spot-zone metering, reproduced from a Cibachrome contact print

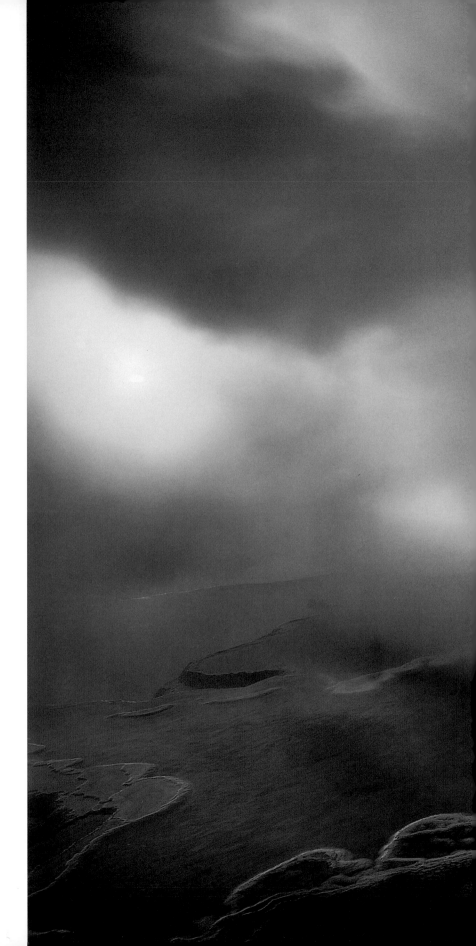

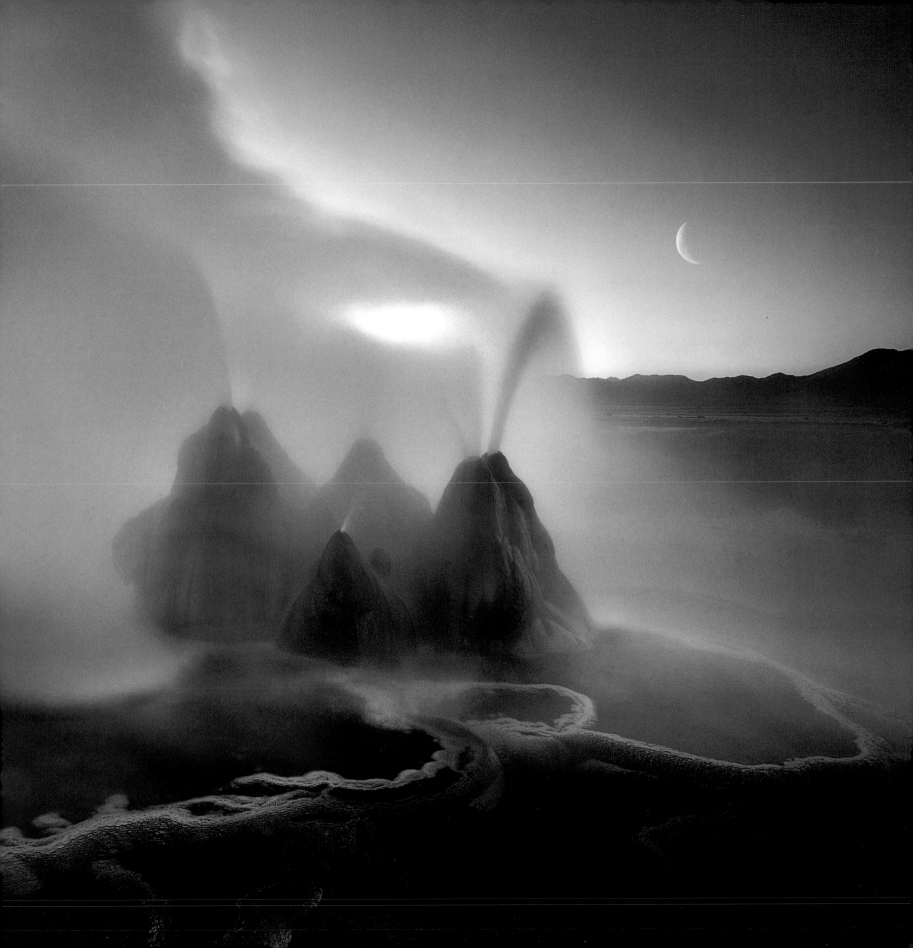

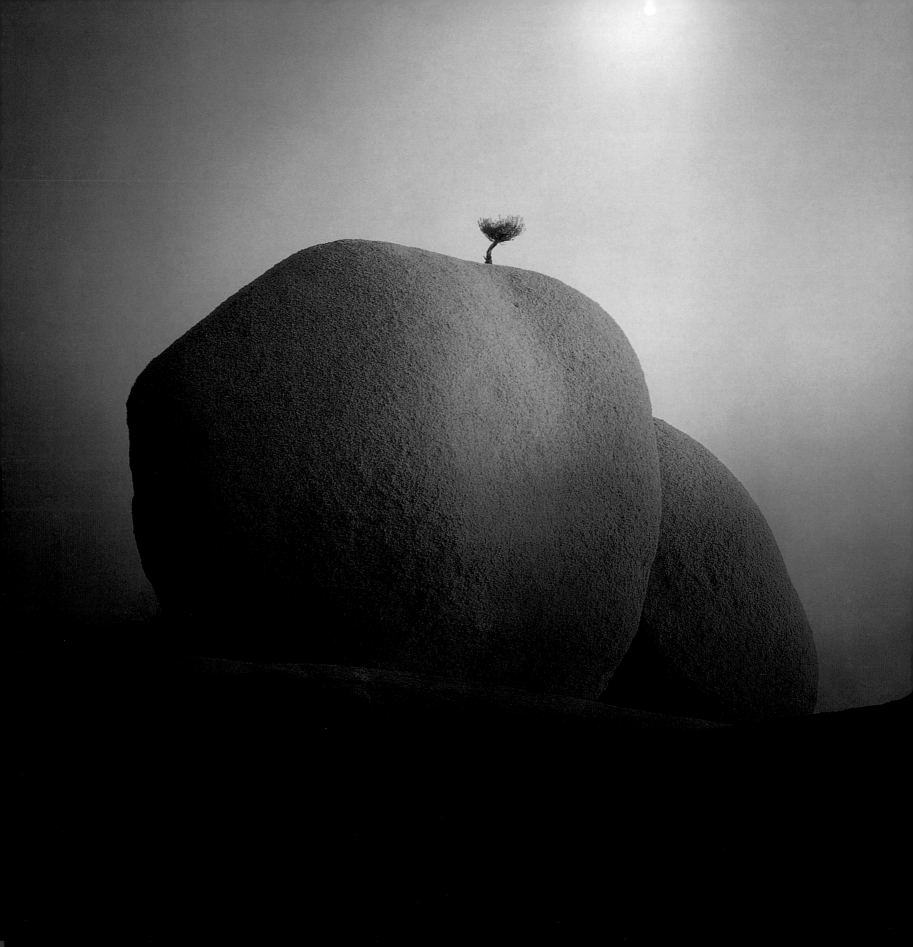

Sunkissed, Southwest desert, 1994

"This is an image that was created by lucky accident, although the romantic in me can't help but wonder how much of it was by chance or fate.

"During 1994 I travelled through the Southwest for several weeks, revisiting familiar places as I often do. I also like to scout for new territories that might yield future images, and I went off to explore the boulder fields on an all-day trek. I came across many areas that had possibilities, and one was this interesting 30ft (9m) tall boulder that had a small tree precariously growing on top. It amazes me how life can find its way through some of the most difficult terrain, and the balanced boulders and the life it sustained inspired me to make this image. The light was rather uninteresting at the time, so I waited until morning for first light, and this defined the shape while bringing attention to the subject.

"An ongoing challenge and important skill for landscape photographers is the ability to previsualize the effect of a particular lighting condition and choice of exposure, and to translate what is in the mind's eye to achieve the image with the tools that are available. This is the key to 'seeing' photographically. Two-dimensional film will not replicate how we see the world, but it certainly can be one of the greatest vehicles there is to give the viewer access to what the photographer sees and feels.

"Most of my images are captured only once I have made a number of trips to an area; rarely do I create my best results from a first attempt. Even more rarely will I create the final image from an accident such as this one. When I returned home after my photo trip, I was so excited to get my film processed and to stand over my light box sorting favorites, and discarding the many bad photographs that it takes to make the few good ones. I was pleased with the first images I saw on the light table. The compositions and exposures of the boulders were decent, with the skies clear blue. Yet, I noticed something very unusual about one transparency. In this one was an amazing sky of strange, smoky-like clouds above the boulders. What was this about? Well, after my trip to the boulder fields I went to the Grand Canyon and photographed a beautiful sunset and apparently I accidentally double-exposed a sheet of film on top of the boulders scene. My jaw hit the floor by this lucky image. It was meant to be!"

8x10in custom Phillips camera (4x5in reducing back), 90mm lens, f/22, Fujichrome ISO 100, spot-zone metering, reproduced from a Cibachrome contact print

Michael Fatali

Michael Frye

Like so many of the highly regarded photographers in this book, Michael Frye started off with a simple love of the great outdoors, and his interest in photography developed through a desire to share with others the visions he encountered.

"I'm one of those people who, if they want to learn something, will just go and do it rather than take a course," he says. "That was how I started to take pictures. At first it was for my personal enjoyment, but after a while I realized that I wanted to make a career out of photography. Making it pay for itself was the problem."

Initially specializing in wildlife pictures, Frye changed direction after taking a job at the Ansel Adams Gallery in Yosemite Valley. "I just missed out on meeting Ansel personally," he says, "which was disappointing, but the experience was very helpful. The gallery was in an area that was perfect for photography, and I got to meet a lot of other photographers who were tackling this subject, some of them very big names. It helped me to make a lot of connections and to learn about not just the technicalities of landscape photography but the business side of things as well."

Frye's own high standards led him to question the landscape pictures that he was producing, and he started to think about ways that he might change his approach to image-making so that they reflected a more personal style. "Like a lot of photographers I went through a period where I felt that I was getting into a rut," he says.

"I was introduced to fine art landscape work. Since that time I've been interested not just in the commercial demands of photography but in producing images that have artistic merit."

"It was around 1994–1995, and I started experimenting with different techniques and new avenues – it's something that I do regularly – and sometimes something interesting comes out of it and at other times not. On this occasion it led me to start taking pictures of landscapes at twilight and at night, using a flash to provide the illumination. I'd never done anything like this before, and I found it to be a very stimulating way of working.

"It also allowed me to convey a different mood. During the day it's difficult to see beyond the surface beauty of nature. But when the sun sets and the forests, mountains, and deserts are enveloped in darkness, nature reveals its hidden power. At night, the wilderness offers a chance to experience something that has become truly rare in the modern world: a sense of mystery.

"This new technique gave me a way of expressing the power and mystery in my photographs. I ventured out at night into wild places throughout the American West, taking with me electronic flashes such as the Norman 400B, and powerful torches. By adding colored filters to the light I could 'paint' elements of the landscape different colors, something that I enjoyed doing because I've always been interested in what color can express in a picture and the sense of mood that it can create.

"I often combined my manmade lights with natural elements, such as stars, the moon, or a twilight sky. Some of the more complex photographs that I've produced have taken several hours to create as I've moved lights into different spots or waited for the moon or some other celestial body to slide into position.

"The resulting photographs are not literal representations of reality. Instead they are meant to convey the mood of the night-time wilderness: the sense of mystery, wonder, peace, and awe that can overtake you when you venture into wild places at night."

Ocotillo, Saguaro cactus and moon at dusk
"I had tried to photograph this once before, but had run out of battery power. When I returned, I found that the moon was rising behind the cactus, and I had to hurriedly set up and take the first exposure of the cactus while the moon was in the right position. I then waited for the moon to move out of the frame, and I then set up two Norman 400D flash heads, one fitted with a blue filter and set to illuminate the ocotillo and the other with a magenta filter and to light up the saguaro cactus. I wanted to keep the two colors separate, and what helped me was the fact that there is more distance between these two plants than it appears."

Mamiya 645, 45mm lens, Fujifilm Provia 100

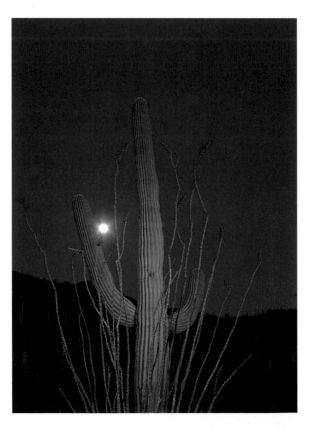

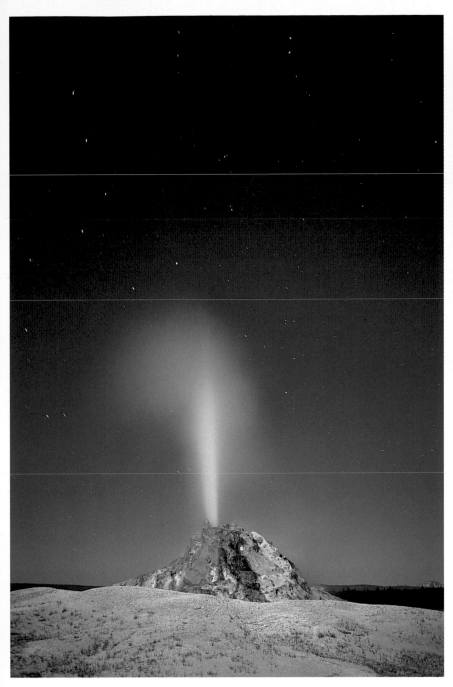

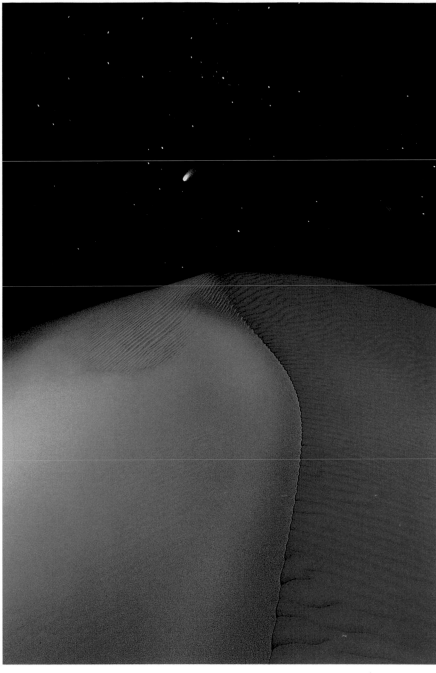

White Dome Geyser by moonlight

"The White Dome Geyser in Yellowstone erupts every 15 to 30 minutes. I decided to attempt a picture of it on a moonlit night when I could rely on natural light to provide much of the illumination that I needed.

"When I heard that the eruption was about to happen I pressed the shutter and kept it open for the two minutes that it was taking place: during that time I took a torch that had a blue filter taped over the front, and I painted in the geyser and the cone. I'll use whatever light is most applicable for a situation – torchlight gives a very precise light that enables smaller details to be highlighted, while the bigger flashes illuminate a much wider area."

Mamiya 645, 45mm lens, Fujifilm Provia 100

Sand dune and Comet Hale-Bopp, Death Valley

"The strength of this photograph is its visual simplicity; making it was technically complex.

"Before dark, I searched the dunes looking for the right foreground. After finding this ridge of sand I waited until the comet moved into position above the dune. A powerful spotlight assisted me in composing and focusing the image in the dark. I locked the camera down on a tripod, the hard part began.

"We think of photographs as capturing a single moment, but this image took hours to make. I added light, bit by bit, to create the image, making a series of separate exposures on the same piece of film. First I opened the shutter for a minute to capture the comet and stars, then positioned a flash with an orange filter to light the left-hand side of the dune; it took 32 pops of the flash (each made during a separate 1/60th sec exposure) to cast enough light.

I then put a blue filter over the flash and repositioned it to light the right-hand side of the dune; this time it took 64 bursts of the flash. I then advanced the film to the next frame."

Mamiya 645, 45mm lens, Fujifilm Provia 100 pushed two stops to ISO 400

Michael Frye

Jeffrey Pine on top of Sentinel Dome, Yosemite National Park, California, USA

"One of the things that I like to do is to photograph well-known landmarks at night. I think it's fun to make these familiar subjects look completely different. This particular Jeffrey Pine in Yosemite has been photographed thousands of times, but I would guess that it's never been done this way before.

"The complexity of my night-time photographs often requires me to have a preconceived idea of how I want the image to look beforehand; it's hard to be spontaneous. Here I had decided to attempt a picture of the Jeffrey Pine with the moon rising behind it. I knew I needed to make this image the night before the moon was full so that it would rise at dusk before the sky was completely dark.

"Before setting up my camera I had to take my best guess at the path that the moon would take, and then to compose my picture so that it would clear the top of the tree. The first exposure – for the moon that's just above the horizon – was made at dusk. I then opened the shutter three more times at 45-minute intervals to record the moon as it travelled through the sky. These four exposures were just for recording the moon; had I processed the film at this point the only thing visible would have been a sheet of black film with just the four moons registered.

"Before lighting the tree I waited until the moon had passed completely outside of the frame. At the time I made this photograph I had just the one Norman 400B battery-operated flash head and so I had to set the rest of the exposure up in two parts. First I opened the camera's shutter on 'B' and fitted a red gel over the flash head, and then moved to a point to the right of the camera position and fired the flash around eight times to build up the exposure that I needed. I then changed the red filter for an orange one, opened the shutter again, and took up position behind the tree, out of the camera's view, and fired the flash another eight times to provide a rim light to the tree. After this, I closed the shutter and the picture was complete. It had taken around three hours to produce from start to finish."

Mamiya 645, 45mm lens, Fujifilm Provia 100 pushed one stop to ISO 200

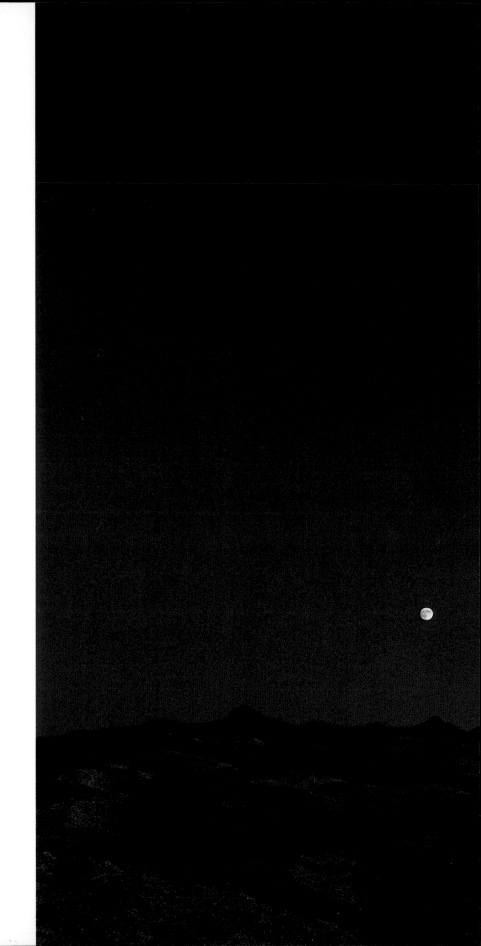

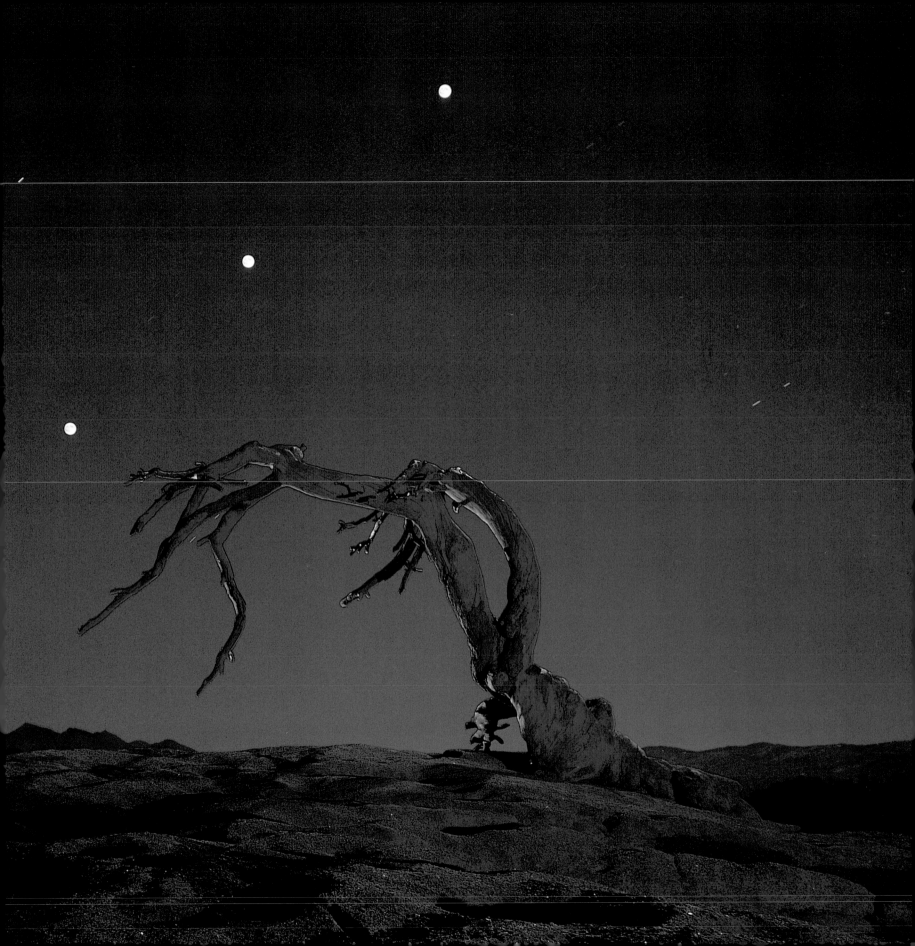

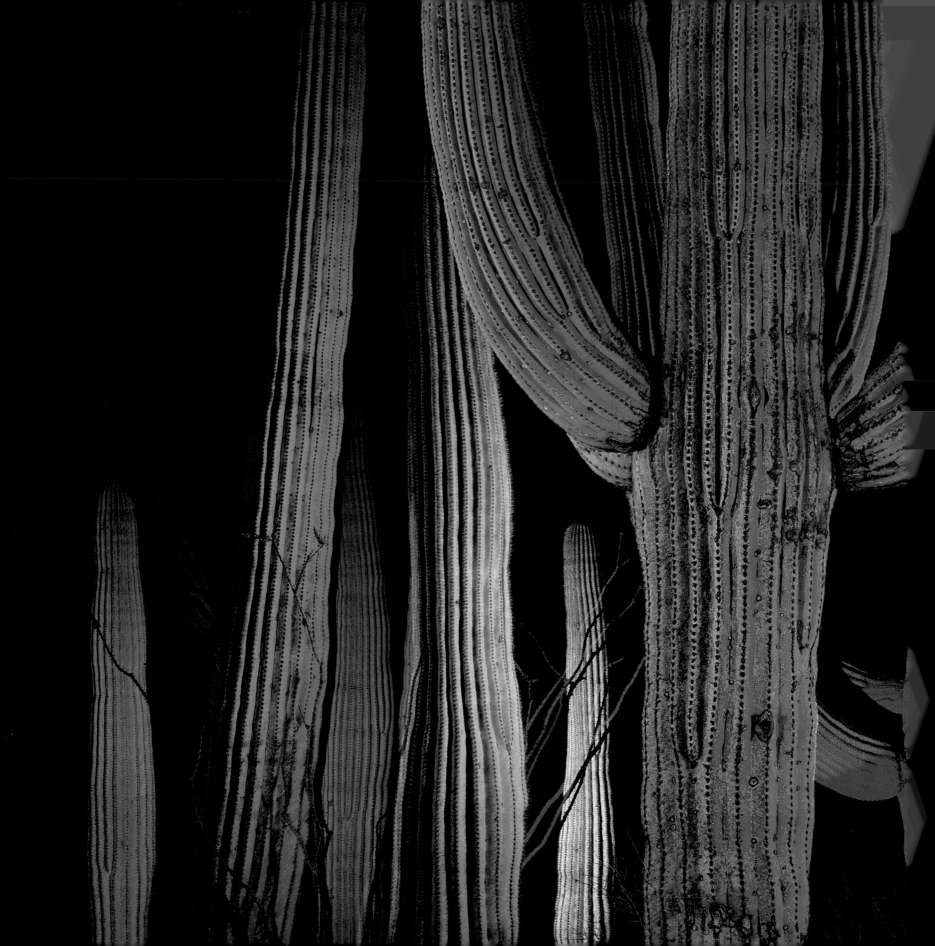

Saguaro cacti, Saguaro National Park, Arizona, USA
"My wife Claudia calls this image 'What Saguaros Do While We're Sleeping'. I think her title captures the mood of this image, and says something about the abundant personality of these giant cacti.

"Most people think of photographs as capturing a single moment. But an image like this is created over time like a painting. I start with a blank canvas of black, unexposed film, and then add light of different colors, from different angles, bit by bit, until I've created the image I've visualized. For this photograph I used a single flash as the light source. I covered the flash first with a magenta-colored gel filter to light the left side of the middle cactus. I then repositioned the flash, changed to a blue gel, and lit the right side of this same saguaro. I moved this same flash to 12 different positions, changing gels each time, to light the other cacti throughout the scene. The flash was on a light stand, and I sometimes had to hide the flash and stand behind one of the cacti so it wouldn't be visible from the camera position. Each pop of the flash was made as a separate exposure on the same piece of film."

Mamiya 645, 150mm lens, Fujichrome Provia 100 pushed one stop, Norman 400B flash with colored gels, Flash triggered by a Wein Ultra Slave, 120 exposures on the same piece of film, each 1/60 sec, with apertures varying between f/8 and f/16

Michael Frye

Sally Gall

NewYork-based photographer Sally Gall approaches landscape from a fine art perspective. She is interested in capturing nature in all its variety; nature as a place of meditation and sensual beauty, both calm and threatening.

She was interested in art from an early age. "I harbored thoughts about becoming a painter," she says. "Photography didn't figure at that time because I didn't know anything about it, but there were various things that started to push me in this direction.

"Although I wanted to have a career that involved art, I didn't want to be isolated in a studio. I was part of a family that travelled a lot and I really enjoyed seeing different things and always took photographs wherever we went. That started to get me interested, and then, in my last year at high school, I learned how to develop film and to make black-and-white prints."

At art school, Gall majored in photography, and she eventually went on to teach the subject at the University of Houston. Throughout this period she was developing her fine art photography and raising her profile. To concentrate on this aspect of her career she moved to NewYork City in 1990. "To me, it was the centre of the art world," she says. "I already had gallery representation in New York, and I thought that it would help to be there."

To supplement her income she took on commercial work that built on her fine art sensibilities. "I was able to get editorial work from travel and outdoor magazines," she says, "plus other commissions that were landscape-related."

She spent seven years putting together a series of personal images that were published in 1995 as a book, *Water's Edge*. She backed this up with major exhibitions and looked for further projects that would be of interest. Her second book was highly individual; she decided to explore the transitional area around the mouth of caves where she felt there existed an interesting mixture of light and darkness.

"One afternoon hiking with my husband through a steamy jungle in Veracruz, Mexico, a downpour compelled us to duck for cover inside the mouth of a cave," she says. "With no flashlights, we groped inward, blinded by the dark. Once we were far enough in, I could begin to make out the vast, deep cavern within.

"Immediately I wanted to leave this place of almost palpable darkness, to run back out into the safety of the open landscape, despite the lashing rain. Somehow I restrained myself long enough to let my eyes begin to adjust to the eerie eclipse-like light. That was when I began to comprehend that I had left the horizon behind and entered the inner outdoors, where night and day coexist and boundaries disappear. I realized that what I was dimly seeing was just as much a part of the landscape as the mountain over top of it or the rain-drenched jungle. I took out my camera, focused, and began to look deeper into this hidden landscape."

She spent three years visiting caves and lava tubes in Thailand, California, and in the Yucatan Peninsula of Mexico and Belize, and she also photographed in ancient quarries and around the aqueducts of Italy and France. She worked throughout with available light that, on many occasions, was almost nonexistent.

"Almost always this meant hour-long exposures in light too low for the best light meter to register," she says. "Traditional tools and techniques that would have been helpful above ground were rendered useless and, when it came to calculating exposure times, I was reduced to guesses I could only verify in the darkroom. If a cloud moved across the face of the sun halfway through the exposure, for example, the subterranean light dropped and I had to recalculate, often adding hours to the exposure time needed to get a single shot."

The project was recently published as the book *Subterranea*, and also led to a major travelling exhibition. It was the latest step in a diverse and challenging career, which looks as though it will establish Gall as an important, much-collected photographic artist.

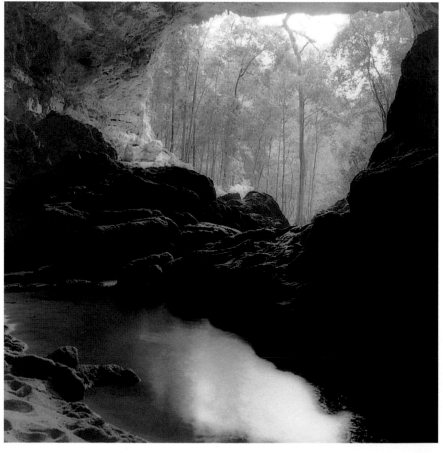

Oasis
"This is from the *Subterranea* series, and it was taken in Belize. I liked the sense of being indoors and outdoors at the same time; it's almost like a picture window that is full of trees."

Hasselblad 503CW, 60mm lens, KodakTri-X

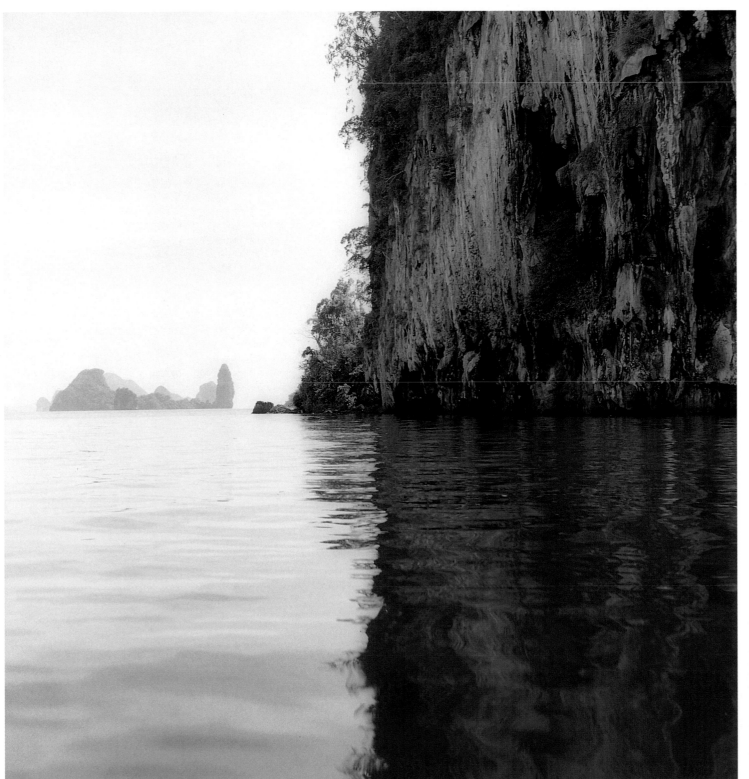

Quadrant

"I photograph a lot of watery landscapes from boats. This image was made in Thailand, and I was interested in the idea here of what is solid and what is liquid, where gravity is.

"I tonally manipulate my prints a lot in the darkroom and I tried to emphasize these feelings of solidity and wateriness in the variation of tones."

Hasselblad 503CW, 60mm lens, Kodak Tri-X

Sally Gall

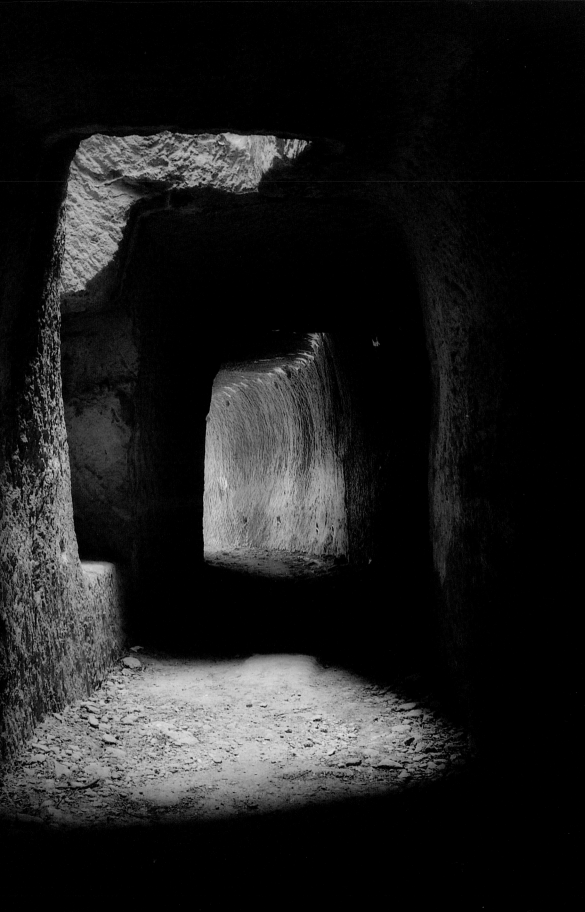

Pont du Gard (*Left*)
"This is an image from the *Subterranea* project, and it was made in an ancient Roman aqueduct near Nîmes in the south of France. Most of the project involved photographing the natural underworld, and yet this ancient manmade tunnel had many similar qualities to the natural caves I had been photographing, so I stretched the boundaries of the project a bit."

Toyo 4x5in field camera, 135mm lens, Kodak Tri-X

Bruges (*Facing opposite*)
"I had a commercial job that involved travelling to Bruges in Belgium and, while I was there, I decided that I would take a couple of days to see if I could find some landscape subjects for myself. I didn't know if I would be successful, but I was lucky enough to come back with this picture. I am interested in taking a picture of a real place and making it slightly 'other' so that while we know it really exists it feels as if it is a part of another world that we do not recognize. It's both believable and strange. This area was one of the beautiful tree-lined canals near Bruges and the trees, which had lost their leaves, were very graphic against the wintry, gray sky. Since I chose to photograph on that day rather than a sunny day, the empty background adds a sense of abstraction to the overall composition. The use of black and white is another level of abstraction; it's another step away from how we experience the world."

Hasselblad 503CW, 60mm lens, Kodak Tri-X

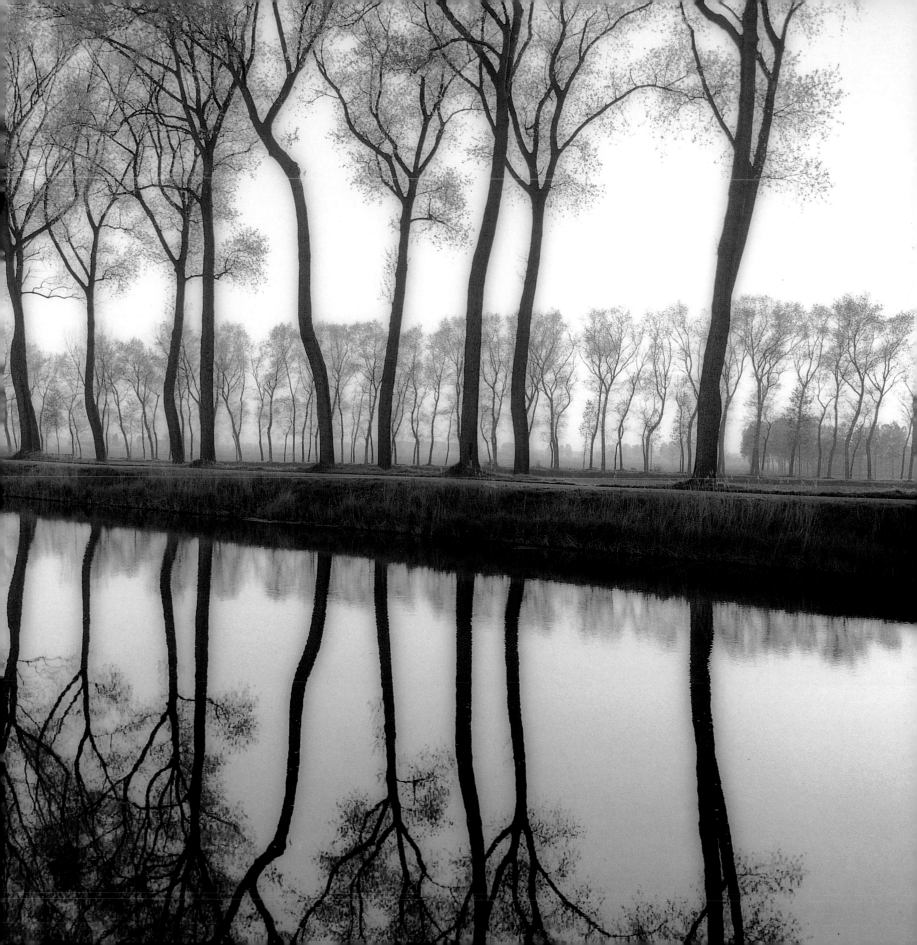

Bob
Hudak

Bob Hudak was introduced to photography at an early age when he was presented by a relative with the gift of a camera. At once smitten, it was taken with Hudak on every family trip during which he experimented with picture-taking. The resulting snapshots were just that – 'snapshots' of the typical scenes encountered on these outings – but the seed of interest had been sown.

Having grown up in predevelopment South Florida, most of Hudak's days were spent in the woods and lakes not far from his home. While photography was a great interest, in his early teens his primary passion was flying, and this culminated in his gaining a pilot's license at the age of 18. In the next four years he spent as much time as possible flying with the intent of notching up enough time in the air to eventually operate a charter flight service.

However, as time went on, he became disenchanted with the idea of flying for a living and, at about the same time, was shown a book of photographs by Edward Weston. Weston's photographs left a profound impression and opened Hudak's eyes to the potential of landscape photography. It had a special resonance for him; watching his homeland literally paved over by developers instilled in him a yearning for the purity of landscapes untouched by man. Photography, at least on a subconscious level, was a way of looking for the youth that was lost along with the lakes and the woods.

While landscape photography became a passionate hobby, it was architectural photography that had commercial potential and this was his specialism for many years. Largely self-taught, he familiarized himself with large-format cameras in order to become proficient. Ultimately, however, he was drawn to making the landscape pictures that he loved to produce in his spare moments, and he began to look for ways to make a living from it.

Having explored the idea of selling through a gallery he decided to go it alone and sell prints through his own website and shows mounted at local museums. While, initially, it was more difficult to attract the interest of potential clients, he thrived on the sense of autonomy and the benefit of often being able to meet face to face with his market.

As his print sales gained momentum, the architectural photography was phased out, allowing Hudak to devote himself to his landscape interests.

However, his love of large-format cameras has continued, and Hudak takes pride in his collection of the unusual vintage models which still deliver a sterling service. One of his favorites is a Deardorff 5x7in model, manufactured around 1939. In terms of size it's almost identical to a 4x5in camera, and yet the negative that it produces is considerably larger, with all the associated advantages. Another regular favorite is his 8x10in camera.

Large-format is big enough to offer him the chance to work with vintage processes that require contact printing, such as platinum, palladium, and silver printing-out paper, while he also produces silver gelatin and silver chloride contact prints for sale to collectors.

His use of traditional cameras and methods sits well with his style of landscape photography. The luminous quality of his black-and-white prints, with their delicate tones and fine detail, represent a fine art approach that is increasingly attractive to collectors on an international scale.

Great Sand Dunes National Monument, Colorado, USA
"When I made this image I knew that if the lighting was right the dunes would have a sculptured look, but at this time the sun was overhead and the modelling wasn't there. I walked around and found an area where I could set up an image that made use of the brush in the foreground, and I decided to set it up as a panoramic composition, lining up the camera so that the split was virtually 50/50 between foreground and background. With the lighting the way that it was at the time it was the only thing I could do, but it was a successful image."

Deardorff 5x7in camera, 450mm lens, Kodak Tri-X

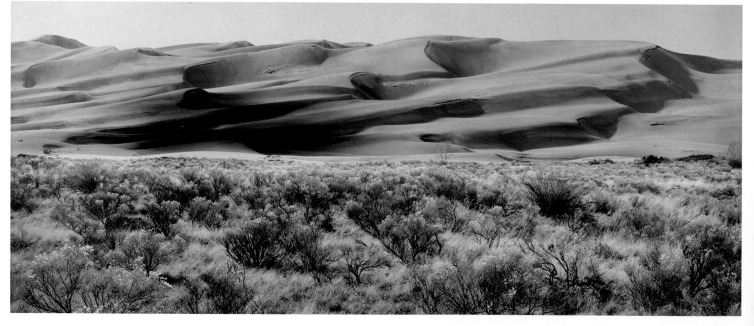

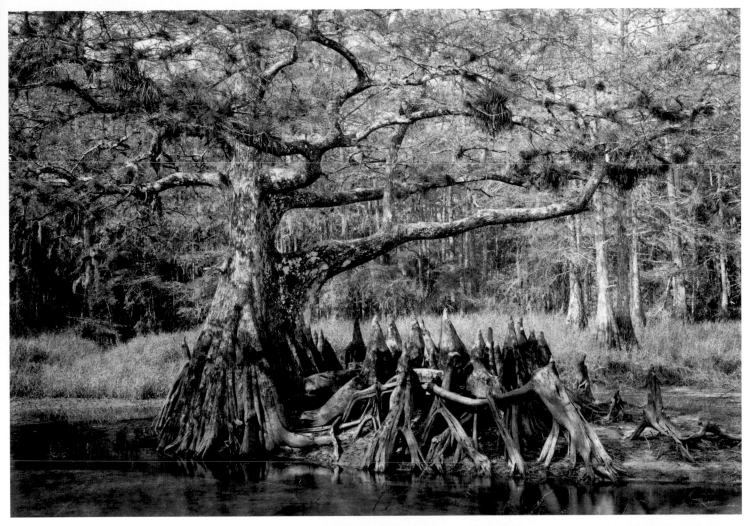

Fisheating Creek, Florida, USA
"This is a little freshwater creek situated in the Everglades, and the water levels here can be up to 7ft (2m) deep, depending on whether or not it's a dry time of year. I had seen these trees several times before, and every time their roots had been submerged, but on this occasion the level of the water had dropped to the point where they were fully visible. I thought that it made a picture but the late afternoon light was horrible. I came back the next day at daybreak and this time the light was exactly as I wanted it."

Deardorff 5x7in camera, 210mm lens, KodakTri-X

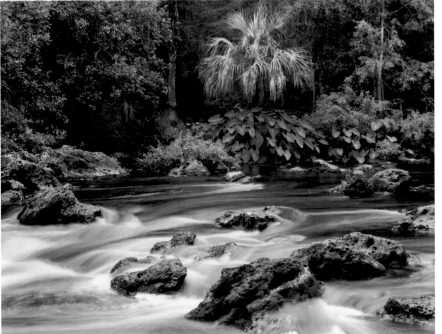

Loxhatchee River, Florida, USA
"The Loxhatchee River is the only wild and scenic river in Florida, and it starts in the Everglades and ends up in the Intercoastal Waterway, and then goes to the sea. This picture of its freshwater section was taken in the town of Jupiter, close to where I live, and it's a very evocative area with a Native American burial ground on the far bank. I set up the camera on a small rise so that it was elevated a few feet above the river itself."

Deardorff 5x7in camera, 210mm lens, KodakTri-X

Bob Hudak

Storm over San Juan Mountains

"In 2000 I took a trip to Colorado and New Mexico and, such is the legacy of great photographers and images from that part of the world, I wasn't confident that I'd return with anything special. One evening, however, as it was starting to get dark, I was driving around and, as the clouds started to build, I saw this storm coming towards me. Sensing an opportunity I drove on and reached a vantage point on the side of a mountain in Santa Fe from which I could set up a picture that featured the San Juan Mountains in the background.

"The problem was that the mountains themselves were hardly visible because of the falling rain, but the clouds were moving so fast that, as I made my exposures, the situation was changing all the time. At times like this you honestly don't know what you are going to get, but I persevered and made about five exposures, and the picture here was the only one where the clouds had parted enough for the mountains behind to be visible, and this was crucial to the success of the picture. The light rays also contributed and, although I couldn't have predicted them appearing exactly as they did, I was pretty sure that something was going to happen, and I knew that it was worth being prepared.

"Landscape is like this; sometimes you have to wait hours for something to happen and at other times everything moves so quickly that you hardly have time to set up. In this case the storm had passed and the rain had stopped in around 15 to 20 minutes, and it was pretty much dark. The moment had gone, but I had made a memorable picture."

Deardorff 5x7in camera, 450mm lens, Kodak Tri-X

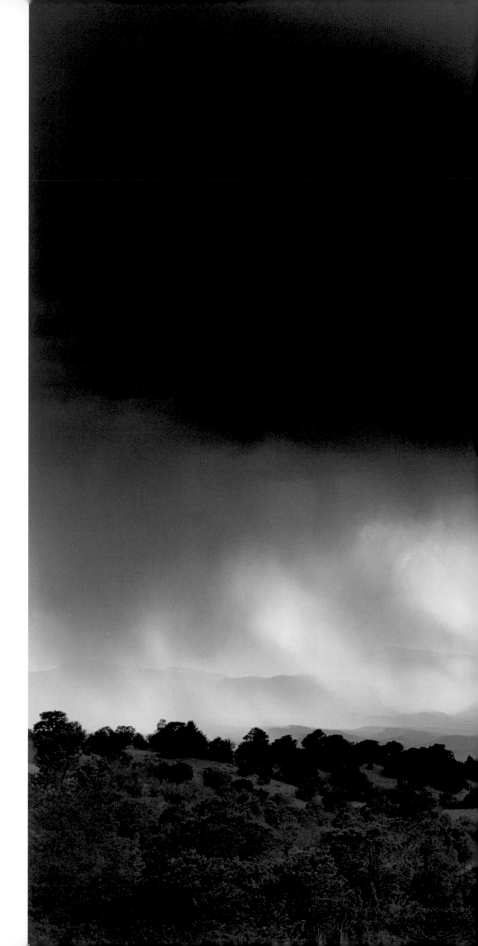

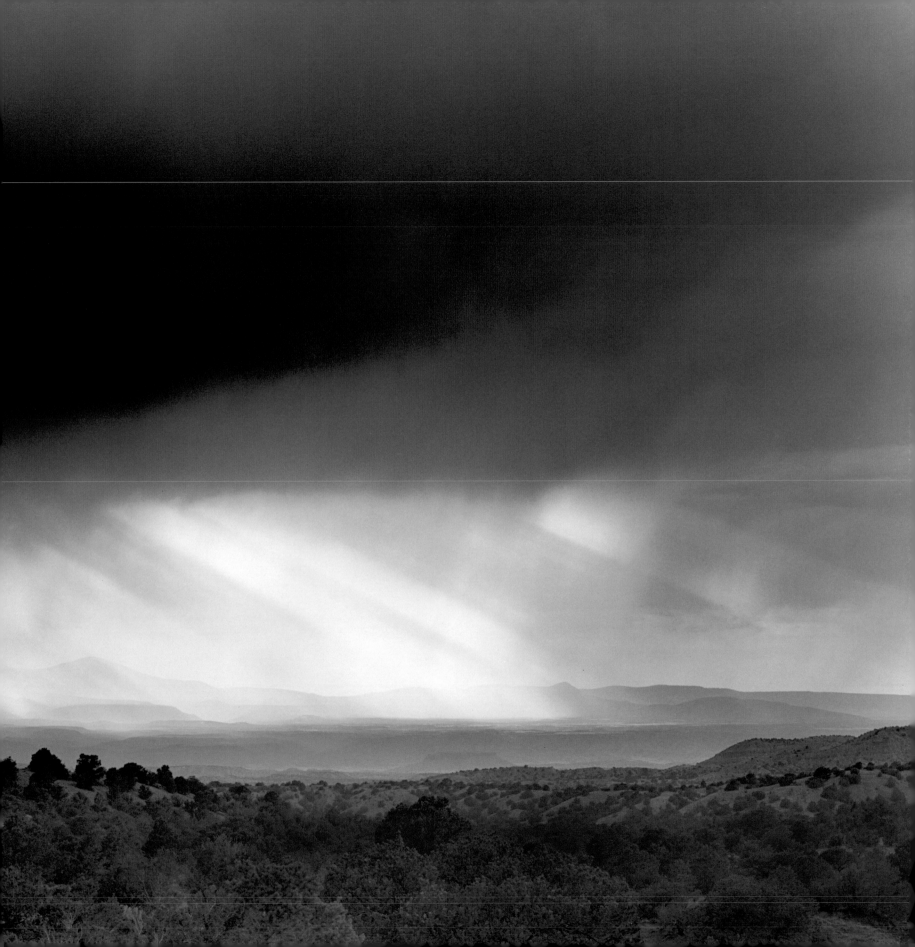

Yousef Khanfar

A Palestinian born and raised in Kuwait, as a young boy Yousef Khanfar grew to understand the reality of war. At a time when there was so much anger and discontent being generated by the unrest in the Middle East, photography offered him a release from conflict.

His interest was sparked by the gift of a camera from his father at the age of six. Khanfar began at once to take photographs, eagerly developing them in the darkroom. He related his photography to the struggle his people were experiencing: "I needed a voice to express my feeling and photography gave me that voice," he says. "I chose to carry my camera instead of a gun, to tell my story and to promote peace around the world."

By the time he was 18, Khanfar had moved to the United States, and was not only delighted by the boundless energy and optimism of his new home country, but as an aspiring landscape photographer found himself enchanted by the scale and variety of the subjects that were now offered to him. With complete self-belief he set about his task, and spent the next 20 years producing a set of pictures that has been described by Ken Whitmire, President of the International Photography Hall of Fame and Museum, as "a breathtaking and dazzling body of work".

Khanfar's philosophy on photography is very simple, "Great images must come from within, from the heart, with feeling," he says. He composes his images with a classicist's discerning eye, looking for simplicity, order and balance. "To be a good landscape photographer you must be a student of nature," he believes. "You must study the land, the light, the elements, the seasons. And you must work with the elements of nature, not against them. Many photographers spend too much time worrying about what the right camera, lens, or film is to use. Instead they should think about what they are trying to say and convey."

He sees the art of landscape photography as being akin to a tripod. "One leg represents the visual idea," he says, "the second is your personal perception of how to realize that idea and the third is the technical know-how to carry it through. Each leg should support the others – remove one leg and the whole collapses. The camera for the photographer should be no more than just another tool. It is like a violin to a musician or a brush to a painter. It is up to the artist to create art, not the tool."

Khanfar is intimately acquainted with the workings of the Linhof Master Technica 2000 5x4in camera, which he purchased direct from the manufacturer in Germany. He shoots most of his work using just three key lenses, all of which are Nikon: a 75mm wide-angle, a 360mm telephoto and a 210mm that he uses as his standard lens.

The only filters that he owns are a polarizer and a neutral density grad, and his film is exclusively Fujifilm Velvia. "I think the brand of film that you use is less important than getting to know it really well," he says. "Obviously you should choose a film with characteristics that match what you are trying to say. Perhaps a fast, grainy film if you want a romantic feel, or a slow, saturated film if color and clarity is your aim. But once you've decided on a film type, it's important to stick to it so that you understand intimately how it will react."

Still driven by a desire for peace, he uses photography as his language to communicate his feeling and emotion to his audience. In 1997 he was the first Palestinian photographer ever to have a one-man exhibition in the International Photography Hall of Fame. A year later he was appointed as the Exhibits Chairman, becoming one of the most respected and influential figures in the photographic community.

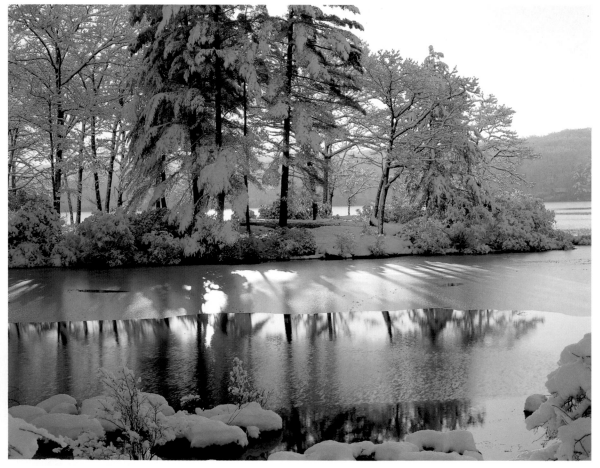

Bear Mountain State Park, New York, USA
As the warm and saturated first light of morning penetrated through the trees, Khanfar was in position to capture a picture that made great use of the reflective properties of the water and the snow.

Linhof 2000 4x5in camera, Nikkor 210mm lens, Fujifilm Velvia

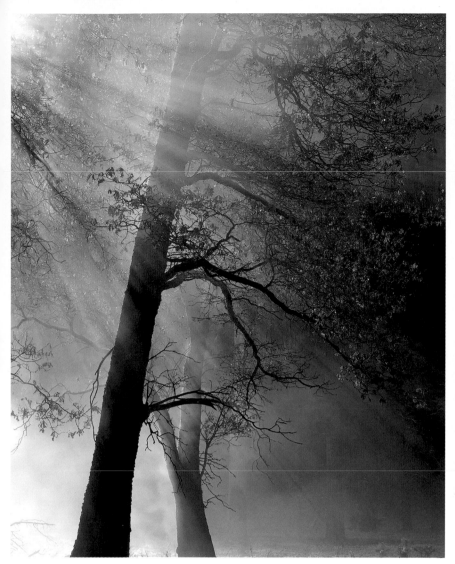

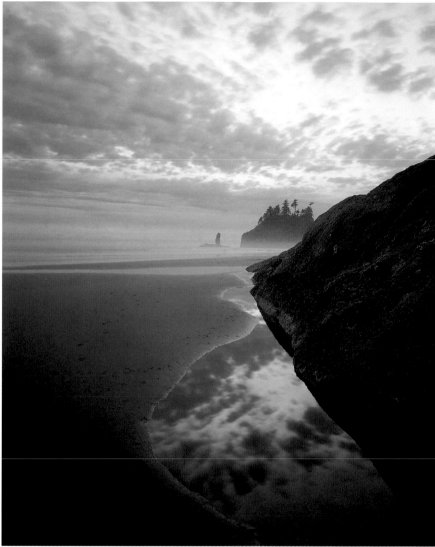

Sierra Mountains, California, USA

After suffering the loss of his mother, Khanfar sought peace in California's Sierra Mountains.

As the sun's rays penetrated the rising mist, he photographed these silhouetted trees, capturing the essence of the emotions that he felt in this place. As a photographer, Khanfar says that he "paints with light" and that it is as much a spiritual endeavor as an artistic one.

Linhof 2000 4x5in camera, Nikkor-T ED 360mm lens, Fujifilm Velvia

The Olympic Peninsula, Washington, USA

Yousef Khanfar captured this scene along the coast of the Olympic Peninsula. "I found this smooth, calm pool that was touched by the reflections of clouds," he says. "It provided almost endless variations for photographs."

Linhof 2000 4x5in camera, Nikkor 75mm, Fujifilm Velvia

Mono Lake, eastern Sierra, California, USA

Mono Lake is one of Khanfar's favorite locations in the US. Nestled in the eastern Sierra, this vast, salty lake is at least 700,000 years old, and offers incomparable scenery and a unique environment where it's possible to find fanciful tufa towers, volcanoes, and deep-blue water. It's also long been a key feeding and resting station for migrating birds.

In 1941, the Los Angeles Department of Water and Power began diverting Mono Lake's tributary streams 350 miles (563km) south to meet the growing water demands of Los Angeles. Deprived of its freshwater sources, the volume of Mono Lake was cut in half, while its salinity doubled. Unable to adapt to these changing conditions within such a short period of time, the ecosystem began to collapse. The lake dropped over 50ft (15m).

It was the last day's shooting for Khanfar after a three-week journey through the region. "I do not go to Mono Lake only to take photographs," he says. "Many times I have gone there to write my poetry and to put down my thoughts." While writing and reflecting on his journey, the weather started to change, and the temperature began to drop rapidly. He went back to his car to get his jacket, and then noticed the moon on the horizon. "Landscape photographers should always scan the landscape for the unusual with a ready mind and heart," he says.

Realizing that he was confronted with a great picture opportunity, he got into his car and drove to the west side of the lake, to a location that he had visited before. He parked his car, unpacked his tripod, and loaded his large-format camera. Then, and only then, he discovered that he had only one plate left from his long trip. He hiked to the edge of the lake, set up, composed with his eyes, then his camera, focused, metered and waited.

He could see the colors changing, the lake becoming calmer and the moon rising, and the whole scene became magical. "Take the time and let the heart tell you when all the elements are perfectly integrated with the whole," he explains. "When you reach that point, make your exposure."

Linhof 2000 4x5in camera, Nikkor 210mm lens, Fujifilm Velvia

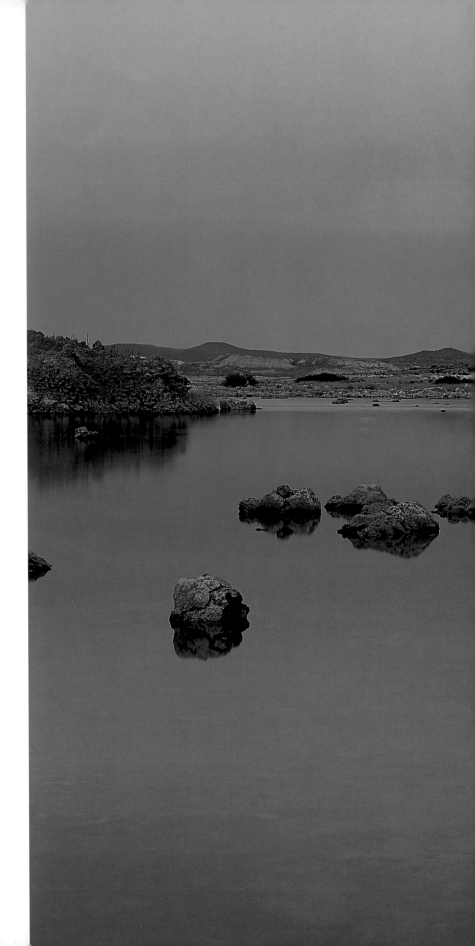

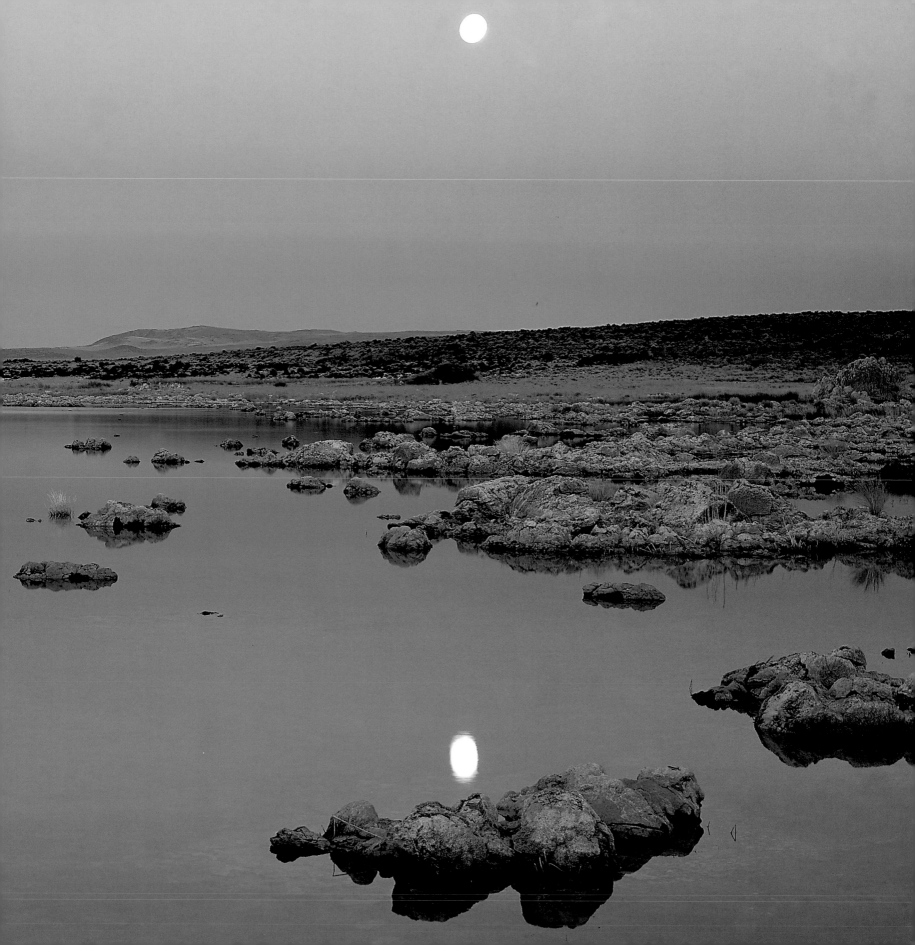

Marty Knapp

The gift of a 35mm camera from his grandfather on his eleventh birthday was the spark that first led Marty Knapp to take a positive interest in photography. "The dials with etched numbers and the velvet-lined leather case that protected its jewel-like lens were irresistible," he says. "That a small tin can could hold the world in it – well, perhaps only 36 pieces of the world – was magical for me. That magic has never died; I still love cameras, both old and new."

Though the camera helped him to become more visually aware, it wasn't until he was in his 20s that Knapp started to take his photography more seriously, and began to consider whether he might be able to make it his career. Initially he just loved taking pictures, but a move to a new home in Olema, close to California's Point Reyes National Seashore in 1973 helped to turn his thoughts towards landscape.

"The company that I worked with moved here," he says, "and the moment I saw the area I fell in love with it. Eventually I started to shoot landscapes in my spare time, just for the fun of it. I taught myself how to make better use of the camera and tightened up on my discipline and, slowly but surely, I started to get better. Even though I put in a lot of work, however, I would still say that I didn't take my first acceptable landscape photographs until 1985."

He continued to work as an office manager in a small manufacturing company, learning all the skills that were necessary for the running of a small business in the process,

something that he was later to find invaluable from his own perspective. A gallery took on his work and he started to make sales of fine art prints. "Eventually that gallery started sending me bigger and bigger checks," he says, "and I realized that perhaps there might be an opportunity for me to take my photography more seriously."

In 1990 he took the plunge, quit his job, and set up a photographic studio and gallery in the town. Much as he had envisaged, at first it was a struggle, and he had to undertake everything from commercial assignments to shoots for magazines. Slowly but surely, however, his reputation as a landscape photographer and master printer started to grow, sales of limited edition fine art prints, all hand-produced and selenium-toned by Knapp, increased, and other projects, such as photo workshops, started to become more viable.

Landscape now accounts for virtually all of the studio's output, and Knapp has all but realized his early dreams. His has developed a very traditional style, based on maximum quality and understanding of the finer points of the craft, and it's clear that much of his inspiration comes from the dramatic black-and-white photography of landscape legend, Ansel Adams.

"I seek to bring the clarity I find in his work to my expression of the landscape," he says. "I spend countless hours walking the trails, ridges, and beaches of this precious world and, every once in a while, I'm blessed to see and record a moment of light that fills me with wonder."

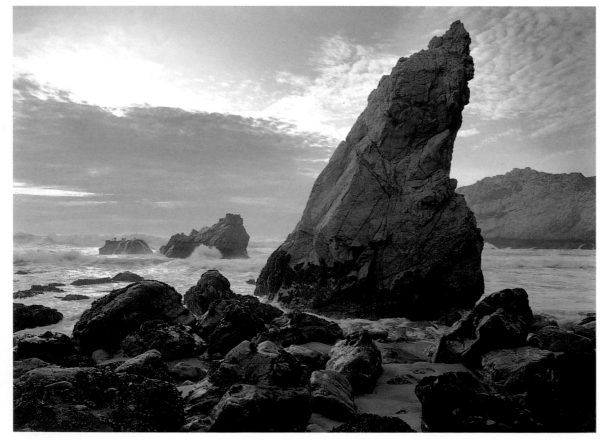

Monolith, McClure's Beach, Point Reyes Seashore, California, USA
"I was looking for subjects on the beach once again, and thought that a rear view of this rock would be interesting. I used it as a foil against the brightness of the sky."

4x5in camera, 90mm Super Angulon lens, Kodak T-Max 400

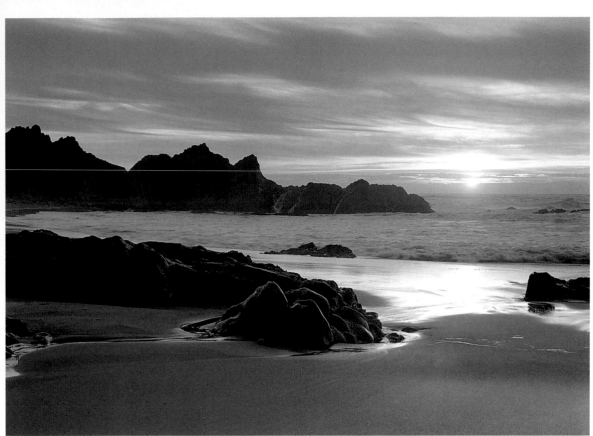

September sunset, McClure's Beach, Point Reyes Seashore, California, USA

"I got this picture almost by accident. I was beyond this point looking for pictures and was not getting anything much, and I packed everything up convinced that there was nothing else to be found. I make a point of looking over my shoulder before I leave a place, however, and at that time I saw this lighting configuration starting to develop.

"What made this picture so exciting for me was the area where the sun is reflecting off the wet sand, and I took just two pictures without bracketing. Sometimes you just know that you've got what you want. I rushed back and developed my film as soon as I got in, and when I saw the contacts this image just glowed."

Horseman 6x9cm camera, 90mm lens, Ilford HP5 Plus

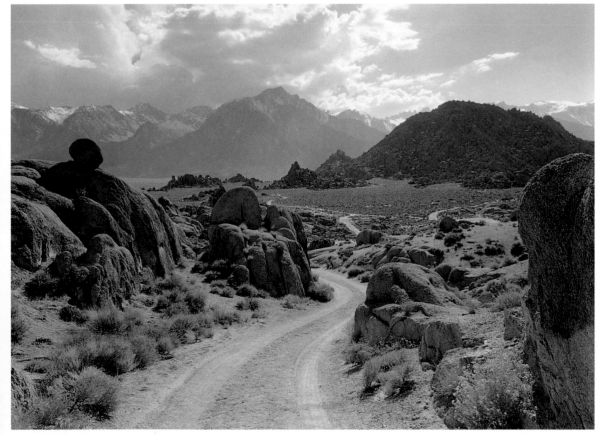

Road, Alabama Hills, California, USA

"I took this picture looking west towards the Sierra Mountains. I had come across this location in the middle of the day, and I sat and waited until the light became more to my liking later in the day and some clouds had drifted into the view."

Horseman 6x9cm camera, 65mm lens, Ilford FP4

Marty Knapp

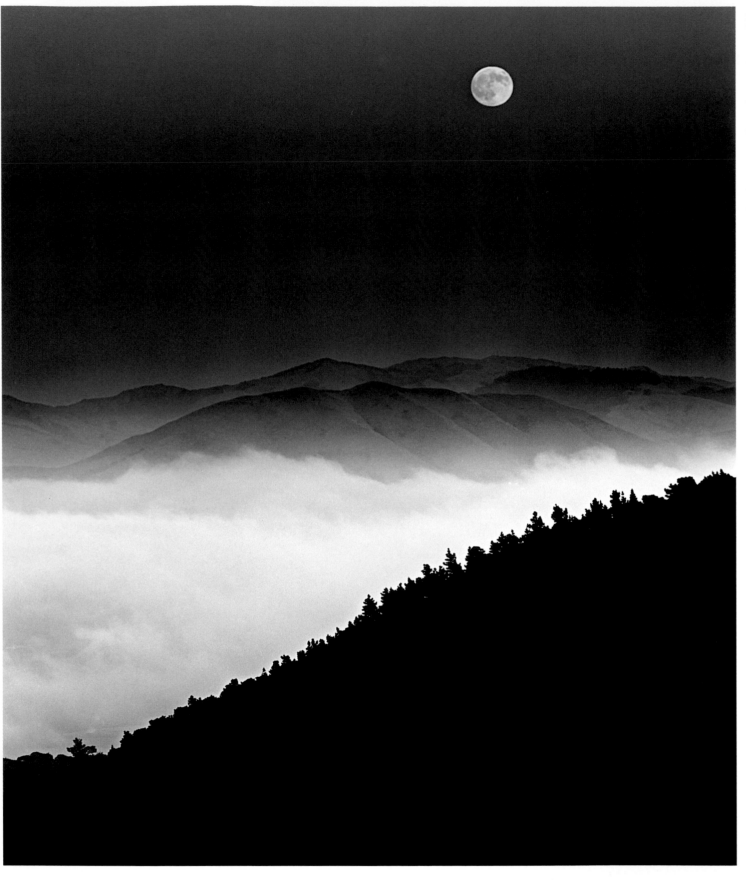

Mount Vision moonrise, Point Reyes Seashore, California, USA
"Including the moon in a picture isn't easy. It takes luck and perseverance. I knew that the moon would rise here over Black Mountain, and set out for a vantage point on Mount Vision. Just over the last 100ft of the climb, I came out into clear air. There was 20 minutes to go before the moonrise, and I knew the conditions would be perfect. The moon stood out against a darkening sky, but there was still enough light on the hills for some detail. The foreground was a silhouette, while the mist hanging in the valley added greatly to the mood. It was one of those rare occasions where all the elements come together, and it gave me a remarkable picture."

Canon F1, 85mm lens, 1/8sec at f/16, Kodak ISO 25 Technical Pan film

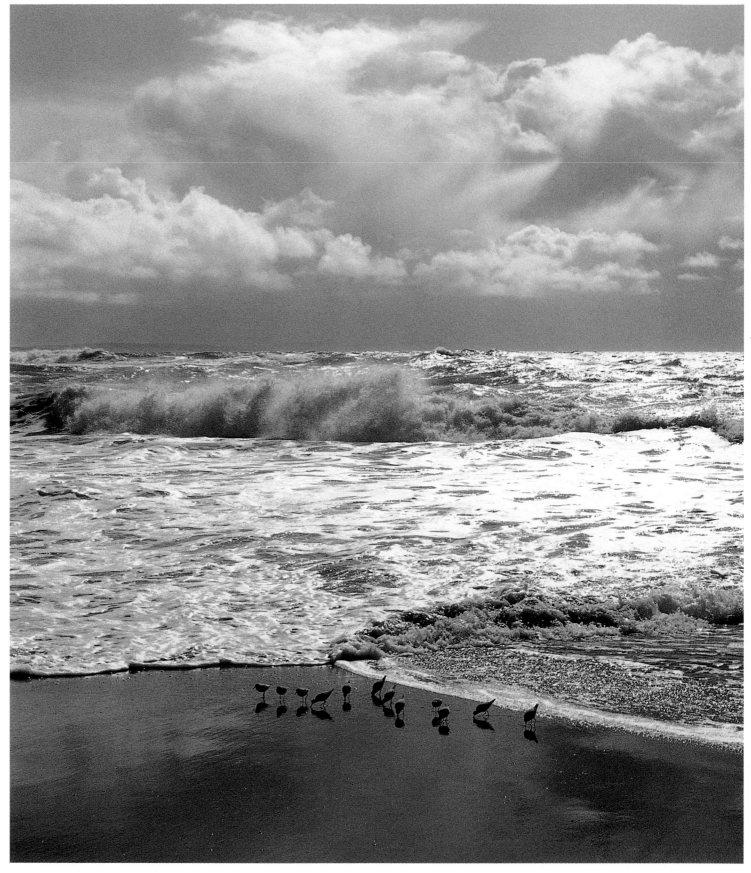

Shorebirds, McClure's Beach, Point Reyes Seashore, California, USA

"The birds here suggested the whole composition by being at the edge of the water. Everything happened so fast and I just tried to shoot a range of exposures before the lighting changed. I was just lucky that I happened to be in the perfect spot to make this image."

Mamiya 645, 80mm lens, Kodak Plus-X

Marty Knapp

Tom Mackie

Born in 1958 in Philadelphia, USA, Tom Mackie earned a degree in commercial photography at Hawkeye Institute of Technology in Iowa, and spent the first five years of his career working as an industrial photographer in Los Angeles.

Unfulfilled by the confines of a commercial studio, he began exploring the vast landscape of the American West, and so began a love affair with landscape photography that endures to this day. "Iowa is a very flat state," he says, "and not particularly conducive to great landscape photography. Working over on the west coast, however, was a different experience altogether. During weekends and holidays I could get to places such as the Rockies and the deserts of the Southwest, and this gave me the opportunity to photograph some of the world's most amazing natural areas."

As an industrial photographer he worked primarily with 35mm and medium-format cameras, but at his processing lab he encountered work by established landscape photographers, in particular James Randklev, that introduced him to the enhanced quality of large-format.

"James is still a good friend of mine," he says. "I saw what he was achieving using 5x4in gear and I picked his brains about landscape photography in general and large-format cameras in particular. After a while I was convinced that this was the way for me to go, so I invested in a 5x4in Wista camera and I've been a fan of these bigger cameras ever since."

By 1985 he had decided that he wanted to set up as a full-time landscape photographer, but his plans changed dramatically when, having met his British-born future wife in Los Angeles, the couple decided to move to the UK. "To many people it did seem like a strange move for a landscape photographer to make," he says, "but it's worked out well for me. I still travel to the US two or three times a year, and I feel that the UK is actually an excellent base from which to explore a large part of the world, because it's so easy to get to places in Europe and to Africa.

"There is also a lot to photograph in the UK itself. I'm based in Norfolk, which many see as a flat, uninteresting county, but it is actually full of variety, and the coastline in particular has real beauty. If conditions are right for photography I can travel to the coast in under an hour, and if one of the rare hoarfrosts occurs then I'm in the right place to go out and get pictures.

"It's also an advantage to me that Norfolk is less attractive to other landscape photographers; I've now established something of a reputation for pictures of this area, and if anyone wants a landscape from this region I'm often the person they will think of contacting."

In recent years, Tom's skills have earned him accolades from the British Institute of Professional Photographers (BIPP), the Ilford Awards, and the Business Calendar Awards. He has also lectured to other professionals on the art and craft of landscape photography, and he regularly adds new work to his stock library, which now consists of over 20,000 images.

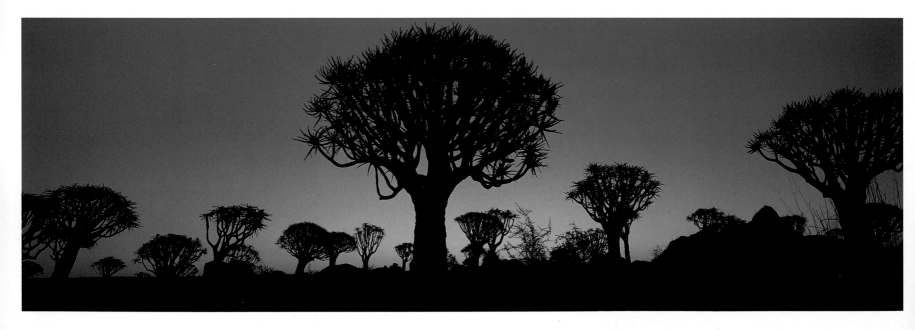

Sunrise at Oby Mill, River Bure, Norfolk, England

"This is one of my favorite locations, not too far from my home, and I've visited here many times to shoot this mill in a whole series of different ways. Some photographers will only visit a place once, but I think that if you find a good spot it pays you to go there several times, and you'll find a different facet of the place each time you visit.

"Because I'm quite close to this location I have the option of looking at the sky first thing in the morning before I set off, and often I can anticipate how things will turn out. If there is the right amount of cloud and the sky is clear at the horizon, then the chances are that the sunrise is going to be a good one. On this occasion it was spectacular, and I got myself in position and simply waited for the color of the sky to reach its height.

"There are two or three windmills on the Norfolk Broads where you can shoot a sunrise that will reflect in the water in this way, but Oby Mill was always the best, because its state of dereliction gave it character. It has now been restored, however, and its cap replaced, so the particular viewpoint has changed since I took this picture, losing some of its pictorial appeal."

Wista 5x4in field camera, 90mm lens, Fujifilm Velvia

Fishing boat at sunset, Wells-next-the-sea, Norfolk, England

"The small town of Wells-next-the-sea in Norfolk is also fairly close to where I live, and it features a large expanse of mud flats that are exposed when the tide goes out. This picture was taken one New Year's Day, when I regularly walk along the coast, and I could tell by the break on the horizon that the sunset was going to be a good one. Then it was a case of looking for an interesting foreground and waiting for the color to reach its peak."

Wista 5x4in field camera, 90mm lens, Fujifilm 50D

Quiver trees at dusk, Namibia
(*Facing opposite*)

"I travelled to Namibia specifically to photograph the dunes and the quiver trees that can be found there. These particular trees, which are actually giant aloes, can be found on a private farm at Keetmanshoop, and have been photographed by some of the top landscape photographers in the world, and yet they look different every time. To achieve the effect here I used a coral graduated filter and fitted it upside down, so that the color went from dark blue to orange, with most of the strong color being lost behind the deep black of the foreground."

Fujifilm GX617, 90mm lens, Fujifilm Velvia

Tom Mackie

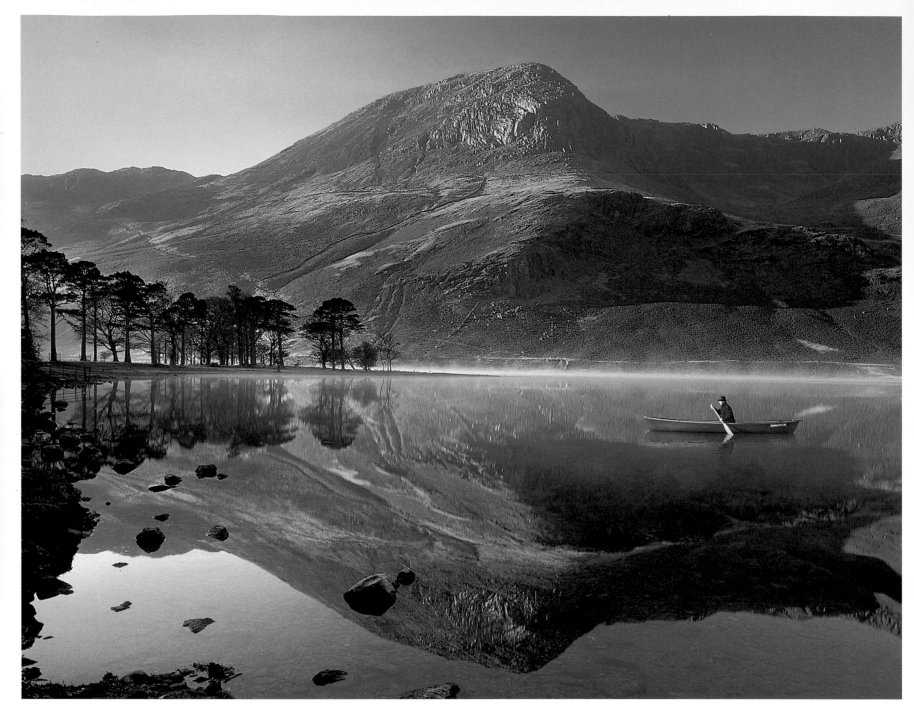

Canoeist on Lake Buttermere, Lake District, England
"The Lake District has very changeable weather, and the first time that I visited the area I was greeted with wonderful conditions, despite it being October, a time when gale-force winds and rain are the norm. I've never seen conditions this good again, despite having been back to this location several times.

This picture sold well as a straight landscape, but I decided to undertake a little digital manipulation and to place the canoeist into the frame. It's a small and subtle difference and it still looks like a straight shot, but it's made a big difference to sales, which have been much better since I added the touch of human interest."

Wista 5x4in field camera, 90mm lens, Fujifilm Velvia

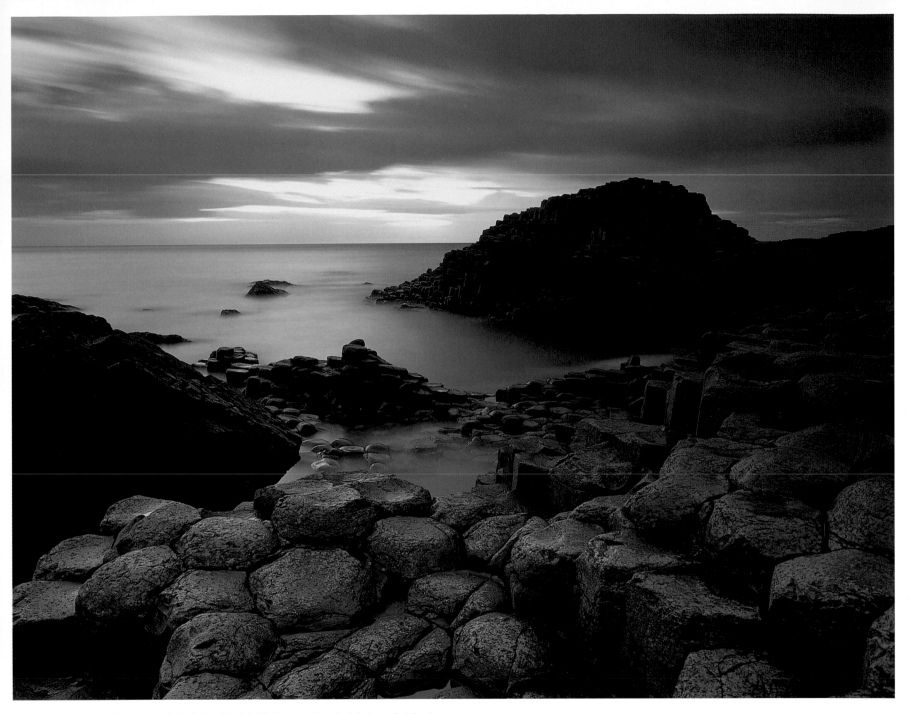

Giant's Causeway, Northern Ireland

"I have seen so many pictures of this location that it was hard not to have a preconceived image of what to expect. Unfortunately, the weather conditions were not cooperating on this late summer's evening. It had started to rain so I had to make a decision whether to retreat to the comfort of my motor caravan or make the best of a bad situation. I decided to try warming up the scene with a sunset filter and a ND grad to keep the sky from burning out. The sunset filter helped to neutralize the blue cast in the basalt formations in the foreground. The light was rapidly disappearing making my exposures exceptionally long which accounts for the wispy effect in the clouds. When the film came back from the lab, I was glad that I had persevered with the rain that evening."

Wista 4x5in field camera, 90mm Schneider lens, sunset filter, 0.9 neutral density grad, Fujifilm Velvia

Tom Mackie

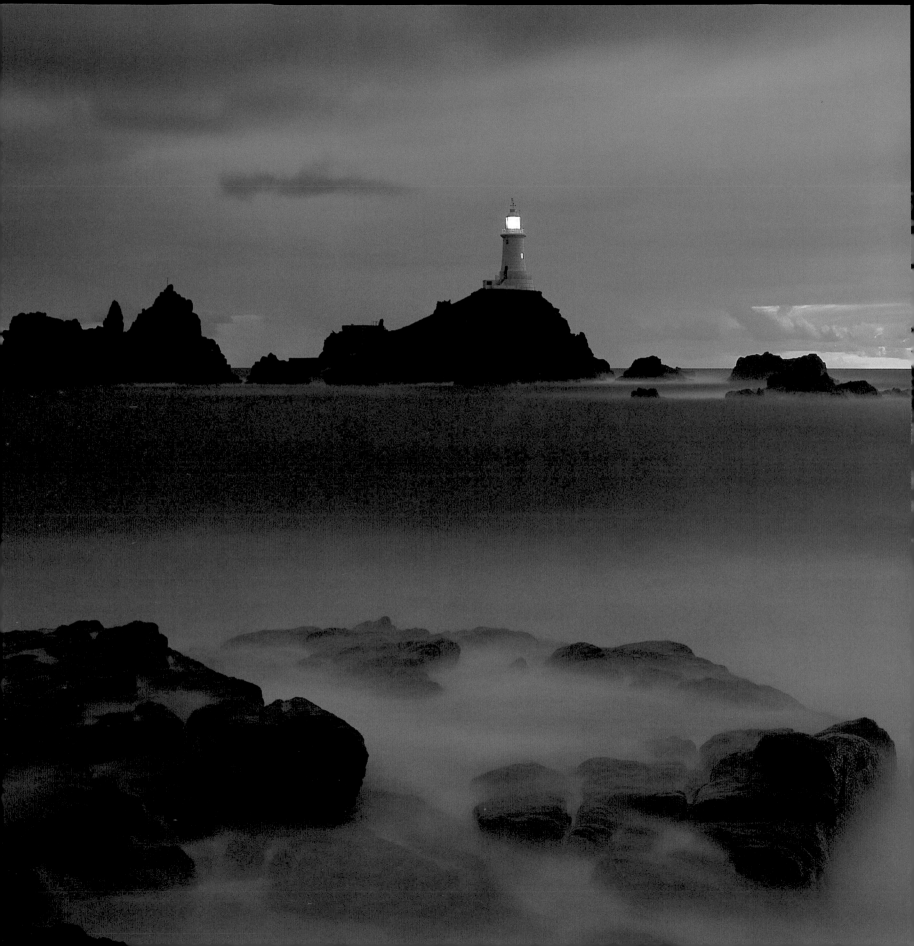

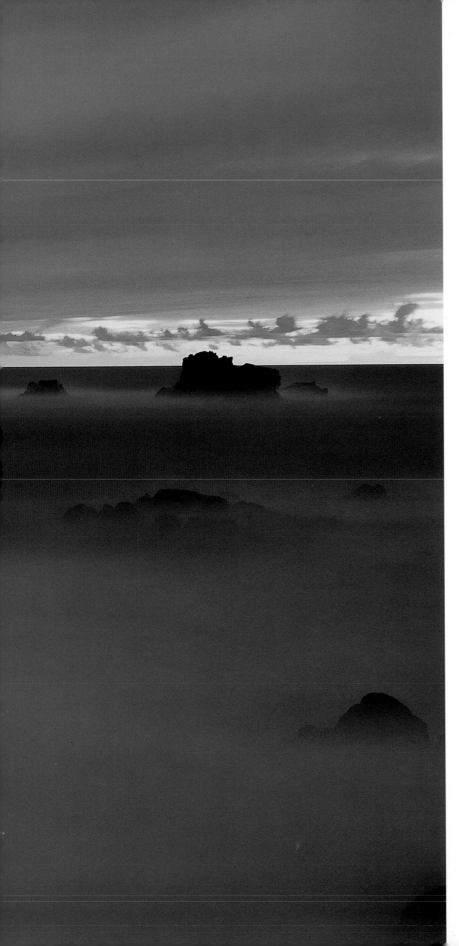

Corbiere Lighthouse, Jersey, Channel Islands

"I travelled to Jersey in the Channel Islands one September with the aim of shooting some stock pictures, and the weather for the entire week was terrible, to the point where I thought it was all going to be a total washout. I did see some potential for pictures of the Corbiere Lighthouse, however, and every evening travelled to a vantage point that I had found to see if I could get a dramatic picture of it.

"I took this image on one of those occasions, just as a storm was clearing from the west and twilight was falling. The conditions were really dull and dark, the waves were crashing on the rocks and the wind was blowing heavily. There didn't seem to be much potential for a picture, but I thought that I would set a long shutter speed, which I knew would give the sea a misty effect, and just see what happened from there. I figured the picture would either work well or go straight in the bin, and it turned out to be very successful.

"The long exposure allowed some movement in the clouds also, and the shutter was open long enough to record several passes of the lighthouse itself, which looked very effective. The fact that the light levels were so low gave the picture an overall blue appearance; no filtration was used, as can be seen by the area of bright sky on the horizon. I shielded the camera from the wind by holding a dark cloth around it, but otherwise this is a picture that I influenced very little.

"It's often the case that the stormy conditions result in the most dramatic pictures. In contrast, on a day when the weather is bright and sunny, the conditions do not provide the dramatic impact that is evident in the Corbiere picture. Darkened stormy skies, or the lighting conditions created when the sun hits a landscape directly after rainfall, can prove far more interesting to the eye."

Wista 5x4in field camera, 150mm Schneider lens, Fujifilm 50D

Tom Mackie

Shinzo Maeda

One of Japan's greatest landscape photographers, Shinzo Maeda, was born in the Tokyo suburbs in 1922. A lover of nature long before he first picked up the camera, he didn't make his first landscape pictures until the age of 33 when, on a hiking trip, he felt the urge to record on film the beauty of the mountain landscapes.

Another 12 years passed before, in 1967, he founded an agency, the Tankei Photo Library, and became a full-time professional. Although he had never received any formal training as a photographer, his talent was quickly recognized, and he soon attracted a dedicated following throughout Japan, and internationally. His philosophy on photography was simple: "The camera will do the work by itself," he said, "so I don't have to be taught by others or study photography from a book." His point was that formal training was unnecessary for those shooting landscape if the photographer admired nature and had a talent.

To Maeda, nature was teacher and model enough, and he found enough subjects around the islands of Japan to keep him fully occupied throughout his entire career. Wherever he travelled, Maeda made sure that he worked with an open mind, his wish being to convey to the viewer "the marvellous moment when I encounter nature without any fixed idea or preconception". At the same time, however, he felt that a photographer needed to have a philosophical view of life that was reflected in his or her work. Without this, in his opinion was that the work would lack distinction.

Maeda's photographs have been compared to the 'haiku', the traditional Japanese poem, a brief interpretation of a subject in which "a moment is grasped, a flash of something larger, something deeper. This sense of Maeda's work is intriguing, and true. Maeda eschewed the long view of famous beauty spots or spectacular scenes in favor of medium-range or close-up views of smaller aspects of nature, as a way to explore and express the intimate, while signifying the whole.

There is never any sign of human habitation or occupation in his work, even when the pictures are taken in suburban areas or private places, such as the courtyard of a temple. Nature is left to speak as if mankind did not exist.

Throughout his career Maeda won a number of major awards, including the top prize of the Japan Photographers' Association, and by the time of his death in 1998, he had published 46 books on photography in Japan and eight in other countries. Akira Maeda, his eldest son, has carried on the tradition started by his father, and is now a recognized landscape photographer in his own right.

Solemn cedar forest, Toei, Aichi, Japan, 1984 (*Opposite*)
"I discovered a beautiful cedar forest in the Okumikawa Mountains, and wanted to take a picture in the mist, so had to visit many times. Between downpours in the rainy season, I have been able to fulfil this desire. When I take pictures in the forest, as I have here, I often use a wide-angle lens to create a good composition, and to achieve depth of focus. My technique is to first find the best wide-angle and gradually narrow it until I'm happy, then use a zoom lens."

Linhof SuperTechnika V 4 x 5, Fujinon 125mm F5.6 lens, 1 second at f/22, Ektachrome 64P

Riverside snow, Minakami, Gunma, Japan, 1976 (*Right*)
"This is a picture that featured in my fourth collection of photographs, *The Moment of Encounter*. In that book I wrote, "I was trying to find a way to bring in the sense of Japanese painting into the landscape photography.

"This picture achieves exactly what I meant by that. How can I express the beauty of the shapes made by snow on the sandbank? They are not only calm but sharp, too. The deep color of the water makes the shapes stand out. They are simple but without being plain, there is no color, but there is depth to it. This is a key example of a picture that shows what I seek to express in landscape photography."

Linhof SuperTechnika V 4 x 5, Fujinon 400mm F8 lens, 1/8sec at f/16, Ektachrome E-3

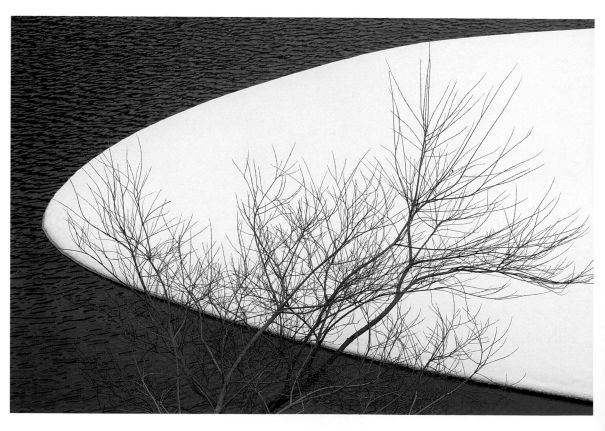

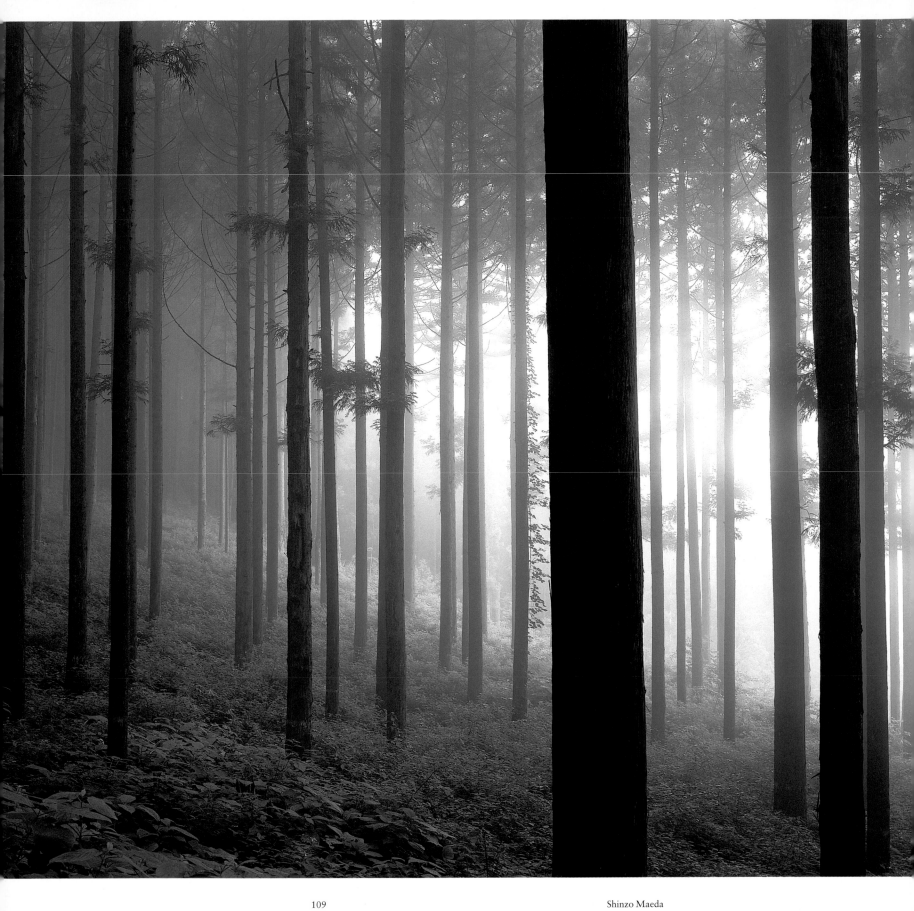

Shinzo Maeda

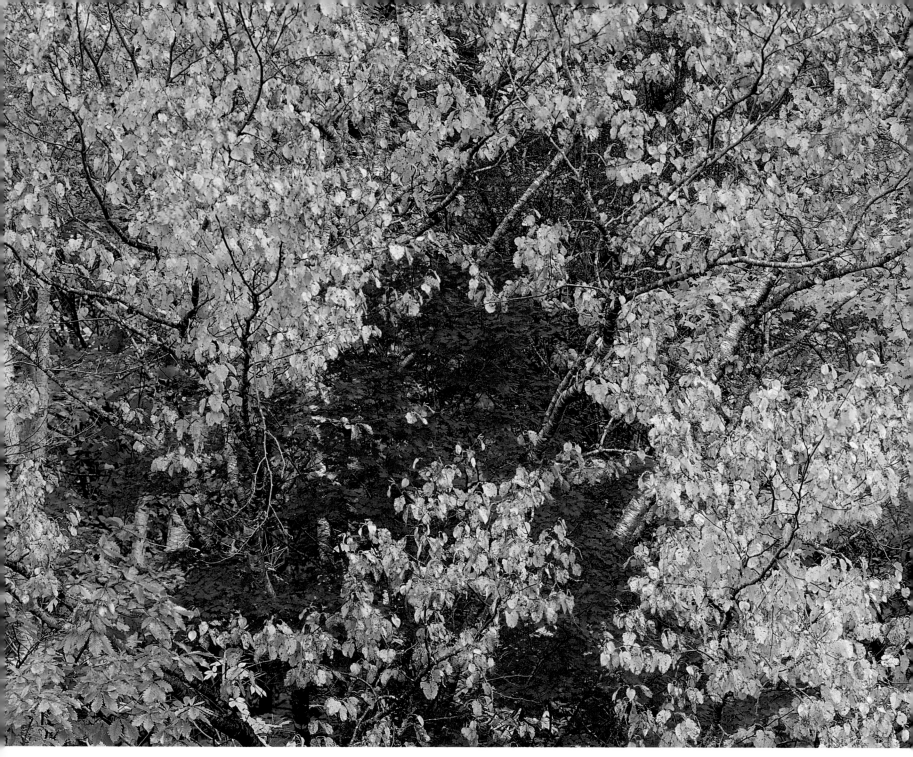

Fall colors, Urabandai, Fukushima, Japan, 1984
"During my long career, I have seen many beautiful fall colors on my picture-taking trips, but had never seen something like this before. The leaves are at their peak of fall color. I think the yellow leaf is called Dakekanba, the red one is Kohauchiwa Kaede (a type of maple). The interesting thing about this image is the way that the yellow and red forms are intertwined."

Toyo 4x5in field camera, Fujinon 600mm F11 lens, 1 second at f/45, Fujichrome 50D

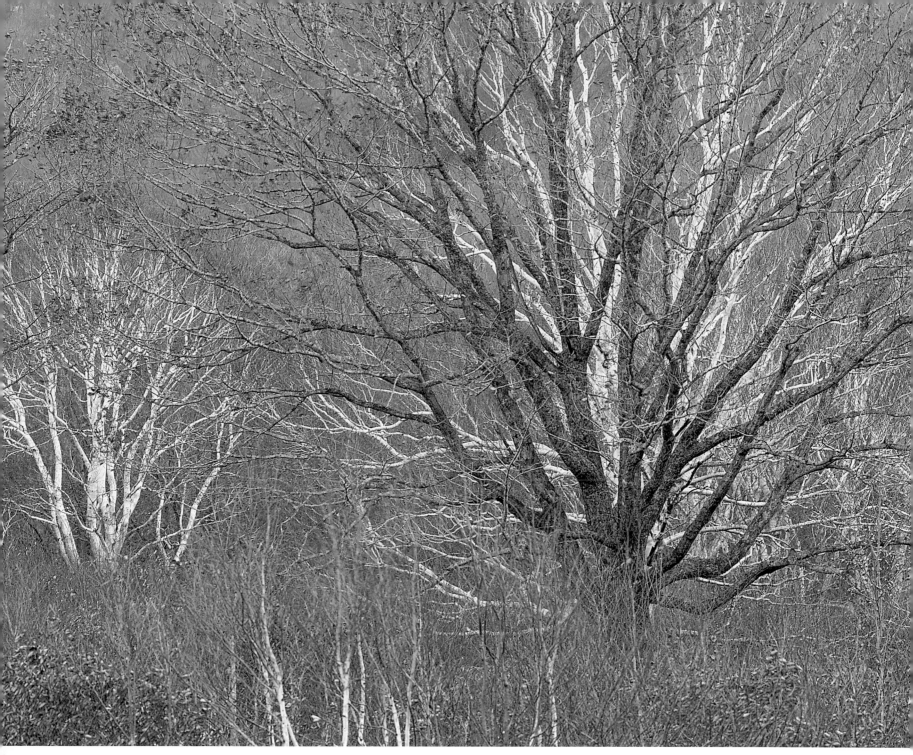

Forest fantasy, Hakkoda, Aomori, Japan, 1980
"This is a favorite picture of mine. Hakkoda Mountain is a volcanic mountain, north of the Ohu mountain range in the Towada Hachimantai National Park. There are spring spas, and many mountain climbers and skiers visit here. There is a crater basin called Tashirotai on the northeast slope of the mountain. There are also wetlands where special plants like skunt cabbages and rare azaleas can be found. I took this picture at sunset while feeling the breath of the trees in the silence."

Toyo 4x5in field camera, Fujinon 600mm F11 lens, 1 second at f/32, Fujichrome 50D

Shinzo Maeda

Nick
Meers

Nick Meers grew up in the classically beautiful English Cotswold countryside, renowned for its gentle charms. His passionate love of landscape started early, and was consolidated following a period spent travelling around New Zealand immediately after he completed his education. Faced with the infinite grandeur of the landscape, he gave the more traditional artistic endeavors of sketching and watercolor painting in favor of grappling with his first 35mm camera.

"You could say that I had a spiritual moment on South Island," he says wryly. "While I was there I witnessed amazing natural lighting effects, and I realized that if I painted them exactly as I saw them then everyone would think that I was color blind! At least if I was able to record them on film then there was a chance that someone would believe that I really had witnessed such remarkable sights." With his new-found interest in photography, on his return to the UK Meers enrolled on what was then the first BA Honours course in photography at Guildhall School of Art.

After graduation Meers was commissioned to shoot the first of a series of over 30 travel books which culminated in the National Parks in California. It was the perfect environment within which to develop his landscape skills. The extreme scale of this region, combined with the abundance of details, propelled a lifelong fascination with light, and its effects upon the natural world.

In his efforts to achieve the highest quality in his image-making, Meers shoots with a range of medium- and large-format cameras. He has a particular passion for the panoramic 'letterbox' format, finding it ideally suited to landscape photography, and he has even built his own bespoke panoramic cameras. Not only do these offer ultimate quality, but they also feature all the usual large-format camera movements, enabling perspective and depth of field to be controlled accurately.

"I was particularly keen to produce a camera that would offer flexibility in terms of the lenses that I could use," he says. "For my landscape work I tend to favor either an ultra-wide or an ultra-long lens, so I created a camera that would offer more versatility, with the ability to use lenses at either end of the visual scale.

"I went to Fujifilm, who kindly arranged to let me have an old 6x17cm body from their repair depot, and I chopped this up so that what I was basically left with was a panoramic film holder that, with a little adaptation, could be made to fit onto the back of a Sinar Norma 7x5in camera. This then allowed me to use the 6x17cm format in conjunction with my range of lenses; my Schneider 72mm allows me to shoot ultra-wide images, while my 800mm Nikkor lens gives me ultra-long telephoto images, and provides fantastic compression of planes within the picture."

The extra time that is involved in setting up a large-format camera is, Meers believes, more of an advantage to the landscape photographer than a drawback. "I've always felt," he says, "that the extra time spent setting up for a picture, and waiting for ideal conditions, usually produces more considered results."

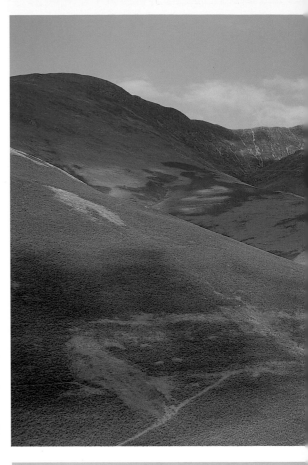

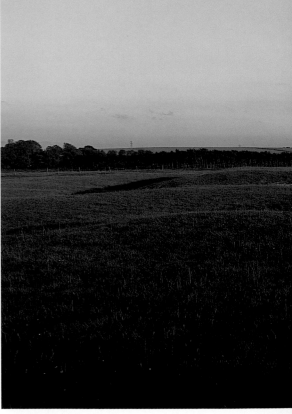

Near Buttermere, Cumbria, England (*Opposite, top*)
"I love the English Lake District because it has such a variety of scenery and changeable lighting and weather conditions. I took this picture while I was in the area shooting stock; I just thought it was interesting lighting and I grabbed the picture while I had the chance."

Fujifilm G617, 105mm lens, Fujifilm Velvia

Stonehenge, Wiltshire, England (*Opposite, bottom*)
"I took this picture from the adjacent main road at a time when Stonehenge had closed for the day, because I didn't want to get any people in the shot. I also spent a lot of time trying to minimize the effect of the ever-present perimeter fencing, which here has been hidden in a dip. The late afternoon light also helped to give me the atmosphere that I wanted."

Fujifilm G617, 105mm lens, Fujifilm Velvia

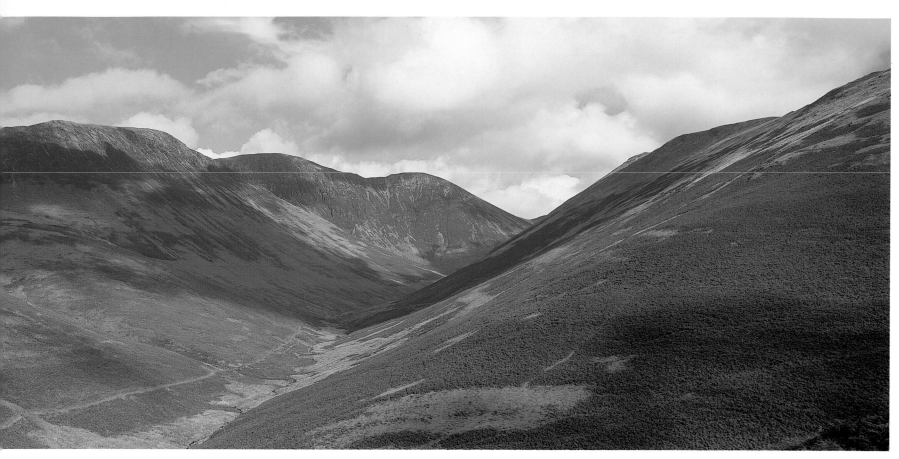

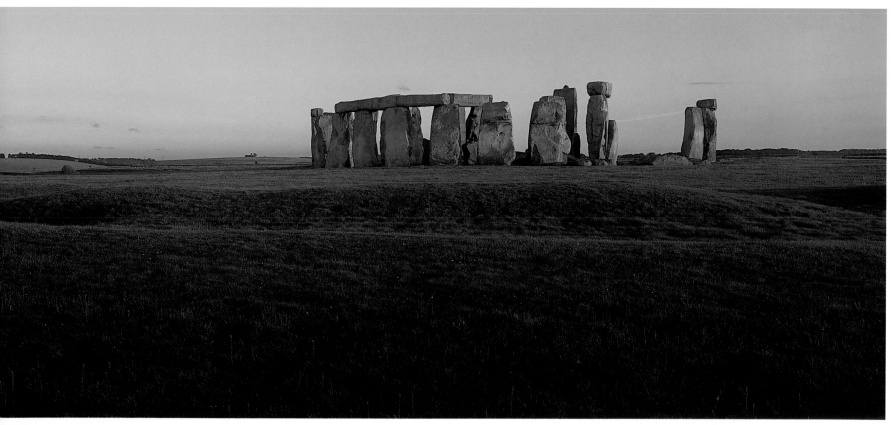

Nick Meers

Early morning view near Putley, Herefordshire, England
"Some years ago when I was commissioned to shoot the pictures for a book entitled *The Shell Guide to Gloucestershire, Herefordshire and Worcester*, I travelled the three counties looking for potential views, and then marking their positions on my maps with a large cross so that I could return later if lighting and weather conditions were suitable.

"Some time later after I had moved to this area I remembered this beautiful scene, literally half a mile down the road from my new home. Even though it was right on my doorstep, I had yet to see it at a time when the conditions were totally right for photography.

"Very early one summer's morning, however – around 4am – my wife awoke and alerted me to the extraordinary dawn light emerging outside, and we leapt out of bed to shoot this picture. We were there within ten minutes and this was the picture that I produced. It's one of my favorites, and I particularly like the herringbone pattern of the fields in the foreground created by rows of cider apple trees, which are so typical of the landscape in this county."

Fujifilm G617, 105mm lens, Fujifilm Provia II

Nick Meers

David Muench

David Muench's sensitivity and determination to champion the strength and beauty of the landscape – the wilderness, in particular – have led to over 40 exhibit-format books, solo exhibitions, and the inclusion of his work in a series of wilderness and conservation publications. A favorite assignment was his 1975 commission to provide photographs for 33 large murals on the Lewis and Clark Expedition, which were destined for permanent collection at the Jefferson Expansion Memorial Museum in St. Louis, Missouri. His work is also held in many private collections.

Meunch's interest is in producing photographs that evoke the spirit of the natural landscape. He wants his work to make people aware of the necessity of preserving what is wild. "Our commitment to preserve our wild lands, and to maintain a balance between economy and ecology, is essential for future generations," he says. "The mystical forces of nature that help shape our destinies are vital to me. I want my work to be a celebration of man and the earth."

While formally educated at the Rochester Institute of Technology, University of California at Santa Barbara, and the Art Center School of Design, Los Angeles, Muench considers the tutorship of nature to be equally important. His own intuitions and perceptions have led him ever deeper into his innovative and oft-emulated style. His near-far approach – in which close-up subjects lead through the mid-ground into the grand, distant landscape – has become a standard for landscape photography.

"Making a photograph is a total and continuing involvement," he says. "Patience and awareness are requisites. Dramatic forms of sun and shadow, unusual light – a decisive moment of mood, the transition between past and future – challenge my mind's eye. This is, for me, a timeless moment."

Muench has worked with a large-format 4x5in camera for most of his career. In recent years, however, he has also worked with 35mm SLR cameras that have allowed him to capture ephemeral and spontaneous moments, and he has been nominated as an 'Explorer of Light' for Canon Cameras.

Rainbow Bridge National Monument, Utah, USA
"There is a conflict for me in photographing this, the largest natural bridge in the world (and a scared Navajo place), in the reflection of Lake Powell. To make the Lake Powell Reservoir the magnificent Glen Canyon was drowned. Rainbow Bridge is actually up a side canyon (Aztec), but the water level of Lake Powell causes the reflection in the lake itself. Here is a case of an environmental atrocity that, nevertheless, provides us with a moment of beauty – and a lifetime of concern."

Linhof 4x5in field camera, 75mm Rodenstock lens, Fujifilm Velvia

Delicate Arch Moonrise, Arches National Park, Utah, USA

"For about a month in summer the moon in this part of the country rises while there is still some light in the evening sky, an event I think of as the changing of the guard. It is delicate timing; things such as cloud cover can have an influence, and planning far ahead is difficult. You just have to be ready to go.

"This happened to be a classic evening. The sky was clear with a full moon, and I walked the mile and a half across slick rock (which consists of sheets of virtually horizontal sandstone rock), to the bowl that is crowned by Delicate Arch. Arriving half an hour before the moon would be in position, I anticipated the right camera placement. The period during which the moon was in exactly the right position for this image was probably less than one minute. Cartier-Bresson defines his greatest photographs as 'The Decisive Moment', and my term for a similar occurance in landscape photography is 'The Timeless Moment'. This was truly one of these. For a brief moment the past and the future come together."

Linhof 4x5in field camera, 300mm Nikkor lens, Fujifilm Velvia rated at ISO 40

David Muench

Marc Muench

Born in 1966 in Santa Barbara, California, where he now resides, Marc Muench has been a professional landscape photographer since he finished his studies at Pasadena Art Center College of Design in the spring of 1989. He now serves as President of Muench Photography, Inc. while continuing to photograph for the Muench Photography collection. He is also son of photographer David Muench.

His photographic specialty is incorporating people within the landscape, in various sports and recreational activities. "I enjoy developing a relationship between people and the landscape," he says, "tying together the personal connection each individual has with the landscape in its various forms of mountains, oceans, valleys, and deserts."

In terms of cameras, Muench uses just about everything, with 35mm coming into its own when it's necessary to work quickly, and medium-format and 4x5in cameras when it is ultimately quality rather than flexibility which is the motivating force. "If I know I'm going to be photographing landscapes and perhaps people also, I'll use the Contax 6x4.5," he says. "My favorite lens for that is a 35mm wide-angle, and usually I have two different backs, each with a different film. My other lenses are 80mm, 120mm macro and 210mm telephoto.

"The 4x5in is perfect for clients who want the grandeur of the landscape in their layouts, with that deep level of detail that only large-format transparencies can give you. But even more so I use 4x5in in my own personal landscape work. Setting up a 4x5in is an entirely different way of working compared to using medium-format or 35mm cameras. So much time goes into it, so much preparation.

"On location with a 4x5in camera, I will spend more time just looking at the scene before me, because you just won't set up a 4x5in or use it as often as you will a 35mm camera. Typically you're going to come back with fewer, but hopefully more precisely composed and exposed images.

"Once I find exactly what I want, I put the camera backpack on the ground, set up the tripod, pull the camera body out, set it on the tripod as fast as I can, and only then do I choose the lens. I typically have three in the field – the 75mm, 210mm, and 450mm – and since I've already previsualized which one I want for the shot, I usually know which one I'm going to use.

"The appropriate lens goes on to the camera, and then I put the dark cloth over my head and start framing the shot. I like to use a tripod head with a separate tilt and shift for lateral and vertical movements. A ballhead doesn't work for me; with that much weight, you can't make the small adjustments. I usually spend most of the remaining time fine-tuning the composition. I'm trying to get every corner of the frame into focus by extending the depth of field to the entire image that's projected by the lens onto the film plane.

"Basically, I'm adjusting the focal plane, which is the front lens board where the lens is mounted, by moving it to project the focal plane forwards, backwards or sideways onto the film plane. That's how field cameras let you completely control depth of field. I use the Super Angulon lens to give me a larger area of coverage, so I can make a broader range of lens board movements and still cover the full film plane. One of the traditional movements that I use is: lens shifts down, film plane stays vertical, and lens tilts forward. That gives the classic near-to-far shot, where everything from the bottom of the frame to the top is sharp, and that's the Muench trademark.

"From swinging the pack from my back to clicking the shutter takes from three to five minutes. I'm working really fast the whole time. I'm not even looking at the shot until I get under the dark cloth, just getting the camera set up and the film holder in my back pocket ready for action. When the light is happening and you've only got those three or four minutes until it's gone, knowing where everything is stowed in your backpack and how to set up fast really is essential to getting the last great shot of the day."

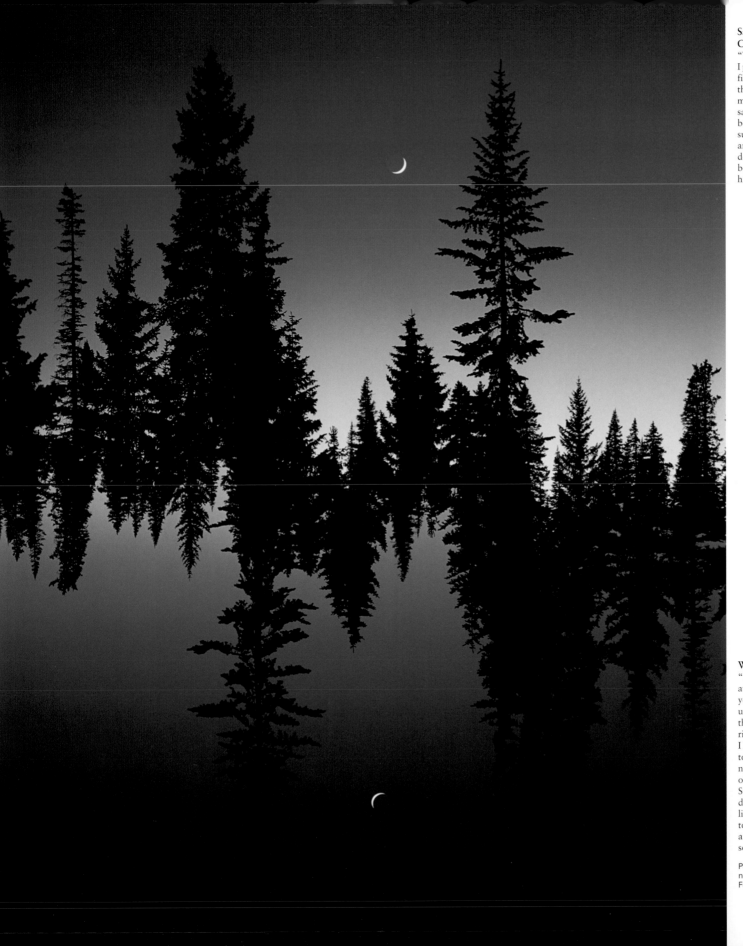

San Juan Mountains, Colorado, USA

"This was a double exposure that I produced in-camera. I took the first exposure and then turned the camera through 180° and made another exposure of the same scene. The picture worked because the lower portion of the subject was in complete darkness and there was no danger of a double exposure, but I had to be careful not to overlap the highlight areas."

Wasatch Mountains, Utah, USA

"I took this picture while I was at college, and I must have been young and crazy because I hiked up this mountain in late afternoon the day before and slept on this ridge and almost froze overnight. I had not gone up there primarily to take pictures; this is the area next to Salt Lake City that is the off-piste ski capital of the United States, and I had wanted to ski down the mountain in the first light of morning. Fortunately I took this picture before I set off, and it shows something of the solitude of this place."

Pentax 6x7cm, 45mm lens, neutral density graduated filter, Fujifilm Velvia

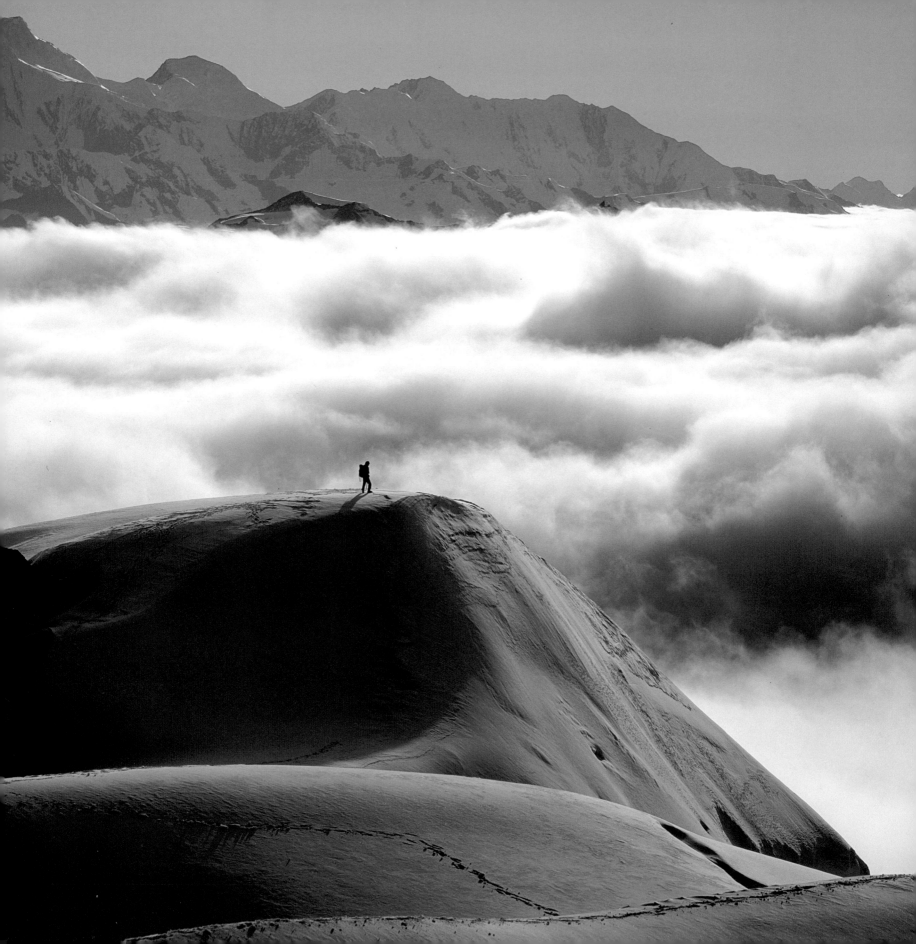

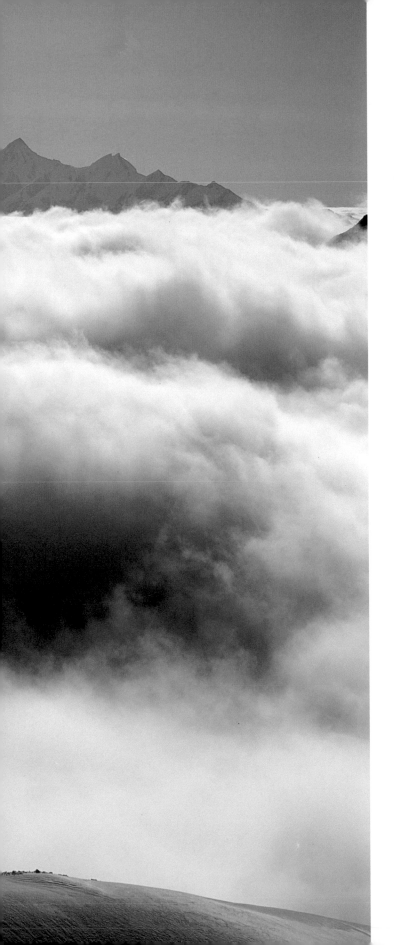

Wrangell, St. Elias National Park, Alaska, USA
"A group of four of us, including my father, decided to head for a really impenetrable part of the Bagley ice field in Alaska, a place so far away from civilization that we had to make three flights, hike, and drive for 80 miles to get there, eventually being dropped off by a bush pilot in a Super Cub plane.

"The aim was to give us an opportunity to spend some time in the ice fields in this region and to explore a lot of the peaks and mountains, some of which had never been climbed or photographed ever before. We had arranged to be picked up again by the pilot five days

later and had taken extra provisions with us so that we could last for an extra three days if the conditions got so bad that the pilot couldn't pick us up at the arranged time.

"This particular morning we left our tent at 4am, hiked over an ice field and across an unusual glacier, and then we climbed to this point, which is about 4,000ft (1,219m) above the valley floor. As the day wore on, this low fog started to come in and it slowly filled up the entire valley and covered the Bagley ice field. Standing on this ridge I wanted to combine all of the elements that I could see – the fog, the dramatic mountains, and the lone climber who was

dwarfed by his surroundings – into one image, and this is the result. There really was this little color in the scene, and it almost looks like black and white.

"I took a Pentax 6x7cm camera with me because this was the largest camera that was practical for such an expedition. I wanted as much detail in the landscape as possible, without encountering a lack of flexibility."

Pentax 6x7cm, 300mm lens, Fujifilm Velvia

Marc Muench

William Neill

Like so many landscape photographers, William Neill developed a love of wild open spaces early in life, tantalized by the beauty that he experienced during family holidays to the national parks in the US. As an adult, backpacking excursions offered him the chance to pick up a camera and explore ways to record the sights he encountered.

It was, however, an altogether different event that changed his outlook on life forever. Aged 18 he took a job in Glacier National Park in Montana and, in the middle of that summer, he was stunned to receive a phone call telling him that his only brother Jim, just two years his senior, had died suddenly from a brain aneurysm.

"Things went on but I now had a different perspective," he says. "I was seeking consolation in nature in a deeper way, and everything had been raised to another level. I was too young to think it through; I wanted to be where it felt better, because of the beauty that was, and always is, there. The landscape was a place where I felt a positive sense of the future."

His interest in photography grew. His explorations had an important spiritual dimension, and enabled him to make an emotional recovery. He realized that this was where his vocation lay, and he scoured bookshops for inspiration, finding it in the work of great masters: Minor White, Wynn Bullock, Edward Weston, Paul Caponigro, Philip Hyde, Eliot Porter, and Ansel Adams. "Here were artists dedicated to their art and to the land," he says. "I saw that photography could be a powerful tool to protect wilderness and to further the environmental cause."

Soon after graduation, a job with the National Park Service brought him to Yosemite National Park, and soon after a role as Photographer in Residence at The Ansel Adams Gallery. Adams was still alive and teaching on occasion at the gallery, along with other leading landscape figures, such as John Sexton. "As an employee I could go to several of the lectures and follow some of the photographers around," he says, "and I learned from them all.

It wasn't just the technicalities that were important: I discovered how photographs should be printed and presented, and what role inspiration had to play. I started to see the potential of photography becoming a career rather than a dalliance."

Neill was at the gallery for five years, absorbing everything that was going on around him, and slowly he started to make his mark as a photographer in his own right, generating work through book and magazine publications without having to take huge risks straight away. "By the time that I left I had developed a clear style and had a publishing history," he says, "and both of these things were vital in terms of being able to survive on my own."

By this time, he was shooting the vast majority of his work on 4x5in format. "I've got the same camera that I started out with," he says, "which is an SP metal Wista field camera. Once I started with 4x5in that was the way that I wanted to continue because it suited me. I wasn't in a hurry and wanted to work in a slow, considered way, and this camera suited that pace.

"I'd rather ask a question than answer one in my work, and the realism of 4x5in allows me to do that. You realize that what you are seeing is something that truly exists; you don't need to throw something out of focus or to produce an abstract to achieve the impact that you want."

Giant sequoia trees, Mariposa Grove, Yosemite National Park, California, USA, 1993
"For all the years I have lived in Yosemite, I have struggled to make a meaningful image of the giant sequoias. The literalness of many of my efforts failed to transmit the intangible presence of the trees. The success of this image relies on what is implied beyond the edge of the frame; trees of such 'weight' at their base can only be imagined."

Wista 4x5in field camera, 6x12cm film back, 150mm lens, Fujichrome 100

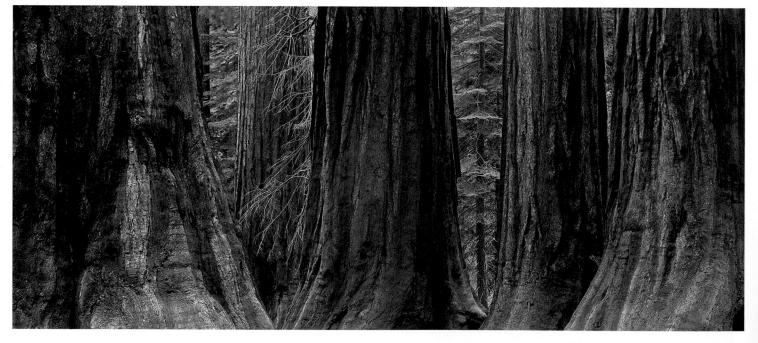

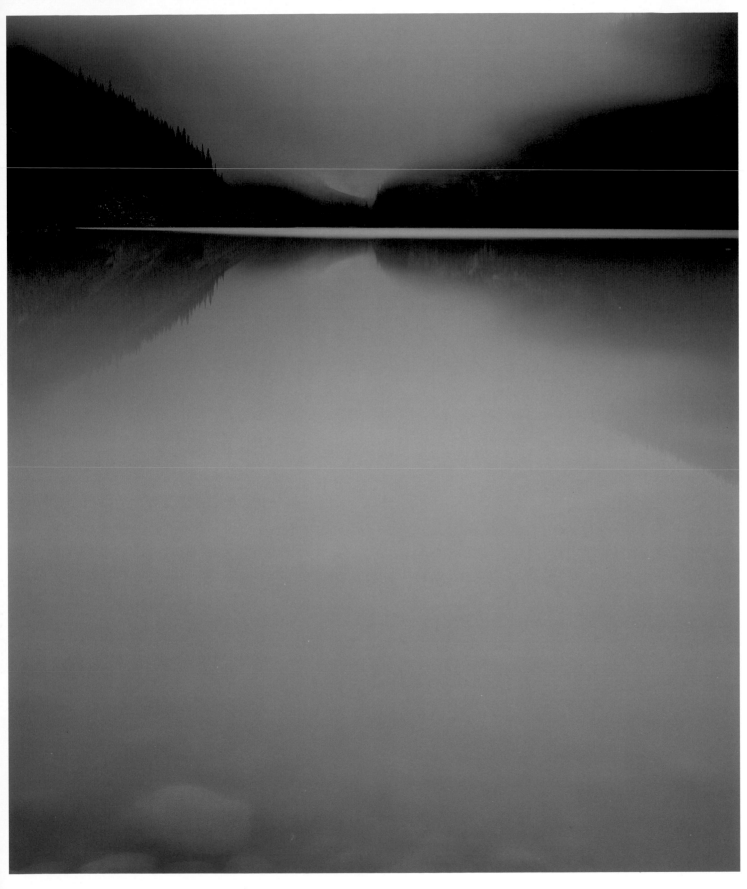

Dawn, Lake Louise, Banff National Park, Canada, 1995

"Lake Louise is such an iconic location that it's like paying a visit to Half Dome.

"I decided to get up at 4am and to set up my camera in the hope of achieving a picture that showed the early morning sunlight on the dramatic mountains in the background. I got there in the dark and waited, but as the light came up it was obvious that the clouds were down too low and that the mountains were not going to be visible. I stood there and appreciated the peace and quiet and thought to myself that I should take at least a couple of pictures to make the early start worthwhile.

"In the end I took just two sheets of film, one an upright image the other a horizontal that excluded the foreground rocks, and each was a two-minute exposure due to the low light levels. I was on a three-week trip and took around 200 sheets of film overall, and sent them off for processing when I returned home.

"It was only when I received the film back that I realized what I had got; had I realized how well this image was going to turn out I would have taken 20 sheets of film! It's one of those rare pictures that, to me, has a spiritual essence, and the response that it has generated from others has been quite powerful."

Wista 4x5in field camera, 150mm lens, Fujifilm Velvia

William Neill

Lava flow entering the sea at twilight, Hawaii Volcanoes National Park, Hawaii, 1994

"The thrill of witnessing the raw beauty of creation comes back to me every time I view my images from Hawaii Volcanoes National Park. Waves receded down the steep beach, then returned to engulf the flowing lava.

"Standing on a small shelf of hardened lava, I could feel the earth rumble underneath me. A strong offshore wind forced me to use a 35mm camera instead of my preferred 4x5in format. I used a moderate shutter speed of about a quarter of a second to convey the dynamic motion of this spectacle."

35mm camera, 70-200mm zoom lens, Fujichrome 100

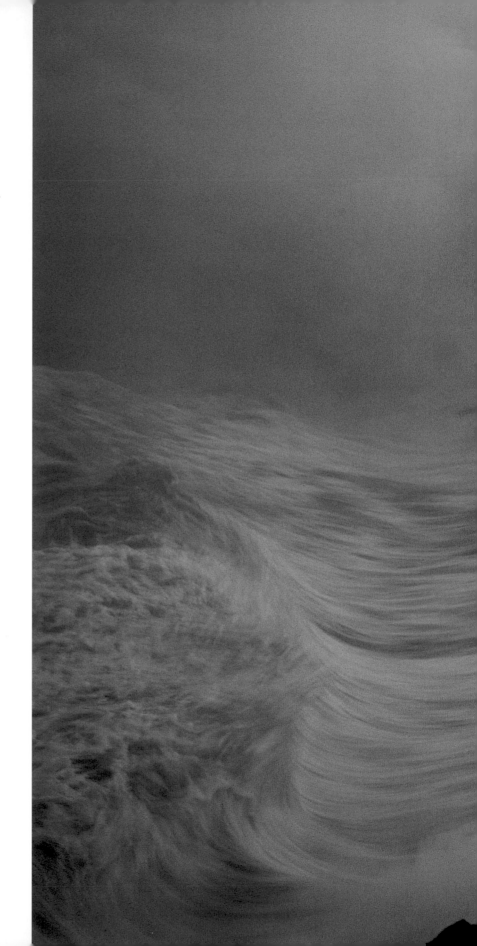

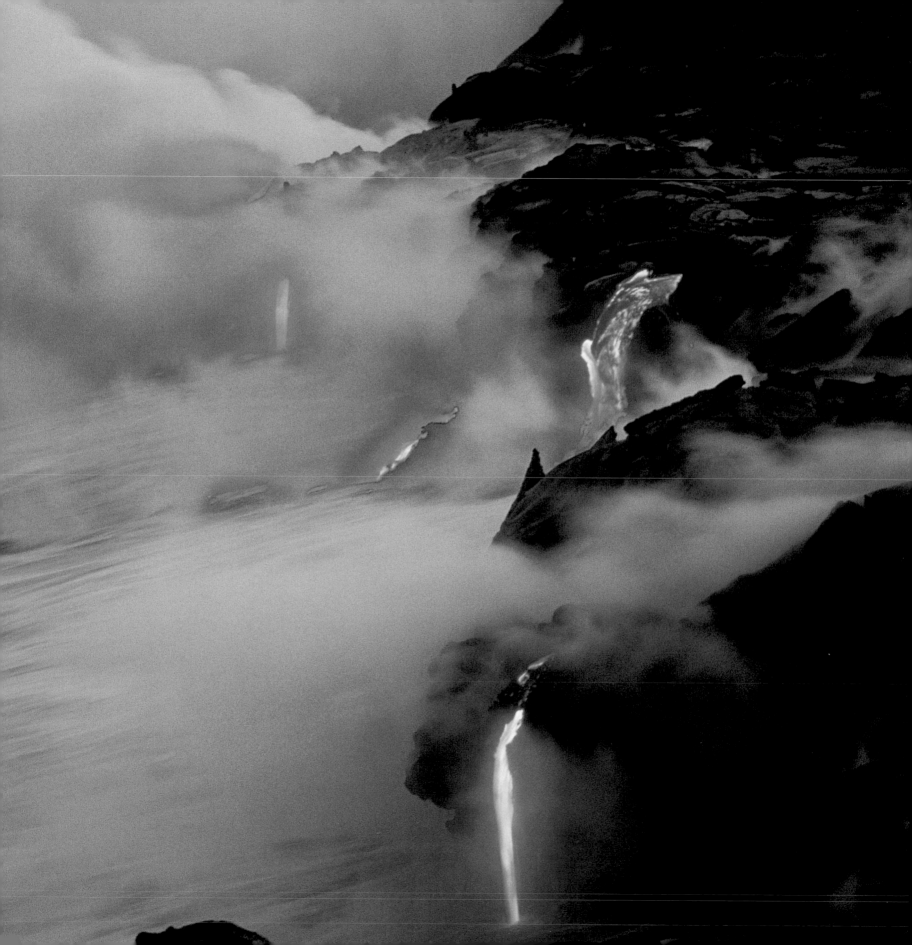

Pat O'Hara

Like so many who have gone on to become dedicated landscape photographers, Pat O'Hara was raised in an area of dramatic natural beauty, the American Northwest. "I grew up surrounded by mountain landscape," he says, "and that influenced me to become interested in environmental education and the interpretation of natural history.

"I studied at university to get the training that I needed to help get a job with the National Park Service, my intention to become involved with developing interpretive materials for park visitors. Early on I realized that the role I would be given would be that of an administrator, and I knew that I would end up confined indoors and that was something that I didn't want to happen.

"Photography had always been an interest of mine, and I decided that I would develop that to the point where I might be able to make a living as a freelancer, a situation that would still allow me to travel to the national parks and work with environmental organizations but to be independent and able to travel the world looking for pictures."

A self-taught photographer, his perseverance paid off, and he started to build a reputation for himself as someone who had a fine eye for landscape. "As someone who had been familiar with mountains my whole life, I found that I had an affinity with vertical relief in the landscape, and a particular love for alpine areas. I was also drawn to ephemeral atmospheric conditions, times when there was something special going on with the weather.

"To me, one of the great attractions of landscape is that conditions might allow you a window of light for no more than 15 seconds that changes a scene completely and makes it incredible for that short period of time, and then it's gone and the whole complexion of the picture changes. I try to prepare myself to be in the environment and ready to receive that gift."

O'Hara's love of the landscape extends beyond the area where he grew up, and he's dedicated his career towards raising awareness of the delicate nature of the environment around the world. The first book he ever worked on was designed to promote the case for increasing the acreage of wilderness areas in the northwest of the United States, and a more recent project has seen him working on a book about the US/Russian proposal to dedicate a Beringian Heritage International Park along the Bering Strait and the Chukchi Sea straddling the Arctic Circle.

O'Hara is also working closely with the country of Georgia (formerly part of the Soviet Republic) to support conservation efforts. "Georgia has been undergoing a transition from being part of the USSR to an independent state," he says. "They formulated a plan to ensure continued protection of nature reserves in the country and to establish a national park system. I worked closely for a couple of years with those who were putting forward the plans, photographing some of the areas that were being discussed and making sure that they had quality images to use to help them in their efforts, and to draw positive attention to the scheme."

In terms of approach, O'Hara uses a mixture of equipment. He says, "In the past I have used large-format view cameras, and a medium-format Fujifilm GX680, but these days I use mainly 35mm Nikon gear. Some remote areas that I photograph are difficult to access and involve hiking, and 35mm is easier to transport. I need to minimize the weight and bulk so that I can fit it into a backpack."

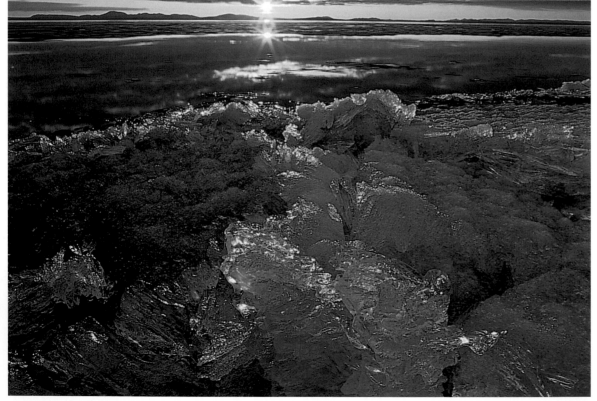

Shoreline ice in the Kotzebue Sound, Alaska, USA
This was taken at around 2am in the Kotzebue Sound, a region of Alaska above the Arctic Circle, and his aim was to achieve a depth of field that stretched throughout the frame. "I wanted to emphasize the ice in the foreground," he says, "as it reflected the beautiful sunset light that was coming from a very low sun."

Nikon F5, 17-35mm zoom at 17mm setting, Fujifilm Velvia

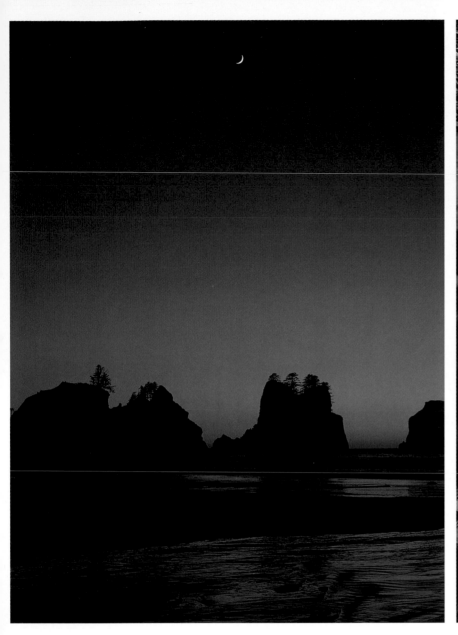

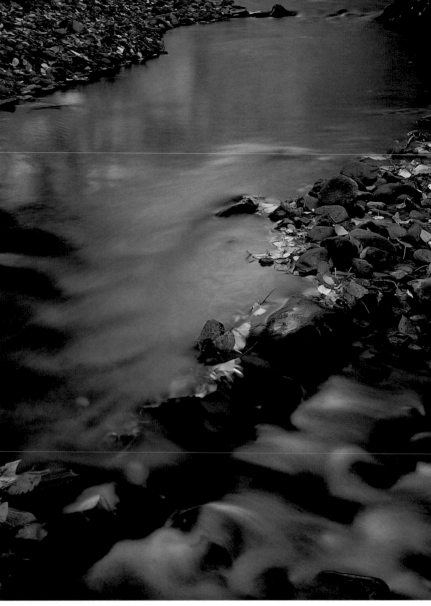

Olympic National Park, Washington, USA
This gloriously moody image was taken at twilight by Pat O'Hara at the Point of the Arches in the Olympic National Park in Washington. He managed to capture it during a brief period when the light in the sky was still bright enough to reflect from the surface of the water, and yet dark enough to ensure that the crescent moon was visible in the sky.

Wista 5x4in field camera, Nikkor 150mm lens, Fujifilm Velvia

Manastash Creek, Washington
This section of Manastash Creek was in shade while the trees encompassing it, rich with autumnal colors, were bathed in bright sunlight. The combination enabled these beautiful reflections to form, and Pat O'Hara discovered his perfect image.

Toyo 5x4in Monorail view camera, 210 Schneider lens, Ektachrome 64

Pat O'Hara

Georgian impressions

Pat O'Hara was in southeast Georgia, close to the border with Azerbaijan, planning to visit a cultural site, the David-Garedja Monastery, which dates from around AD500. While there, he came across this scene nearby, and was struck by the way that the poppies around this tree were moving rapidly in the wind. He tried to design a composition that would express his impression of this place, instead of producing a straight record.

"I decided that I would make a triple exposure," he says, "and I had to try to previsualize what I wanted and then to figure out a way of making an image that would work under the windy conditions that I was facing.

"With the camera fixed firmly on a tripod, the first exposure was a combination of a slow shutter speed and a small aperture. The fact that the wind was blowing ensured that all the flowers were blurred, but I knew that the base of the trees would be sharp.

"The second exposure utilized a fast shutter speed and a wide aperture, which created a shallow depth of field. This allowed some of the flowers to register sharp on the film, while others were out of focus. The final exposure also involved the aperture being used wide open, but I de-focused the lens slightly so that it was soft overall.

"I tried this technique out eight times, and had a number of variations of this image to choose from when I finally processed the film, and then I simply selected the one that had worked the best. Trying out spontaneous ideas like this in the field is one of the things that I enjoy doing the most; I imagine that a similar effect to this could have been created by scanning a transparency in and using post-photographic digital editing, but I enjoyed achieving the result that I conceived in the field."

Nikon F5, 80-200mm zoom lens, Fujifilm Velvia

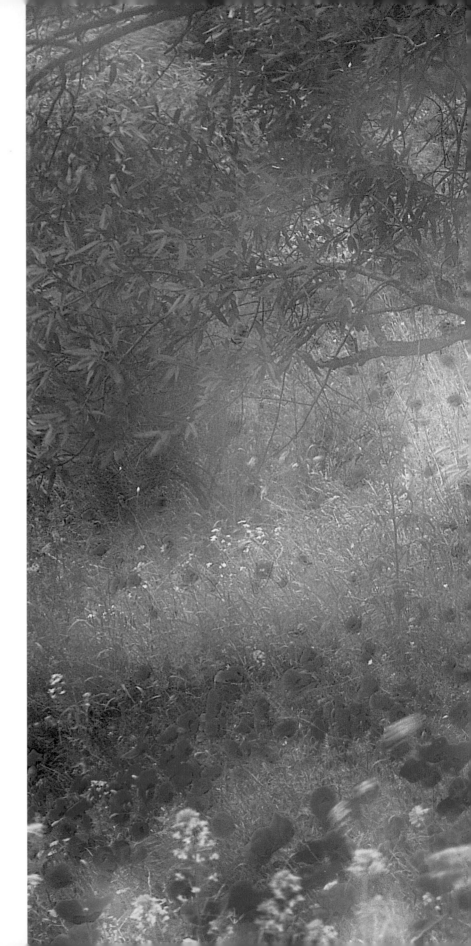

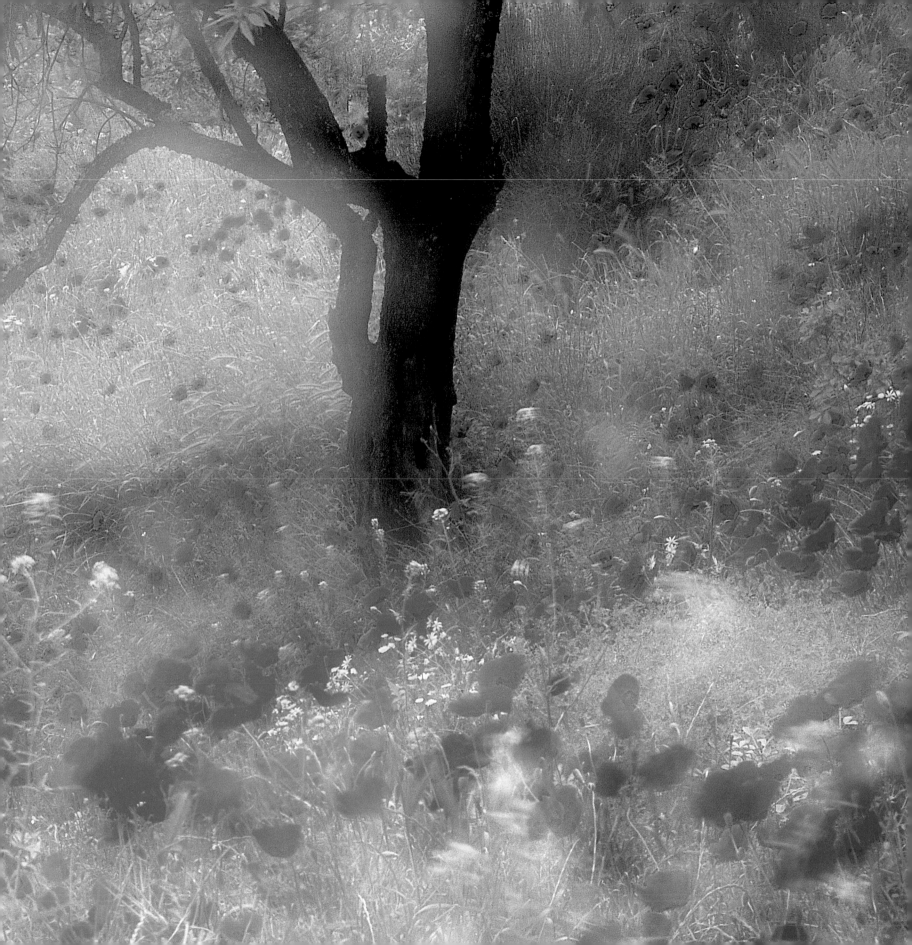

Colin Prior

Colin Prior had an unusual start to his photographic career. An accomplished diver, his first taste of success was winning an underwater photography competition at the age of 19, and with it came not only the prize of a trip to the Caribbean, but the realization that he could make the grade as a professional photographer.

"I had always been interested in art," he says, "but I couldn't find a medium that would give me the perfection that I wanted. Then I discovered photography, and everything just fell into place.

"The competition really was a turning point in my life. It gave me enormous confidence and I thought that if I could produce good pictures underwater then I must be able to do something worthwhile topside. I believe that there is a lot of similarity between underwater and landscape photography: both involve adventure and both make huge demands on the photographer and the gear. You don't want anything to fail you at the big moment, and you have to keep yourself in a total state of preparedness so that if conditions are right you will be able to take advantage."

Whether diving or climbing to the top of a mountain, Prior gets into a state of mind that he terms 'invisibility', which involves being so familiar with his gear that it effectively just disappears, leaving him free to concentrate on creating the pictures that he wants. Once he reaches that point he just focuses totally on the images in front of him, and the rest just comes naturally.

There is no doubting Prior's love of the natural world and, in particular, the rugged landscape of his native Scotland. He talks fondly of being in the mountain environment when the lighting and the atmosphere are just perfect: "At times like that I feel part of what's happening there. For a lot of pictures I'm really just witness to something that's taking place. I like to think that I'm recording something that may not happen again in the same way."

Despite his empathy with his subject, Prior is a realist, and he knows that his photography could have remained nothing more than an expensive hobby if he hadn't figured out a way of making it pay. He's done so to great effect, targeting the art market with his own prints, calendars and cards, and setting up a distribution network in eight or nine countries that enables him to make an increasingly viable income. This subsidizes his landscape work, enabling him to continue the task of chasing his pictures.

"There is a price to be paid for all this," he reflects. "In order to develop the business I have had to make a big investment of time in the sales and marketing side of things and build up the infrastructure of the business. As it evolves it frees me up to go back into the field more and more."

In the mid-1990s he also landed a dream assignment: the job of shooting a calendar for British Airways over a four-year period, an assignment that took him on an all-expenses paid first-class trip around the world. More than a million miles later Prior had visited 35 countries, and had photographed in places such as the Nepalese Himalayas, Chile's Torres del Paine, Pakistan's Karakoram, and Namibia's baking red deserts, and the calendar went on to become much sought-after and decorated.

His trademark camera is the Fujifilm 6x17cm panoramic, a large, but portable model that delivers just four pictures from a roll of 120 film. "So much of photographic composition is based on the rule of thirds," he says, "and the 6x17cm, and 35mm for that matter, offers a 3:1 ratio of width to depth, which helps to make these the most powerful landscape formats. Nothing else comes close."

What drives Prior above all else is the fear of not being passionate enough about his subject to produce work that rises above the ordinary, and it's also a fear of reaching a point in his life and realizing that he had never achieved anything significant. "You have to follow your own passions and instincts," he says. "A lot of photographers are guilty of neglecting these, and they end up spending time playing golf or fishing and letting their work slip. I would like to think that, as I get older, I can look back and say 'that's what I did,' and 'that's my work,' and it doesn't get any better than that."

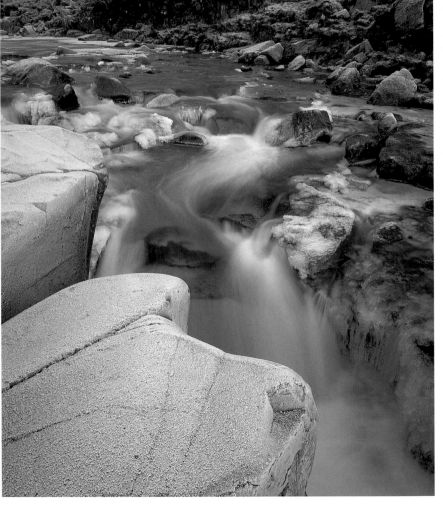

Rocks and ice in the River Etive, Argyll, Scotland
"If there are a lot of clouds in the sky and the light is soft and overcast, then landscapes will look mundane. These are, however, perfect conditions for shooting details, and it was on a day like this that I shot this particular picture. I used a 5x4in view camera, because this featured camera movements that allowed me to alter the plane of focus and to keep everything sharp from the closest foreground right through the picture. This kind of camera allows you to create pictures such as this that couldn't be done in any other way, the downside being that it takes so long to set up."

Linhof Technikardan, 90mm lens, Fujifilm Velvia

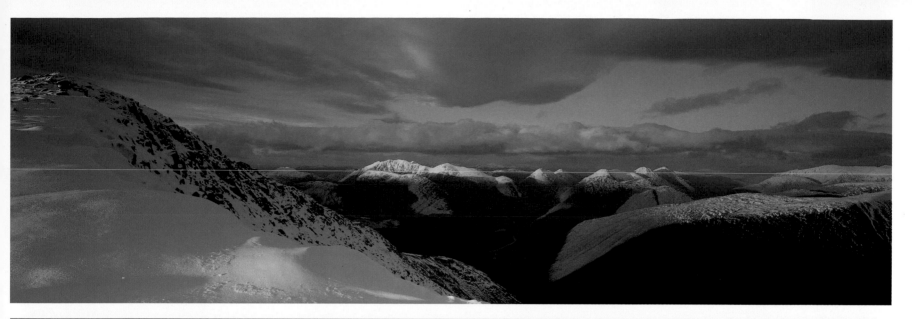

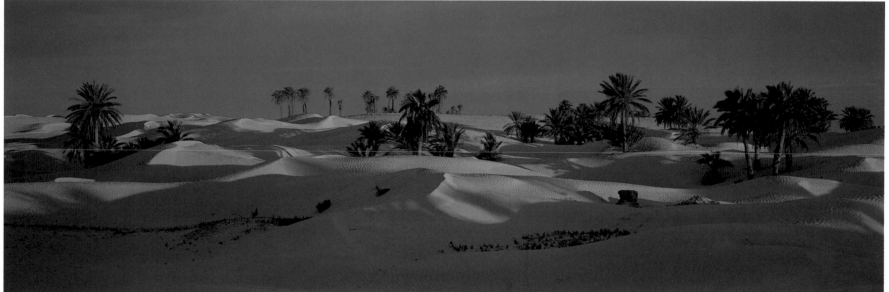

Glen Etive, Bidean nam Bian and the Glen Coe peaks from Ben Starat, Scotland (*Top*)
This picture, taken from the summit of Ben Starat, is described by Prior as "probably the best image that I have ever taken." It was a triumph of optimism; Prior anticipated that the sun, which had been hidden behind a cloud of ice crystals for most of the day, would have one last attempt before disappearing for the evening.

"I had noticed a gap on the horizon," he says, "and felt sure that the sun would pass through this, giving me some direct sunlight on the mountains for the last few minutes of the day."

What actually transpired was beyond his wildest dreams, as the evening glow bathed areas of the foreground and picked them out in glorious warm colors. It was the kind of natural effect that made Prior aspire to be a landscape photographer in the first place, and as he stood admiring the scene in front of him, two eagles appeared, who also became bathed in vivid, golden light.

"It was magnificent to see," says Prior. "If I had taken a 35mm camera and a 300mm with me, it would have been the most wonderful image of the eagles with the golden mountains behind them. Such a picture wasn't practical for me,

however, and I actually needed them not to be in my picture because I was shooting at 1 second at f/22, and they would have looked like black streaks at that kind of shutter speed. So I simply admired them, and was lucky enough that they had gone by the time I took this picture."

Fujifilm 6x17cm, Fujifilm Velvia

Zafranne Oasis at dawn, Sahara Desert, Tunisia (*Above*)
"When I arrived to take this picture early one morning, there was a heavy cloud base, and I wasn't sure if I would get anything at all. I did notice, however, that there was a small gap at the horizon, and I realized that if the sun were to break through at all then it would only be for a matter of minutes. I was lucky and there was some sunlight, but only for around three minutes, and in that time I took three rolls of film which, on a 6x17cm, amounted to 12 pictures. Then the sun was gone and, within the hour, it was raining! I shot here on other mornings when

the weather was more what you would have expected – the sun in a clear blue sky – and it was nothing like as interesting."

Fujifilm 6x17cm, Fujifilm Velvia

Colin Prior

Moonrise over Rannoch Moor, Argyll, Scotland

Colin Prior took this image on a freezing evening one February, and it's an occasion he'll never forget. "Quite simply it was one of the most amazing photographic sessions I've ever undertaken," he says. "I climbed a mountain known as Stob Gabhar to shoot a specific image of Glen Coe as the sun was setting, and came away with this and two other big pictures taken in three separate directions over the course of an hour or so. The conditions were just perfect."

After the sun had set and the first two images had been taken, Prior and his companions were keen to make their descent because freezing conditions were developing. "I remembered, however, that the previous evening there had been nearly a full moon," he says, "and I knew that the conditions were right for us to see the moon again this evening. The light was perfect: the sun had set but, because we were so high up, it was still illuminating the upper atmosphere, while the ground itself was in shadow.

"We watched as the moon rose over the vast desolate stretch of Rannoch Moor and, because it was catching light from the sun, it really was this color. It was very, very satisfying to see it all come together after we had made the sacrifice of time to wait for it.

"We had to descend the mountain in darkness, using the lights from our helmets to see where we were going. It was a difficult and slow descent because the snow was knee deep, and we then had a two-mile walk to where our vehicle was parked, but all the effort was well worth it."

Fujifilm 6x17cm, Fujifilm Velvia

Colin Prior

Lynn Radeka

Land of Standing Rocks, Canyonlands National Park, Utah, USA, 1988

"While driving into the Maze District of Canyonlands National Park, I noticed a cloud mass above an area that is called the 'Land of Standing Rocks'. I stopped and set up my 4x5 in view camera. Using Tri-X film and a yellow-orange filter, I made this negative seconds before a jet trail cut across the sky.

"This print requires a contrast reduction mask, shadow contrast increase mask and my own fog mask. They give me control over values throughout the image. A great deal of burning and dodging is also required.

This final image symbolizes for me the American West."

Having travelled and photographed the American landscape extensively since the late 1960s, Lynn Radeka has made America's West his forte. His love of the grandeur and intimate details found in abundance in these regions was born on his first trip to Death Valley in 1966, and it's a feeling that has never left him.

As his career evolved in the early 1970s, he had the good fortune to have his work critiqued and encouraged by four inspirational role models, legendary photographers Ansel Adams, Wynn Bullock, Henry Gilpin, and Al Weber. The influence of landscape masters such as these provided a framework for his own approach to photography, in particular guiding him towards the acquisition of the darkroom skills necessary to interpret his images as high-quality black-and-white prints.

Since the mid-1970s, Radeka has been utilizing a variety of elaborate pin-registered contrast masks, including shadow masks, highlight masks, fog masks, and specifically designed combinations of both, to help him achieve results that are precisely controlled and in tune with his intentions at the time of shooting. In the late 1980s, he developed his printing technique further and adopted the extensive use of very effective 'shadow contrast increase masks' (SCIM) in order to coax amazing variations of contrast in localized areas of the image.

Varied combination toning, localized print 'bleaching', and specialized paper selection are but a few of the other fine-tuned elements that go into the making of a uniquely original black-and-white Radeka photograph. The results hark back to the great traditions of American landscape photography and demonstrate the potential for personal input and interpretation that is still available to those who master the black-and-white medium.

Exploring the theme of landscape, Radeka has concentrated on areas that fascinate him as a photographer, in particular the American desert, the Pacific Southwest, and the West.

The deserts of California, Utah, New Mexico, and Arizona have been a particularly fertile hunting ground for Radeka over an extensive period, which have lead to the publication of a series of seven black-and-white duotone posters, sold in America's western national parks. Images that have been gathered together over a period of over 30 years have also been showcased in a fine art book entitled *Light and Shadow: The American Desert*.

The states of Washington and Oregon in the Pacific Northwest also provide the locations for many of Radeka's favorite locations and, since 1975, he has been photographing the glorious mountains and forested slopes of the Cascade Mountain range as well as the quaint port towns of the Puget Sound and the dynamic skylines of Seattle, Portland, and Vancouver.

Also closely connected to landscape is the series that he has been working on for several years that depicts man's influence on his surroundings, in the form of ghost towns, American forts, and battlefields. As someone who has undertaken an extensive study of these areas for a number of years, Radeka has been granted special access to some of the West's most photogenic, yet carefully guarded ghost towns and historic sites.

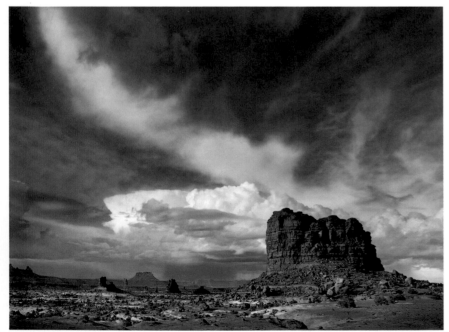

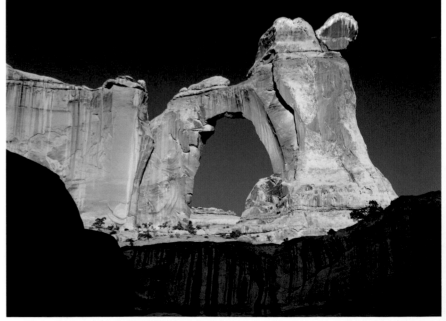

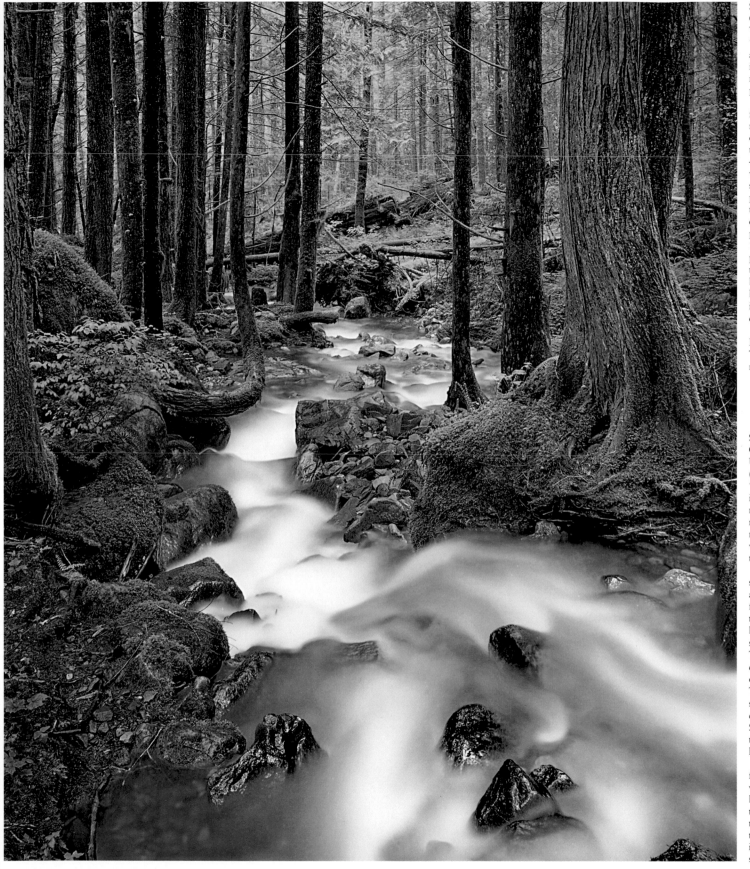

Stream through forest, North Cascades National Park, Washington, USA, 1982 (*Left*)

"This photograph resulted from a desire to produce a dream-like image of a soft, cottony stream meandering through a dense pattern of trees.

"Since the light level in this forest was quite low, it was necessary to use an exposure of several minutes – taking care to allow for reciprocity failure – and this allowed the moving water to blur, enhancing the soft quality of the stream. The print is difficult to make owing to the delicate balance of contrasts required. I use a soft print developer such as Ansco 120, coupled with a grade III paper and careful masking techniques." The crisp, black boulders in the foreground bring life to the image, and this is, in part, thanks to Radeka's developing techniques.

"I use 'SLIMT' (Selective Latent Image Manipulation Technique) development, which results in a superior negative."

Sunrise, Angel Arch, Canyonlands National Park, Utah, USA, 1985 (*Opposite, right*)

"I first photographed Angel Arch in 1975, obtaining a similar negative to this one. That early negative, however, had some major flaws. Ten years and many visits later I was able to re-shoot the picture to my satisfaction.

"The newer negative is superior in many ways. I utilized a deep yellow-orange gelatin filter (No. 16) in order to enhance the dramatic separation between the warm-colored, sunlit arch and the blue sky. The negative was given normal development and prints well on a strong grade II paper. The shadowed cliff is dodged substantially to maintain ample detail, followed by a localized SCIM to enhance the contrast in this area and to emphasize the lines in the rock.

"The window of opportunity for this shot is 45 seconds, after which the morning sunlight begins to spill onto the rim at the base of the arch, eliminating the clean, hard shadow edge that is seen here. To me, this image succeeds because of the simplicity and boldness of form."

Lynn Radeka

Moon over Zabriskie Point, Death Valley National Park, California, USA, 1980

"I took this image shortly after sunrise, waiting for the sunlight to fully bathe the background mountain range, while the morning light had not yet touched the entire foreground. Within seconds of making the exposure, drifting clouds obscured the moon making it almost invisible. I shot without a filter and developed the Tri-X film that I was using in HC-110 developer to normal contrast.

"First attempts at printing this negative were a failure and I ended up filing the negative for over ten years. In the early 1990s, however, I was asked to produce a poster for Death Valley National Park and I eventually rediscovered this negative hidden away in my files. My post-visualization of the print was completely different to that of a decade before owing to the passage of time and a more objective approach to the image.

"Fortunately, the negative contained all the necessary information to achieve an excellent print. Using a relatively soft grade II paper, I gave the entire sky area of the print, including the background mountains, a substantial amount of extra exposure in order to darken it to the degree necessary to obtain a well-balanced image, while ensuring that subtle detail was revealed in the moon. Burning was done just to the point of bringing out the 'mood' of the scene, which to me represents a relationship between the moon and the lunar-like landscape of the foreground mud hills.

"In order to enhance the tactile quality of the foreground mud hills, a SCIM was used to increase the local contrast of the foreground area. The use of this mask requires perfect pin-registration on the enlarger and negative carrier. In addition, I hand-bleached the background mountain range on the print using my highlight-brightening Ferricyanide formula. This brightened the mountain range and increased the local highlight contrast rather severely, causing the brilliance of the morning sunrise to be emphasized. The difference between a straight print made from this negative and my final, more expressive, print is substantial."

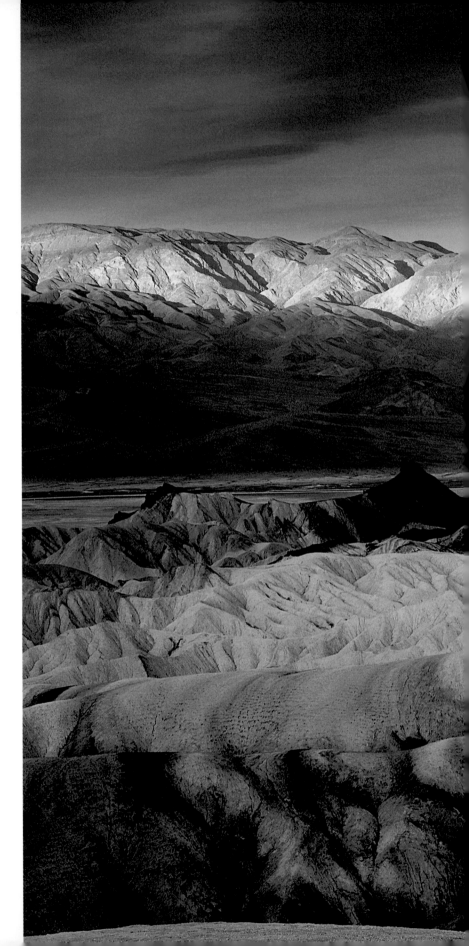

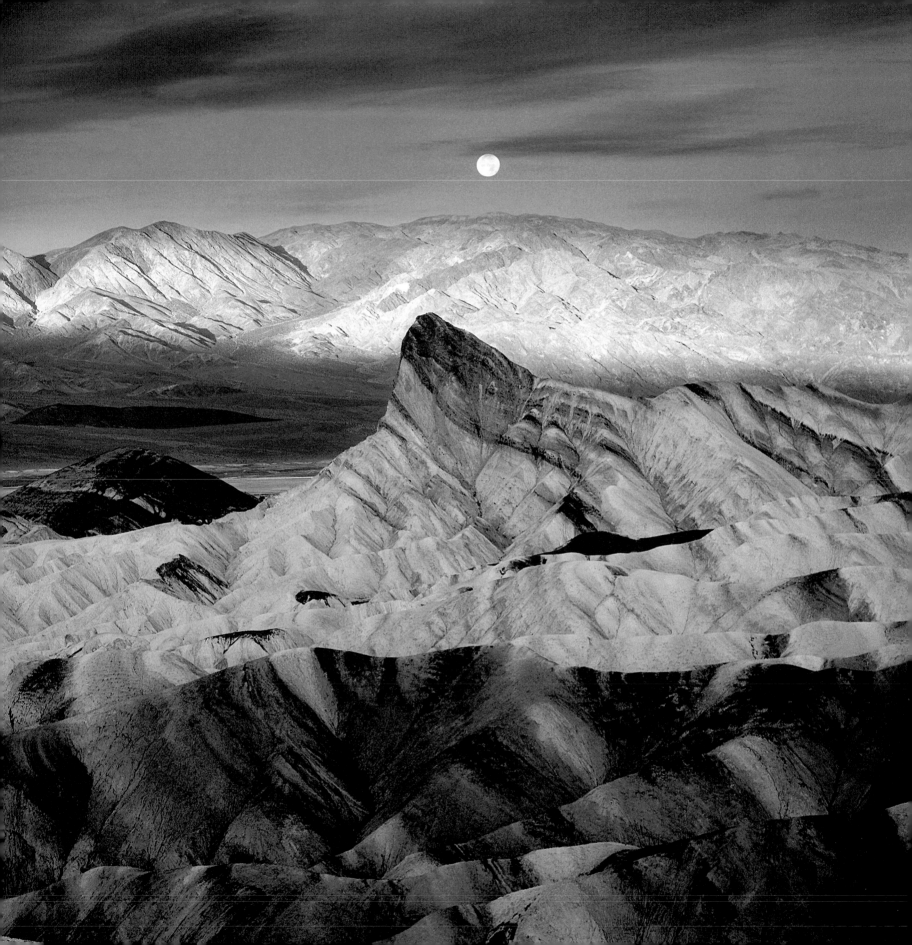

James Randklev

Born and raised in Port Angeles, Washington, as a child James Randklev had the nearby Olympic National Park as his playground. This beautiful protected area was his inspiration; he explored everything from tide pools to ancient forests.

"I think that, had I been born in a major city I wouldn't have taken anything like the interest in the natural world," he says. "As it was, Olympic Park was a very special place that grew on me like an old friend. As I matured I became more interested in backpacking to the deeper reaches of the Park to feed my desire to explore the flora and fauna. I wanted some way of recording the natural beauty so that I could show others, and it was a logical move for me to invest in a camera that I could take with me on my expeditions. Photography was simply about recording what I saw until one pivotal defining moment in February 1969.

"Heading west from Port Angeles one day, I decided to explore the rugged ocean strip of Olympic National Park at La Push Beach Trail II. It was only possible to reach the beach by hiking through dense spruce and hemlock. When I arrived I was witness to a terrific Pacific storm on windswept headlands. At this location the sea has created a pile of driftwood and dead trees at the back of the beach that is about 40–50ft (14m) wide, and beyond that the storm was lashing the waves so hard that it was creating sea foam.

"It was an incredible scene, and I photographed it with a rock island that was around 100 yards offshore in the background. I knew it was something special, and when I had the picture processed I realized that nothing would be the same again. The picture had become a moment of expression, and I was incredibly excited about that. I knew at that point that photography was more than a hobby, it was part of me, and I realized that my life was going to change forever."

Despite realizing the direction that he wanted to take, Randklev knew that he still had a long way to go before he could make landscape photography his career. Having studied the work of landscape masters David Muench and Ansel Adams, he made the decision to move from 35mm to medium-format in 1972, and the following year, still unhappy with the resultant quality, he moved up to 4x5in camera, a format that he preferred.

From 1970 to 1990 he had a full-time job at the UCLA in California, but photography was his passion and it took all of his spare time. The nature of his job also meant that he could take leave of absence in the summer and spend time visiting locations looking for pictures. He visited all of the national parks in the United States during this period, and amassed around 2,000 large-format pictures in the process.

His breakthrough was inevitable, and this came in 1977 when the world famous Sierra Club, America's oldest and most influential grassroots environmental organization, gave landscape photographers the opportunity to submit images for use in their calendars. Randklev sent off a batch of 70 images, more in hope than expectation, and was astonished to have eight of them accepted. He says, "It opened the door for me to other publishers."

Finally, in 1990, he was given the chance to have a book of his pictures published, and he realized that it was decision time. "I knew that I wouldn't have time to complete the project unless I quit my job," he says, "so I went full-time."

Now established as one of the Sierra Club's most published photographers, he has over 125 nature calendars to his credit plus several books, and his work appears regularly in magazines and advertisements. He has also been exhibited in shows throughout the world and, in 1997, was the only American to exhibit in the International Exhibition of Nature Photography in Evian, France.

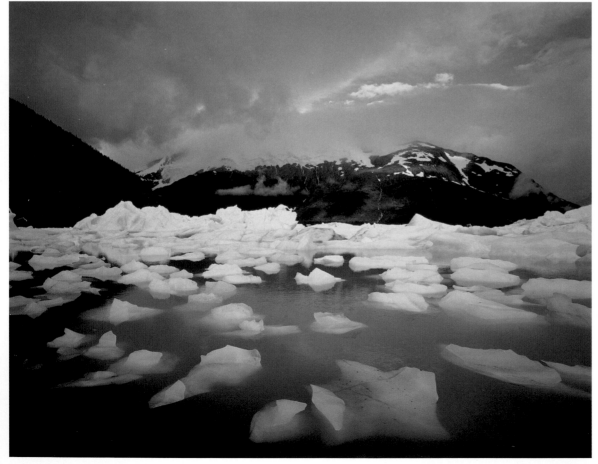

Iceberg and mist on Portage Lake, Kenai Peninsular, Alaska, USA

"Although it wasn't quite such a defining moment as La Push, encountering this scene was still special. When my friend and I arrived in the parking lot only around 100ft (30m) from the lake, we just sat and looked at this scene in absolute silence.

It was one of the few times when I was so in awe of the scene that I couldn't get the camera out.

"When we talked to local people later we found out that it was very rare to see this number of icebergs in this location."

Linhoff Technika IV 4x5in camera, Fuji 50D

Bass Head Lighthouse, Acadia National Park, Maine, USA
"This is a beautiful lighthouse situated on the edge of a cliff overlooking the bay, and it was a popular place to go. Just as the sun started to set and to warm up the light for this view, a lady with a bright pink sweater walked into the frame in the distance and just stood there. I waved at her to ask her to move and she simply waved back. Then, just as the light was about to go, she turned and walked away and was hidden by a bush. I had time for one exposure before she reappeared, and wasn't sure what I was going to get, but this picture worked out well."

Linhoff Technika IV 4x5in camera, 135mm Nikkor lens, Fujifilm Velvia

Reflections on Holly Creek, Cohutta Wilderness, Georgia, USA
"This is a picture from the first book that I produced on Georgia. It was taken in the Appalachian Mountains in the north of the country, and not only can you see the reflections of the fall colors in the water, but you can see the leaves at the bottom of the pool as well."

Wista 4x5in camera, 135mm lens, Fuji Velvia

James Randklev

Winter light, El Capitan, Yosemite National Park, California, USA

"After reading John Muir's book *My First Summer in the Sierra,* and revelling in the magnificent black-and-white prints of Ansel Adams, I knew Yosemite National Park was a place that I needed to experience for myself. It inspired my own creative soul to photograph this valley of granite and waterfalls over and over. And why not, Yosemite is one of America's great icons of natural beauty. This park is celebrated for its 'eloquent light' and on a special day one February I found myself caught up in the moment.

"As I drove along the one-way road on the banks of the Merced River, I pulled off at a nearby viewing area that showcases the magnificent granite face of El Capitan. A snowstorm had cleared and I took one image with the soft, gray light playing out on the valley floor. I had viewed this scene a dozen times before, but for the moment it wasn't anything special. I packed up my 4x5in field camera and tripod, and started to walk back to my truck. I always look over my shoulder as if to say goodbye to an old friend, when suddenly the sunset light burst through a crack in the clouds and displayed a band of firelight on the face of El Cap.

"I ran down to the river's edge and frantically struggled to set up my camera, afraid the moment would pass. At last, I was ready. With no time to enjoy this amazing light show, I shot pictures as fast as I could slide the film holders into the back of the view camera. In 90 seconds the precious light had vanished, yet somehow I managed to capture the glow on film. I could not have choreographed a more perfect moment in time."

Wista 45 SP, 135mm Nikkor lens, Fuji 50D 4x5in sheet film, Gitzo tripod

Galen Rowell

Born in 1940 in Berkeley, California, Galen Rowell was introduced to the wilderness early. He began climbing mountains at the age of ten on Sierra Club outings and, at 16, made his first roped climbs in Yosemite Valley. Over the next 15 years he logged more than a 100 first ascents of new routes there and in the High Sierra backcountry.

Taking photographs evolved as a way to share this world with friends and family. In 1972 he sold his small automotive business to become a full-time photographer. Less than a year later he landed his first magazine assignment: a cover story for *National Geographic*.

Galen pioneered a special brand of wilderness photography in which the photographer transcends the position of observer with a camera to actively participate in the image. His close bond to his subject matter came across clearly in the early mountain climbing photographs that first attracted the attention of the public, but his landscape imagery, often made on the same adventures, has proved to be even more evocative because of the visual power he created from what he described as "a continuing pursuit in which the art becomes the adventure and vice versa".

"'Photography was a means of visual expression," he said, "to communicate what I had seen to people who weren't there. At first I was disturbed that 99% of my images didn't look as good as what I had seen. The other 1%, however, contained some element – a beam of light, a texture, a reflection – that looked more powerful on film than to my eye.

"Without this I never would have been drawn towards photography as a career. I became fascinated with trying to consistently combine photographic vision and a visualization in my mind's eye to make images that exceeded the normal perception before my eyes."

In 1984 he received the Ansel Adams Award for his contribution to the art of wilderness photography, and eight years later he received a National Science Foundation Artists and Writers grant to photograph Antarctica.

His favorite landscapes feature unexpected convergences of light and form, unique moments captured by a combination of imagination and action, allied with an understanding of outdoor optical phenomena. He called these images 'dynamic landscapes', and his quest for them was documented in his bestselling 1986 book *Mountain Light: In Search of the Dynamic Landscape*.

"The publication of *Mountain Light* put my philosophy on the line with the story behind my work," he said. "Before *Mountain Light*, the magazines I had worked for never let me say what really motivated my work, and how different my style of participatory photography is compared to that of an observer with a camera who is not part of the events being photographed. It is the difference between being a landscape viewed as scenery from a highway turnout and a portrait of the earth as a living, breathing being."

Rowell was very widely travelled, and he also participated on major expeditions to Mount Everest, K2, and Gasherbrum II (not to the summit), and he made the first one-day ascents of Himalayan peaks such as Cholatse and the Great Trango Tower. He also made the highest complete ascent and descent of a mountain on skis on Mustagh Ata, as well as a 258-mile (425km) winter traverse of the Karakoram Himalaya.

"Although I plan to continue travelling to and photographing exotic places indefinitely," he once said, "I have a confession to make. I've known all along that more of what I am seeking in the wilds is right here in my home state of California than anywhere else on earth. But there is a Catch 22. I couldn't say it with authority until I had all those journeys to Tibet, Nepal, Pakistan, China, South America, Antarctica, and Alaska behind me."

When not carrying out assignments for *Life*, *National Geographic*, *Outdoor Photographer* or other prestigious titles, Rowell was either writing at his home in California, climbing in the High Sierra, working at the Mountain Light Gallery that he set up to market his work, or taking pictures with his wife Barbara Cushman Rowell, a photographer and writer in her own right.

Tragically, both Galen and Barbara died in the summer of 2002 when a light plane they were travelling in went down south of Bishop Airport in California returning from a circumnavigation of the Bering Sea. The couple leave a legacy of fine imagery behind them, with Galen's reputation as one of the finest landscape photographers of his generation firmly established.

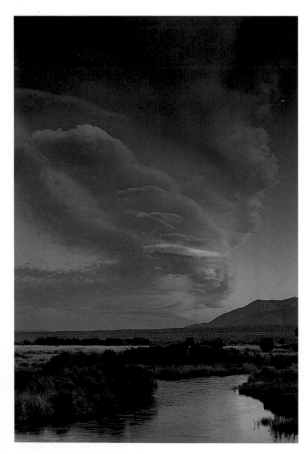

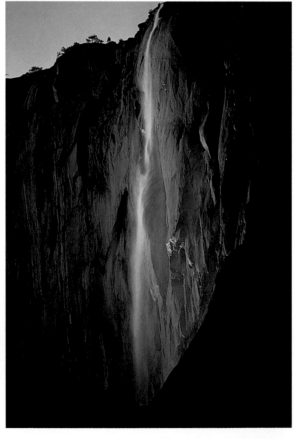

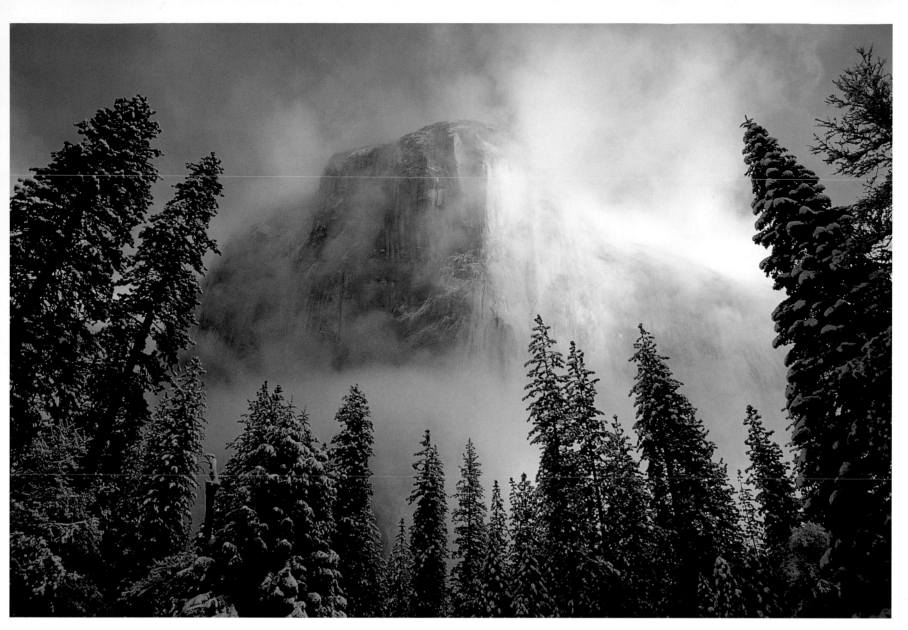

Lenticular cloud over the Owens River, eastern Sierra, California, USA (*Far left*)
"The rich colors of afterglow are related to a subject's height above the surface of the earth and its reflectivity. The planet's curvature accounts for why high peaks and clouds receive sunlight so long before dawn and after sunset in the flatlands. The light they receive has taken a much longer path through disturbed air, and so much blue light has been scattered away that vivid orange and red hues appear when the atmospheric conditions are right.

"Knowing that afterglow on the lenticular cloud was highly likely, I searched out a situation that would complement its form and color on the ground. I discovered a bend on the Owens River in the Eastern Sierra, California, that not only mimicked the shape of the cloud, but which also had the same color because of reflection."

Last light on Horsetail Fall, Yosemite, California, USA (*Facing opposite*)
"This natural phenomenon occurs each February while the sun sets at the right angle on El Capitan, striking Horsetail Fall while the cliff is in deep shadow.

"One evening, I spotted it just as the light was fading. I had no reason to expect to ever see it again, but the following evening there it was.

"I knew exactly what to do. I drove at double the speed limit. With no turnout with a clear view of the fall from the angle I needed, I went to the woodlot, grabbed a camera with a 300mm lens, and hopped the fence.

"The framing was ideal; the red plume of the sunlit fall dropped below a shadowy sweep of buttress in the foreground before it dissipated in the veil of water lower down. From the side, the way the fall lit the cliff was especially accentuated. My problem was how to hold the lens high enough to miss the trees and steady enough to shoot at 1/60th of a second wide open in weak light. I grabbed my tripod and had just enough time to make several exposures before the light flickered out as it had the night before."

Nikon FTN with 300mm lens, Kodachrome II (ISO 25)

Clearing storm over El Capitan, Yosemite, California, USA
"At the end of a winter storm in Yosemite Valley, I drove to a high vantage point for photographs while clouds filled the valley. I stopped near El Cap for a quick photo of the Cathedral Spires emerging from the mist, but when I tried to move on, my car was stuck in the snow. As I sat cursing my bad luck, I saw the clouds parting. Mist rose from cliff and forest as I have never seen it before or since."

Nikkormat FTN with 24mm lens, Kodachrome II (ISO 25)

Galen Rowell

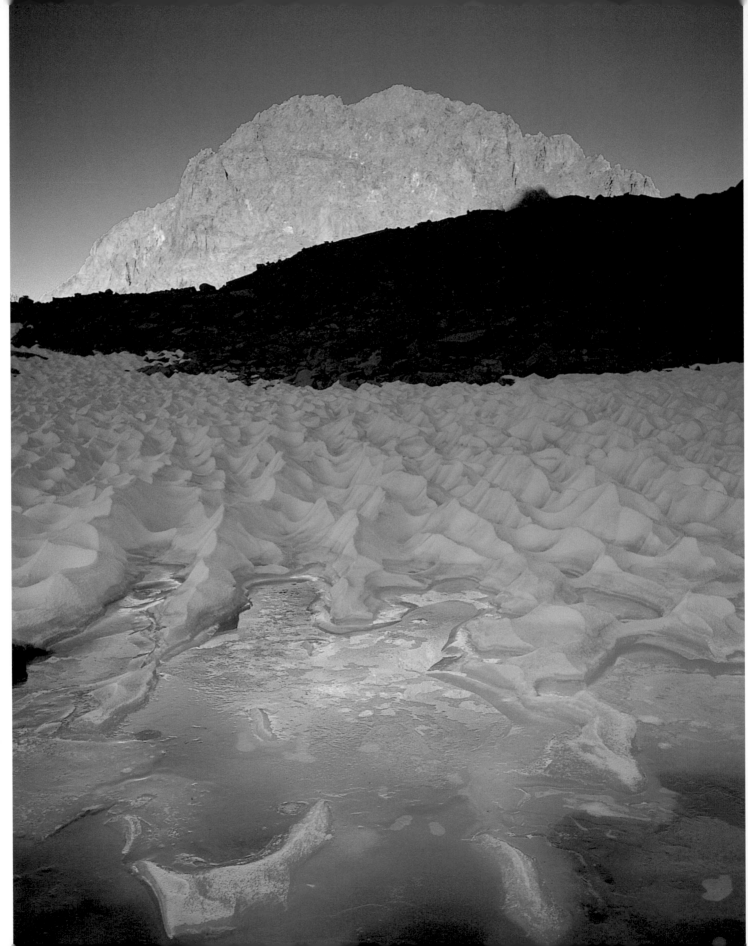

Late summer snow under Mount Williamson, southern Sierra, California, USA

"This is not a found image. I imagined it before seeing it, spotted the location as I walked over a snowfield on my way to a route on the east face of Mount Tyndall, and came back when I knew the light would be optimum.

"The spot was not photogenic at midday, and I didn't take a single photograph. I was aware of its potential because I had been thinking about two different photographs during the hike, and my ideas converged here. I wanted to make a landscape of alpine glow on Mount Williamson, which would be in clear view from our evening camp even though we would be deep in the eastern shadow of Mount Tyndall. On the other hand the sun's cups, caused by differential melting of the snow, fascinated me. In shadowy light they lacked power, and in direct light their whiteness and jagged patterns tended to overpower other aspects of the scene.

"As I crossed the snowfield I thought about putting my two ideas together. I began looking for a place where I could compose an image with orange light on Mount Williamson in the background and ice blue sun caps in shadow in the foreground.

"To mix the different colors of light, I also wanted some sort of reflection. Because the direct light on the peak would be far more intense than the weak shadow light, I also needed a scene with a dark area on the horizon so that I could use a split neutral density filter and not have its graduated area show up in my image. This spot had all the right elements, including that we would be coming back past it at sunset.

"That evening we began descending our ropes as the glow of last light started to creep up Mount Williamson. I made a beeline for my chosen spot. I put a 24mm lens with the split filter on my camera, lay down to line up the reflection, and shot several frames at 1/15sec, bracketing apertures above and below my meter reading of f/11."

Nikon FM with 24mm lens, Kodachrome 25

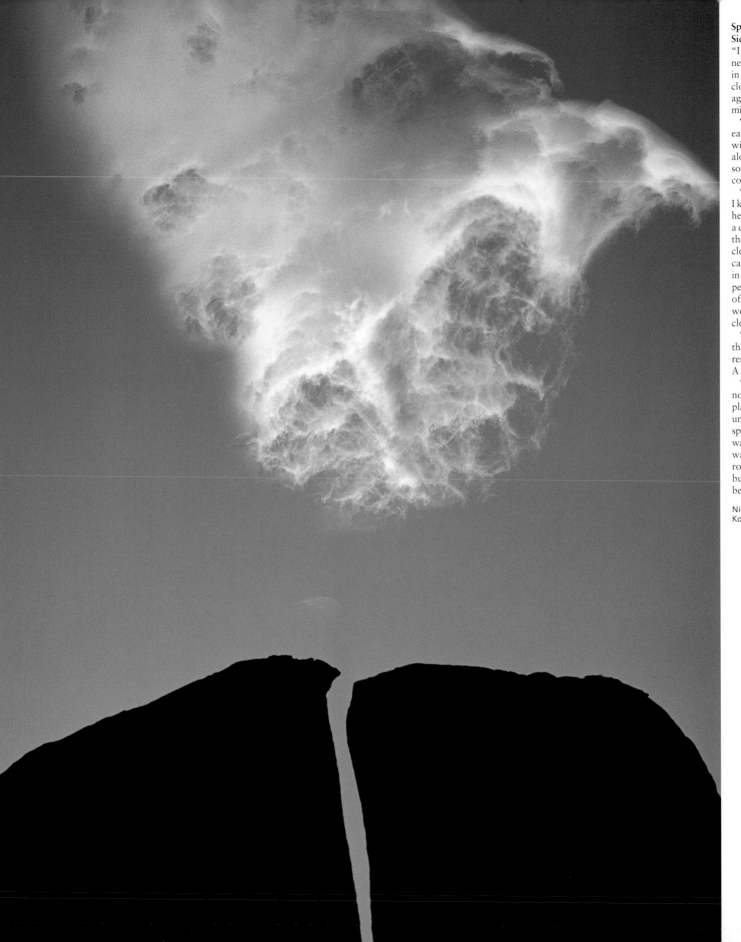

Split rock and cloud, eastern Sierra, California, USA

"I saw this cloud moving over nearby while I was climbing in the Buttermilk region. The cloud was there in perfect detail against the evening sky, but missing was a sense of place.

"I had to have a contrasting, earthbound subject to match with the cloud. I began driving along dirt roads, looking for something to give me a sense of combined order and disorder.

"The landscape was striking. I knew that the feeling in my heart could not be put on film in a direct way. My eyes could scan the land and mentally pull in the cloud at the same time. With a camera, it would lose the cloud in a sky cluttered with less perfect clouds. Even if the rest of the sky was clear, the image would lack power unless the cloud was large in the frame.

"I had to expose for detail in the sunlit cloud, which would render earth surfaces black. A silhouette was my only hope.

"I looked at the boulders, but none worked. Then I recalled a place with larger rocks. I drove until I saw this 80ft (25m) high split boulder. It was what I wanted. I set up my camera and waited for it to pass behind the rock, thus creating an unlikely but purposeful marriage between disparate forms."

Nikkormat FTN with 200mm lens, Kodachrome 25, polarizing filter

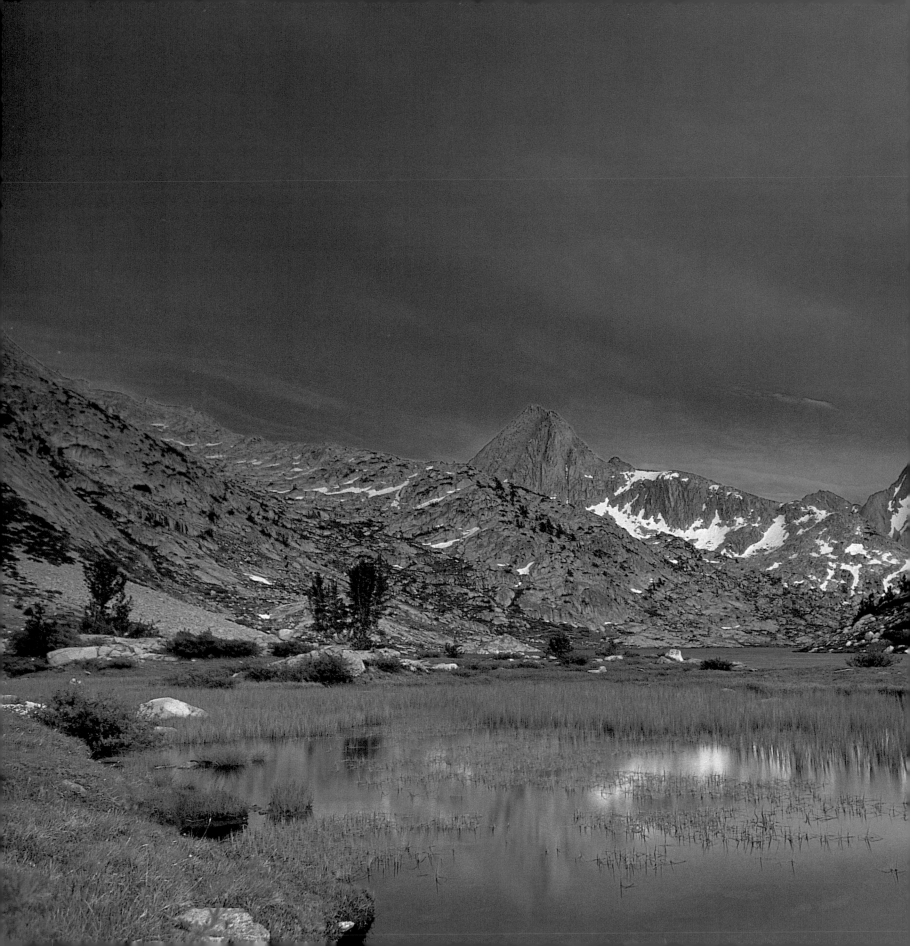

Stormy sunset over Evolution Lake, Kings Canyon National Park, California, USA
This stormy sunset over Evolution Lake along the John Muir Trail in Kings Canyon National Park, California, shows the wild beauty of the High Sierra.

The colors are wholly natural, with a graduated neutral density filter holding back the intense crimson glow to allow an exposure for the shadowed grasses.

Galen Rowell

John Shephard

Growing up in Washington state, with its abundance of glorious scenery and wild places, John Shephard always harbored a love of the great outdoors, a passion that manifested itself through landscape photography. Self-taught, he took pictures for himself that often served to illustrate slide shows that he put together, while his main career as a teacher of Spanish generated the bulk of his income.

Things changed dramatically in 1998 following a chance encounter while Shephard was on a photographic assignment to cover the spring color of tulip fields in the Skagit Valley in Washington State. "I was out very early looking for the dawn lighting," he recalls, "and there was one other person there already, who turned out to be the celebrated Australian landscape photographer Ken Duncan. It transpired that Ken was undertaking a book project that involved him shooting pictures in all of the 50 states of America and, by the greatest stroke of luck, he was looking for someone with local knowledge who could assist him.

"Our conversation turned into a type of job interview, and I suddenly found myself with a new career. It really was a moment when fate took a hand, because the experience that I gained throughout the next two years as I assisted Ken throughout the remainder of his project, covering 40 states in the process, was phenomenal. He was so giving in terms of time and knowledge and, even though I didn't get a lot of opportunity to shoot my own pictures in that time, it helped to move me up to the next level."

Shephard followed Duncan back to Australia and spent another two years there, starting to build up his landscape portfolio and to put together the framework for a career as a professional landscape photographer. As part of that process he went looking for a style that he could call his own, and ultimately he decided to concentrate on a panoramic approach, which he felt was particularly suited to landscape and which, at that time, had not been exploited in the States.

"I invested in a Noblex 135U," he says, "which has a picture format of 67x24mm. I love the angle of view that it allows me to present, which I feel matches quite closely the way the eye sees a scene, and that helps me to achieve my aim, which is to produce work that allows the viewer to almost feel as though they are standing alongside me. Fitting everything that I see into a square or a rectangular format makes it much more difficult for me to express the way that I feel about a scene.

"The Noblex is quite a light camera, and one of the reasons that I love it so much is the fact that it is easy to carry around when I'm backpacking. I supplement the Noblex with 35mm gear on occasion, in the form of a Contax G2 rangefinder camera, which can be used in a very manual way. I appreciate this facility, because the more landscape photography that I undertake the less I want the camera to do for me. It helps me to work faster if I can take full control, and that kind of speed can be vital if I'm trying to capture a particular lighting effect on film."

With his career now taking off, sales of fine art limited edition prints are helping to provide a steady income for the business, enabling Shephard to pursue more personal work.

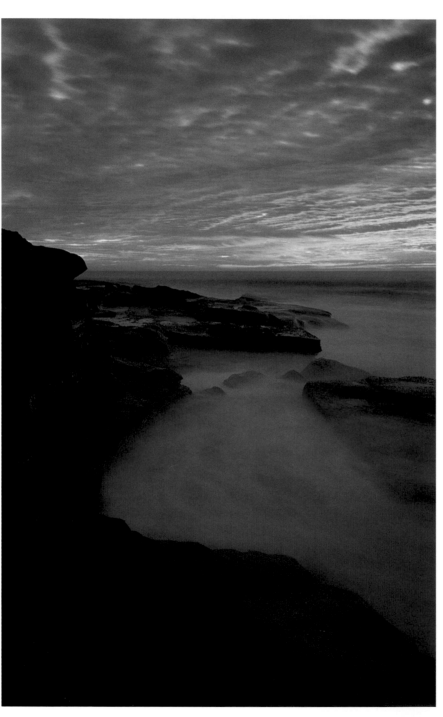

Awakening, Terrigal, New South Wales, Australia
"I had just arrived in Australia, and one morning my daughter woke up at 2.30am, and once she was asleep I was wide awake. I felt a strong urge to get my camera gear and set off to take some photographs.

"I drove to Terrigal, a lovely beachside community near Sydney. The surf was not too rough so I climbed along the rocks until I got to a spot that had compositional interest. I was soon rewarded with an incredible sunrise. I composed vertically to balance the contour of the rocks with that of the clouds and to allow the waves in the foreground to invite the viewer into the scene. After 20 frames, I knew I had the shot.

"As I made my way back, I saw another photographer scramble down the rocks to catch the light. He could tell that I had 'got it'. 'What luck to capture that!' he said. 'No,' I said, 'I just got out of bed.'"

Contax G1, 28mm lens, Fujifilm Velvia rated at ISO 40, Manfrotto tripod and Contax cable release

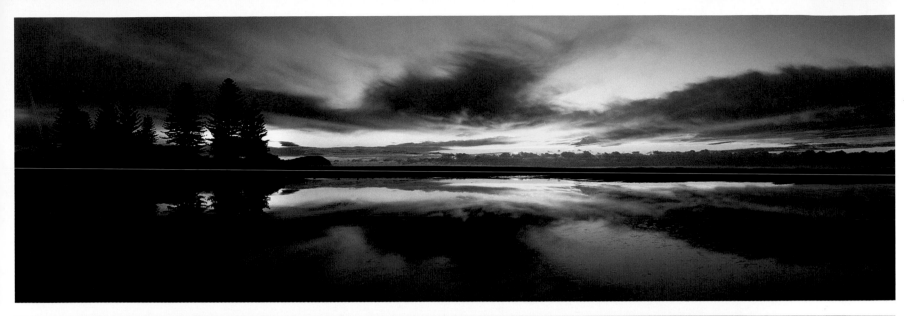

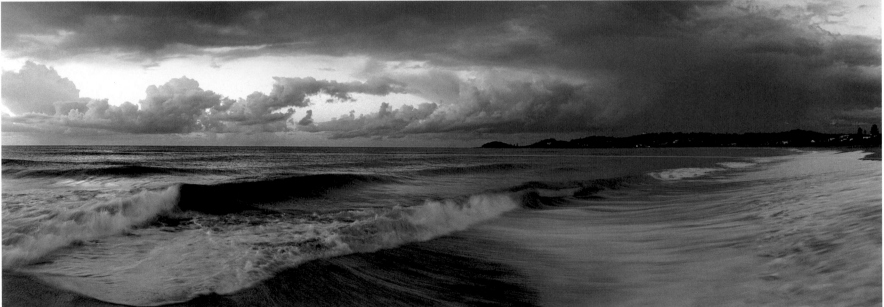

Reflected dawn, Terrigal, New South Wales, Australia (*Top*)
"Not many people are willing to get up three hours before sunrise to get to a location and watch, wait and, hopefully, have a view to shoot. With beach shots, however, I find that sunrise is the only time to take photos if your desire is to exclude people. Everyone is out on beaches to check out the sunset, but only a few people are ever out of bed to watch the sunrise.

"I had first seen this lagoon on a windy day and full of beachgoers. Realizing the potential it offered, I diligently arrived an hour before sunrise for 18 straight days until the right combination of a still lagoon and a colorful sunrise worked together."

Noblex 135U, Fujifilm Velvia rated at ISO 40, Manfrotto tripod and Horseman cable release

Tasman Sea, Terrigal, New South Wales, Australia (*Above*)
"I find it wise to get to a place well before the time that I intend to shoot it. This scene was photographed an hour before sunrise, which ensured that a very long exposure was required. Shooting like this can be extremely challenging; vague exposure times coupled with reciprocity failure can produce many failures, but with practice, you can get very creative compositions and mood. The actual scene was darker than it appears here and so, technically, it is overexposed, but the image needed to look like this so that the foreground rocks were fully visible."

Contax G1, 28mm lens, Fujifilm Velvia rated at ISO 40, 5 minutes plus at f/16, Manfrotto tripod and Contax cable release

John Shephard

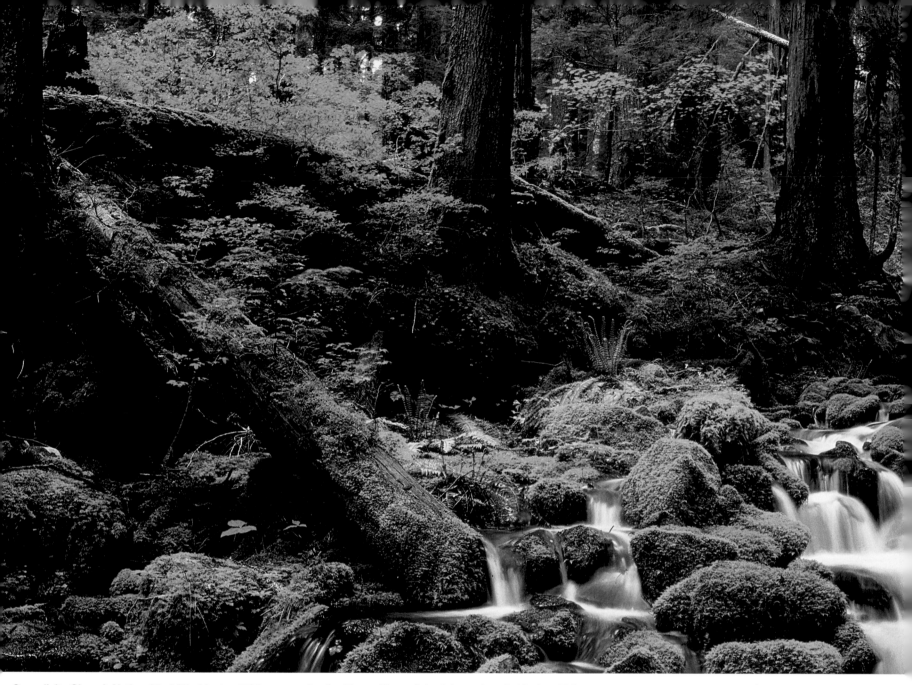

Serendipity, Olympic National Park, Washington, USA

"The Olympic National Park in Washington state houses one of two temperate rainforests in the world and, with overcast and wet conditions for the majority of the year, it is an excellent location for water shots. This shot was actually taken on a hike to shoot Sold Duc Falls. I had seen pictures of the falls and thought they would make a great subject. 'Serendipity' was one of those shots you get along the way.

"The trail to Sol Duc Falls sees high traffic for most of the year. The day I happened to arrive, a group of 30 to 40 photographers from a workshop also happened to be on the trail. It was madness. At first, I found myself very frustrated with the situation. I had just driven four hours only to try to shoot around people with a panoramic camera, which is never an easy task. Eventually,

I realized that waiting until they left was the only thing I could do. Within 30 minutes they were gone, leaving me able to compose both myself and the shot".

Noblex 135U, Fujifilm Velvia rated at ISO 40, 3 or 4 seconds at f/8, Manfrotto tripod and a Horseman cable release

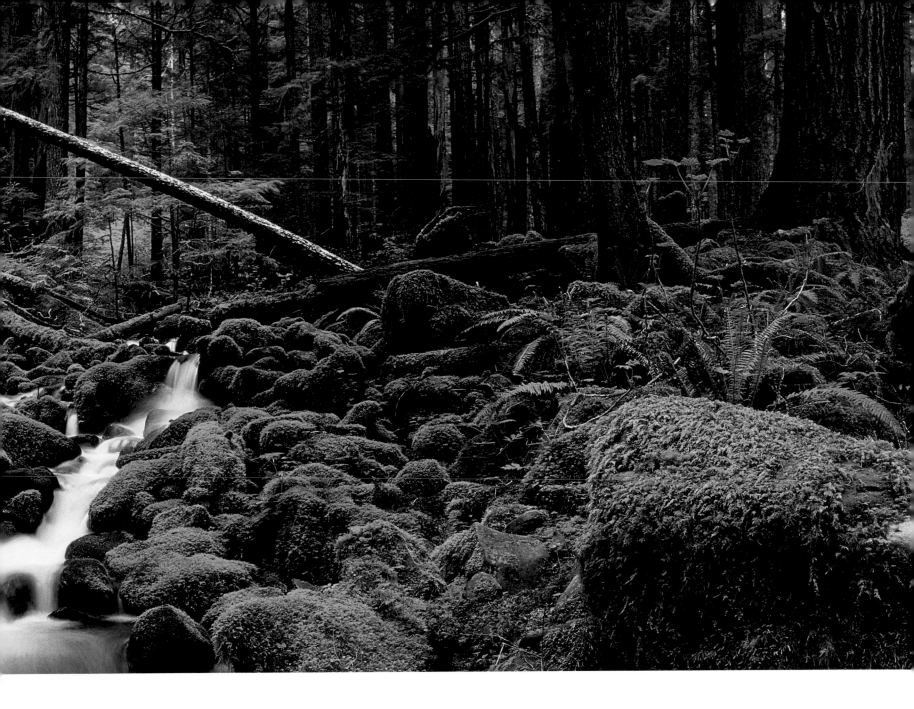

John Shephard

Tom Till

One of the most long-established and published of America's photographers, Tom Till has built up a huge collection of international landscape images, and yet still feels a thrill every time he receives his film back from the lab. "It feels like I have Christmas 25 times a year," he says. "I have a great job, and I feel very lucky and blessed to spend my life in the world's most beautiful places.

"The first and biggest thrill is being in the field all the time. Although I get a great deal of personal satisfaction and fun from my work, photography is really about sharing what you are experiencing with others not lucky or patient enough to be there themselves. It's also about noticing things everyone else passes by."

Till had a childhood obsession with the American Southwest desert, and when he was old enough he travelled there to explore the region for himself. Thrilled to find that it was everything that he had imagined, he eventually moved there and then decided to take up photography as a means of expressing his passion for the landscape.

"My first job was as a school teacher," he says, "and this was a good transitional career for me because it meant that I had a steady income and it gave me time to build up my photographic knowledge and to start to acquire a number of clients who wanted to use me. In the end it was quite a seamless move to become a professional, and I gave up my teaching in 1985."

Till is a regular user of 4x5in cameras, which he considers to be ideally suited to landscape work. "I taught myself to use one," he says, "not through choice but because there were few other options. I had signed up for a course that was due to be taken by one of my favorite photographers, Philip Hyde, but it was cancelled and I just decided to go it alone. I still don't know if I'm using the camera correctly: I have friends who learned about 4x5in cameras at college and I believe they work in a different way to me, so perhaps I've been doing it wrong all these years!

"It is the perfect tool for landscape photographers, however. I'm a fanatic for detail, and the 4x5in format captures everything you could ask for. A 35mm image can also look good, but if you want ultimately to produce really big prints then the quality will suffer accordingly. I also like the way the movements of a 4x5in camera allow me to control the near/far focus in a scene very simply.

"The downside, of course, is the weight of the equipment that you have to carry up and down mountains to get yourself in position to take the pictures that you want – 40–50lb (21kg) is quite normal – and there are plenty of photographers in my age bracket who have had knee trouble simply because of the stress this kind of activity places on your joints. I've avoided this so far, and I count myself lucky to have done so."

Till has used a 4x5in Toyo 45 A 11 field camera since 1976, and supplements this with a Linhof Master Technica for telephoto work. He reckons to be in the field around 250 to 300 days a year, including shooting in the Moab area of Utah which is close to his home, and he works his equipment so hard that he replaces the Toyo with a new model every two years or so to ensure that it continues to give him the good, reliable service that he requires.

Bee plant and Pretty Phacelia (*Left*)
"I made this image in the area of the proposed San Rafael wilderness, at a time when these flowers were appearing in huge numbers following heavy rains. It's a phenomenon that happens about once every 15 years, when conditions are perfect."

Toyo 4x5in field camera, Rodenstock 210mm lens, Fujifilm Velvia

Snow at White House Ruin, Canyon De Chelly National Monument, Arizona, USA (*Right*)
" I had studied the weather forecasts, and was aware that it was due to snow - a fairly rare event. It made for a great picture, but my position was extremely treacherous, made difficult by my heavy backpack."

Toyo 4x5in field camera, Nikkor 75mm lens, Fujifilm Velvia

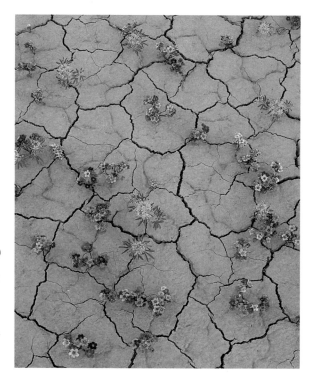

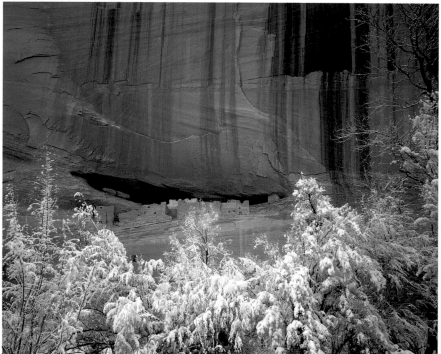

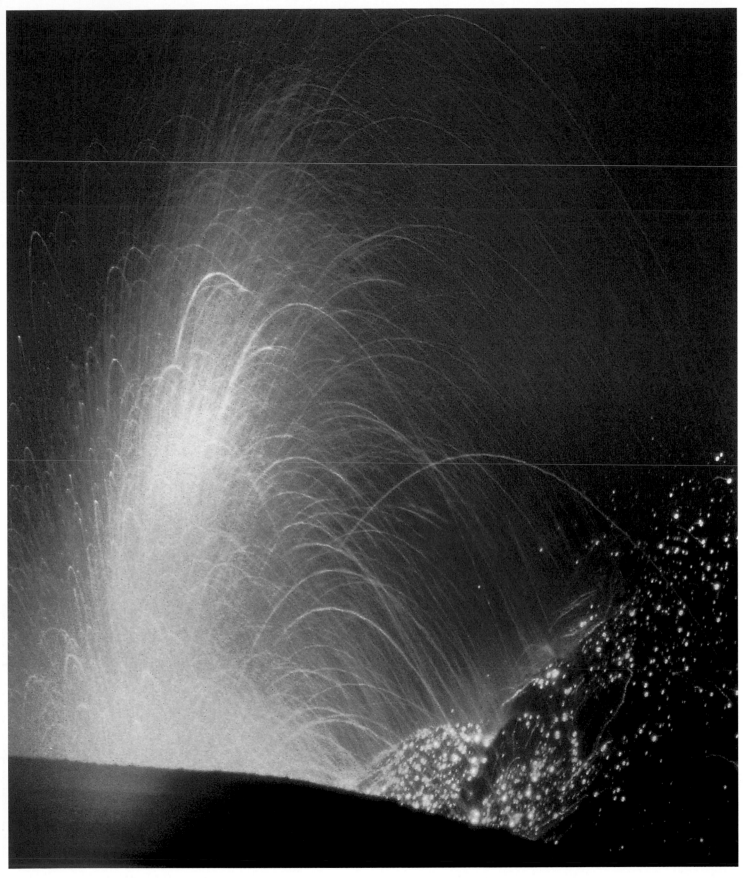

Erupting crater at Stromboli Volcano, Aeolian Islands, Italy
"I took this picture at dusk, following a long climb to get to the rim of the crater. Volcanoes are very unpredictable, but this one was erupting around every 45 minutes or so. I had to shoot when the light was falling to get the most spectacular pictures, and this was the one that worked out the best."

Pentax 6x7cm camera, 500mm lens, Fujifilm F400 film, pushed two stops to ISO 1600

Tom Till

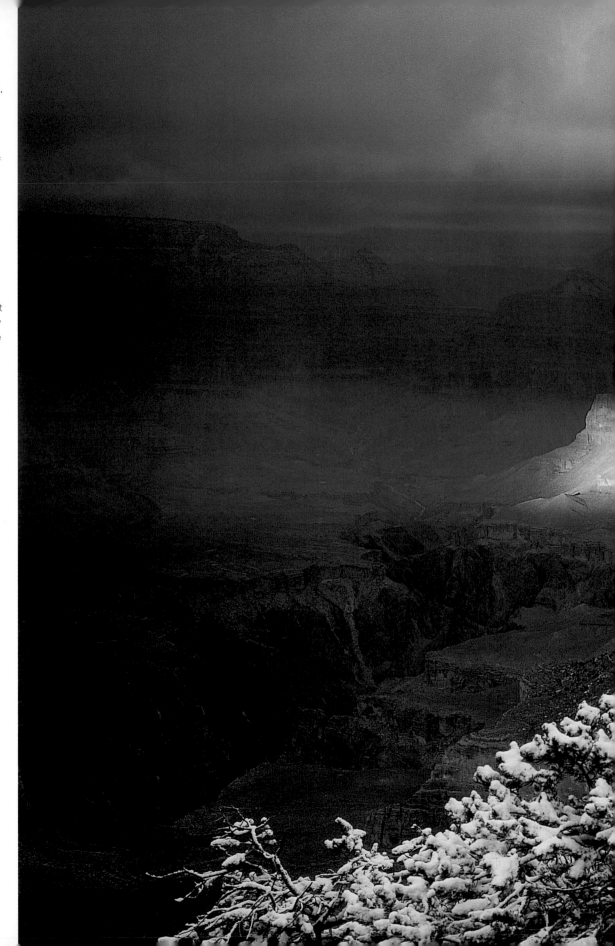

Morning spotlights in Grand Canyon, Arizona, USA

"I'm always looking for varied lighting conditions in my landscape pictures, and spotlights – small patches of sunlight that strike a scene that is otherwise in shade – are one of the most pictorial and interesting things that you can hope to find.

"I've been to the Grand Canyon at dawn in search of pictures dozens and dozens of times, and this was just a lucky morning. I find that luck is one of those elements that is seriously underrated in landscape photography! Of course, the more that you're in the field the luckier you tend to get and, with me, it's not just a case of turning up and hoping for something to happen.

"I'm a real weather student, and consequently some things were not unexpected. I knew, for example, that there would be a snowfall that morning, and I also knew that there would be a storm building up, which carried the potential for interesting lighting, and so I was prepared for something to happen.

"This was a scene that featured enormous contrast between the highlight and shadow areas, and I fitted a graduated neutral density filter to take some of the strength out of the spotlights so that the Velvia film I was using could cope with the scene. The fact that there was snow on the ground was a bonus, because I knew it would reflect what light there was, and would ensure that there would be detail in the foreground."

Toyo 4x5in field camera, 120mm Schneider lens, Fujifilm Velvia

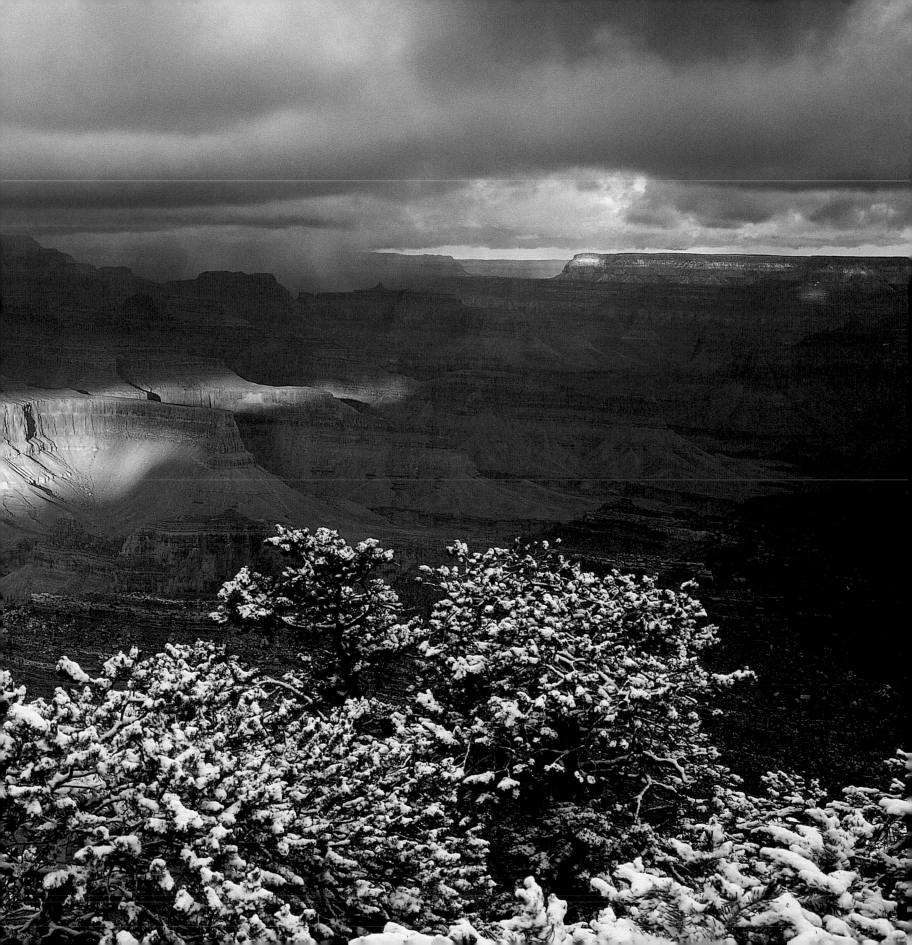

Jan Töve

The distinctive landscape style of Jan Töve reflects his very personal approach to, and interpretation of, his subject. "I don't see the point in working in a purely representative way," he says. "When I travel to somewhere like Australia to shoot landscapes, for example, there's no point in going to Ayers Rock to take the pictures that everyone else takes. I would rather concentrate on a detail, something like a section of tree bark that I find appealing, and through this try to say something that is different and personal to me."

Based in Sweden, Töve dates his interest in nature photography back to 1978. Initially focusing on wildlife – in particular birds and animal behavior – his love of landscape evolved over time into his first passion, and in 1990 he became a professional photographer specializing in landscape.

One of his first self-commissioned projects was entitled 'Beyond Order'. His interest in chaos theory informed the thought process behind this project and has inspired his photography ever since. "During visits that I had made to several different environments," he explains, "I felt that randomness was more obvious where man had not been present. In wild nature you find disturbances caused by such things as wind, water, fire and so on. You find yourself in a borderland between life and death, chaos and order, between what we call ugliness and beauty. But in reality there is no beauty in nature and no ugliness either. It's up to us to value what we see.

"Man causes chaos in his own world and in the natural world, but at the same time he is always searching for control and order, so that chaos can be avoided; just look at the way that gardens, parks, and cities are planned and laid out. Even if you look at a map you'll find straight borderlines drawn on a desk long ago. But in wild nature you'll never find the straight lines. Instead you find disturbances, such as a withered flower, a dead frog, a rainy day, muddy water, or a scrubby forest, and these are the things that I find interesting, and which I like to focus on."

Töve has always worked with medium- and large-format cameras, not just because of quality considerations, but because he feels that it matches the contemplative style that he advocates. "Because you can't rush large-format photography," he says, "I find that it calms me down to work with bigger cameras, and that initially was what made me start to look at nature in a very different way. I like to find the composition and to wait for the light; it's one of the reasons why I live so close to many of the landscapes that I photograph most often. If the picture I go out to take doesn't happen on a particular day, then I'll go out and look for it again the next day, and keep going until I know that I've got the image that I want."

His individual approach has brought him many accolades, including that of Scandinavian Nature Photographer of the Year in 1995. He has also been successful on a regular basis in the prestigious Wildlife Photographer of the Year competition, and has had several exhibitions of his work both in Sweden and around the world.

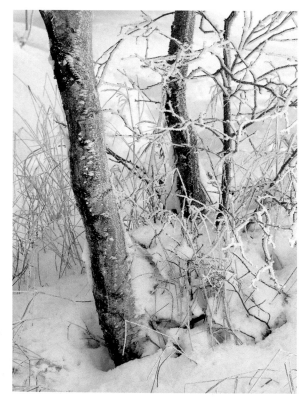

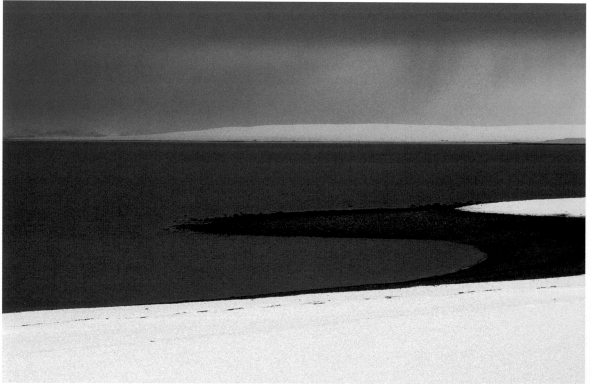

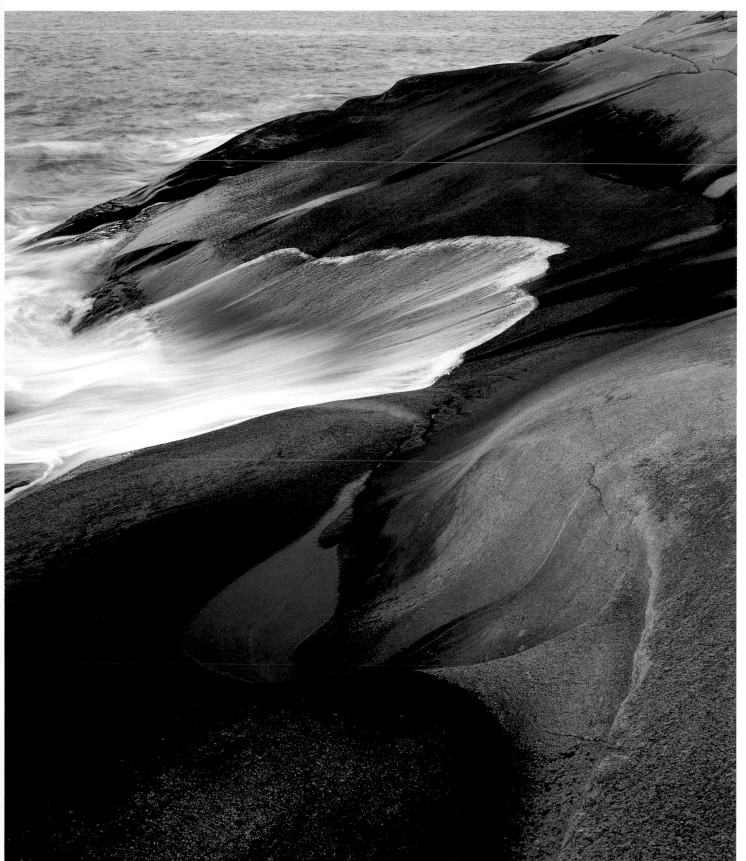

The wave

"I've always felt that the shape of certain rocks can echo the form of waves in the sea, and I found what I was looking for on this section of Swedish coastline. Once I knew what I wanted to achieve, it was a case of waiting for a wave to come in that would perfectly complement the rock in the foreground. I took a number of images, but the shape of the wave was perfect only in this frame."

Pentax 6x7cm, 55mm lens, Fujifilm Velvia

Birch tree in snow
(*Facing opposite, left*)
"I took this picture in an area of Sweden known as Komosse, and was attracted by the very subtle lighting, which enabled the boundary between shadow and highlights to be very soft. When it is printed on matt paper it looks like a painting of a hare in the snow that I saw when I was a child."

Pentax 645, 55mm lens, Fujifilm Velvia

Varanger, Norway (*Facing opposite, right*)
"I wanted to go somewhere where I could feel the emptiness and loneliness of landscape, and to strip a scene to its essentials. This picture is an example.
I composed so that there was no foreground, and excluded everything I could to simplify the image.
"I had already seen how blue the natural light could become shortly after sunset, and decided to take a picture that utilized this. This was taken half an hour after the sun had left the sky, and the landscape was just shimmering, with the snow and the water reflecting back what light was left. I took a lot of pictures in similar conditions, which I felt benefitted the right landscape."

Pentax 6x7cm, 90mm lens, Fujifilm Velvia

Jan Töve

Charlie Waite

Lake Titicaca, Bolivia
"Feeling ill from altitude sickness and standing precariously on a school child's desk, this was the only image that emerged after a ten-day trip to Bolivia. As I looked through my ground glass screen, it seemed as if I might be staring into the heart of a sapphire."

Fuji 6x7cm camera, 300 lens, 1/8sec at f/22, polarizing filter, Provia F

Inheriting a love of photography from his Rolleicord-owning father, Charlie Waite initially harbored thoughts of becoming an actor, and his first job was as an £8-per-week stage manager at a theatre in Salisbury, England. While there he was approached by another actor who enquired if he might produce a publicity portrait for him. Waite obliged and, as word of his sideline spread, he found himself taking on more commissions of this kind. He bought a Hasselblad to handle the workload and, before long, was earning more from his photography than his acting career.

However, portrait work didn't captivate him and, when, in the mid-1970s, he found himself regularly accompanying his actress wife Jessica down to the west of England while she was filming on location, he used his spare time to explore the surrounding countryside and to shoot landscape pictures purely for his own satisfaction.

Realizing that he wanted to take his photography more seriously, in 1978 he enrolled for a one-year City and Guilds course. "It wasn't a practical course at all," he says, "but that suited me, because I was more interested in learning about photographic technique and the right way to do things. I knew I was making mistakes, and I wanted to be in a position where I knew where I was going wrong, because I figured that only then could I move on and start to think more about artistically expressing myself.

"It's a little like wanting to be a great cook, and yet not knowing how to make the oven work. I needed to learn more, and the course was the best way of doing that."

Post-graduation, Waite rented a studio in London's Battersea and took commissions for commercial work, but creatively he felt stifled. His break came in the early 1980s via a fortuitous route; while house-hunting he encountered a director of the illustrated book department at publishing house Weidenfeld and Nicholson. When asked what he did, Waite instinctively replied 'landscape photography,' even though a career of this kind was more of an aspiration than a reality at that point.

As luck would have it a landscape project was in planning stages, and Waite was invited to submit a portfolio – although he didn't possess one. He spent a frantic weekend throwing one together from pictures that he had taken for his own pleasure. He landed the commission, which was to illustrate *The National Trust Book of Long Walks,* and this was duly published in 1982.

Although financially it wasn't a project that made a lot of sense, it was the introduction to a dream career for Waite, and other books soon followed, giving him the opportunity to travel all around Europe and to devote himself to landscape photography full time. He's never looked back from those early days, and his 1992 book *The Making of Landscape Photographs,* in which he accompanied his pictures with his own words, detailing how each picture was made and including technical notes, is still a volume that is in major demand from aspiring landscape photographers everywhere.

As well as being one of the most recognizable faces on the UK landscape scene, Waite has also branched out into other areas, setting up a British-based company 'Light and Land' which offers a full range of photographic holidays, with expeditions led by Waite and other top names in landscape and nature photography to locations all over the world. It's a logical extension of his business, and it's given him the opportunity to meet others who share his passion for landscape and to pass on some of his almost evangelical zeal for the subject to other like-minded photographers.

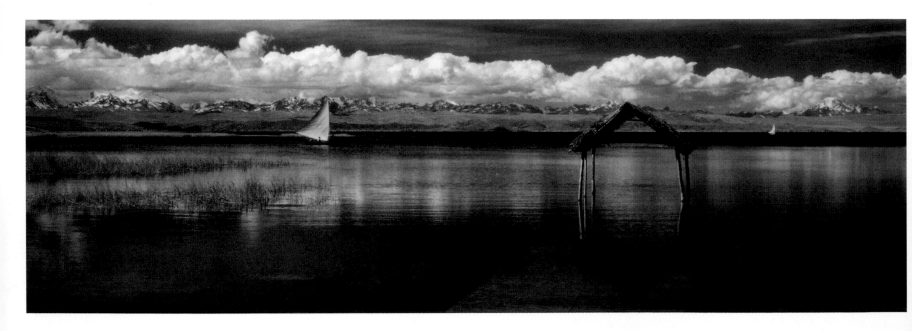

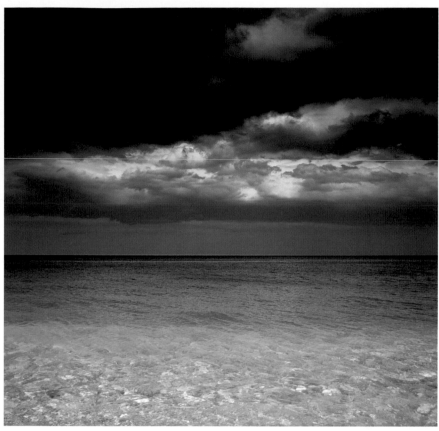

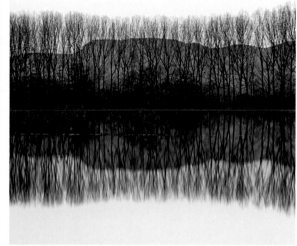

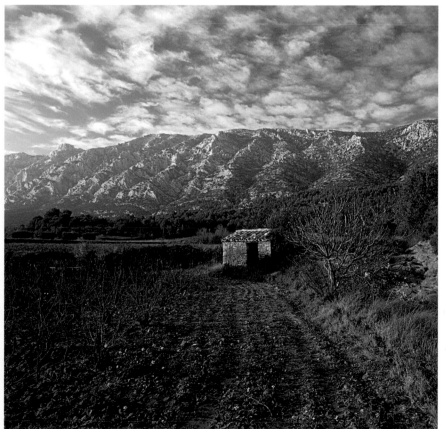

Monte Sainte Victoire, Bouches-du-Rhone, southern France *(Left)*

"I was working in the south of France, and passed this location every day. There was nothing very special about it. It's a sign of how important a chance combination of elements can be in landscape photography. One day the scene was transformed.

"All the disparate elements in this picture linked together, and that's what attracted me. The mackerel sky works with the clefts in the rocks, and its shape is echoed in that area of the picture. The furrows in the soil in the foreground also repeat this pattern, and the roof tiles on the small building have a similar design. There's a real relationship between the sky and the land, and it is finished off with the warmth of the sun.

"Lighting such as this can allow the two-dimensional nature of photography to be transcended. Often I'll take up a high viewpoint, and this allows more planes to be revealed. While the alteration is not dramatic, it gives extra dimension."

Hasselblad 500CM, 50mm lens, Kodak Ektachrome 64

Corfu, Greece *(Above, left)*

"One of the most thrilling phenomena for the landscape photographer is to be present at the precise time and place when a weather transition occurs. I was a solitary figure huddled on the beach in the driving rain awaiting the storm to pass."

Fuji Velvia, 50mm lens, 1/15sec at f11, 0.45 neutral density graduated filter

Selestat, France *(Above, right)*

"I took this picture looking due west as the sun sank under the horizon. Anything photographed in this way against a bright light will appear as a silhouette, but what has made this picture work so well is that there are two silhouettes here which have each taken on quite different colors."

Hasselblad 500CM, 50mm lens, 81B warm-up filter, Fujifilm Velvia

Charlie Waite

David Ward

Having photographed commercially a wide variety of subjects from dogs to racing cars, David Ward's first love remains the landscape. "I suppose that I've always loved beautiful places," he says, "and can probably date it right back to the times when, as a child, I was taken on holidays to the Lake District and Cornwall."

Despite his interest, Ward had never really encountered the great names of landscape photography until he undertook a degree in Film and Photographic Art, for which he gained a first-class honours. His dissertation on American landscape photography from the mid-19th century to the early 1980s included an appraisal of such luminaries as Alfred Stieglitz, Ansel Adams, and Edward Weston.

"A lot of my course concerned the ways that photography could be seen as an art form," he says, "and I became very interested in the approach that had been taken by some of the pioneers. I've never tried to emulate what they did in my own photography, however; rather I'm much more influenced by modern landscape photographers who are working in color, people such as Jack Dykinga and Michael Fatali.

"Through them I've learned the value of detail and abstraction, and that's what I look for in my own approach, rather than the grand vista. I'm not interested in producing something that looks like a postcard. The pictures that interest me are those that represent a personal statement by the photographer about how they see the world."

Working with large-format cameras since the early 1980s, he has spent much of his career heaving 20kg (44lb) of gear up English fells during unsociable hours in pursuit of immortalizing that special moment on film. "I couldn't find a conventional camera bag that was large enough to hold the gear that I wanted to carry with me," he says, "and so I adapted a mountaineering rucksack that was big and robust enough to carry my Linhof Technikarden 5x4in camera, 6x12cm back, 72mm, 90mm, 150mm, 270mm and 400mm lenses, and Gitzo carbon fibre tripod, which is fitted with a Manfrotto 410 geared head.

"In terms of accessories, the most useful things I've got are Lee graduated neutral density filters to help me reduce the overall contrast in a scene. The Lee product is excellent because it really is completely neutral and won't affect the color balance of a scene. An 85C filter is very useful if I'm using a long exposure in neutral lighting conditions. The Fujifilm Velvia that I favor can turn a little green if the exposure I'm using is over 15 seconds, and the 85C simply corrects the color balance."

The skills that Ward acquired as a location photographer working in advertising, design, and publishing are now being passed on to fellow devotees of the landscape via workshops and magazine articles. His teaching philosophy involves making the whole experience entertaining as well as informative. He now works principally for conservation and heritage organizations including the British Countryside Agency and the Heritage Lottery Fund in the UK.

Virgin River, Zion National Park, Utah, USA (*Left*)
"This is a picture that could only be taken when this section of the Virgin River was in shadow and was capable of reflecting the colors around it. The blue tones here were reflected from the sky, while the green is from a group of sunlit aspen. The aspen weren't lit until mid-morning, and then the light started to hit the water, and I only had about five minutes within which to take this unfiltered picture."

Linhof Technikarden 5x4in camera, 270mm lens, Fujifilm Velvia

Stanage Edge (*Right*)
"It was my first visit to this location, and I was walking around looking for a suitable place to take a picture from.

"The weather was uninspiring and I couldn't find anything that I liked but, as I was walking back, the sun came through the clouds and the scene was transformed. I set up my camera and had to take care not to include the heads of climbers, which kept popping up over the top of the ridge."

Linhof Technikarden 5x4in camera, 90mm lens, No. 6 graduated neutral density filter and polarizer, Fujifilm Velvia

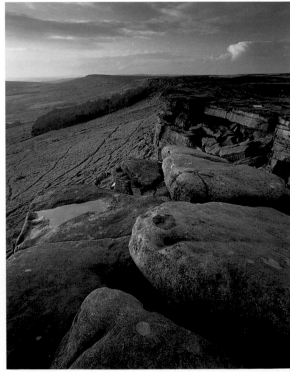

Zion Maple (*Below*)

"This was another picture that I took on the Virgin River and, although it looks as though I was working with a minimal depth of field, it's the movement of the water throughout an eight-second exposure that has caused this apparent blur."

Linhof Technikarden 5x4in camera, 270mm lens, 81B filter, Fujifilm Velvia

Reeds at Loch Dalbeg, Scotland

"This is a location that I've known for a long time, and I tried twice before to shoot this view but on both times was unsuccessful, mainly because I was there at the wrong times of year. This time I went in October, and the fall conditions turned out to be perfect, particularly when the early evening light warmed the scene."

Linhof Technikarden 5x4in camera, 90mm lens, two-stop graduated neutral density filter, Fujifilm Velvia

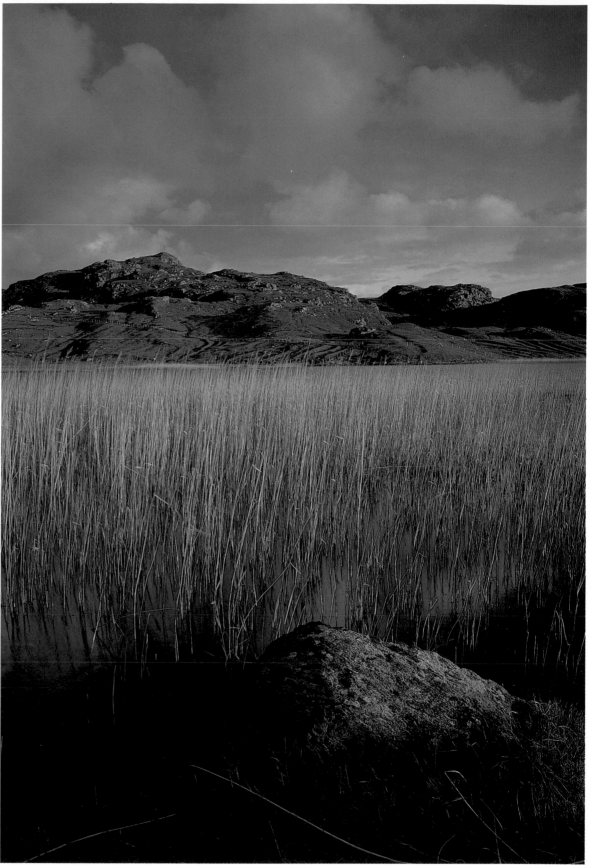

David Ward

Ben Damph Forest, Scotland

"One of the landscape photographers that I really admire is Paul Wakefield, and the inspiration for this picture came from him really because he had taken a picture from a very similar spot to this. When I got the opportunity to visit this area while leading a workshop, I wasn't interested in recreating his picture, but found the viewpoint that he had used – a small ridge with a view across the loch to the mountains beyond – almost by accident.

"On this particular day it was typical Scottish weather, very dark and uninspiring, and I didn't really think we were going to get anything. With a 5x4in camera there's no such thing as a grab shot, however, and you need to set up, compose the scene and then have the patience to wait, however hopeless the situation might appear to be. Ultimately the preparation paid off, because for a miraculous four minutes the sun came through and this was the scene that we saw.

"Analysing the picture there are a few things that really help to make it work. The small area of shadow that can be found along the top of the hill in the middle distance to the left of the frame is really important, because it separates this area from the water. Another small detail, but one that is essential to the overall strength of the picture, is the tiny gap above the top of the boulder, allowing a small area of the loch to get between this and the mountains beyond. There's also the fact that had the sun been fully out and the mountains behind bathed in light, the picture would have lost much of its atmosphere and would have just looked like a postcard scene. These are the kind of things that make a picture special, but conditions were such that I did have to work to get the best out of the situation.

"I fitted a two-stop graduated neutral density filter to reduce some of the contrast that was in the scene and I also fitted a polarizer and an 81B filter. The grass didn't need any extra warmth, but the background was still cold and this combination of filters helped to bring it back to neutral."

Linhof Technikarden 5x4in camera, 90mm lens, Fujifilm Velvia rated at ISO 32

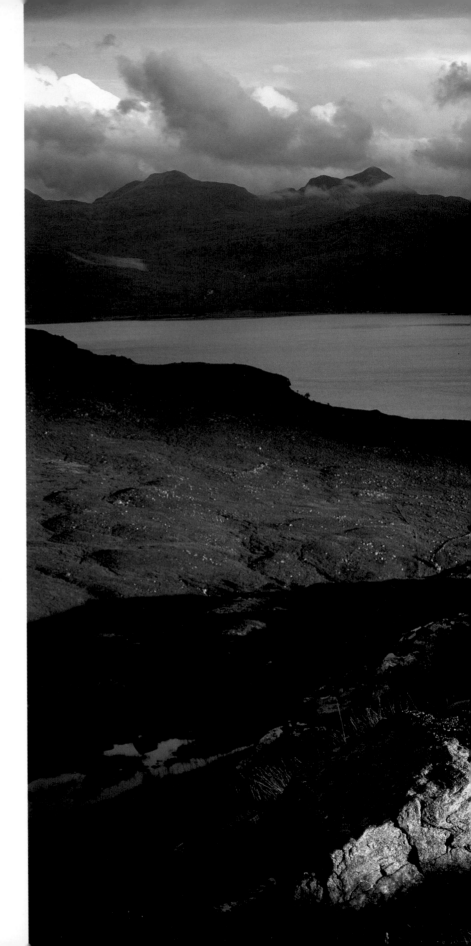

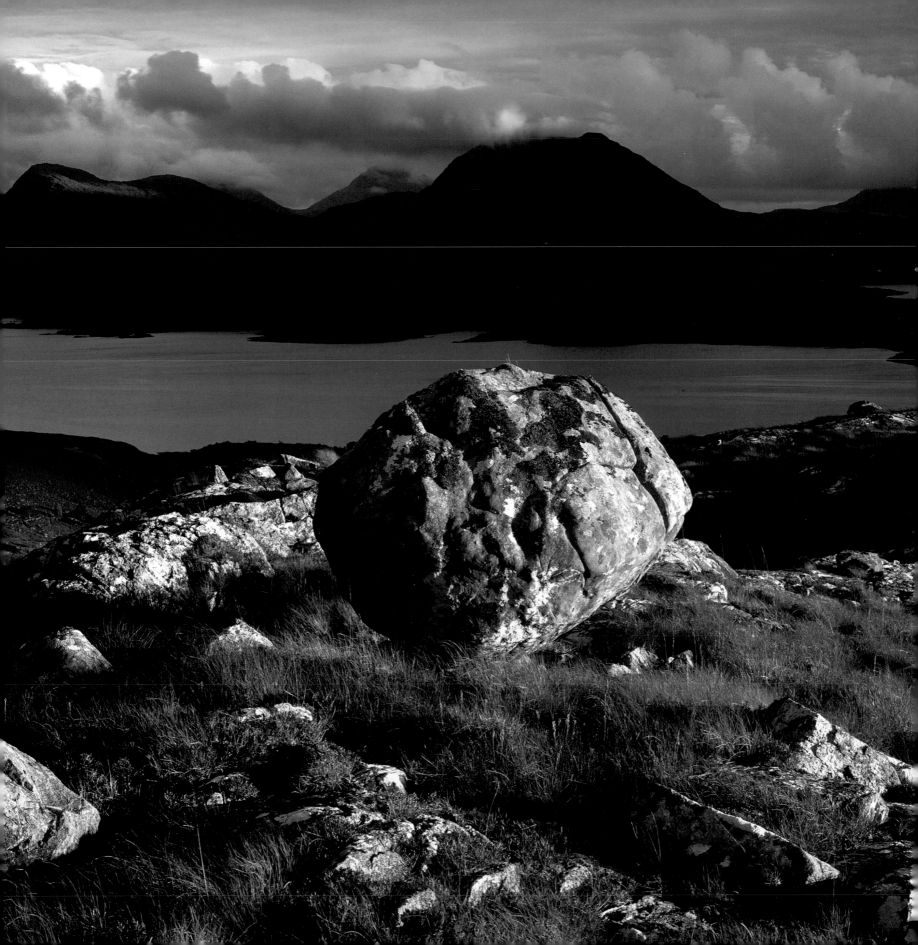

Kennan Ward

Born in Chicago, Illinois, in 1954, Kennan Ward never made a conscious decision to take up photography. Rather landscape and natural history was, and still is, his prime passion in life, and it was a logical step for him to first join the National Park Service in 1973 as a search and rescue ranger. While pursuing this outdoor career he took a Natural History/Environmental Studies degree from the University of California in Santa Cruz, graduating in 1979. He also completed independent studies that led to a joint degree in Wildlife Biology.

"Photography was just one of those things that I always enjoyed doing," he says. "I was the unofficial documentor of my family simply because I was the only one who didn't seem to crop everyone's head off. When my job as a park ranger took me out to the West and Alaska, the scenery that I encountered there was so beautiful compared to the surroundings that I had grown up with in the Mid-west that I felt obliged to record it on film to show the people back home what it looked like."

In 1980, aged 26, Ward was taking time off from his duties as a ranger in Yosemite National Park when he produced two of his most iconic landscape photographs, 'Half Dome lightning strike' and 'Double rainbow'. Such was their popularity that it gave him the opportunity to consider turning professional, and he decided to make photography his career, using his pictures as the illustrations for a series of high-quality postcards, notelets, calendars, and postcards.

Ward works in the field with his wife Karen who, since 1986, has contributed to the image library as a photographer in her own right, while also assisting in the research and business management of the couple's successful publishing company, Wildlight Press, Inc.

Assignments have taken the pair all around the world, to some of its remotest regions – Alaska remains a favorite location, while he's also travelled to the Arctic, Newfoundland, and Midway Atoll – through to many wilderness regions throughout the US. "Despite making my living as a photographer," says Ward, "I still consider that I'm a naturalist first and foremost, and photography was simply something that I happened to be able to teach myself.

"I think that, providing you love the subject that you're taking pictures of, your relationship with that area will help you to deliver something that is insightful and special. When I'm taking workshops this is one of the points that I emphasize all the time – photograph what you know, and this is likely to be what you are best at."

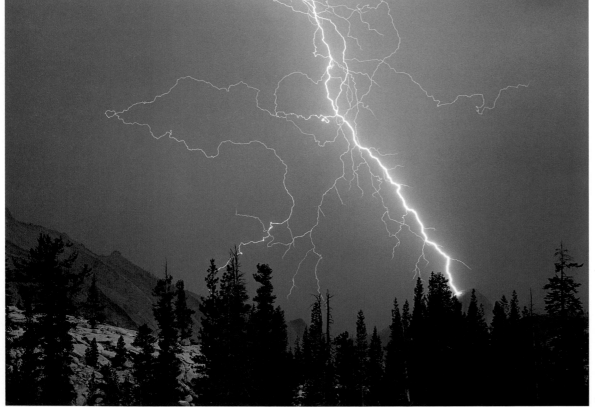

Half Dome lightning strike

"In the summers at Yosemite, cumulus cloud build-up occurs in the late afternoons along the Sierra crest, and the roll of thunder and the flash of lightning are frequent companions to the churning skies.

"It was this climatic behavior that I was studying in July of 1980 in the High Country of Yosemite. One late afternoon I watched the build-up of clouds, and towards dusk set up a tripod near Olmstead Point. Within the composition was Cloud's Rest on the left, and Half Dome on the right, a favorite composition for alpine glow at sunset.

"After watching lightning go cloud to cloud and produce some small ground arcs, there was a period of calm. After eight to ten minutes an eerie feeling went through my body. Then my hair follicles stood to attention. I quickly triggered the cable release and within seconds – ZAP! – a blinding light and an intense roar. I fell to the ground and was dusted with pine boughs and cones. A dead quiet followed, except for the ringing in my ears. I got up,

released the cable, and turned to the next frame in my camera.

"When I am asked how to shoot lightning a disquieting feeling comes over me. My first few statements are discouraging. I inform people that the odds of getting a lightning fusion on film are a billion to one. In fact, the only known photograph other than this one is a small fision recorded through a 1200mm lens by Professor E. Philip Krider of the University of Arizona. Photographing lightning is much more hazardous than photographing grizzlies or sharks.

"Individual flashes of lightning will vary greatly in intensity; but it has been estimated that the bolt on Half Dome was an acre or more in size. That's a huge amount of light, but luckily I had my aperture set to f/32 and so the picture wasn't overexposed."

Nikon FE, Nikkor 55mm macro lens, Kodachrome 64 rated at ISO 80

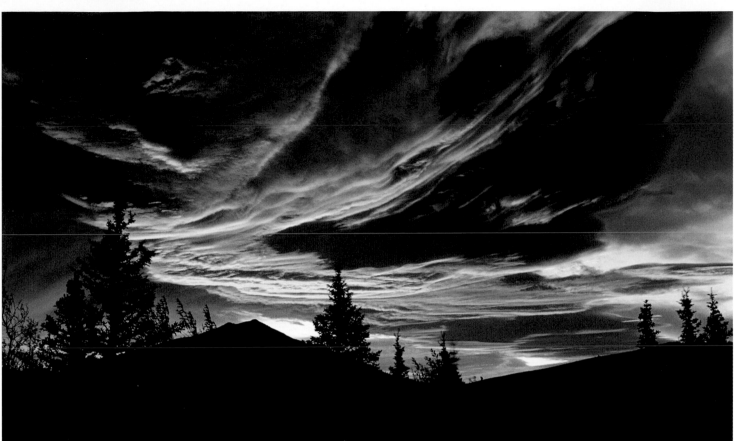

Teklanika sunrise

"The Teklanika River flows north from the Alaska Range and is one of my favorite landscapes. One late summer morning, around 4.30 am, we awoke to a sky that turned our blue tent red. We hurried to a favorite spot on the river, in awe of the most brilliant sunrise I have ever seen. The dimension of true colors from blue to red, orange and black amazed us. The idiom 'red in morning, take a warning' was true that day, as a three-day storm followed."

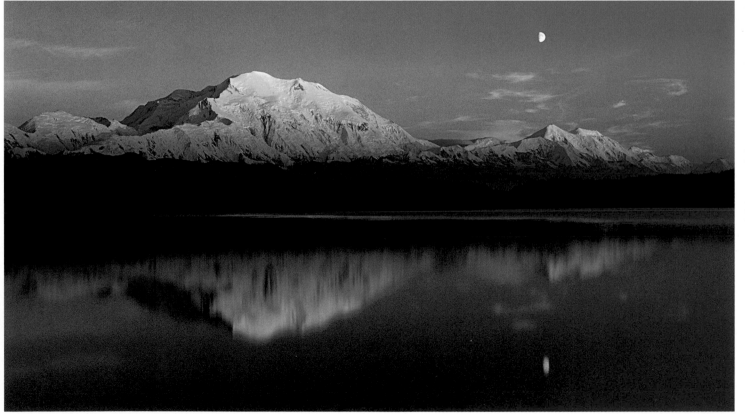

Denali moonrise

"Since 1972 when I was a ranger in Denali National Park, I dreamt about this wild landscape. Often I would plan trips based on the moon phase. Of course summer in Alaska is a difficult time to photograph the moon, as the midnight sun never sets in Alaska.

One summer we were camping in the park and I was keeping an eye on the full moon, but cloudy weather hid the lunar light. Finally, I awoke to a clear early morning with alpine glow that painted the landscape with dreamy conditions just before the moon began to wane."

Kennan Ward

Art Wolfe

A multifaceted photographer, who is every bit as well-regarded for his wildlife photographs and pictures of indigenous people as he is for his landscape work, Art Wolfe grew up with a natural affinity with the great outdoors. "I was one of those kids that you see around with a pair of plastic binoculars, the type that's always out there chasing birds and investigating the woodland around where he lives," he says. "That was my very early connection with nature.

"I was also the school artist, because my mother was an artist and it just kind of rubbed off on me. So, basically I had these two early influences and, 25 years later, they combined to produce a nature photographer."

Wolfe graduated from the University of Washington in Seattle with Bachelor degrees in fine art and art education. "While at university I was studying art during the week and then climbing at weekends and taking pictures, and so I was applying a lot of the art training that I was being given to my photographic compositions," he says. "Eventually my allegiance shifted from painting to photography because it was much easier for me to generate original compositions with a camera than with a brush."

He was completely self-taught as a photographer. "It's not something that I say so much with pride as something that just happens to be reality," he says. "When I went to art school there was no equivalent programme available for those who wanted to be photographers. Maybe if I had wanted to be a photojournalist that would have been different, but certainly there was nothing available at that time for those wanting to go into nature photography."

As his career began to build, he found himself on the road more than at home. Over the course of his 25-year career, he has worked on every continent and in hundreds of locations. He now spends at least nine months of the year travelling all over the world, giving lectures, and shooting up to 2,000 rolls of film, including material for new book projects. He has taken an estimated one million images in his lifetime, and released over 45 books to date.

His work has earned him a multitude of awards, including the accolade of Outstanding Nature Photographer of the Year by the North American Nature Photography Association in 1998, and in 2000, received a coveted Alfred Eisenstaedt Magazine Photography Award.

The philosophy behind his photography is simple and to the point. "Whatever subject I happen to be shooting," he says, "I make clean, clear records conveying the emotion of the moment when I took the picture. I try to keep my composition simple, even when I'm working with a wide-angle lens, because I believe that this creates a purer form of communication."

Wolfe is similarly pragmatic about the equipment that he uses. "For me a camera is simply a tool," he says, "and I will use different ones to tackle different assignments. My approach has always been to use whatever camera and lens that I consider will get me the best shot in a given situation, and I see no reason why I should change that way of thinking now."

Startrails over Deadvlei, Namibia
"Capturing this image required a double exposure and a little forethought. With a compass I determined where the Southern Cross or Crux constellation would rise in relation to two silhouetted acacias within Deadvlei. I composed the image with a low horizon line to ensure greater emphasis on the desert sky.

"For the first exposure, I wanted to create a black sky while retaining detail in the landscape, so I combined a polarizer and a two-stop graduated neutral density filter. This effectively darkened the sky. I also underexposed the entire scene by one full exposure setting to absolutely guarantee a black sky. I waited until night fell before initiating the second exposure.

"During the second exposure I placed my camera on Bulb setting and used a locking cable release to take an eight-hour exposure of the stars' movement across the sky. The brilliance of the stars also brought the exposure on the land up to a proper exposure."

Canon EOS-IN, Canon 17-35mm lens, first exposure: 1/60sec at f/2.8, polarizing filter, graduated neutral density filter, Fujichrome Velvia, second exposure: eight hours at f/2.8, Fujichrome Velvia

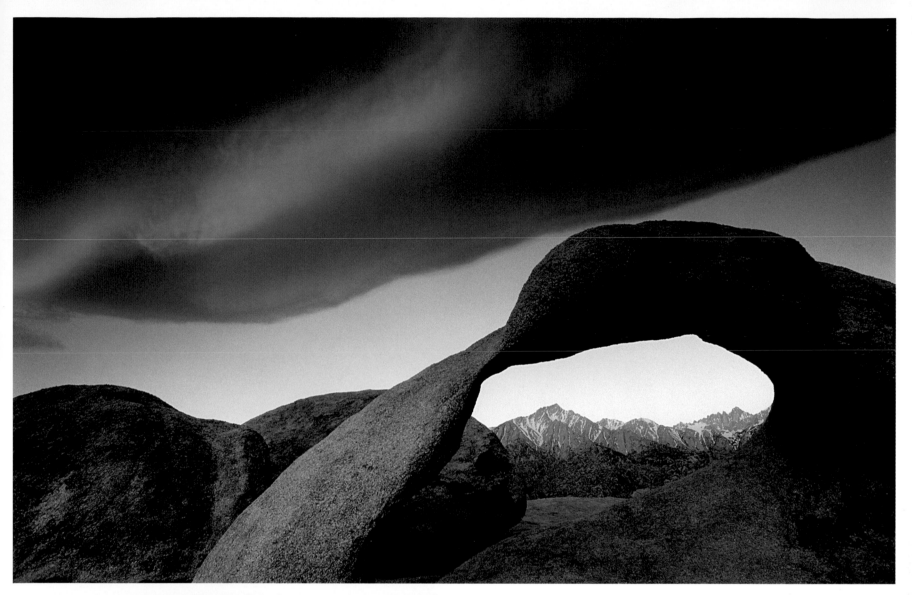

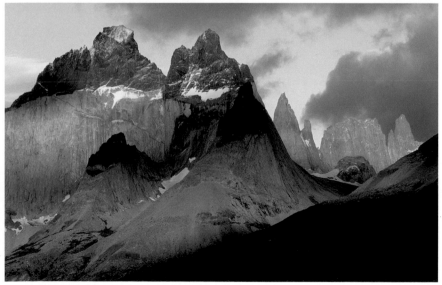

Torres del Paine National Park, Chile (*Left*)
"Torres del Paine is a spectacularly beautiful national park within Chile's Patagonian region offering excellent opportunities to photograph both wildlife and landscapes. In this photograph, an interesting play of shadow and light results as the sun rises through layers of intermittent clouds on the eastern horizon. Sunrise can be an especially rewarding time to photograph as the sun ascends unobstructed above the flat Patagonian Pampas directly to the east of the southern Andes."

Canon EOS-1N, Canon 70–200mm lens, 1/15sec at f/16, Fujichrome Velvia

Granite Arch, Sierra Nevada, California, USA (*Above*)
"Known locally as the 'Sierra Wave', a lenticular cloud hangs in the air above the Sierra's crest, and forms along the range's eastern flank.
On the morning that I took this picture I was framing the Lone Pine Peak and Mount Whitney within a tiny arch, when the cloud began glowing in the rising sun. I shifted to include the cloud as a strong compositional element that balanced the arch on the right."

Canon EOS-1N, Canon EF 17–35mm lens, 1/2sec at f/22, 2-stop graduated neutral density filter, polarizing filter, Fujichrome Velvia

Art Wolfe

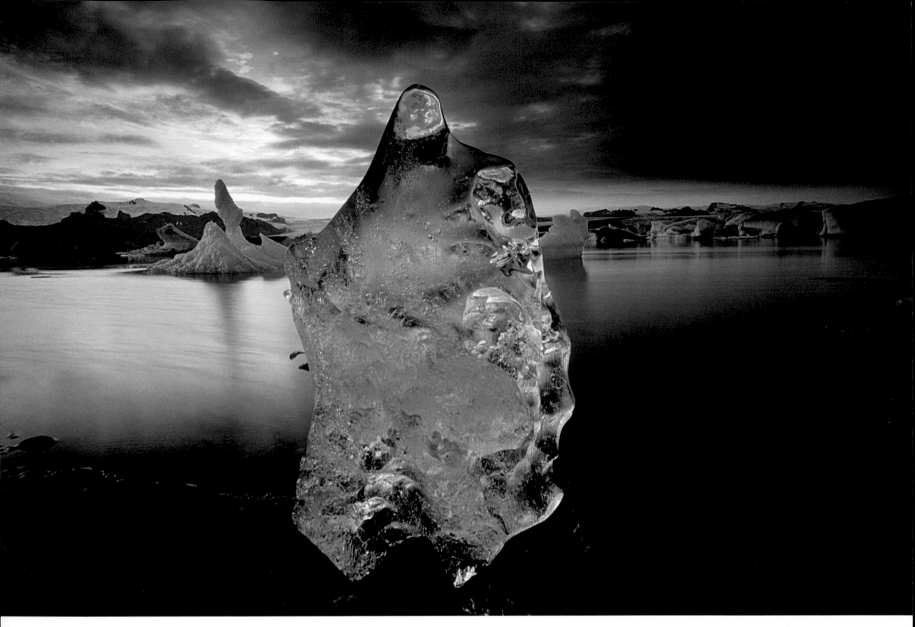

Jokulsarlon Lagoon, Iceland

"I really enjoy working a subject and I had the cooperation of the weather when I was at this stunning locale in Iceland, just a mile inland from the turbulent North Atlantic. This dynamic location was created as two large glaciers receded; now the tides continue to gnaw at the glaciers' termini, causing a steady avalanche of icebergs. At sunrise – 3am in the far north – I was wandering along the shore and found this stranded crystal clear iceberg. I especially like the way the heavy overcast in the background of the photo accentuates and balances the brightened icebergs in the fore- and mid-ground."

Canon EOS 1N, 17–35mm lens, 2 seconds at f/22, 2-stop neutral density filter, Fujichrome Velvia

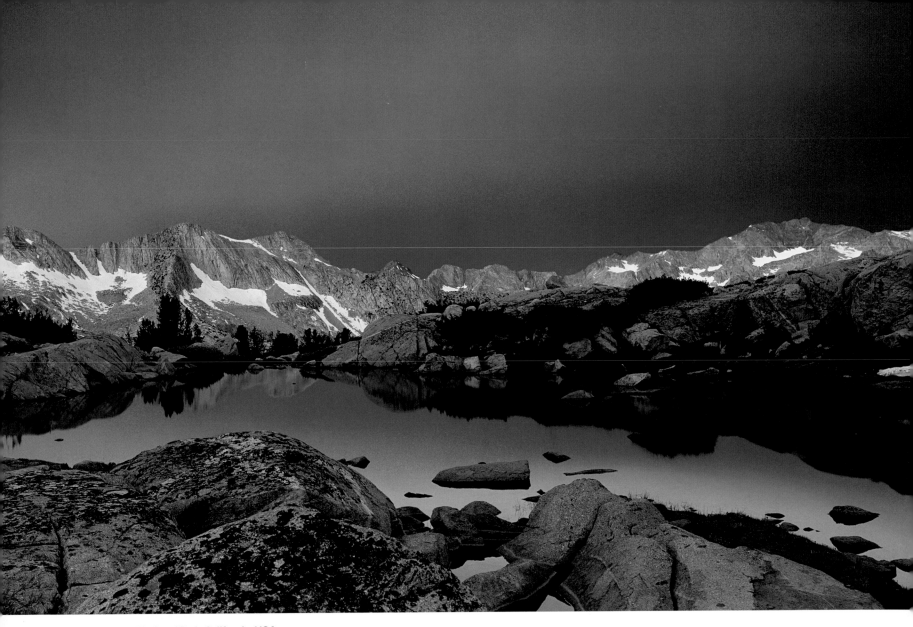

Dusy Basin, Kings Canyon National Park, California, USA
"I hate to wake up early, but I've become resigned to the fact
that it is an inevitability in the photographer's profession;
I rarely sleep in past 6am. On clear days, my photography is
usually over before most people begin to stir. The benefits of
rising early become quite evident in this photograph looking
west across a small tarn in Dusy Basin in California's Kings
Canyon National Park. Here the contrast between the pastel
blue hue of the earth's shadow is clearly distinguished from
the prevailing pinks of pre-dawn light."

Fujifilm 6x17 panoramic body, Fujifilm 90mm wide-angle lens, 4 seconds at
f/22, 2-stop graduated neutral density filter, Fujichrome Velvia 120 film

Art Wolfe

Directory

Theo Allofs
Allofs Photography, PO Box 5473,
Haines Junction, YT, Y0B1L0, Canada
Tel: 1-867-634-3823
Fax: 1-867-634-2207
info@theoallofs.com
Website: www.theoallofs.com

Catherine Ames
cathames@blueyonder.co.uk
Website: www.catherineames.com

Andris Apse
Andris Apse, Okarito P O Box 3,
Whataroa, South Westland,
7955, New Zealand
Tel: 64-3-753 4241
Fax: 64-3-753 4116
andris@andrisapse.com

Bibliography:
– Landmarks, 1981, Readers Digest
– Wild New Zealand, 1981, Readers Digest
– Travellers New Zealand, 1985, Pacific Tourism Promotions
– New Zealand From the Air, 1986, Whitcoulls Publishers
– Thailand: Seven Days in the Kingdom, 1987, Times Editions
– Surprising Lands Down Under, 1989, National
 Geographic Society
– This is New Zealand, 1990, Sheffield House
– New Zealand the Beautiful Wilderness, 1991, Welden
– Magnificent Wilderness, 1991, Random Century
– New Zealand Subantarctic Islands, 1991, Department
 of Conservation
– New Zealand Landscapes, 1994, Craig Potton Publishing
– New Zealand Landscapes, first published 1994, now in its
 ninth reprint, Craig Potton Publishing
– Spectacular New Zealand, 1995, First Class Publications
– Nueseeland, 1996, Bruckman
– Te Wahipounamu, 1997, Craig Potton Publishing
– New Zealand the Millenium, 1999, Shadowcatcher
– Te Wahipounamu, Southwest New Zealand World
 Heritage Area
– Day Break 2000, 2000, North Word Press
– New Zealand Horizons, 2000, Craig Potton Publishing

Yann Arthus-Bertrand
Website: www.yannartusbertrand.com

Selective bibliography:
– L'Ile de France: Vue du Ciel, 1988, Éditions du Chêne
– L'Alsace: Vue du Ciel, 1989, Éditions du Chêne
– Le Kenya: Vu du Ciel, 1989, Éditions Nathan
– La Bourgogne Vue du Ciel, 1990, Éditions du Chêne
– Les Iles de France: Vues du Ciel, 1991, Éditions du Chêne
– Le Lot en Quercy, 1992, Éditions Nathan Image
– Les Côtes D'Armor: Vues du Ciel, 1992, Éditions de
 la Martinière
– L'Egypte: Vue d'en Haut, 1992, Éditions de la Martinière
– La Loire: Vue du Ciel, 1992, Éditions du Chêne
– Les Côtes de Bretagne: Vues du Ciel, 1993, Éditions du Chêne
– Dogs, 2000, Cassell
– Cats, 2000, Cassell
– The Earth from Above, 2001, Thames & Hudson
– The Earth from the Air for Children, 2002, Thames & Hudson

Niall Benvie
Tel/fax +44 (0) 1356 626 128/ 0780 1067 160
niall@niallbenvie.com
Website: www.niallbenvie.com

Bibliography:
– The Art of Nature Photography, 1999, David & Charles
– Creative Landscape Photography, 2001, David & Charles

Jim Brandenburg
Ravenwood Studios, 14568 Moose Lake Road,
Ely, Minnesota, 55731, USA
Tel: 1-218-365-5105
Website: www.jimbrandenburg.com

Bibliography:
– White Wolf: Living with an Arctic Legend, 1988,
 Northword Press
– Minnesota: Images of Home, 1990, Blandin Foundation,
 Grand Rapids
– Brother Wolf: A Forgotten Promise, 1993, Northword Press
– To the Top of the World: Aventures with Arctic Wolves, 1993,
 Walker and Company
– Sand and Fog: Adventures in Southern Africa, 1994, Walker
 and Company
– An American Safari: Adventures on the North American
 Prairie, 1995, Walker and Company
– Scruffy – A Young Wolf Finds his Place in the Pack, 1995,
 Walker and Company
– Chased by the Light: A 90 Day Journey, 1998,
 Northword Press

Christopher Burkett
Contact: info@christopherburkett.com
Website: www.christopherburkett.com

Bibliography:
– Intimations of Paradise 1999, self-published

Mike Busselle
Tel +44 (0) 1732 455607
Fax +44 (0) 1732 740385
mikebuss@btinternet.com
Website: www.michael-busselle.com

Selective bibliography:
– Master Photography, 1977, Mitchell Beazley
– The Encyclopaedia of Photography, 1984, Octopus Books
– Landscapes in Spain, 1988, Pavilion
– Three Rivers of France, 1989, Pavilion
– Discovering Spain, 1997, Pavilion
– To Live in France, 1997, Thames & Hudson
– French Vineyards, 1998, Pavilion
– Better Picture Guide to Travel Photography, 1998, RotoVision
– Better Picture Guide to Landscape Photography, 1998,
 RotoVision
– Pauillac, 1998, Mitchell Beazley
– Better Picture Guide to Color Photography, 2000, RotoVision
– Creative Digital Photography 2002, David & Charles

Joe Cornish
Website: www.joecornish.com

Bibliography:
– First Light, 2002, Aurum Press (Argentum)

Charles Cramer
Contact: cc@charlescramer.com
Website: www.charlescramer.com

Ken Duncan
Tel: 1-800-807-737 (within Australia)
 +61-2-4367-6777 (International)
Fax: +61-2-4367-7744
info@kenduncan.com
Website: www.kenduncan.com

Selective bibliography:
– The Last Frontier: Australia Wide, 1987, Weldon Publishing
– Australia Wide: Spirit of a Nation, 1991, Collins
– Spirit of Australia, 1992, © Panographs
– The Australia Wide Yearbook 1992, © Panographs
– Spectacular Sydney 1992, © Panographs
– From Forest to Sea 1993, © Panographs
– Birth of a Nation: The Rocks, 1995, © Panographs
– The Great South Land 1997, © Panographs
– The Ken Duncan Collection, 2000, © Panographs
– America Wide: In God We Trust, 2001, © Panographs
– Sensational Sydney, 2002, © Panographs
– Classic Australia, 2002, © Panographs
– Australia Wide: The Journey, 2002, © Panographs
– 3D Australia, 2003, © Panographs
– Spirit of America, 2003, © Panographs

Jack Dykinga
Jack Dykinga Photography,
2865 N, Tomas Road, Tucson, Arizona 85745, USA
Tel: 1-520-743-0242
Fax: 1-520-743-0277
pete@dykinga.com
Website: www.dykinga.com

Bibliography:
– The Secret Forest, University of New Mexico Press
– Frog Mountain Blues, 1994, University of Arizona Press
– Stone Canyons of the Colorado Plateau, 1996, Harry N Abrams
– The Sonoran Desert, 1997, Harry N Abrams
– The Sierra Pinacate, 1998, University of Arizona Press
– Desert: The Mojave and Death Valley, 1999, Harry N Abrams
– Large Format Nature Photography, 2001, Watson-Guptill

Patrick Endres
2923 Moose Mountain Road, Fairbanks, Alaska, 99709, USA
Tel: 1-907 479 9196
Fax: 1-208 545 5687
patrick@alaskaphotographics.com
Website: www.alaskaphotographics.com

Bibliography:
– The Making of Ice Art, Wide Angle Productions

MacDuff Everton
M and M Inc, Macduff Everton, 3905 State St, 7–213 Santa
Barbara, CA 93105, USA
Tel: 1-805 898 0658
Fax: 1-805 898 1458
info@macduffeverton.com
Website: www.macduffeverton.com

Selective bibliography:
– That's Not Entirely True, 1985, Tixcacalcupul Press
– The Cities of Ancient Mexico: Reconstructing a Lost World,
 1989, Thames & Hudson
– The New Archaeology and the Ancient Maya, 1990, Scientific
 American Library
– The Modern Maya: A Culture in Transition, 1991, New
 Mexico Press
– The Code of Kings: The Language of Seven Sacred Maya
 Temples and Tombs, 1998, Simon & Schuster
– The Western Horizon, 2000, Abrams

Michael Fatali
P.O. Box 327, Springdale, Utah 84767, USA
Tel: 1-435-772-2422
fatali@fatali.com
Website: www.fatali.com

Bibliography:
– Dancing with Light (due to be self-published in 2005)

Michael Frye
Contact: michael@michaelfrye.com
Website: www.michaelfrye.com

Bibliography:
– The Photographer's Guide to Yosemite, 2000,
Yosemite Association

Sally Gall
47 Vestry Street, #2N, New York, New York 10013, USA
info@pipeline.com
Website: www.sallygall.com

Bibliography:
– The Water's Edge, 1995, Chronicle Books
– Subterranea, 2003, Umbrage Editions

Bob Hudak
Contact: bob@bobhudak.com
Website: www.bobhudak.com

Yousef Khanfar
6957 Northwest Expressway, Suite 219,
Oklahoma City, Oklahoma, 73132, USA

Bibliography:
– Voices of Light, 2000, Proguide Publishing

Marty Knapp
Tel: 1-415-663-8670
Fax: 1-415-663-8663
Website: www.martyknapp.com

Shinzo Maeda
Tankei Co Ltd, 402 Maison Aoyama 2-7-26,
Mezon-Aoyama-402, Kitaaoyama minato-ku,
Tokyo, Japan
Tel: 81 3 3405 1681

Bibliography:
– Scenes in Four Seasons, 1985, Nippon Camera sha
– White Fantasy, 1987, Kodansha International
– Autumn Colors, 1989, Kodansha International
– Spring Earth, 1990, Kodansha International
– Kamikochi, 1991, Kodansha International
– Colors of the Seasons, 1991, Nippon Camera sha
– Summer Hills, 1999, Kodansha International

– Flower Landscapes, 1999, Kodansha International
– Autumn Hills, 1999, Kodansha International
– Expressive Trees, 1999, Kodansha International
– Winter Hill, 1999, Kodansha International
– Seasonal Pictures, 1999, Kodansha International
– Spring Hills, 1999, Kodansha International
– Intimate Seasons, 2001, Kodansha International

Tom Mackie
34 Brickle Road, Stoke Holy Cross,
Norwich NR14 8NG, UK
Tel: +44 (0) 1508 494906
tom@tommackie.com
Website: www.tommackie.co.uk

Bibliography:
– Photos with Impact, 2003

Nick Meers
Contact: p@noramics.com
Website: www.nickmeers.com

Selective bibliography:
– The Spirit of the Cotswolds, 1988, Michael Joseph
– Enigmatic England, 1991, Sutton Publishing
– Panoramas of English Gardens, 1997, Phoenix
– Panoramas of England, 2000, Phoenix
– Panoramas of English Villages, 2000, Phoenix
– A Year in the Garden: In England, Wales and Northern Ireland,
 2001, Harry Abrams
– Stretch: The Art of Panoramic Photography, 2003, RotoVision

David and Marc Muench
Muench Photography Inc, 142 Santa Felicia Drive,
Goleta, California, 93117, USA
Tel: 1-805 685 2825
Fax: 1-805 685 2826
Website: www.muenchphotography.com

Bibliography:
– Primal Forces
– David Muench's Arizona
– Images in Stone
– American Landscape
– Ancient America
– The Rockies
– Ski Rockies
– Nature's America
– National Parks
– Utah
– California
– Platau Light
– American Portfolios

William Neill
William Neill Photography, 40325 River View Court,
Oakhurst, California, 93644, USA
Tel: 1-800-575-4604
bill@williamneill.com

Bibliography:
– By Nature's Design, 1993, Chronicle Books/Exploratum
– Yosemite: The Promise of Wildness, 1994, Yosemite Association
– The Color of Nature, 1996, Chronicle Books/Exploratum
– Landscapes of the Spirit, 1997, Bullfinch Press
– Traces of Time, 2000, Chronicle Books/Exploratum

Pat O'Hara
PO Box 955, Port Angeles, WA 98362, USA
Tel: 1-360-457-4212
Fax: 1-360-457-5136
pat@patohara.com
Website: www.patohara.com

Selective bibliography:
– Washington Wilderness, 1984, The Mountaineers Books
– Olympic National Park, 1985, Woodlands Press
– Mount Rainier National Park, 1985, Woodlands Press
– Grand Teton National Park, 1985, Woodlands Press
– Yosemite National Park, 1985, Woodlands Press
– Yellowstone National Park, 1986, Woodlands Press
– Great Smoky Mountains National Park, 1986, Woodlands Press
– Grand Canyon National Park, 1986, Woodlands Press
– Washington, 1987, Westcliffe Publishers
– Washington's Wild Rivers, 1990, The Mountaineers Books
– Wilderness Scenario, 1991, AWG Publishing
– Olympic, 1993, AWG Publishing
– Nature's Holy Realm, 1997, Northword Press
– Washington's Mount Rainier National Park, 1998,
 The Mountaineers Books

Colin Prior
Earthgallery, 3 Wren Court,
Strathclyde Business Park, Bellshill,
Lanarkshire, ML4 3NQ, UK
Tel: +44 (0) 1698 844430
Website: www.earthgallery.net

Bibliography:
– Highland Wilderness, 1993, Constable
– Scotland: The Wild Places, 2001, Constable
– Living Tribes, 2003, Constable

Lynn Radeka
Contact: lynn@radekaphotography.com
Website: www.radekaphotography.com

Bibliography:
– Ghost Towns of the Old West, 1991, Mallard Press
– Cameracraft: Landscapes, 2002, AVA Publishing
– Darkroom Magic, 2003, Fountain Press
– Light and Shadow: The American Desert (in preparation)

James Randklev
Tel: 1-520-243-9335/520-743-9335
randklev@aol.com
Website: www.jamesrandklev.com

Bibliography:
– In Nature's Heart: The Wilderness Days of John Muir, 1993,
 The Nature Company
– Wild and Scenic Florida, 1994, Brown Trout Publishers
– Georgia Impressions, 2001, Far Country Press
– Olympic National Park Impressions, 2002, Far Country Press
– Florida Impressions, 2002, Far Country Press
– Florida: Simply Beautiful, 2003, Far Country Press
– Bryce Canyon National Park, 2003, Far Country Press

Galen Rowell
106 South Main Street, Bishop, California, 93514, USA
Tel: 1-760-873-7700
Fax: 1-760-873-3233
staff@mountainlight.com
Website: www.galenrowell.com
Selective bibliography:
– Galen Rowell's Vision
– North America The Beautiful
– Inner Game of Outdoor Photography
– The Yosemite (with text by John Muir)
– Mountain Light
– High and Wild
– California The Beautiful
– The Art of Adventure
– Poles Apart
– Mountains of the Middle Kingdom
– My Tibet
– Bay Area Wild
– Coastal California
– Living Planet
– Throne Room of the Mountain Gods
– The Vertical World of Yosemite

John Shephard
Contact: info@johnshephard.com
Website: www.johnshephard.com

Tom Till
PO Box 337, Moab, Utah, 84532, USA,
Tel: 1-435-259-5327
tom@tomtill.com
Website: www.tomtill.com

Selective bibliography:
– In the Land of Moab, Fable Valley Publishers
– Along New Mexico's Continental Divide Trail
– Great Ghost Towns of the West
– Always in Season
– New Mexico's Wilderness Areas
– Seasons of the Rockies
– The Land and The Indians
– Utah Reflections
– Utah Wildflowers
– Utah Then and Now
– Utah: A Celebration of the Landscape
– Utah: Compass Guide

Jan Töve
Contact: jan.tove@telia.com

Bibliography:
– Speglingar 1996, Borås Tidnings förlag
– Skogaryd: A History of a Forest, 1999, Fryxell-Langenskiöldska
 Stiftelsen
– Safari 2000 (with photographer Janos Jurka), Bonnier Carlsen
– Beyond Order, 2001, Nya Vyer
– Lake Hornborga, 2002 (iwith photographer Tore Hagman),
 Naturvårdsverkets förlag,

Charlie Waite
Charlie Waite, PO Box 1558,
Gillingham, Dorset, SP8 5WF, UK
landscape@charliewaite.com

Selective bibliography:
– National Trust Book of Long Walks, 1982, Weidenfeld
– Long Walks in France, 1983, Weidenfeld
– Landscape in Britain, 1983, Pavilion
– English Country Towns, 1984, Webb & Bower
– The Loire, 1985, George Philip
– Provence, 1985, George Philip
– Languedoc, 1985, George Philip
– Dordogne, 1985, George Philip
– Villages in France, 1986, Weidenfeld
– Tuscany, 1987, George Philip
– Landscape in France, 1988, Elmtree
– Scottish Islands, 1989, Constable
– Charlie Waite's Venice, 1989, George Philip
– Charlie Waite's Italian Landscapes, 1990, Hamish Hamilton
– Charlie Waite's Spanish Landscapes, 1992, Hamish Hamilton
– The Making of Landscape Photographs, 1992, Collins & Brown
– Seeing Landscapes, 1999, Collins & Brown
– In My Mind's Eye, 2002, GMC Publications Ltd

David Ward
Rowley Cottage, Westhope, Hereford, HR4 8BU, UK
Tel: +44 (0) 1432 830 781
Fax: +44 (0) 1432 830 781
enquiries@davidwardphoto.co.uk
Website: www.davidwardphoto.co.uk

Kennan Ward
P,O,Box 42, Santa Cruz, CA 95060, USA
Telephone 1-800-729-5302
Website: www.grizzlyden.com

Bibliography:
– Grizzlies in the Wild, 1994, NorthWord Press
– Journeys with the Ice Bear, 1998, NorthWord Press
– Denali: Reflections of a Naturalist, 2000, NorthWord Press
– Born to be Wild: The Bears, 2000, WildLight Press
– The Last Wilderness: Arctic National Wildlife Refuge, 2001,
 WildLight Press

Art Wolfe
Telephone 1-206-332-0993
Fax 1-206-332-0990
info@artwolfe.com
Website: www.artwolfe.com

Selective bibliography:
– The Art of Photographing Nature
– Penguins, Puffins and Auks
– Wild Cats of the World
– Photography Outdoors
– Moose
– Rhythms of the Wild
– Primates
– Journey Through the Northern Rainforest
– The Living Wild
– Africa
– The Nature of Lions

Many thanks to all who contributed to this book, particularly the photographers who have so willingly contributed their work and their expertise. And, of course, continuing thanks to Sarah, Emilia and Charlie, who have supported me through the entire project.
Terry Hope

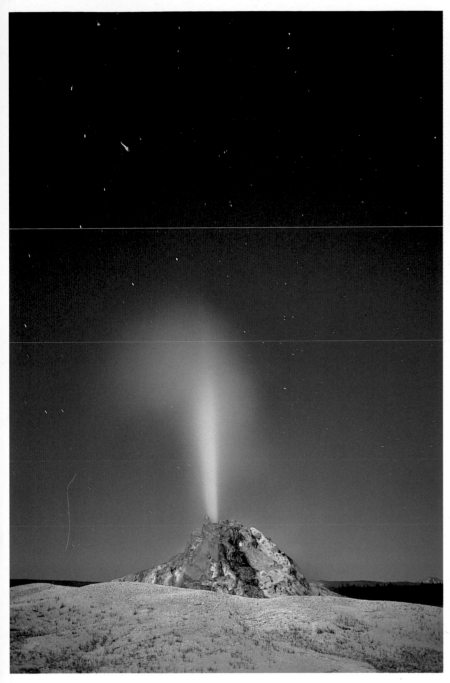

White Dome Geyser by moonlight

"The White Dome Geyser in Yellowstone erupts every 15 to 30 minutes. I decided to attempt a picture of it on a moonlit night when I could rely on natural light to provide much of the illumination that I needed.

"When I heard that the eruption was about to happen I pressed the shutter and kept it open for the two minutes that it was taking place: during that time I took a torch that had a blue filter taped over the front, and I painted in the geyser and the cone. I'll use whatever light is most applicable for a situation – torchlight gives a very precise light that enables smaller details to be highlighted, while the bigger flashes illuminate a much wider area."

Mamiya 645, 45mm lens, Fujifilm Provia 100

Sand dune and Comet Hale-Bopp, Death Valley

"The strength of this photograph is its visual simplicity; making it was technically complex.

"Before dark, I searched the dunes looking for the right foreground. After finding this ridge of sand I waited until the comet moved into position above the dune. A powerful spotlight assisted me in composing and focusing the image in the dark. I locked the camera down on a tripod, the hard part began.

"We think of photographs as capturing a single moment, but this image took hours to make. I added light, bit by bit, to create the image, making a series of separate exposures on the same piece of film. First I opened the shutter for a minute to capture the comet and stars, then positioned a flash with an orange filter to light the left-hand side of the dune; it took 32 pops of the flash (each made during a separate 1/60th sec exposure) to cast enough light.

I then put a blue filter over the flash and repositioned it to light the right-hand side of the dune; this time it took 64 bursts of the flash. I then advanced the film to the next frame."

Mamiya 645, 45mm lens, Fujifilm Provia 100 pushed two stops to ISO 400

Michael Frye

Jeffrey Pine on top of Sentinel Dome, Yosemite National Park, California, USA

"One of the things that I like to do is to photograph well-known landmarks at night. I think it's fun to make these familiar subjects look completely different. This particular Jeffrey Pine in Yosemite has been photographed thousands of times, but I would guess that it's never been done this way before.

"The complexity of my night-time photographs often requires me to have a preconceived idea of how I want the image to look beforehand; it's hard to be spontaneous. Here I had decided to attempt a picture of the Jeffrey Pine with the moon rising behind it. I knew I needed to make this image the night before the moon was full so that it would rise at dusk before the sky was completely dark.

"Before setting up my camera I had to take my best guess at the path that the moon would take, and then to compose my picture so that it would clear the top of the tree. The first exposure – for the moon that's just above the horizon – was made at dusk. I then opened the shutter three more times at 45-minute intervals to record the moon as it travelled through the sky. These four exposures were just for recording the moon; had I processed the film at this point the only thing visible would have been a sheet of black film with just the four moons registered.

"Before lighting the tree I waited until the moon had passed completely outside of the frame. At the time I made this photograph I had just the one Norman 400B battery-operated flash head and so I had to set the rest of the exposure up in two parts. First I opened the camera's shutter on 'B' and fitted a red gel over the flash head, and then moved to a point to the right of the camera position and fired the flash around eight times to build up the exposure that I needed. I then changed the red filter for an orange one, opened the shutter again, and took up position behind the tree, out of the camera's view, and fired the flash another eight times to provide a rim light to the tree. After this, I closed the shutter and the picture was complete. It had taken around three hours to produce from start to finish."

Mamiya 645, 45mm lens, Fujifilm Provia 100 pushed one stop to ISO 200

Bob Hudak

Bob Hudak was introduced to photography at an early age when he was presented by a relative with the gift of a camera. At once smitten, it was taken with Hudak on every family trip during which he experimented with picture-taking. The resulting snapshots were just that – 'snapshots' of the typical scenes encountered on these outings – but the seed of interest had been sown.

Having grown up in predevelopment South Florida, most of Hudak's days were spent in the woods and lakes not far from his home. While photography was a great interest, in his early teens his primary passion was flying, and this culminated in his gaining a pilot's license at the age of 18. In the next four years he spent as much time as possible flying with the intent of notching up enough time in the air to eventually operate a charter flight service.

However, as time went on, he became disenchanted with the idea of flying for a living and, at about the same time, was shown a book of photographs by Edward Weston. Weston's photographs left a profound impression and opened Hudak's eyes to the potential of landscape photography. It had a special resonance for him; watching his homeland literally paved over by developers instilled in him a yearning for the purity of landscapes untouched by man. Photography, at least on a subconscious level, was a way of looking for the youth that was lost along with the lakes and the woods.

While landscape photography became a passionate hobby, it was architectural photography that had commercial potential and this was his specialism for many years. Largely self-taught, he familiarized himself with large-format cameras in order to become proficient. Ultimately, however, he was drawn to making the landscape pictures that he loved to produce in his spare moments, and he began to look for ways to make a living from it.

Having explored the idea of selling through a gallery he decided to go it alone and sell prints through his own website and shows mounted at local museums. While, initially, it was more difficult to attract the interest of potential clients, he thrived on the sense of autonomy and the benefit of often being able to meet face to face with his market.

As his print sales gained momentum, the architectural photography was phased out, allowing Hudak to devote himself to his landscape interests.

However, his love of large-format cameras has continued, and Hudak takes pride in his collection of the unusual vintage models which still deliver a sterling service. One of his favorites is a Deardorff 5x7in model, manufactured around 1939. In terms of size it's almost identical to a 4x5in camera, and yet the negative that it produces is considerably larger, with all the associated advantages. Another regular favorite is his 8x10in camera.

Large-format is big enough to offer him the chance to work with vintage processes that require contact printing, such as platinum, palladium, and silver printing-out paper, while he also produces silver gelatin and silver chloride contact prints for sale to collectors.

His use of traditional cameras and methods sits well with his style of landscape photography. The luminous quality of his black-and-white prints, with their delicate tones and fine detail, represent a fine art approach that is increasingly attractive to collectors on an international scale.

Great Sand Dunes National Monument, Colorado, USA
"When I made this image I knew that if the lighting was right the dunes would have a sculptured look, but at this time the sun was overhead and the modelling wasn't there. I walked around and found an area where I could set up an image that made use of the brush in the foreground, and I decided to set it up as a panoramic composition, lining up the camera so that the split was virtually 50/50 between foreground and background. With the lighting the way that it was at the time it was the only thing I could do, but it was a successful image."

Deardorff 5x7in camera, 450mm lens, Kodak Tri-X

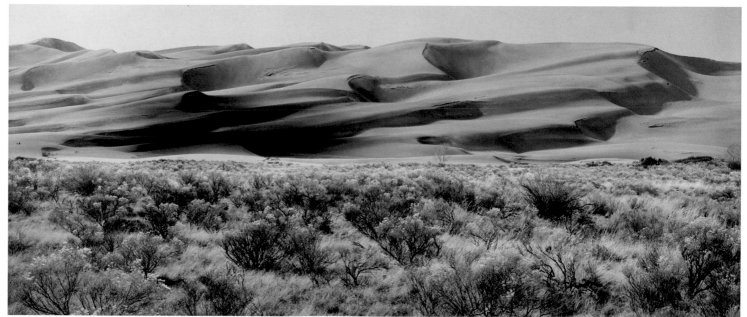

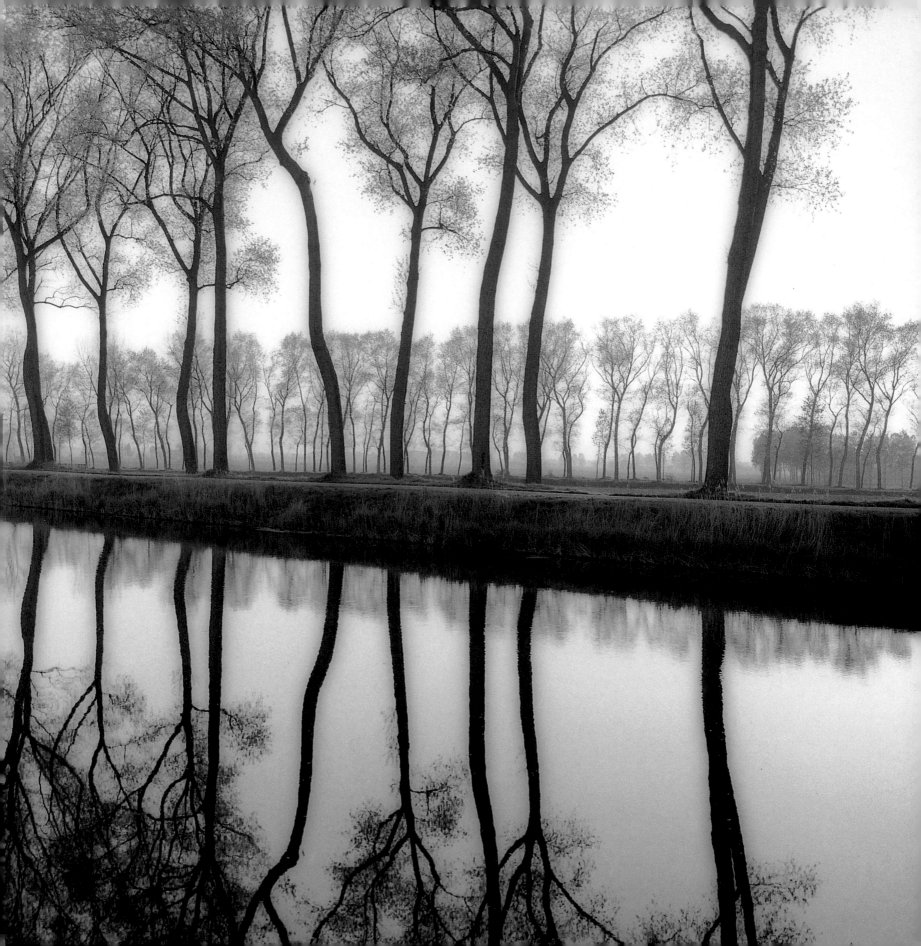

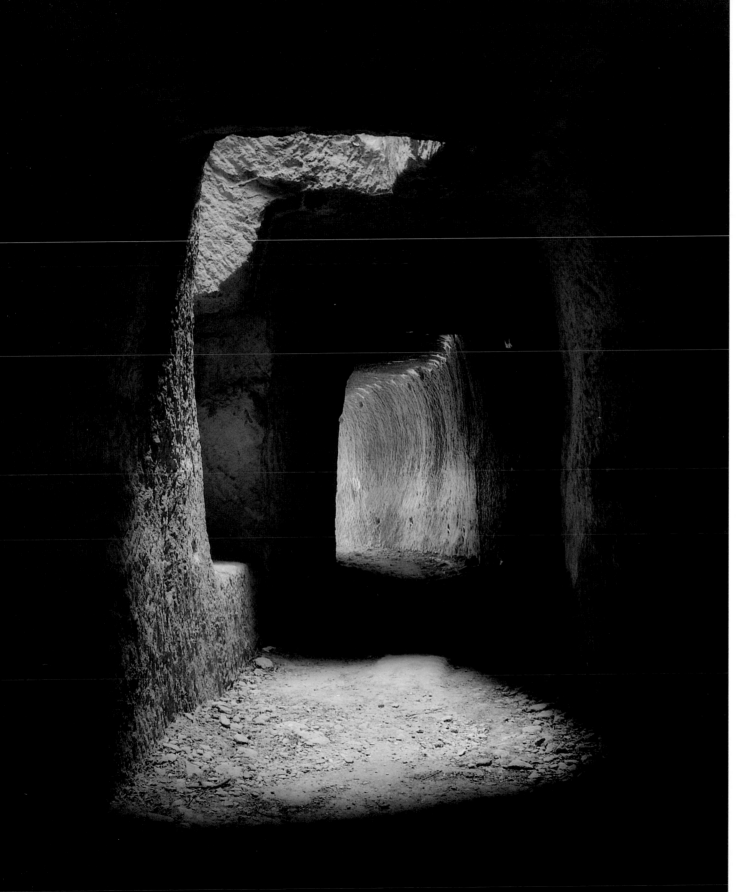

Pont du Gard (*Left*)
"This is an image from the *Subterranea* project, and it was made in an ancient Roman aqueduct near Nîmes in the south of France. Most of the project involved photographing the natural underworld, and yet this ancient manmade tunnel had many similar qualities to the natural caves I had been photographing, so I stretched the boundaries of the project a bit."

Toyo 4x5in field camera, 135mm lens, KodakTri-X

Bruges (*Facing opposite*)
"I had a commercial job that involved travelling to Bruges in Belgium and, while I was there, I decided that I would take a couple of days to see if I could find some landscape subjects for myself. I didn't know if I would be successful, but I was lucky enough to come back with this picture. I am interested in taking a picture of a real place and making it slightly 'other' so that while we know it really exists it feels as if it is a part of another world that we do not recognize. It's both believable and strange. This area was one of the beautiful tree-lined canals near Bruges and the trees, which had lost their leaves, were very graphic against the wintry, gray sky. Since I chose to photograph on that day rather than a sunny day, the empty background adds a sense of abstraction to the overall composition. The use of black and white is another level of abstraction; it's another step away from how we experience the world."

Hasselblad 503CW, 60mm lens, KodakTri-X

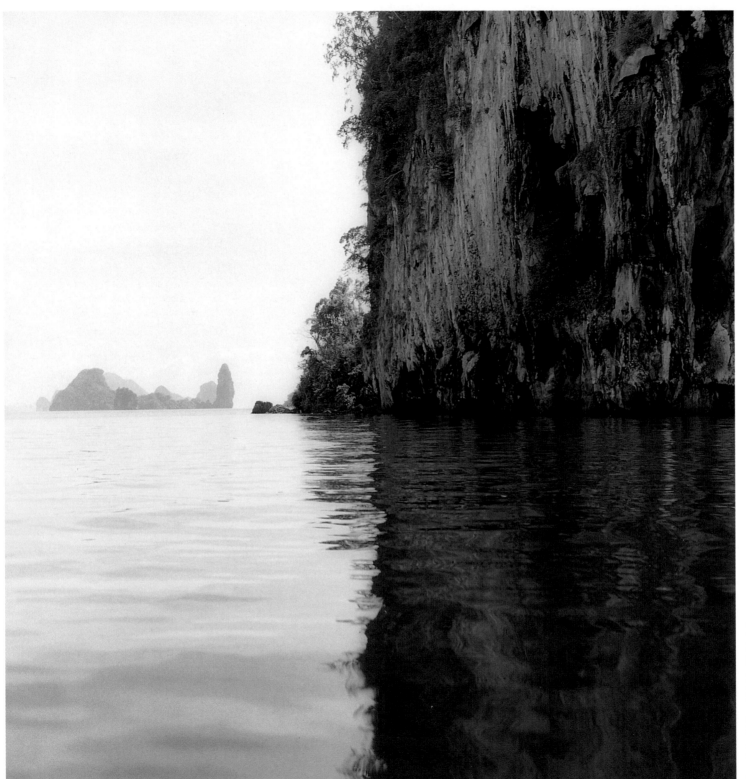

Quadrant

"I photograph a lot of watery landscapes from boats. This image was made in Thailand, and I was interested in the idea here of what is solid and what is liquid, where gravity is.

"I tonally manipulate my prints a lot in the darkroom and I tried to emphasize these feelings of solidity and wateriness in the variation of tones."

Hasselblad 503CW, 60mm lens, KodakTri-X

Sally Gall

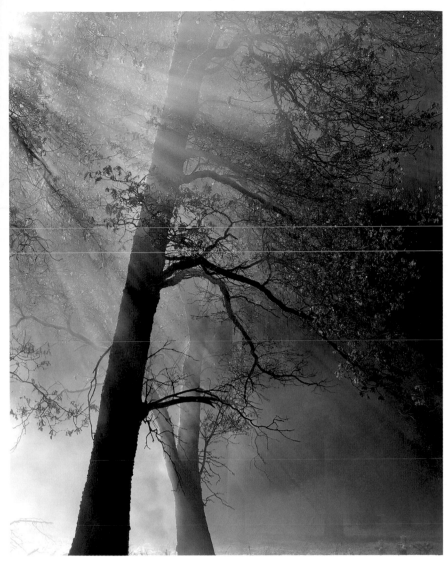

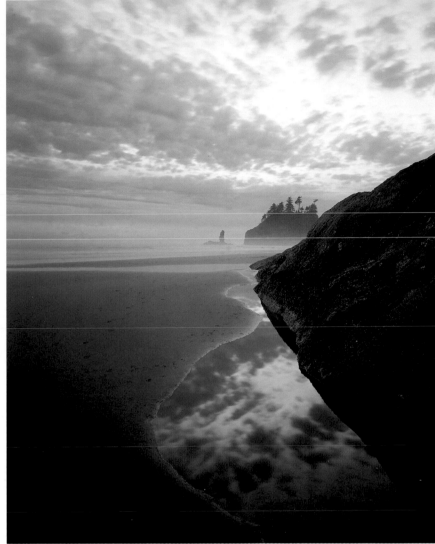

Sierra Mountains, California, USA
After suffering the loss of his mother, Khanfar sought peace in California's Sierra Mountains.

As the sun's rays penetrated the rising mist, he photographed these silhouetted trees, capturing the essence of the emotions that he felt in this place. As a photographer, Khanfar says that he "paints with light" and that it is as much a spiritual endeavor as an artistic one.

Linhof 2000 4x5in camera, Nikkor-T ED 360mm lens, Fujifilm Velvia

The Olympic Peninsula, Washington, USA
Yousef Khanfar captured this scene along the coast of the Olympic Peninsula. "I found this smooth, calm pool that was touched by the reflections of clouds," he says. "It provided almost endless variations for photographs."

Linhof 2000 4x5in camera, Nikkor 75mm, Fujifilm Velvia

Yousef Khanfar

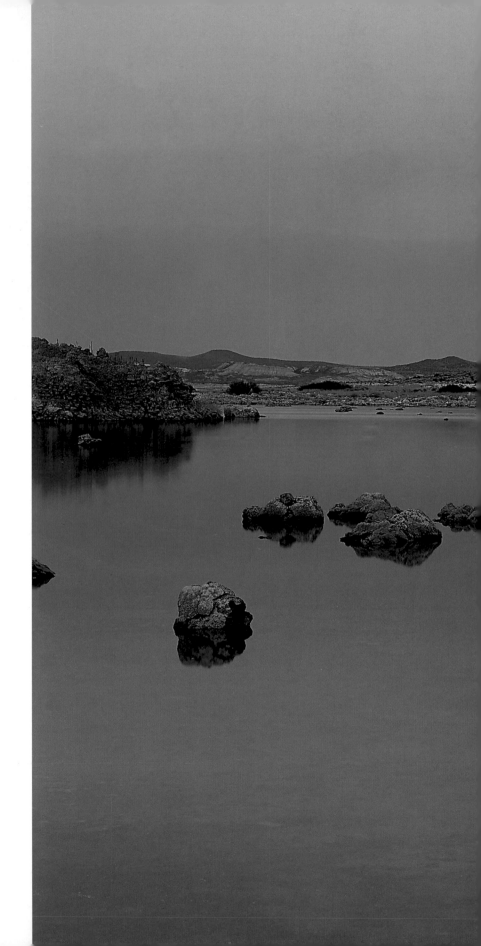

Mono Lake, eastern Sierra, California, USA

Mono Lake is one of Khanfar's favorite locations in the US. Nestled in the eastern Sierra, this vast, salty lake is at least 700,000 years old, and offers incomparable scenery and a unique environment where it's possible to find fanciful tufa towers, volcanoes, and deep-blue water. It's also long been a key feeding and resting station for migrating birds.

In 1941, the Los Angeles Department of Water and Power began diverting Mono Lake's tributary streams 350 miles (563km) south to meet the growing water demands of Los Angeles. Deprived of its freshwater sources, the volume of Mono Lake was cut in half, while its salinity doubled. Unable to adapt to these changing conditions within such a short period of time, the ecosystem began to collapse. The lake dropped over 50ft (15m).

It was the last day's shooting for Khanfar after a three-week journey through the region. "I do not go to Mono Lake only to take photographs," he says. "Many times I have gone there to write my poetry and to put down my thoughts." While writing and reflecting on his journey, the weather started to change, and the temperature began to drop rapidly. He went back to his car to get his jacket, and then noticed the moon on the horizon. "Landscape photographers should always scan the landscape for the unusual with a ready mind and heart," he says.

Realizing that he was confronted with a great picture opportunity, he got into his car and drove to the west side of the lake, to a location that he had visited before. He parked his car, unpacked his tripod, and loaded his large-format camera. Then, and only then, he discovered that he had only one plate left from his long trip. He hiked to the edge of the lake, set up, composed with his eyes, then his camera, focused, metered and waited.

He could see the colors changing, the lake becoming calmer and the moon rising, and the whole scene became magical. "Take the time and let the heart tell you when all the elements are perfectly integrated with the whole," he explains. "When you reach that point, make your exposure."

Linhof 2000 4x5in camera, Nikkor 210mm lens, Fujifilm Velvia

Yousef Khanfar

A Palestinian born and raised in Kuwait, as a young boy Yousef Khanfar grew to understand the reality of war. At a time when there was so much anger and discontent being generated by the unrest in the Middle East, photography offered him a release from conflict.

His interest was sparked by the gift of a camera from his father at the age of six. Khanfar began at once to take photographs, eagerly developing them in the darkroom. He related his photography to the struggle his people were experiencing: "I needed a voice to express my feeling and photography gave me that voice," he says. "I chose to carry my camera instead of a gun, to tell my story and to promote peace around the world."

By the time he was 18, Khanfar had moved to the United States, and was not only delighted by the boundless energy and optimism of his new home country, but as an aspiring landscape photographer found himself enchanted by the scale and variety of the subjects that were now offered to him. With complete self-belief he set about his task, and spent the next 20 years producing a set of pictures that has been described by Ken Whitmire, President of the International Photography Hall of Fame and Museum, as "a breathtaking and dazzling body of work".

Khanfar's philosophy on photography is very simple, "Great images must come from within, from the heart, with feeling," he says. He composes his images with a classicist's discerning eye, looking for simplicity, order and balance. "To be a good landscape photographer you must be a student of nature," he believes. "You must study the land, the light, the elements, the seasons. And you must work with the elements of nature, not against them. Many photographers spend too much time worrying about what the right camera, lens, or film is to use. Instead they should think about what they are trying to say and convey."

He sees the art of landscape photography as being akin to a tripod. "One leg represents the visual idea," he says, "the second is your personal perception of how to realize that idea and the third is the technical know-how to carry it through. Each leg should support the others – remove one leg and the whole collapses. The camera for the photographer should be no more than just another tool. It is like a violin to a musician or a brush to a painter. It is up to the artist to create art, not the tool."

Khanfar is intimately acquainted with the workings of the Linhof Master Technica 2000 5x4in camera, which he purchased direct from the manufacturer in Germany. He shoots most of his work using just three key lenses, all of which are Nikon: a 75mm wide-angle, a 360mm telephoto and a 210mm that he uses as his standard lens.

The only filters that he owns are a polarizer and a neutral density grad, and his film is exclusively Fujifilm Velvia. "I think the brand of film that you use is less important than getting to know it really well," he says. "Obviously you should choose a film with characteristics that match what you are trying to say. Perhaps a fast, grainy film if you want a romantic feel, or a slow, saturated film if color and clarity is your aim. But once you've decided on a film type, it's important to stick to it so that you understand intimately how it will react."

Still driven by a desire for peace, he uses photography as his language to communicate his feeling and emotion to his audience. In 1997 he was the first Palestinian photographer ever to have a one-man exhibition in the International Photography Hall of Fame. A year later he was appointed as the Exhibits Chairman, becoming one of the most respected and influential figures in the photographic community.

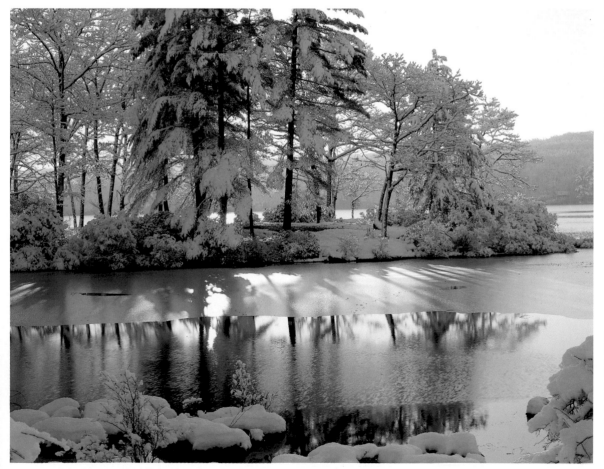

Bear Mountain State Park, New York, USA
As the warm and saturated first light of morning penetrated through the trees, Khanfar was in position to capture a picture that made great use of the reflective properties of the water and the snow.

Linhof 2000 4x5in camera, Nikkor 210mm lens, Fujifilm Velvia

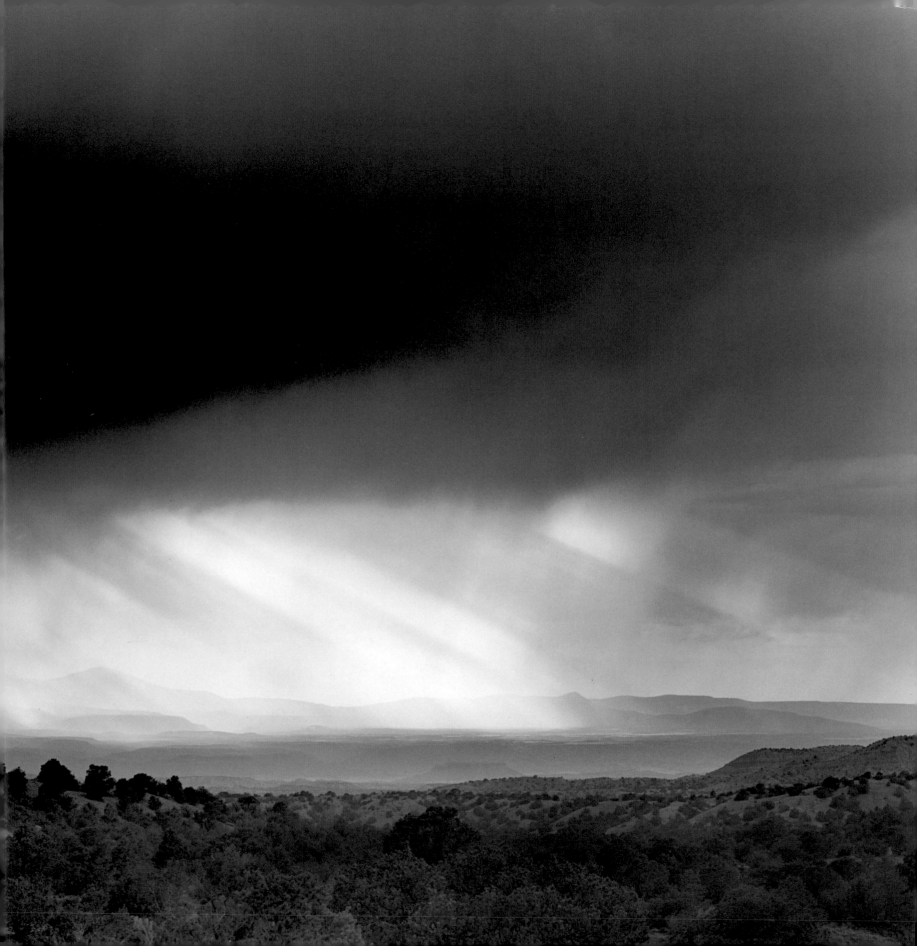

Storm over San Juan Mountains

"In 2000 I took a trip to Colorado and New Mexico and, such is the legacy of great photographers and images from that part of the world, I wasn't confident that I'd return with anything special. One evening, however, as it was starting to get dark, I was driving around and, as the clouds started to build, I saw this storm coming towards me. Sensing an opportunity I drove on and reached a vantage point on the side of a mountain in Santa Fe from which I could set up a picture that featured the San Juan Mountains in the background.

"The problem was that the mountains themselves were hardly visible because of the falling rain, but the clouds were moving so fast that, as I made my exposures, the situation was changing all the time. At times like this you honestly don't know what you are going to get, but I persevered and made about five exposures, and the picture here was the only one where the clouds had parted enough for the mountains behind to be visible, and this was crucial to the success of the picture. The light rays also contributed and, although I couldn't have predicted them appearing exactly as they did, I was pretty sure that something was going to happen, and I knew that it was worth being prepared.

"Landscape is like this; sometimes you have to wait hours for something to happen and at other times everything moves so quickly that you hardly have time to set up. In this case the storm had passed and the rain had stopped in around 15 to 20 minutes, and it was pretty much dark. The moment had gone, but I had made a memorable picture."

Deardorff 5x7in camera, 450mm lens, Kodak Tri-X

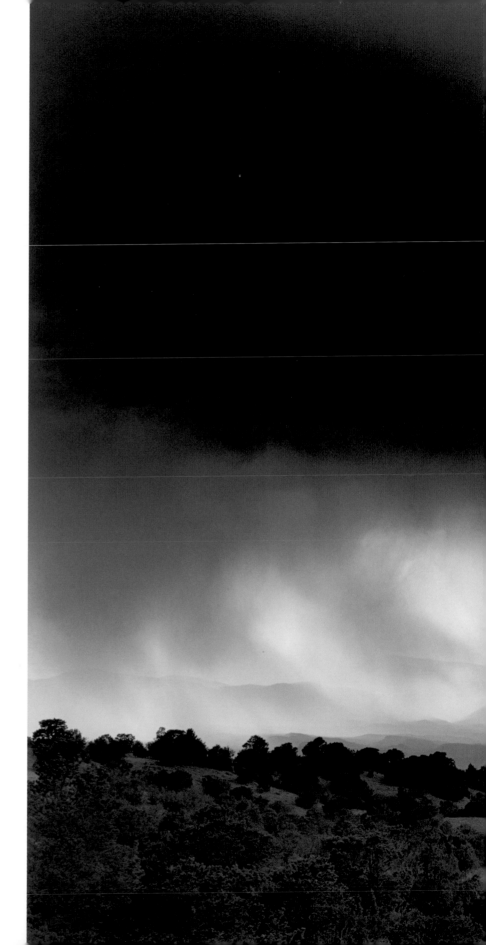

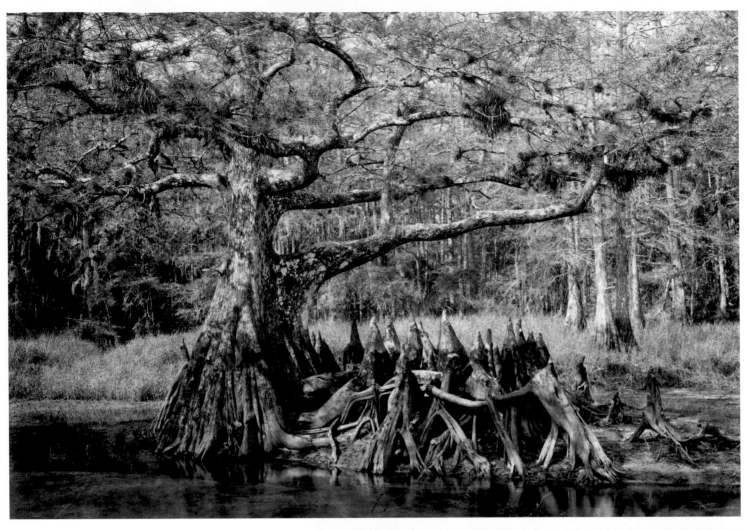

Fisheating Creek, Florida, USA
"This is a little freshwater creek situated in the Everglades, and the water levels here can be up to 7ft (2m) deep, depending on whether or not it's a dry time of year. I had seen these trees several times before, and every time their roots had been submerged, but on this occasion the level of the water had dropped to the point where they were fully visible. I thought that it made a picture but the late afternoon light was horrible. I came back the next day at daybreak and this time the light was exactly as I wanted it."

Deardorff 5x7in camera, 210mm lens, Kodak Tri-X

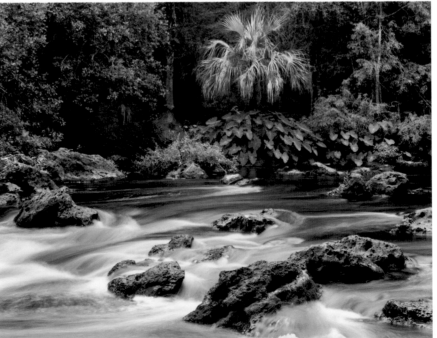

Loxhatchee River, Florida, USA
"The Loxhatchee River is the only wild and scenic river in Florida, and it starts in the Everglades and ends up in the Intercoastal Waterway, and then goes to the sea. This picture of its freshwater section was taken in the town of Jupiter, close to where I live, and it's a very evocative area with a Native American burial ground on the far bank. I set up the camera on a small rise so that it was elevated a few feet above the river itself."

Deardorff 5x7in camera, 210mm lens, Kodak Tri-X

Bob Hudak

Sally Gall

New York-based photographer Sally Gall approaches landscape from a fine art perspective. She is interested in capturing nature in all its variety; nature as a place of meditation and sensual beauty, both calm and threatening.

She was interested in art from an early age. "I harbored thoughts about becoming a painter," she says. "Photography didn't figure at that time because I didn't know anything about it, but there were various things that started to push me in this direction.

"Although I wanted to have a career that involved art, I didn't want to be isolated in a studio. I was part of a family that travelled a lot and I really enjoyed seeing different things and always took photographs wherever we went. That started to get me interested, and then, in my last year at high school, I learned how to develop film and to make black-and-white prints."

At art school, Gall majored in photography, and she eventually went on to teach the subject at the University of Houston. Throughout this period she was developing her fine art photography and raising her profile. To concentrate on this aspect of her career she moved to New York City in 1990. "To me, it was the centre of the art world," she says. "I already had gallery representation in New York, and I thought that it would help to be there."

To supplement her income she took on commercial work that built on her fine art sensibilities. "I was able to get editorial work from travel and outdoor magazines," she says, "plus other commissions that were landscape-related."

She spent seven years putting together a series of personal images that were published in 1995 as a book, *Water's Edge*. She backed this up with major exhibitions and looked for further projects that would be of interest. Her second book was highly individual; she decided to explore the transitional area around the mouth of caves where she felt there existed an interesting mixture of light and darkness.

"One afternoon hiking with my husband through a steamy jungle in Veracruz, Mexico, a downpour compelled us to duck for cover inside the mouth of a cave," she says. "With no flashlights, we groped inward, blinded by the dark. Once we were far enough in, I could begin to make out the vast, deep cavern within.

"Immediately I wanted to leave this place of almost palpable darkness, to run back out into the safety of the open landscape, despite the lashing rain. Somehow I restrained myself long enough to let my eyes begin to adjust to the eerie eclipse-like light. That was when I began to comprehend that I had left the horizon behind and entered the inner outdoors, where night and day coexist and boundaries disappear. I realized that what I was dimly seeing was just as much a part of the landscape as the mountain over top of it or the rain-drenched jungle. I took out my camera, focused, and began to look deeper into this hidden landscape."

She spent three years visiting caves and lava tubes in Thailand, California, and in the Yucatan Peninsula of Mexico and Belize, and she also photographed in ancient quarries and around the aqueducts of Italy and France. She worked throughout with available light that, on many occasions, was almost nonexistent.

"Almost always this meant hour-long exposures in light too low for the best light meter to register," she says. "Traditional tools and techniques that would have been helpful above ground were rendered useless and, when it came to calculating exposure times, I was reduced to guesses I could only verify in the darkroom. If a cloud moved across the face of the sun halfway through the exposure, for example, the subterranean light dropped and I had to recalculate, often adding hours to the exposure time needed to get a single shot."

The project was recently published as the book *Subterranea*, and also led to a major travelling exhibition. It was the latest step in a diverse and challenging career, which looks as though it will establish Gall as an important, much-collected photographic artist.

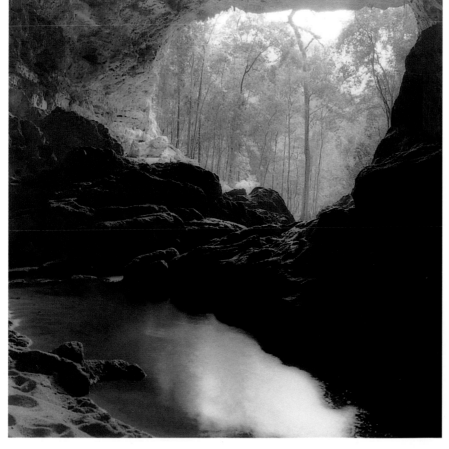

Oasis
"This is from the *Subterranea* series, and it was taken in Belize. I liked the sense of being indoors and outdoors at the same time; it's almost like a picture window that is full of trees."

Hasselblad 503CW, 60mm lens, Kodak Tri-X

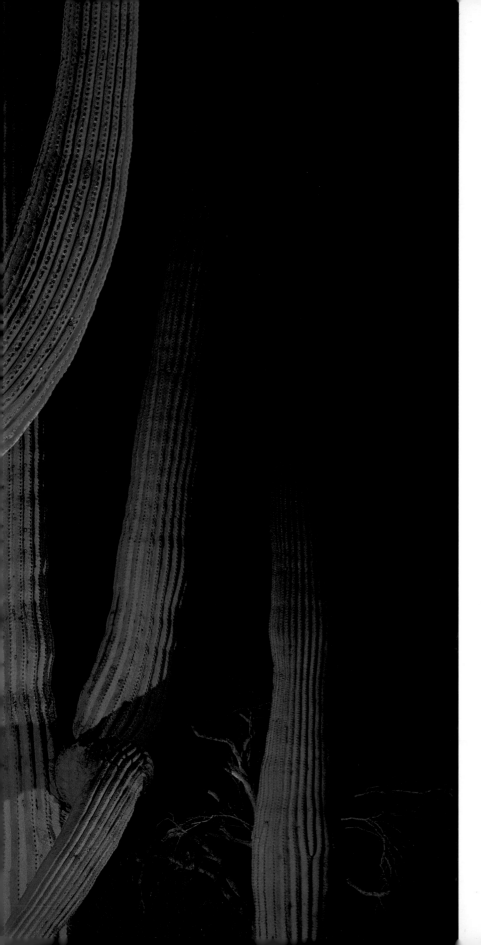

Saguaro cacti, Saguaro National Park, Arizona, USA
"My wife Claudia calls this image 'What Saguaros Do While We're Sleeping'. I think her title captures the mood of this image, and says something about the abundant personality of these giant cacti.

"Most people think of photographs as capturing a single moment. But an image like this is created over time like a painting. I start with a blank canvas of black, unexposed film, and then add light of different colors, from different angles, bit by bit, until I've created the image I've visualized. For this photograph I used a single flash as the light source. I covered the flash first with a magenta-colored gel filter to light the left side of the middle cactus. I then repositioned the flash, changed to a blue gel, and lit the right side of this same saguaro. I moved this same flash to 12 different positions, changing gels each time, to light the other cacti throughout the scene. The flash was on a light stand, and I sometimes had to hide the flash and stand behind one of the cacti so it wouldn't be visible from the camera position. Each pop of the flash was made as a separate exposure on the same piece of film."

Mamiya 645, 150mm lens, Fujichrome Provia 100 pushed one stop, Norman 400B flash with colored gels, Flash triggered by a Wein Ultra Slave, 120 exposures on the same piece of film, each 1/60 sec, with apertures varying between f/8 and f/16

Michael Frye

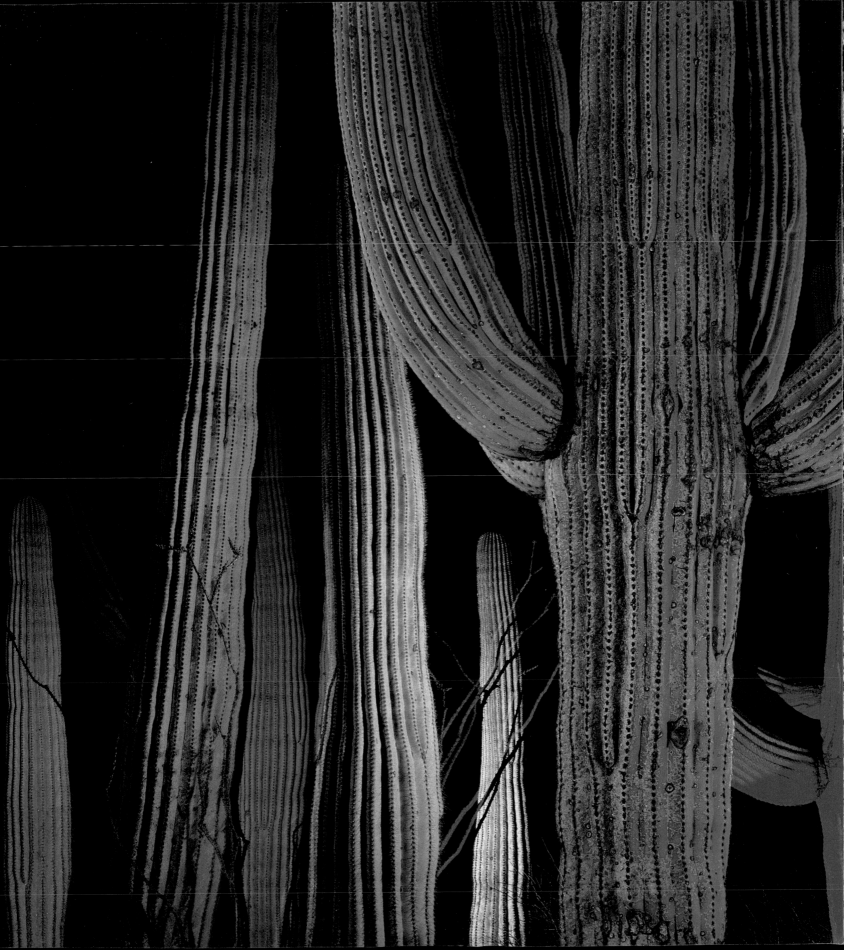

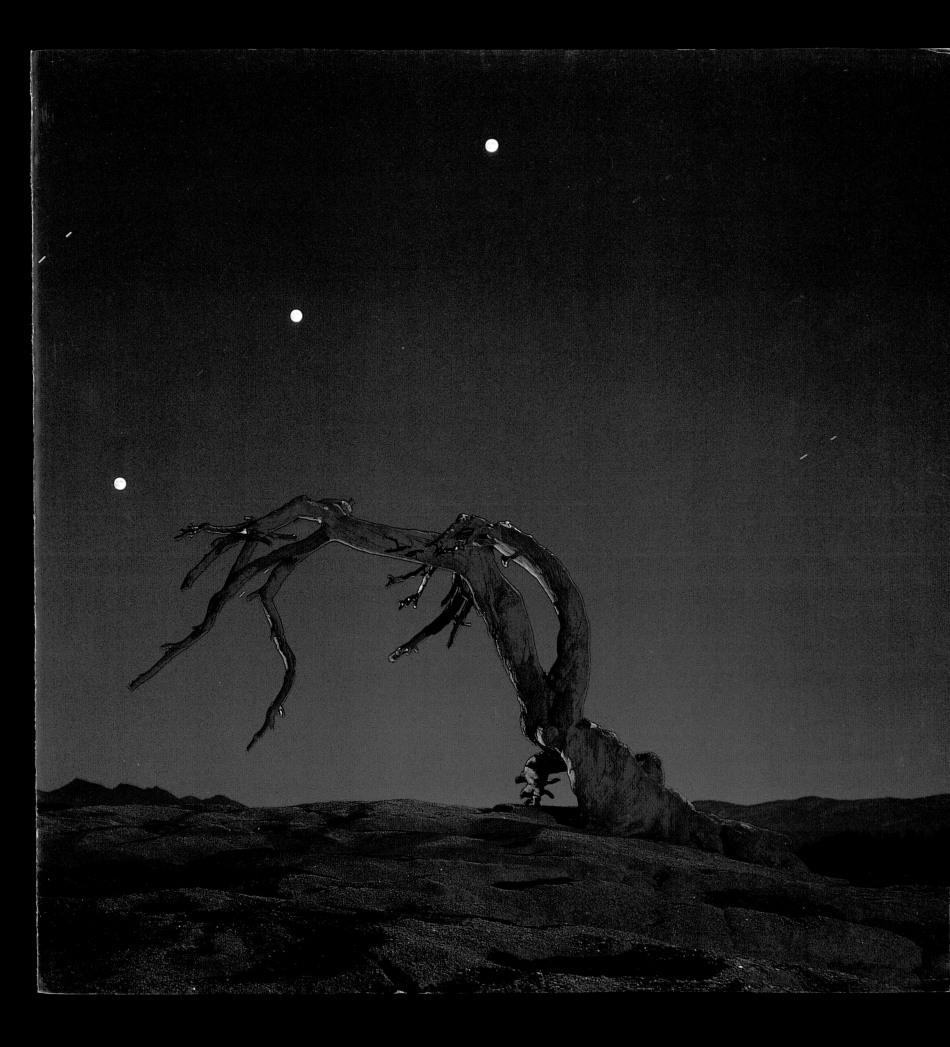